Giuseppe Maria Crespi and the Emergence of Genre Painting in Italy

by John T. Spike

with essays by
Mira Pajes Merriman
and
Giovanna Perini

Centro Di
Kimbell Art Museum
Fort Worth

This catalogue is published on the occasion of an exhibition of paintings shown exclusively at the Kimbell Art Museum, Fort Worth, September 20 - December 7, 1986.

Giuseppe Maria Crespi and the Emergence of Genre Painting in Italy was organized by the Kimbell Art Museum and supported by a federal indemnity from the Federal Council on the Arts and Humanities.

Library of Congress Cataloging-in-Publication Data

Spike, John T.
Giuseppe Maria Crespi and the Emergence of Genre
Painting in Italy.

Exhibition held at the Kimbell Art Museum, Fort Worth,
Tex., Sept. 20-December 7, 1986.
Bibliography: p.
Includes index.
1. Crespi, Giuseppe Maria, 1665-1747—Exhibitions. 2.
Crespi, Giuseppe Maria, 1665-1747—Influence. 3. Genre
painting-18th century—Italy—Exhibitions.
I. Crespi, Giuseppe Maria, 1665-1747. II. Merriman, Mira
Pajes, 1932- . III. Perini, Giovanna. IV. Kimbell Art
Museum. V. Title.
ND623.C799A4 1986 759.5 86-20057

ISBN 0-912804-24-6
ISBN 0-912804-25-4 (pbk.)

Centro Di catalogue number 205
Designed by Matilde Contri, Centro Di
della Edifimi srl, Florence
Text editor: William B. Jordan

Typeset by Linograf snc, Florence
Photolito by Mani snc, Florence
Printed and bound in Italy by Officine Grafiche
Fratelli Stianti spa, Florence 1986

Cover illustration: Giuseppe Maria Crespi, 1665-1747
The Lute Player (detail)
Museum of Fine Arts, Boston
Cat. no. 5

CONTENTS

Austria
Salzburg: Salzburger Landessammlungen
Vienna: Kunsthistorisches Museum, Gemäldegalerie

Federal Republic of Germany
Berlin: Staatliche Museen Preussischer Kulturbesitz,
Gemäldegalerie
Stuttgart: Staatsgalerie

France
Paris: Galerie Cailleux
Paris: Musée du Louvre

German Democratic Republic
Dresden: Staatliche Kunstsammlungen,
Gemäldegalerie Alte Meister

Great Britain
Birmingham: Birmingham Museum and Art Gallery
London: Harari and Johns Ltd.
London: H.M. Queen Elizabeth II, Windsor Castle
London: Sir Denis Mahon
London: The National Gallery

Ireland
Dublin: The National Gallery of Ireland

Italy
Bassano del Grappa: Museo Civico
Bologna: Collezioni Comunali d'Arte
Bologna: Collezioni d'Arte della Cassa di Risparmio
Bologna: Pinacoteca Nazionale
Bologna: Private collection
Florence: Galleria degli Uffizi
Milan: Pinacoteca di Brera
Rome: Museo del Palazzo di Venezia
Turin: Galleria Sabauda
Venice: Ca' Rezzonico
Venice: Fondazione Scientifica Querini Stampalia

Switzerland
Lugano: Thyssen-Bornemisza Collection

The United States of America
Baltimore: Walters Art Gallery
Boston: Museum of Fine Arts
Chicago: The Art Institute of Chicago
Coral Gables: Lowe Art Museum, University of Miami
El Paso: El Paso Museum of Art
Hartford: Wadsworth Atheneum
Malibu: J. Paul Getty Museum
Millbrook: Pamela Askew
New York: Alan E. Salz
New York: Private collections
New York: Suida-Manning Collection
Norfolk: The Chrysler Museum
Raleigh: North Carolina Museum of Art
Washington: National Gallery of Art

The role of the art museum as a publisher of scholarly books has grown enormously in the past two decades as the quantity and quality of international loan exhibitions have increased. Although the Kimbell Art Museum has hosted important traveling exhibitions since shortly after its opening in 1972, it was not until ten years later that it organized the first loan exhibition of its own. The initial stimulus to do so was provided by specific works of art, either long held and valued in the collection, or recently added to it, by artists who deserved further study. Thus two exhibitions presented in 1982 had their roots in the Kimbell's own collection — *Elisabeth Louise Vigée Le Brun* and *Jusepe de Ribera: Lo Spagnoletto.* Both of these were accompanied by scholarly catalogues that made significant contributions to the literature on the artists. Other exhibitions organized by the Museum in the past four years — including *The Art of Gianlorenzo Bernini: Selected Sculpture* (1982); *The Great Age of Japanese Buddhist Sculpture: A.D. 600-1300* (1982); *Henri Matisse: Painter/Sculptor* (1984); and *Spanish Still Life in the Golden Age: 1600-1650* (1985) — were generated because of particular expertise among the Museum's curatorial staff, and their catalogues remain in demand long after the exhibitions have closed.

Giuseppe Maria Crespi and the Emergence of Genre Painting in Italy is an exhibition inspired by a work added to the Kimbell collection in 1984. While intended to provide a context for the appreciation of this exquisite oil on copper, entitled *The Nurture of Jupiter,* it actually fulfills the much larger role of introducing to the American public for the first time the work of the most innovative and sophisticated Bolognese painter of the first half of the eighteenth century. Since *The Nurture of Jupiter* is not a genre painting, the exhibition was conceived to trace the artist's entire development and range of subject matter, as well as to document the impact of one important aspect of his career upon the work of other Italians of his century — Giambattista Piazzetta, Pietro Longhi, and Giacomo Ceruti.

The representation of everyday subjects became fairly widespread in Italian painting during the seventeenth century, but it was officially frowned upon, and the chief practitioners were minor masters — in particular the Netherlandish painters resident in Rome known as the Bamboccianti. In marked contrast, the eighteenth century witnessed a flowering of interest in and an acceptance of genre painting by great artists in Italy. This movement, in retrospect, seems all the more brilliant for its evocation of the decorative and social preoccupations of the Rococo Age.

This exhibition establishes Giuseppe Maria Crespi as a prime mover behind this transformation of taste. The leading artist in Bologna at the turn of the eighteenth century, Crespi defied the anti-genre strictures of prevailing artistic theory. Paintings of his countrymen at work at their trades, or relaxing in their popular festivals, became integral to his oeuvre. His fresh approach to a wide variety of subject matter — genre scenes, history paintings, still lifes, religious themes and mythologies — reveals a sensitivity and a tenderness nourished by a profound understanding of human nature and an interest in the everyday lives of men and women. Crespi exercised a decisive influence in eighteenth-century Italy and enjoyed major patronage in Bologna, Venice, Rome, and Florence, where he was particularly favored by Grand Duke Ferdinand de' Medici. He also attracted an international clientele and received commissions from important German, French, and English collectors.

Crespi's influence was widely felt by other major artists. G.B. Piazzetta and Pietro Longhi made their way from Venice to study the older painter's works in Bologna. Piazzetta, a profound master of religious subject matter, is also considered the founder of genre painting in Venice. Longhi devoted his entire career to intimate views of drawing rooms, both humble and magnificent, and brought genre painting into the forefront of Venetian culture during the eighteenth century. Giacomo Ceruti, the great Lombard master, was not directly influenced by Crespi but shared many of his concerns, dividing his production between portraits of his comfortable patrons and incisive yet sympathetic depictions of the urban poor of his day. Artists of lesser stature, such as Giuseppe Gambarini and Gaetano Gandolfi, were also affected by Crespi's art and are examined in the exhibition as well. This catalogue provides the first extensive treatment of the subject in English.

This exhibition was conceived by Edmund P. Pillsbury, Director of the Kimbell Art Museum. Its organization was undertaken on behalf of the Museum by John T. Spike, noted New York historian of Italian art. Dr. Spike selected the works to be exhibited, wrote the catalogue entries and the introductory essay on the artist's development. We wish to express our deep appreciation of his excellent work.

It is a pleasure also to acknowledge the contributions of two other scholars. Mira Pajes Merriman, Professor of Art History, Wichita State University, and author of the definitive catalogue raisonné of Crespi's oeuvre, also conferred on the selection of loans and wrote an outstanding essay on the development of genre painting in Italy. Her generous cooperation, including the loan of many of her personal photographs, was essential to the realization of the exhibition and catalogue. Dottoressa Giovanna Perini, a widely-published younger scholar of Italian art, took an active interest in the project from an early stage and contributed to the catalogue a fresh and

comprehensive documentary account entitled "Genre Painting in Eighteenth-Century North Italian Art Collections and Art Literature."

It was a privilege for us to work with Alessandra Marchi Pandolfini and Gerd Olsson of Centro Di in Florence, our collaborators on the publication of the catalogue. They provided invaluable assistance in editorial matters and in obtaining photographs from Italian sources. Our collaboration was in every respect a satisfying and pleasurable one.

Lastly, we wish to thank the lenders to the exhibition, without whose generous cooperation it would have been impossible. It is hoped that the assembling of these works and the collective thoughts of the authors of the catalogue will result in a lasting contribution to our understanding of Italian painting in the eighteenth century.

William B. Jordan
Deputy Director, Kimbell Art Museum

Reclusive, proud, and obstinate, the Bolognese painter Giuseppe Maria Crespi (1665-1747) was one of the most independent and forceful personalities in Italian art during the first decades of the eighteenth century. Crespi's reputation is hardly known in the United States, and it is one of the objectives of this exhibition and publication to call attention to several important works by him that are in American collections. Since 1948, paintings by Giuseppe Maria Crespi have been exhibited and studied on a number of occasions in the museums of his native Bologna;[1] *Giuseppe Maria Crespi and the Emergence of Genre Painting in Italy* is the first time that a major selection of his works has been shown outside of Italy.

To use the phraseology of his own time, Crespi was a "universal painter" (meaning "versatile"), who worked with ease in a wide range of subject matter — from historical to sacred and from genre paintings to portraits. And he gave form in his pictures, regardless of their subjects, to an acute vision of reality transmitted to the canvas, paradoxically it would seem, with an unbridled freedom of expression and brushwork.[2] Crespi was a supremely natural painter in the sense that his figures and their actions are observed from life. However, he was not an illusionistic painter, as Jusepe de Ribera was, because his brush and palette always fulfill expressive roles.

This exhibition has a twofold objective: in the first place, we wish to celebrate Crespi's personal achievements as an artist; secondly, we intend to examine Crespi's importance for the "emergence" of genre painting in eighteenth-century Italy. The thirty-five paintings by Crespi in this exhibition constitute about a tenth of the artist's known works, and have been selected to suggest the profile of his artistic development.[3] In order to assess the impact of his art in his own time, about twenty paintings by five other masters — all younger than Crespi — have been juxtaposed to his works.

Perhaps the most radical manifestation of Crespi's artistic independence lay in his insistence on genre painting as an essential aspect of his life's work, a practice which set him apart from contemporary Italian masters of the first rank. Both Piazzetta and Longhi traveled as students to Bologna in order to learn from Crespi; in this exhibition, the genre paintings of these masters are compared for the first time. Crespi's influence on genre painting in his native Bologna is represented in this show in works by Giuseppe Gambarini and Gaetano Gandolfi. During the latter half of the 1730s, as Crespi's activity was drawing undiminished to its close, a painter from Lombardy, Giacomo Ceruti, was active in Venice and began to render the daily life of the poor in paintings that are among the most profound statements on the human condition that that century produced.

Ceruti's training was not linked to Crespi. The latter's sources lay in Bologna and Emilia in central Italy, while Ceruti drew upon the naturalistic impulses of his native Lombardy, the same ones that gave rise to Michelangelo da Caravaggio at the end of the 1500s. Indeed, in 1762 a great connoisseur of that day, Count Francesco Algarotti, pointed out (in his *Saggio sopra la pittura*) that Caravaggio and Crespi shared similar attitudes towards nature, as did two other artists with specific relationships with Crespi, namely Guercino (the early style prior to the Roman sojourn, 1621-1623), who was Crespi's inspiration, and Giambattista Piazzetta, his adherent.[4] Ceruti would have seen paintings by Crespi in the leading collections in Venice and several important altarpieces in Bergamo. Could he have seen (in copies) Crespi's *Seven Sacraments* now in Dresden? The comparison on this occasion of Crespi's *Confirmation* with Ceruti's *Group of Beggars* (cat. no. 46) gives rise to the question. Finally, however, Ceruti is represented in this show because he succeeds Crespi as the most sympathetic observer of man as a creature who possesses qualities apart from his social status. As such, both artists are spiritual antecedents of Goya.

John T. Spike

1) The principal of these have been the *Mostra celebrativa di Giuseppe Maria Crespi*, Palazzo Comunale, 1948; *Maestri della pittura del seicento emiliano*, Palazzo dell'Archiginnasio, 1959; *Natura ed espressione nell'arte bolognese-emiliana*, Palazzo dell'Archiginnasio, 1970; and *L'arte del settecento emiliano, la pittura, l'Accademia Clementina*, Palazzo del Podestà e di Re Enzo, 1979.

2) This paradox is at the core of Emilian art, as was brilliantly argued by Francesco Arcangeli in *Natura ed espressione nell'arte bolognese-emiliana*, Bologna, 1970.

3) This estimate of the total oeuvre is based on the catalogue raisonné compiled by Mira Pajes Merriman, *Giuseppe Maria Crespi*, Milan, 1980. Professor Merriman's fully-illustrated catalogue is the essential point of departure of any study of Crespi; in addition to its documentation of individual paintings, the text includes valuable essays on the artist's biography, development, and genre paintings, among other topics, to which the reader is referred for information beyond the scope of this exhibition catalogue.

4) Algarotti, 1779, p. 211. Luigi Crespi, 1769, p. 208, attempts to rebut Algarotti without mentioning him by name. He makes his oblique reference to Algarotti's *Saggio sopra la pittura* in an edition of 1756; Schlosser (*La letteratura artistica*, ed. 1977) does not cite any editions earlier than 1762.

The exhibition *Giuseppe Maria Crespi and the Emergence of Genre Painting in Italy* has been more than three years in the making. As is well known, international loan shows are collaborative efforts that call upon the assistance of the professional staffs of museums and libraries in many countries, not to mention the generosity of private collectors. I would like to take this occasion to express my personal debts of gratitude, as completely as I can, to the following persons who contributed to the successful organization of this show. First, and above all, the many lenders to the exhibition must be credited for making the treasures in their care available for study. It is our hope that the success of this exhibition will repay their expressions of support.

During the preparation of this exhibition, I have been in constant correspondence with museum colleagues in Italy, England, and the United States; from their kindnesses, I have benefited again and again. The lending collections are listed separately, but within those institutions, and in other roles, many people have taken part: Luisa Arrigoni, M.V. Attrill, James Barber, Bernard Barryte, Dante Bernini, Robert P. Bergman, Alessandro Bettagno, Suzanne Boorsch, Edgar Peters Bowron, Giorgio Busetto, Jean Cadogan, Gian Carlo Cavalli, Caterina Caneva, Anna Ottani Cavina, Marco Chiarini, Giorgio Ciolli, Piero Corsini, Italo Faldi, Oreste Ferrari, Laura Giles, Alain Goldrach, Marco Grassi, Mary Jane Harris, Gregory Hedberg, William J. Hennessey, George Hersey, Anna Maria Maetzke, Paul Magriel, Denis Mahon, Pietro Marani, Alessandra Marchi, Ettore Merkel, Oliver Millar, Jennifer Montagu, Gottfried Mraz, Otto Naumann (who encouraged me in the first place to address the subject of Italian genre painting), D. Stephen Pepper, Wolfgang Prohaska, Fernando Rigon, Giandomenico Romanelli, Giovanni Romano, Pierre Rosenberg, Erich Schleier, Thomas M. Schneider, Gregorio Sciltian (†), Leonard P. Sipiora, Nicola Spinosa, Timothy J. Standring, David W. Steadman, Julien Stock (who kindly called my attention to the prints after paintings by Crespi in the Cottonian Collection of the Plymouth City Art Gallery & Museum), Walter L. Strauss, Claudio Strinati, Peter C. Sutton, Rosalba Tardito, Nicholas Turner, Francesco Valcanover, Franca Varignana, Malcolm Waddingham, Roger Ward, Eric M. Zafran.

Our project from its inception enjoyed the encouragement of Andrea Emiliani, whose scholarship of Bolognese painting has long been an inspiration to others, and whose consultation was invaluable to the realization of this exhibition. My researches for the catalogue were undertaken at the Frick Art Reference Library, the New York Public Library, and in the Jane Watson Irwin Study Center of the Thomas J. Watson Library of the Metropolitan Museum of Art, New York; the Witt Library, Courtauld Institute, London; Bibliotheca Hertziana, Rome; and in the Kunsthistorisches Institut in Florence, to whose director, Gerhard Ewald, I would like to express my thanks for inviting me to stay at the foresteria during one of my visits to Florence. I conducted archival research in the Archivio di Stato, Bologna, and the Archivio di Stato, Florence. For many courtesies, I am indebted to the professional staffs of all these institutions.

I owe a singular debt of gratitude to Tiziana Di Zio of the Archivio di Stato, Bologna, for her collaboration on my Crespi researches in the Bologna archives. Dott.ssa Di Zio was instrumental in locating the Bologna documents published in this catalogue, and she very kindly (and patiently) corrected my transcriptions of the original manuscripts.

My studies for this publication have leaned heavily on the contributions of three major works of scholarship to which I would like to pay particular homage. First, of course, is Mira Pajes Merriman's invaluable catalogue raisonné of paintings by Giuseppe Maria Crespi (1980). Professor Merriman was also ever ready to help me in my research. I found two other texts of constant importance to my research, both of them familiar titles to students in this field: *Patrons and Painters* by Francis Haskell (1963; 2nd ed. 1980); *Pittura bolognese 1650-1800. Dal Cignani ai Gandolfi* by Renato Roli (1977).

The staff of the Kimbell Art Museum is known for its distinguished record of professionalism: special thanks to Karen King, Peggy Buchanan, Helen Pallas-Viola and Margaret Booher. It has been a privilege to be associated with this museum. I am grateful to Edmund P. Pillsbury, Director, for the invitation to undertake the selection and organization of the show. William B. Jordan, Deputy Director, has been committed to this project from its inception, and he took in hand the final editing of this publication. This has been throughout an enjoyable and instructive association for me.

Finally, I would like to thank my beloved wife, Michele, and son, Nicholas, for their patience and encouragement during my travels abroad and late-night hours of writing. Michele Spike edited my first draft and compiled my bibliography for this book.

J.T.S.

When Giuseppe Maria Crespi began his career during the 1680s, the contemporary critics on art were unanimous on one point: paintings of genre subjects – that is, of incidents of daily life and labor – were unworthy intruders into the pantheon of art. The depiction of daily life in the tavern or before the hearth, in the countryside or at the marketplace, had come to be the speciality of minor masters, in particular the Netherlandish painters called (disparagingly) the "Bamboccianti." In marked contrast, the eighteenth century witnessed a flowering of genre painting in Italy as practiced by the leading masters. Under the impetus of Giambattista Piazzetta and Pietro Longhi, genre painting was brought into the forefront of Venetian culture and was regarded even by contemporaries as among the most brilliant manifestations of the Age of Enlightenment. Crespi lived to see this development and rightly deserves recognition for his contribution to this reversal of taste.

The painting of incidents and personalities from everyday life was widespread in antiquity but mostly neglected in European art until the sixteenth century.[1] In Italy the new interest in genre painting took a decisive step forward in the 1570s with the plentiful market and kitchen scenes produced (usually under the guise of allegories of the seasons and senses) by the dal Ponte family in Bassano and by Vincenzo Campi in Cremona.[2] During the last two decades of the sixteenth century, the youthful experiments of the three Carracci in Bologna, but especially those of Annibale, and of Michelangelo da Caravaggio in Rome, established the outlines of genre painting for the whole of the seventeenth century.

Rome, Raphael, and antiquity made classicists of Annibale and his students following his relocation from Bologna in 1594. With the demise of Caravaggesque painting in the 1630s, genre subjects ceased to be recognized as viable avenues for the creation of important works of art. Mattia Preti had been the last Italian to make a strong effort, and the Frenchman Valentin de Boulogne had been the last Caravaggesque painter to succeed. The depiction of ordinary people in commonplace settings (taverns, courtyards, country fairs, carnivals, and pastures) became the exclusive domain of the painters who were influenced by Pieter van Laer, nicknamed "Il Bamboccio" ("puppet, doll" stemming from his deformed physique).[3] Van Laer was a Dutch painter who arrived in Rome during the mid-1620s and attracted in the next decade a considerable circle of followers, mostly Netherlanders. These painters were universally known as the Bamboccianti, and the related word "bambocciate" came to be used by contemporaries to identify their paintings. For almost the balance of the century, the charming, unpretentious canvases of several generations of Bamboccianti were disparaged by the major masters of the time, although they were avidly acquired by

collectors. From the ranks of the Bamboccianti only one artist emerged who is today considered to have been of the very first order: the Fleming Michiel Sweerts. However, Sweerts did not enjoy particular recognition in his own day.[4]

In the 1680s, Bologna rivaled Rome as the most prestigious school of painting in the world. In the eyes of the classicist critics (whose points of view were the only ones seen in print), artistic legitimacy was a factor of master-pupil lineage. Critical approval in both of these cities was forthcoming if an artist could claim descent from the schools founded in Bologna and in Rome during the 1590s by Annibale, Agostino, and Ludovico Carracci. The antithetical current in seventeenth-century art, the Baroque, had scarcely been seen in Bologna since the latter 1620s, when the free-spirited Guercino made his definitive conversion to the classical orientation of Guido Reni, likewise a Carraccesque painter. In Rome, in 1672, it was somehow conceivable for G.P. Bellori to publish his lives of the most eminent Roman artists without mention of Gian Lorenzo Bernini or Pietro da Cortona. In the 1680s, the Roman school was presided over by Carlo Maratti, whose master, Andrea Sacchi, was descended from Annibale Carracci through Francesco Albani. At the same time, Carlo Cignani held sway over Bolognese painting and did so into the next century, and his prize student, Marcantonio Franceschini, was just making the first steps of a triumphant career. We see in Bologna the same pattern as in Rome: Cignani had inherited the Carraccesque mantle from Francesco Albani following Albani's return to Bologna.

In 1678, the leading critic in Bologna, Count Carlo Cesare Malvasia, published in his *Felsina pittrice* (the lives of the Bolognese painters) an exchange of letters between Sacchi in Rome and his old professor, Albani, in Bologna. In making public this correspondence from 1651, Malvasia did his part to perpetuate the disapproval that these two masters of the grand manner heaped on the Bamboccianti, blaming on them the "unhappy state of painting, since at most there remained only six painters in Europe, with all of the Bamboccianti against them, like pigmies pissing on the feet of a giant."[5] The classicizing painters may have been jealous of any monies spent elsewhere, but they need not have lamented the status quo, since the authority of the Carraccesque academy was unchallenged.

Even in polyglot Rome, an academic conception of art was pervasive during the 1680s, when Crespi stood at the threshold of his career. It is surprising to read the negative judgments on Rembrandt made by Abraham Breughel in a letter of 1665 to Antonio Ruffo, his patron in Messina. The story of how Ruffo commissioned Guercino and Preti to paint each a half-length figure as pendants to a canvas by Rembrandt has been often told. Informed by Ruffo of his dissatisfaction that the pictures by Guercino and

Preti did not suit the Rembrandt, Breughel, a transplanted Fleming and a still-life specialist no less, could only conclude that "the paintings by Rembrandt are not greatly valued here; it is true that the pictures of heads are fine, but one can spend one's money better in Rome."[6] And in another letter, Breughel explained the Roman point of view in more detail:

I see that your excellency has had made some half-length figures by the best painters in Italy, and that none of these equals that by Rymbrant [Rembrandt]. I can agree with this, but one has to consider that the great painters, such as those your excellency has employed, are reluctant to apply themselves to the bagatelle of a half-length, clothed figure, of which only the point of the nose is illuminated, with everything else left in the dark. The great painters study in order to represent a beautiful nude, in which one can see the intelligence of the draftsmanship; on the contrary, an ignorant painter [read: Rembrandt] seeks to cover everything with clumsy, dark draperies, and thus conceal the contours. This sort of painter, who practices one kind of painting only, for instance portraits, is not counted in the ranks of painters. Once someone came to Pietro da Cortona, and said, 'I would like to have my portrait done, as well as a picture of flowers.' Sig. Pietro replied, 'Go to those who make such things, not to me. These are not things for great men, to concern themselves with such bagatelles, which can be done by almost anyone.'[7]

For our purposes, the testimonies of Sacchi, Albani, and Abraham Breughel serve to point up the dichotomy that was widely perceived in Bologna and Rome to exist between the highest aspirations of Italian art and the naturalistic painting that the Northern Europeans had imported. There did not seem any possibility for a young painter in Bologna during the 1680s to reconcile these divisions within his art and forge a major career. However, that is precisely what Giuseppe Maria Crespi proceeded to do.

The Life and Career of Giuseppe Maria Crespi

Crespi's career began quietly enough in his native Bologna about the year 1680.[8] His parents, Girolamo Crespi (or "Cresti")[9] and Isabella Cospi, were members of the middle class, although his mother may have been a distant relation of the noble Cospi family. The Cospi are best known to history as a Bolognese house with close ties to the Medici, Grand Dukes of Tuscany;[10] indeed, in January 1708, it was Count Vincenzo Ranuzzi Cospi who rescued the painter Crespi from the worst crisis of his career by providing him with a letter that enabled him to meet and obtain the assistance of Grand Prince Ferdinand de' Medici.

Crespi's father was not an artist: hardly remarkable in itself, but significant in retrospect, since Crespi thereby began his studies without any artistic prejudice. His cast of mind was such that he never acquired one. He was presumably about twelve years old when his father obliged his wishes and sent him to learn how to draw. The chosen painter, Angelo Michele Toni (1640-1708), is known today only for the distinction of having handed Crespi his first pencil. Toni appears to have been a professional copyist. If so, he made an impression of a kind on his pupil, because Crespi's studies during the 1680s consisted mainly of independent self-improvement through the painting of copies. (This regimen might seem unpromising, but he chose his models well, as we shall see.) After describing the extent and excellence of Crespi's copies from paintings by Federico Barocci, for one, the artist's principal biographer, Giampietro Zanotti (1739), concluded, somewhat amazed: "...and so pleasing was this study to him, that I think that he owes more of what he knows and does to this practice [of copying] than to any other."[11]

Sometime around 1680, having finished his time with Toni, young Giuseppe Maria Crespi joined those other students who went every day to the cloister of the monastery of S. Michele in Bosco in order to copy the figures in the grandiose frescoes depicting the life and miracles of Saint Benedict, painted in 1604-1606 by Ludovico Carracci and others. Every painter in Bologna practiced drawing at some time or other in front of these frescoes. In the case of Crespi, however, the qualities of Ludovico Carracci, and of the other masters of four generations earlier, impressed the young man so much that he evidently dedicated himself to the revival of the first manner of the Carracci, most notably the naturalistic styles of Annibale Carracci and G.F. Barbieri, Il Guercino, prior to their relocations to Rome (in 1594 and 1621-1623, respectively). Although Crespi would eventually study with Canuti, Cignani, and Burrini, and learn from each of them, he never became a full-fledged follower of any contemporary master. The students at the cloister gave nicknames to one another. Crespi was dubbed "lo Spagnuolo," "the Spaniard," on account of his plain and tight-fitting clothes. The sobriquet, often shortened to "lo Spagnolo" for ease of pronunciation, stuck with him for the rest of his life, almost to the exclusion of his proper name. When winter came, all the boys except for Crespi stopped coming to the open-air cloister. Zanotti tells the anecdote of how the monks took pity on him, and made a movable windbreak for him out of mats and similar rags (a *serraglio di stuoje*).[12] This curious apparatus attracted the attention one day of Domenico Maria Canuti, who stopped to look over Crespi's shoulder. Canuti was sufficiently impressed by Crespi's drawing, not to mention his ardor, to invite him to enter his studio. Crespi spent an unspecified time in Canuti's school, perhaps a year or two. He became the master's favorite, but lost patience with the petty persecutions of Canuti's envious nephews. Canuti was of the same generation as Carlo Cignani, but practiced a notably more

energetic art. He encouraged the young Crespi to look seriously at the proto-Baroque work of Ludovico Carracci.

In the early 1680s, Crespi was again unattached to a studio — as worrisome then as it is today for a painter who is not represented by a gallery. But the elder master Canuti (before his death in 1684) still helped the youth however he could, and even arranged with the abbot of S. Michele in Bosco a commission for Crespi to copy the entire cloister *de' Carracci* in small canvases. (Unfortunately, the frescoes had deteriorated at an alarming rate.) Once more, Crespi's copies at S. Michele in Bosco brought him unexpected opportunities. This time, two eminent visitors entered the cloister as Crespi sat at his easel. They were Carlo Maratti from Rome, accompanied by the Bolognese *caposcuola*, Carlo Cignani. After suggesting some corrections in the work, Maratti praised Crespi's talent and invited him to come to Rome in order to study with him. Crespi respectfully declined with the explanation that his father and family were dependent upon him. In the event, Crespi never visited Rome and never admitted any desire to do so. On the evidence of his art, he most likely did not believe that either Annibale or Guercino had improved themselves in the Eternal City.

Carlo Cignani was recently returned, in 1681, from prestigious assignments in Parma. Cignani now organized in his studio sessions for drawing from live models — an "*accademia del nudo*" which Crespi began to attend. Seeing his talent, Cignani admitted him into his school proper, where he remained for about two years, until late in 1686, when Cignani moved with his family to Forlì. During this time, Crespi is reported to have executed his first

1. Annibale Carracci, The Butcher Shop. *Kimbell Art Museum, Fort Worth, Texas.*

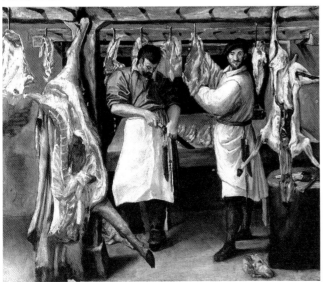

commissions for altarpieces. Beyond this, his biographer, Zanotti, confines his account of Crespi's activity in the mid-1680s to the recitation of the young man's numerous copies after the masterpieces of one hundred years before: the Carracci fresco cycles in the Magnani and Fava palaces; and the two famous altarpieces in the church of S. Gregorio by Annibale Carracci and Guercino, each of them early works in which these now-hallowed artists had set out, in the full vigor of youth, to confound the establishment of their own time. Crespi was still painting copies of Guercino's *Investiture of Saint William of Aquitaine* in 1708 and was sufficiently proud of his skill at it to send one to his new patron, Grand Prince Ferdinand de' Medici in Florence.[13] Cignani's departure for Forlì was greatly regretted by the Bolognese (who never forgot him: when the Accademia Clementina was founded twenty years later, Cignani was elected in absentia Principe for life), but the events that followed were of crucial importance for Crespi. Cignani's former studio was rented by Giovan Antonio Burrini, and Crespi accepted the opportunity to share the space with him. In 1687, there was no doubt but that Burrini (1656-1727) was the most promising new personality in the Bolognese school. A prize pupil of Canuti's, Burrini was only nine years older than Crespi, but he gave every sign that he could succeed his master as the foremost painter in fresco. During the first half of the 1680s, Burrini had painted, in the Villa Albergati in the countryside at Zola Predosi, a decorative cycle that surpassed any other of the time for its liveliness and wit.[14] During the two years that Crespi and Burrini shared a studio, the more experienced of the two may rarely have been at home, since he was continually occupied with frescoes in churches and public buildings in Bologna and in Turin.[15]

The freshest aspect of Burrini's style was his adoption of the deep colors and exuberant brushwork of Venetian Renaissance painting. His disposition evidently struck a chord in Crespi, who was well aware of course that Venice had provided a critical quotient in the development of Annibale Carracci's first style. There is much of Burrini's influence in the earliest surviving major painting by Crespi, the banquet *a là* Veronese, now in the Art Institute of Chicago (cat. no. 1).

Crespi painted this *Wedding at Cana* on commission for Giovanni Ricci, a wealthy merchant.[16] Burrini had made the introduction, and was most likely gratified when Ricci proposed to sponsor his friend. Zanotti, who wrote his biography of Crespi in close consultation with him, tells the story as follows:

They made an arrangement that Crespi would paint for Ricci whenever he had no other commission, and Ricci would buy the painting for a good price. If Ricci afterwards sold a painting, all of the proceeds would remit to Crespi. This pact remained in effect and was diligently observed by Ricci, just as it always pleased lo Spagnuolo to work for

him. As far as I know, such an honest and liberal procedure was never practiced by anyone else, and it was certainly to the infinite advantage of lo Spagnuolo, who never again wanted for money... For his part, Ricci derived no small profit, since countless works by lo Spagnuolo remained in his hands, as one can see [in 1739] in the possession of Antonio Marchesini, nephew and heir of Ricci, who is the proprietor of a very beautiful group of pictures and innumerable drawings.[17]

Ricci's patronage included provision for studies outside of Bologna. According to Luigi Crespi (1769), Ricci sent his father to Venice to see the paintings of Veronese, Titian, and Bassano, then to Parma to study Correggio and Parmigianino, and finally to the province of Umbria, where Federico Barocci had lived and worked.[18] In short, without any omissions, Giuseppe Maria Crespi faithfully re-created the formative voyages of Annibale Carracci during the 1570s and 1580s.

There were unforseen ramifications to his newfound security, ones that evidently entertained his patron and the public and that may have helped to foster his interest in genre painting. In the passage quoted above, Zanotti goes on to say, almost incredulously:

...lo Spagnuolo never again wanted for money, and he would make the stories and caprices that came into his imagination. Very often also he painted common things, representing the lowest occupations, and people who, born poor, must sustain themselves in serving the requirements of wealthy citizens.[19]

During the same period in which he painted the *Wedding at Cana*, ca. 1687-1688, Crespi made a sensation when he put on public view two paintings that Zanotti judged "highly imaginative, of great force, with many parts very vividly expressed.[20] One represented a coarse assemblage of laborers working a winepress, the other a butcher's shop, with many butchers engaged in their trade. The response to these "curiosities" was so favorable that Crespi was encouraged to paint two smaller versions. None of these four pictures can be traced today, but they may have been similar to the two vertical canvases of musicians and peasants in the collection of Denis Mahon, London (cat. nos. 10 and 11). It is a wonder that Zanotti did not associate Crespi's debut as a genre painter with the last Bolognese master to paint a bucher's shop, Annibale Carracci. Two treatments of the subject are known by him, a large picture at Christ Church, Oxford, and a small canvas in the Kimbell Art Museum (fig. 1). Annibale's activity as a genre painter during the 1580s has been often discussed: he painted several half-lengths of friends and acquaintances drinking wine or working in his studio, or just visiting. Annibale's drawings of domestic life are more numerous than his paintings and present an even wider range of such scenes (figs. 2, 3 and 4). Annibale had tapped an age-old current of Emilian naturalism that in his day had surfaced most recently in the fishmonger pictures of Bartolomeo Passarroti and even in drawings by Parmigianino, the high stylist of the Maniera (fig. 5). Genre subjects existed in Bolognese painting of the 1680s, but were confined to half-lengths of handsome youths and similarly picturesque types that were

2. *Annibale Carracci,* A Domestic Scene. *Pen and black ink and gray wash. The Metropolitan Museum of Art, New York, Gift of Mrs. Vincent Astor and Mrs. Charles Payson: Harris Brisbane Dick Fund and Rogers Fund.*
3. *Annibale Carracci,* Two Studies of a Boy and two of a Girl. *Red chalk heightened with white chalk on buff paper. The Metropolitan Museum of Art, New York, Harris Brisbane Dick Fund and Rogers Fund.*

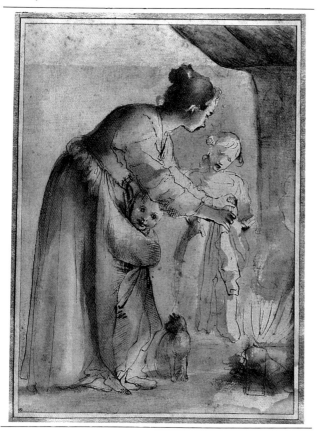

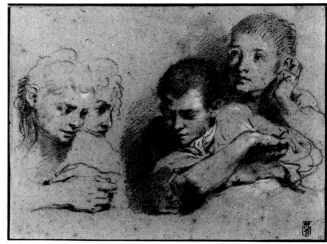

lacking any sort of naturalistic bite. Lorenzo Pasinelli and Giovan Antonio Burrini made plenty of these,[21] and Crespi's earliest essays undoubtedly included his share. Treatments of common people and scenes from real life can also be found in the informal media of prints and drawings (although mostly as caricatures), and some of Burrini's drawings could be cited for their likely encouragement to Crespi's interests in genre.[22]

At the end of the 1680s, we find Crespi again working independently and attending the life academy in the Palazzo Ghisilieri. Here he took many prizes for drawing, and in 1690 one of the directors, the eminent Count C.C. Malvasia, commissioned an altarpiece from Crespi. This painting, *The Temptation of Saint Anthony,* can still be seen *in situ* in the church of S. Nicolò degli Albari.[23] The composition and figure style owe the most to Crespi's former protector, Canuti, and Luigi Crespi commented aptly that "anyone would think that it had been done by one of the most celebrated pupils of the Carracci."[24] Crespi's mischievous sense of humor soon disaffected this important patron. One evening at the Ghisilieri academy, Crespi circulated a caricature of Malvasia in the likeness of a dead chicken.[25] He was expelled when his excuses did not satisfy the offended party.

His solution was to abandon Bologna and to depart immediately for Venice. He seems to have had a perfect confidence that he would be called home, and after a short time, Senator Ghisilieri came personally to collect him. However, he never again went to Malvasia's academy.

During the 1690s, Crespi worked on his own and attracted an increasingly prestigious clientele. During this decade, commissions came to him from no less a patron than Prince Eugene of Savoy, who was compiling a major collection and building magnificent residences in Vienna. Moreover, Crespi now gained assignments in competition with older masters, and more than once to the disadvantage of Burrini. Sadly, Crespi's former associate began to decline during this period, working quickly and not in his best manner, and, as high as Crespi's star had risen at the turn of the new century, Burrini's had quite faded away.

Crespi received relatively few commissions in his career to work in fresco. A contributing factor was his steadfast refusal to collaborate with specialists in *quadratura* (architectural illusionism), which was highly favored in Bologna.[26] But most significant perhaps was the lasting impression created by his frescoes in two rooms in the Palazzo Pepoli.[27] These

4. Annibale Carracci, The Chimney Sweep. *Pen and brown ink and wash on a yellowish brown ground. National Galleries of Scotland, Edinburgh.*

5. Francesco Mazzola, called Parmigianino, Peasant Woman Seated at a Table Kneading Dough. *Red chalk. Szépművészeti Múzeum, Budapest.*

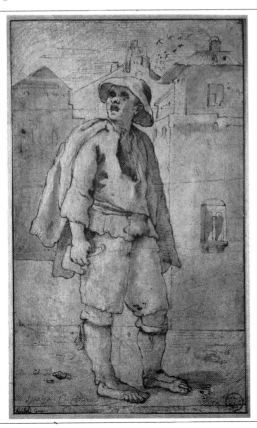

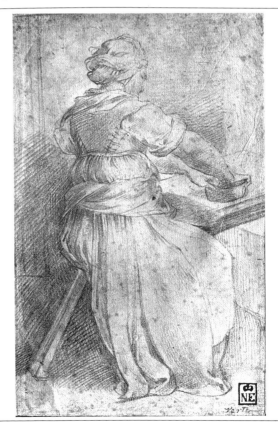

works must date from the 1690s, to judge from their affinities with his paintings for Prince Eugene of Savoy. Both of the vaults are painted with mythological subjects, invoking Olympus and Hercules, but neither is treated with a scintilla of classical decorum. It is obvious that the artist took more pleasure in placing nearest to the viewer various figures of the Four Seasons and the Parcae represented in the guise of peasants and nymphs. These lighthearted decorations, however much they may appeal to our own taste, have little in common with the ponderous style of Canuti's ceiling in the same palace, and it must be admitted that Crespi used in a city residence a scheme more suitable for a villa in the country.[28] The academically minded Zanotti mentions their existence without issuing a single word of approval.

By the turn of the century, Crespi's career had progressed to the point that he was able to admit students into his own school; he had as many as thirty. In 1701, Crespi was commissioned by Grand Prince Ferdinand de' Medici to paint *The Vision of Saint Margaret of Cortona* (fig. 6) to replace Lanfranco's altarpiece of 1622 in the church of S. Maria Nuova, Cortona. Newly discovered documents indicate that Ferninand's concern in this matter was

6. *Crespi,* The Vision of Saint Margaret of Cortona. *Museo Diocesano, Cortona.*

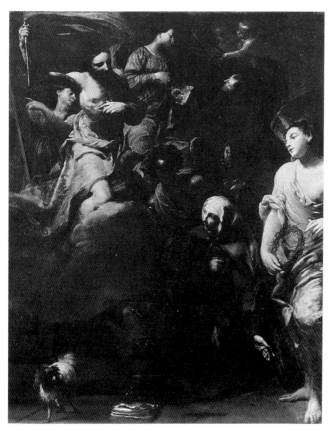

the expeditious removal of the Lanfranco to his own picture gallery, and that the selection of Crespi was delegated to agents in Bologna.[29] These documents reveal that Crespi was fully occupied in 1701 with further commissions from Vienna.[30] Notwithstanding the reference point of 1701 for the Cortona altarpiece, the chronology of Crespi's painting in the decade from roughly 1695 to 1706 (the date of the Uffizi *Massacre of the Innocents*) remains to be clarified. For the Marshal Enea Caprara, who died in 1701, he had already painted pastorals of nymphs and putti presumably similar to the large painting on copper at the National Gallery of Art, Washington, or the two copper pendants in the Kress Collection of the El Paso Museum of Art (cat. nos. 7 and 8).[31] The artist's works in other media can help shed light on his chronology. The immature handling of the etcher's needle in Crespi's print *A Sleeping Shepherd Tickled by a Shepherdess* justifies a dating midway through the first decade of the eighteenth century, or even slightly earlier (fig. 7).[32] This engaging motif became a favorite of the Venetian followers of Giambattista Piazzetta, who came to Bologna at this very time.

The years 1706 and 1708 constitute another turning point in Crespi's career. The earlier date refers to his painting of *The Massacre of Innocents* (*Uffizi*) (fig. 8); in the latter year, he came into personal contact with Grand Prince Ferdinand de' Medici, when he personally delivered the contested picture to Tuscany. Many genre paintings made for Ferdinand and for others after these dates are known. Crespi's most important genre painting prior to 1706 is his *Lute Player* (cat. no. 5), which pertains to the decorative tradition already practiced by Pasinelli and Burrini. Apart from Zanotti's descriptions of the *Winepress* and the *Butcher's Shop,* the existing evidence suggests that paintings of the common life of the streets and courtyards remained of secondary concern prior to his visit to Florence in February 1708.

Ferdinand de' Medici became a devoted patron and effective champion of Crespi. Ferdinand's letters make it clear that he regarded Crespi as a remarkable humorist,[33] and he appreciated as well the quickness of the artist's unconventional mind and brush. Florentine collectors proved to be inordinately fond of the Bamboccianti, and it cannot be a mere coincidence that Crespi's major work during his 1709 sojourn in the Medici villa at Pratolino was a bambocciata, *The Fair at Poggio a Caiano* (Uffizi) (cat. no. 9).

The death of this patron in 1713 was deeply regretted, but the encouragement of Ferdinand and the other collectors in his circle had made a lasting impression. Crespi devoted himself to genre painting for most of the second decade of the eighteenth century. Street scenes, laborers, laundresses, and the like served as points of departure for his visual poetry. According to Zanotti, upon his return from

Florence in 1709, Crespi decided to design and etch a series of prints illustrating Giulio Cesare Croce's comic tale of three country bumpkins, Bertoldo, Bertoldino, and Cacasenno. The same source reports that the success of these prints led Crespi to paint a series of copper plates of these subjects acquired by Prince Doria-Pamphilj, Rome.[34] Although the whole series does not survive, Crespi's preparatory design, his etching, and subsequent painting, *Menghina Coming from the Garden Meets Cacasenno* (figs. 9, 10, 11), give some idea of its character.

About 1712, Crespi reached a new level of inventiveness in his series *The Seven Sacraments* painted for Cardinal Ottoboni in Rome.[35] Caravaggesque painting has been celebrated, of course, for its daring translation of sacred stories into genre-like settings. On the other hand, the Sacraments are liturgical ceremonies, as much symbols as they are events. Nicolas Poussin had painted two archetypal series of the Sacraments in the form of analogues selected from scripture. No one

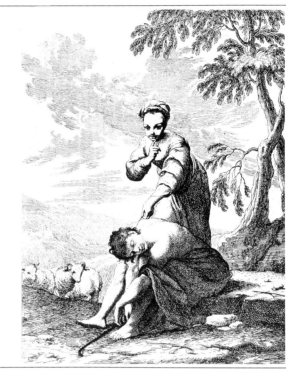

7. *Crespi,* A Sleeping Shepherd Tickled by a Shepherdess. *Etching. Pinacoteca Nazionale, Bologna.*
8. *Crespi,* The Massacre of the Innocents. *Uffizi, Florence.*

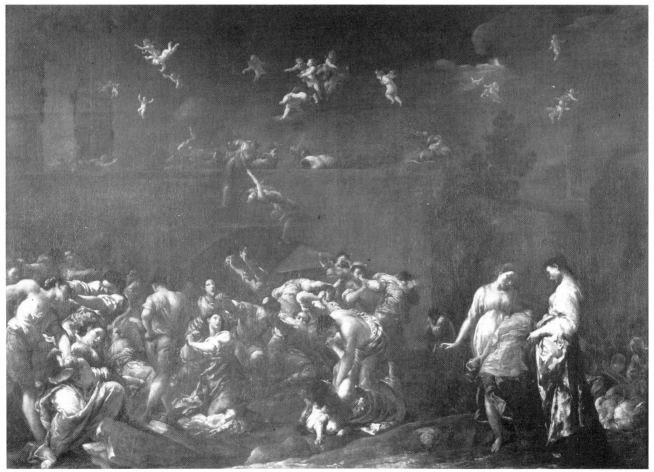

19

before Crespi had endeavored to paint a sacred story as an episode of daily life — without the presence of saints or patriarchs — that any visitor to a Catholic church or hospital would be likely to witness. In the aftermath of Crespi's *Sacraments*, every aspect of the human condition became a conceivable subject for art under the rubric of genre.

Given his success with the demanding format of the *Sacraments*, in which he accomodated nearly life-sized figures into a highly compressed pictorial field,[36] it is remarkable that Crespi essentially abandoned compositions of this kind for the remainder of his career. One of his last paintings, however, happens to be his single greatest treatment in this format, *Saint John of Nepomuk Confessing the Queen of Bohemia* (cat. no. 30). The inspiration for this late masterpiece is in fact his *Confession* of thirty years before, the Sacrament that gave rise to the entire series.

During the last two decades of Crespi's life, as his sons grew up and two of them, Antonio (1712-1781) and Luigi (1708-1779), became painters, he disbanded his school and stayed at home with his family. Except to go to daily mass, he rarely went out after his wife's death in 1722. Crespi continued to paint genre pictures, but seemingly with less variety than during the period 1708 to about 1720. Most of the later genre pictures are pastorals, although there are important exceptions. Luigi Crespi reports a new development, his father's use of a homemade camera obscura to project street scenes onto the wall of his studio;[37] there is evidence of this technique in some of Crespi's genre paintings from the 1730s (cf. cat. no. 27), and probably not before, as some have assumed. Overall, Crespi's genre style after the late 1720s becomes subtly elegaic by comparison with his earlier inclination to celebrate the virtues of vigorous labor. One of his most famous genre pictures, *The Woman Washing Dishes* in the Contini-Bonacossi Collection of the Palazzo Pitti, for example, is different in mood from the boisterous markets and street scenes of the 1710s (cf. figs. 12 and 16).

During the 1720s, Crespi became an important painter of altarpieces commissioned from churches throughout Emilia and Tuscany, and north to Bergamo. Although this sphere of his activity is beyond the scope of our present study, religious subjects increasingly occupied his mind, even for private commissions, and, fittingly, his last masterpiece, *Saint John of Nepomuk Confessing the Queen of Bohemia*, is a sacred story cast as a work of genre.

It is not clear how Crespi's innovations were received in Bologna's academy of painters, the Accademia Clementina. Upon its founding in November 1709,

9. *Crespi,* Menghina Coming from the Garden Meets Cacasenno. *Red chalk. The Metropolitan Museum of Art, New York. The Elisha Whittelsey Collection. The Elisha Whittelsey Fund.*

10. *Crespi,* Menghina Coming from the Garden Meets Cacasenno. *Etching. British Museum, London.*

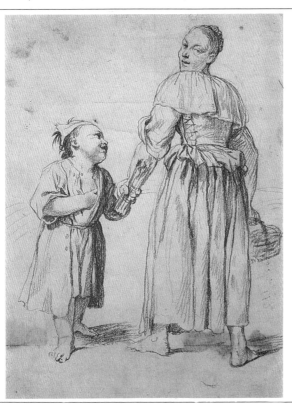

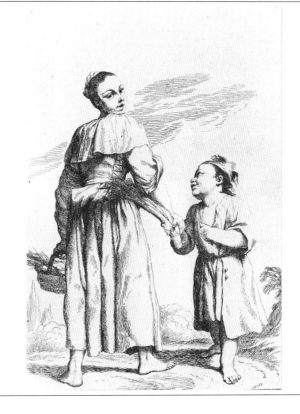

Crespi had been elected and regularly invited to participate as one of the directors of the drawing classes. However, he disappears from the academy assemblies in 1711,[38] evidently disgusted that the two noble sponsors of the Accademia Clementina were elected to membership. Luigi Crespi publishes several pages of complaints by his father about this subject.[39] He was initially appalled that the academy had included artisans in its body alongside true professors of art and, further, that it had then opened its doors to people who were not any kind of artist at all. Zanotti's fair-minded biography, which is after all a chapter in his *Storia dell'Accademia Clementina*, is an indication that Zanotti, for one, was prepared to excuse the solitary ways of a genius.

Crespi and Genre Painting in Bologna

Did Crespi's achievements with genre painting inspire other Bolognese painters to follow his lead? In point of fact, Crespi stood isolated, a giant oak against a tide of academicism. Although he had many pupils during the first two decades of the eighteenth century, none of them made a noticeable mark. Zanotti and especially the later critics, such as Lanzi, maintained that Crespi's vision was too personal to be

taught.[40] The single exception was Antonio Gionima, who transferred from Aureliano Milani's studio to Crespi's in 1719.[41] Gionima adopted the slighter proportions that Crespi introduced into his figures during the 1720s, and he added a native instinct for rapid movement and sinuous contours. However, Gionima died prematurely in 1732, and genre subjects by him are quite rare, perhaps reflecting the master's own interests in that decade. Gionima's first master, Aureliano Milani (1675-1749), is one of the few Bolognese painters of a certain quality whose works reveal that he occasionally cast a sidelong glance at Crespi's activities. Shortly after his relocation in Rome in 1719, Milani painted a *Country Market* (Museo Civico, Pesaro) and a *Mission* (Molinari Pradelli Collection, Bologna) for a Bolognese nobleman.[42] Both works contain echoes of Crespi's treatments of these subjects.

Crespi's own son Luigi found portraiture more to his taste than genre, and he eventually developed into a portraitist of some attainment. Luigi's reputation has perhaps been restricted too long to his historiographic contributions as the compiler of the third volume of Malvasia's *Felsina pittrice*; it can seem anomalous, though, to see in his works the typical

11. Crespi, Menghina Coming from the Garden Meets Cacasenno. *Oil on copper. Private collection, New York.*

12. Crespi, The Woman Washing Dishes. *Palazzo Pitti, Florence, Contini Bonacossi Collection.*

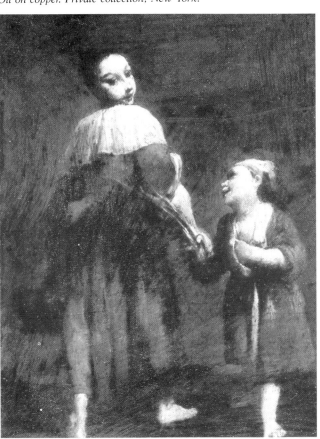

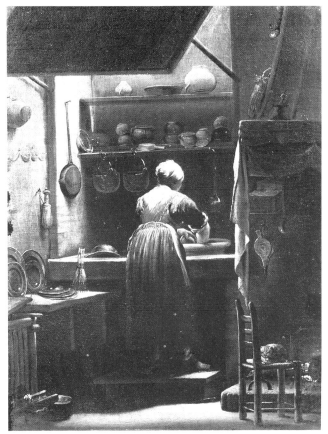

forms of G.M. Crespi's pictures overlaid with a glossy academic veneer. The scholar Silvia Evangelisti concluded a recent article about Luigi Crespi with the following lines:

The personages portrayed by Luigi Crespi form an imaginary gallery that is perhaps not of primary interest for eighteenth-century painting, but is rather suggestive as a collection of documents from a society that was retreating ineluctably into provincialism; the former glories were fading for this *Felsina pittrice*, and Luigi Crespi had written a kind of epitaph.[43]

Giuseppe Gambarini (cat. nos. 31-33), although short-lived (1680-1725), left a considerable body of genre paintings. A pupil of Pasinelli and Benedetto Gennari,[44] he made an inconclusive sojourn in Rome in 1709. In the next year or so, he was still painting mythologies in the manner of Pasinelli and Cignani, when he was suddenly smitten by the impulse to compose multi-figured scenes of country dances, monks receiving alms, and the like. These pictures are light-hearted in mood and unabashedly decorative in purpose. So many of Gambarini's figures, however, are borrowed from Crespi that it is reasonable to conclude that Gambarini had access to Crespi's studio early in the second decade. Gambarini was not averse to the re-use of the motifs that he borrowed from Crespi, and his designs were inherited by his mediocre follower, Stefano Gherardini (1696-1756), so that in pictures of forty years' remove, these same Crespi figures appear still hard at work but looking very tired (fig. 13).[45]

Gaetano Gandolfi (1734-1802) and his elder brother Ubaldo Gandolfi (1728-1781) instilled life into the school of Bologna at the close of the eighteenth century, although at the cost of Bolognese artistic autonomy. The year spent together in Venice, 1760, was decisive in their development. After their return, Bolognese painting became a satellite of Venetian, and, with due credit to both artists, Gaetano Gandolfi can be considered the "Tiepolo" of Bologna. Both Gaetano and Ubaldo painted many half-length genre figures of boys and girls, old men and women. Usually these are decorative in character, inspired by the Venetian examples of Nogari and Piazzetta — being a possible case, therefore, of cultural cross-breeding in view of the latter's debt to Crespi.[46]

13. Stefano Gherardini, Interior with a Music Teacher. *Location unknown.*

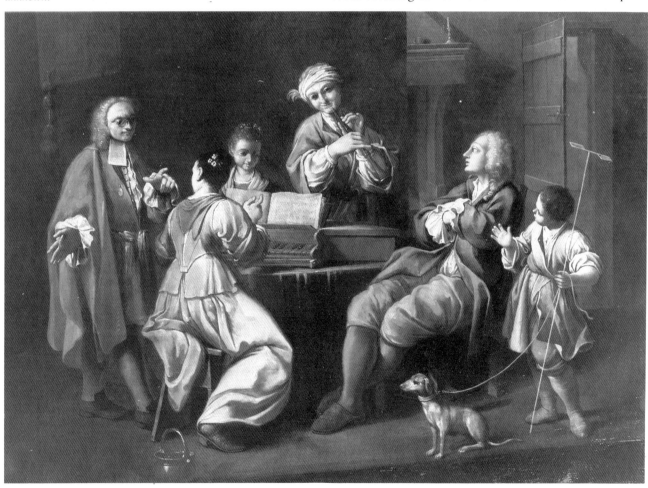

On the night of January 31, 1708, Giuseppe Maria Crespi left Bologna under the cover of darkness and crossed over the Apennines to Florence. Rolled under his arm was a painting that he had made and now intended to present as a gift to the foremost art collector in Italy, Ferdinand de' Medici, Grand Prince of Tuscany. The subject of the painting was The Massacre of the Innocents; it was the most difficult composition that the forty-year-old Crespi had ever attempted. The canvas was of normal dimensions, four feet by five feet, but on its surface he had depicted more than one hundred figures engaged in violence (fig. 8). On the previous day, armed men had come to Crespi's house and had broken down his door in an attempt to seize the painting. Dressed in the same rude clothes in which he had escaped out of a window, he made his way in the rain to Florence, with the hope that the excellence of his brush and the justness of his cause would win him the protection of the Grand Prince.[47]

Crespi was taking a calculated risk: he was carrying a major painting as a gift to a man who was known to be obsessed with music and art; he held a letter of introduction from Count Vincenzo Ranuzzi Cospi, Ferdinand's trusted agent in Bologna; and he was hoping that Ferdinand would be beguiled by the wit with which he could recount the operatic travails that had befallen him.[48] Everything that the desperate artist hoped would come to pass did, and more. Crespi succeeded in arousing Ferdinand's sympathy, because Don Carlo Silva, the priest who had initiated the commission for the *Massacre of the Innocents*, had goaded Crespi on to his best effort with the promise that the painting was destined to be a gift to the Grand Prince. After seeing its perfection, however, the priest had reneged on his promise and sought to keep the painting for himself. (Heresay evidence at the deposition quoted Silva as saying that he never meant to keep his word.[49]) In the face of threats and assault, Crespi had opted instead to flee Bologna in order to present the canvas in person to the prince. Among other actions, Ferdinand intervened on Crespi's behalf in the legalities filed against him by Silva, and he pacified the Bolognese nobility who had taken the side of the priest (and dispatched the intruders to Crespi's house). Ferdinand decided to accept the painting (it is still in the Uffizi) and to reciprocate the artist's generosity with a handsome payment. He opened his collections to Crespi and bade him return for an extended visit with his family in the next year, 1709. The Grand Prince and his consort, Violante di Baviera, stood as godparents at that time at the baptism of Crespi's third son, christened Ferdinand. During the interval left to him prior to his death in 1713, the health of the Grand Prince steadily declined, but there is evidence that Ferdinand continued to acquire all of

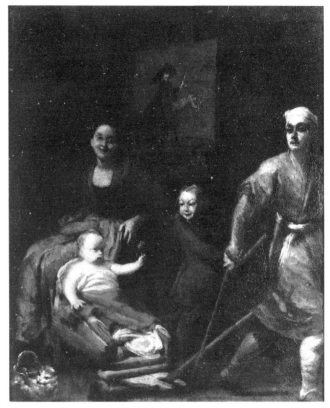

14. Crespi, The Painter's Family. *Uffizi, Florence.*

the paintings by Crespi that the artist cared to send him.

We know all about these events because Crespi was fond of telling the story. And from documents that survive in three archives — the Notarial Archives in Bologna (relative to the suit filed by the disgruntled priest, Don Carlo Silva), the papers of the Ranuzzi-Cospi family (relative to the settlement orchestrated by Count Vincenzo Ranuzzi Cospi on instructions from Florence), and from Ferdinand's correspondence preserved intact in the Archivio Mediceo in Florence — we know that this episode unfolded just as Crespi said it did. [This documentation is transcribed in Appendices II, III and IV to this catalogue.]

Both of Crespi's principal biographers, Giampietro Zanotti (1739) and his son Luigi Crespi (1769), pointed out that Ferdinand sought only paintings of "pleasant and common" subjects (i.e. genre) from Crespi; neither author, however, saw this interaction between patron and painter as the turning point in Crespi's career, as it seems so clearly from our own perspective to have been. To Francis Haskell goes all the credit for finding Ferdinand's letters to and from Crespi in the archives and for using these as the basis for reconstructing the series of events that had been sketched by Zanotti and Luigi Crespi.[50] In 1921, M.

Marangoni had already rescued from neglect Crespi's *Massacre of the Innocents* and *The Fair at Poggio a Caiano*, which he discovered in storage at the former Medici Villa of Poggio Imperiale. The paintings and the letters considered as a whole suggest that Ferdinand's encouragement of Crespi led the painter to infuse his art with wit and lively detail that he had hitherto restrained. Some historians in the past have even suggested that Crespi began to paint genre subjects only after his encounter with Ferdinand, but this argument overstates the case, as Mira Pajes Merriman has pointed out.[51]

The development of Crespi's art under Ferdinand's patronage can be traced with some exactitude during the period 1708-1709 owing to the documentation which is transcribed here for the first time (Appendix II). When Crespi reached Florence in the early days of February 1708, he learned that the Grand Prince was in Livorno for the carnival. Continuing to the coast, he gained an audience with Ferdinand, during which the artist seems to have been somewhat on the wrong foot, thinking that he was addressing the prince's private secretary. When all this was cleared up, and the *Massacre of the Innocents* was produced and admired, Ferdinand embraced Crespi as a friend,

"as if no person had ever been dearer to him."[52] Crespi immediately received quarters in the Medici palace, and was commissioned a pair of still-life paintings, with the stipulation that these should be finished in a day's time. Exactly how Ferdinand came to have such confidence in Crespi's speed of execution is not known, and it seems at first anomalous that Crespi was bid to paint still lifes, which he had never previously tried, so far as we know. This may be explained because still-life painting was as highly valued in Florence as it was disparaged in Bologna. The Medici court employed still lifes as decorations and in its pursuit of horticultural science. In 1708, no fewer than four talented still-life specialists were in the service of Tuscany: Bartolomeo Bimbi, Cristoforo Munari, Nicola van Houbraken, and Andrea Scacciati.

Crespi fulfilled this assignment to the complete satisfaction of the prince, meeting the deadline besides. In the meantime, the matter of Don Carlo Silva's claims to the *Massacre of the Innocents* had

15. *Alessandro Magnasco,* A Hunting Party. *Courtesy, Wadsworth Atheneum, Hartford, Connecticut, The Ella Gallup Sumner and Mary Catlin Sumner Collection.*

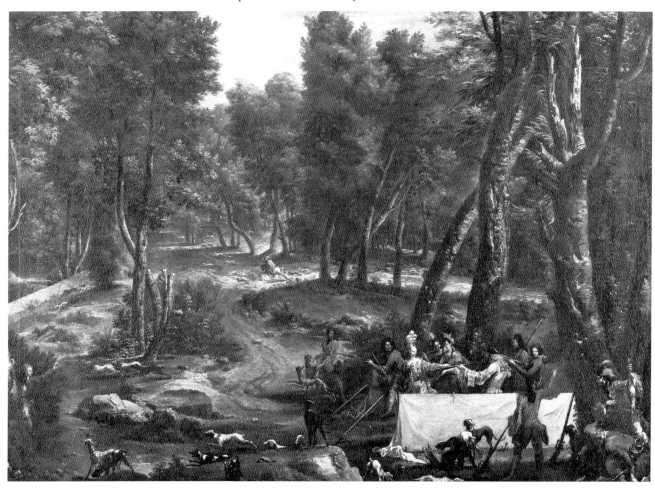

pursued Crespi to Livorno. On February 4th, the Marchesa Eleonora Zambeccari wrote from Bologna to Ferdinand in order to request the restitution of the painting.[53] Don Carlo Silva was very highly recommended, and she reminded Ferdinand that Silva had visited his villa at Pratolino in the company of the Marchese Antonio Pepoli. These efforts at influence were in vain, however: the Marchesa's letter crossed in the mails with Ferdinand's of February 10th to Vincenzo Ranuzzi Cospi:

I have seen with every demonstration of cordiality and true sympathy the painter Giuseppe Crespi whom you favored to accompany with a letter. I therefore owe a special debt to you, not only for his talent, but for his affectionate service. I regard him with complete benevolence, having already written to release him from the affair with the painting.[54]

From Ferdinand's next letter to Ranuzzi Cospi, of February 15th, we learn that Crespi had already departed, or would do so momentarily, for Bologna. Ferdinand charged Ranuzzi Cospi to protect "this Virtuoso" and to "give him in all of his needs the signs of my partiality."[55] Bound into the archives following Ferdinand's secretary's minute of this letter to Ranuzzi Cospi is an undated, untitled memorandum which is evidently a page of notes containing Ferdinand's instructions as to what further actions to take regarding Crespi. There are references to gifts (valuables were kept in "*cassette*") and to correspondence to be written, such as the letter of reassurances to Crespi's old friend and protector, Giovanni Ricci, which was duly penned two days later. Of particular interest in the remark, "Show him the *Galleria* and the *Stanze*."[56] Evidently Crespi stopped in Florence on his way home in order to view the Grand Prince's collection. Ferdinand specifically wished to show off the rooms recently painted by Sebastiano Ricci.

This information provides a helpful context for some remarks made by Crespi in his jubilant letter addressed to Ferdinand from Bologna on February 26, 1708: "While seeing the precious paintings of your Highness, I was shown a small picture said to be by Tintoretto; I can truthfully say that it is from my own hand. I also saw with great satisfaction the works by Sebastiano Ricci, which in truth and in all candor are expressed with spirit and knowledge."[57] Ferdinand's reply, dated March 3rd, states: "I learned with pleasure that which you have assured me about the little picture in this collection believed to be Tintoretto; and I enjoy your sincere expression about the works made here by the painter Sebastiano Ricci."[58]

Throughout March and April 1708, Crespi and his new patron exchanged frequent letters. The artist's letters of March 7th and another undated one written in April accompanied gifts of a small *Nativity* painted on copper and a self-portrait in which he holds a miniature likeness of the Grand Prince.[59] This portrait seems to have been executed with a calculated

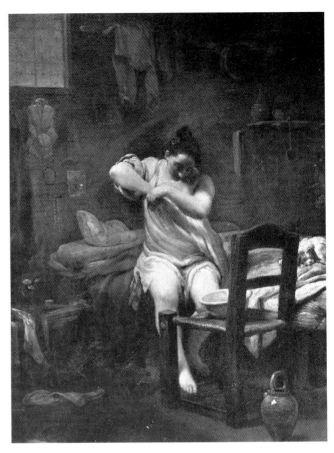

16. *Crespi,* The Flea Hunt. *Oil on copper. Uffizi, Florence.*

casualness; in any event, that is how it was received by Ferdinand, who responded in a well-known letter already cited by Haskell: "The portrait of yourself that you have sent to me is very well met, in it your brush has portrayed your lively face and your hilarity."[60]

Don Carlo Silva continued to press his suit for the *Massacre of the Innocents,* and the dispute was not destined to be settled until the end of 1709. In June and November 1708, Silva wrote two appeals to Ferdinand, and he seems not yet to have surmised the extent of the Grand Prince's affection for Crespi. He writes suggestively, but mostly in exasperation, that if he had not had Ferdinand's righteousness to appeal to, he should have been alarmed by "the incredible fortune that the aforesaid painter has had in finding protectors who heatedly defend his equivocations."[61] At the end of November 1708, Antonio Morosini, an agent in Ferdinand's employ, passed through Bologna and met with Vincenzo Ranuzzi Cospi. He wrote unenthusiastically to Florence that he had acquired three "*pezzetti di quadri*", of which he names only one, a work by Niccolò dell'Abbate, "the master of the Carracci."[62] From the other correspondence exchanged in late November and early December between Ferdinand, Crespi, and Giovanni Ricci, it

25

transpires that Crespi and Morosini had disagreed on some minor point,[63] and that the dell'Abbate was a gift to Ferdinand from Giovanni Ricci.[64] And finally, from Fredinand's letter to Crespi of December 1st (originally published, slightly modified, by Luigi Crespi in 1769[65]), it turns out that the two "*pezzetti di quadri*" that Morosini had not troubled to name were Crespi's *The Painter's Family* (fig. 14) and his copy after Guercino's *The Investiture of Saint William of Aquitaine*.[66]

Crespi's diminutive picture of his family romping *a casa*, aptly described as "the most informal portrait group that had yet appeared in Italian art,"[67] stands indefinably between portraiture and genre painting and serves as yet another instance of the artist's indifference to pictorial conventions. The picture contains a private joke between Crespi and Ferdinand: the painting on the easel is a caricatured rendition of Don Carlo Silva ascending the Apennines on the back of a donkey, apparently en route to present his arguments to the Grand Prince.[68]

For his part, Silva persisted in unsettling Crespi's life in Bologna. Crespi's letter following Morosini's visit in November betrayed a certain anxiety in its profuse expressions of dependence upon Ferdinand. During this period witnesses were being called to testify in Crespi's defense in the lawsuit that Silva had brought against him. As trying as these occasions must have been for the artist, the transcripts of testimony given on his behalf by Giovanni Ricci, Zanobio Troni (November 19, 1708), Lorenzo Manzini (January 10, 1709), and Pier Girolamo Papi are a valuable source of information.[69] The depositions of the witnesses brought by Silva are as yet untraced.

From Ferdinand's exchange of letters with the Marchese Antonio Pepoli in Bologna in early January 1709, we can surmise another of Silva's harassments. It was necessary for Ferdinand to intervene through the agency of Antonio Pepoli in order to persuade Count Alessandro Pepoli to save the frescoes by Crespi in his city palace. The count was reportedly concerned that the work be "corrected" in some way.[70] At least as likely a motivation for this insult to the artist would have been the enmity of Don Carlo Silva, whose chief patrons were the Pepoli. While the Silva litigation was in progress, Crespi evidently felt safest in close proximity to his out-of-town protector. He spent most of 1709 in residence with his family in the Medici villa at Pratolino. On February 6th, he had assigned his power of attorney to Giovanni Ricci,[71] and his safe return to Bologna is noted in his letter to Ferdinand of November 3rd. In December 1709, Don Carlo Silva accepted Ferdinand's offer of a financial settlement and ceased his litigation.[72] Ferdinand also took care to mend fences for Crespi in Bologna. In December 1709, he wrote to Marchesa Eleonora Zambeccari and urged her to grant Crespi an audience so that they might be on closer terms.[73]

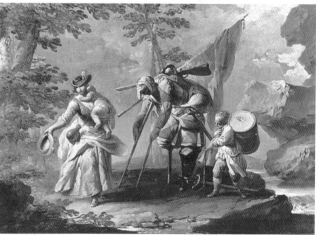

17. *Gian Domenico Ferretti,* Harlequin the Painter. *Spencer Museum of Art, Lawrence, Kansas.*
18. *Gian Domenico Ferretti,* Harlequin Returning from the Wars. *Spencer Museum of Art, Lawrence, Kansas.*

During Crespi's sojourn in Tuscany in 1709, he made his earliest known venture into the tradition of Bamboccianti painting. *The Fair at Poggio a Caiano* (cat. no. 9) represents a country fair replete with crowds of people, a cattle and livestock market, a charlatan on a makeshift stage, a pottery vendor, a young man enticing a maiden with a flask of wine, and so forth. The painting was made to be perused, like a magazine, and it contains plenty of jokes for the private benefit of the prince.[74] According to Zanotti, Crespi recorded an actual event of high hilarity, when Antonio Morosini disguised himself and play acted the presentation of a country charlatan.[75] A comparable satire of Ferdinand's court circle is documented in a painting of a few years earlier, about 1706, by Alessandro Magnasco (fig. 15), which tells the tale of a hunting party.[76] Crespi undoubtedly knew the Ligurian Magnasco, who was resident in Florence in 1709, and he probably appreciated the exuberance of the older master's

handiwork. However, neither artist appears to have been influenced by the other.[77]

As *The Fair at Poggio a Caiano* demonstrates, Crespi was persuaded by his Florentine patrons to make a study of the Bamboccianti. It is probable that Crespi was specifically urged to admire the work of the otherwise unremarkable Theodor Helmbreker (1633-1696).[78] Something like a passion for the genre paintings of Helmbreker, the last of the Bamboccianti, had seized Florentine collectors during the last two decades of Ferdinand's life. All of the leading galleries contained multiple examples by him: a 1706 inventory of possessions owned by the Ughi (later patrons of Crespi, for whom he painted an amusing self-portrait) lists 17 canvases by him.[79]

In 1705, the Grand Prince had written to Helmbreker's principal maecenas in Rome, Alessandro Marucelli (who had 21 pictures by him), as follows:

> You could not have better flattered my taste, nor earned more of my gratitude, than through your gift to me of the little picture by Theodoro, which is truly beautiful... I intend to place it in my personal cabinet, among the works of small format that I have by each of the most celebrated painters.[80]

Helmbreker painted the standard Bamboccianti subjects, with figures in the same scale and proportion to buildings in the background as one finds in Crespi's *The Fair at Poggio a Caiano*. Helmbreker's octagonal painting *Laundresses at a Fountain* (private collection, Rome),[81] or another one like it, would seem to be the direct inspiration for Crespi's two tondi, *Shepherdesses* and *Boys Playing*, now in the Museo Civico, Pisa, and presumably painted for Ferdinand in 1709 or shortly thereafter.[82] The same source of inspiration is identifiable in Crespi's earliest treatment of *The Flea Hunt* (recorded in the Medici collections *ab antiquo*, thus presumably painted for Ferdinand) (fig. 16). However characteristic of bambocciate this subject of impromptu hygiene may have been, Crespi's paintings of young ladies searching for fleas far exceed the interpretative scope of Helmbreker's art or that of any other Bamocciante. In them Crespi avoids any sense of caricature by presenting a concrete fact of humble life. Although to some degree their intent may be comic, they also reveal a profound sympathy for the human condition.[83]

Patronage by Florentine collectors other than the Medici is cited throughout the biographies by Zanotti and Luigi Crespi. During the lifetime of Ferdinand, it was seemingly *de rigeur* for the courtiers in his circle to acquire pictures by the Grand Prince's favorites. According to Zanotti, Crespi made visits to Florence at the behest of Ferdinand, other than that of 1709, and painted there a "thousand things" of "every kind."[84] Perhaps the leading collector in Ferdinand's circle was the Marchese Andrea Gerini, an amateur of great sophistication who communicated with

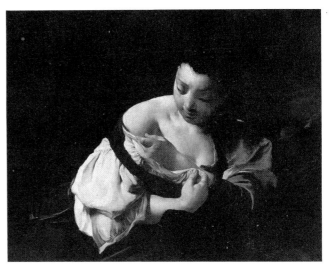

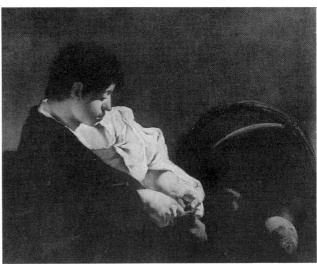

19. *Giambattista Piazzetta,* The Flea Hunt. *Courtesy, Museum of Fine Arts, Boston.*
20. *Giambattista Piazzetta,* A Boy Counting Money. *Courtesy, Museum of Fine Arts, Boston, Ernest W. Longfellow Fund.*

connoisseurs in other cities, among them A.M. Zanetti the Elder in Venice.[85] Gerini owned at least two pictures by Crespi, an unnamed "*quadretto*" lent to a public exhibition in 1715, and a life-sized "*Figura rappresentante Circe*" exhibited by the Gerini in 1767.[86] This last is to be identified with *The Cumaen Sybil* (Musée des Beaux-Arts, Besançon[87]), which was reproduced in the engravings made in 1825 of the Gerini gallery.[88]

On the other hand, Florentine interest in Crespi appears to have waned as the epoch of Ferdinand de' Medici receded into history. This is not to say that the artist no longer received important commissions from institutions in Tuscany (including altarpieces in Lucca, Prato, and Pistoia) or from private collectors (their names appear in the sources).[89] But the long interval between the individual Gerini loans may be

indicative of declining interest in his work, especially in view of the family's extensive participation in the intervening exhibitions in the cloister at SS. Annunziata in 1724, 1729, and 1737. In point of fact, no works by Crespi appeared in the 1729 exhibition, and only a single painting by Crespi was shown in 1724, a *Madonna and Child* lent by a certain Auditore Venuti,[90] who was presumably related to or synonymous with the Auditore Domenico Girolamo Venuti from Pesaro, in whose chapel in Cortona Grand Prince Ferdinand had replaced Lanfranco's altarpiece with one by Crespi in 1701 (fig. 6).[91] The most avid collector of drawings in Florence, Cavalier Francesco Maria Gaburri, owned Crespi's *Self-Portrait*,[92] but did not noticeably exert himself to obtain other sheets from his hand: Gaburri eventually lent 284 drawings to the SS. Annunziata exhibitions in 1706, 1724, 1729, and 1737, but none by Crespi.[93]

Crespi's interaction with Florence remained in the realm of lessons received, not given. Because he never resided in Florence long enough to warrant the establishment of a studio proper, he had no direct followers among the local painters. In general, the legacy of frescoes and the many, many canvases that the Neapolitan Luca Giordano (1634-1705) left behind him in the course of five visits to Florence prevailed.[94] Giordano was a decorator in the fullest sense of the word, and neither naturalism nor genre painting proved to be important to him or for eighteenth-century Florentine painting generally.

A partial exception to the slight impact that Crespi's genre paintings had on Florentine art is the case of the painter Gian Domenico Ferretti (1692-1768), who went to Bologna to study with Felice Torelli in the early 1710s.[95] Various echoes of Crespi's facial types and poses can be discerned in Ferretti's early works, after his return to Florence. Ferretti also painted genre subjects, especially his amusing ruminations on the Life of Harlequin (figs. 17 and 18). However, the satirical mood of his brand of genre painting owes more to Magnasco than to Crespi.

21. Crespi, Boy Holding a Flute. *Location unknown.*

22. *After Crespi,* Boy Holding a Flute. *Etching by Pietro Monaco. British Museum, London.*

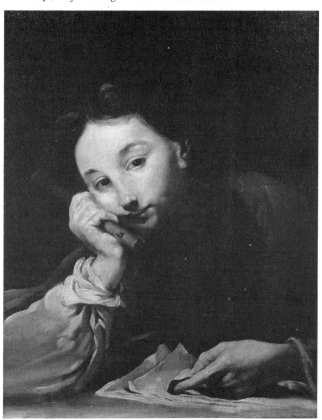

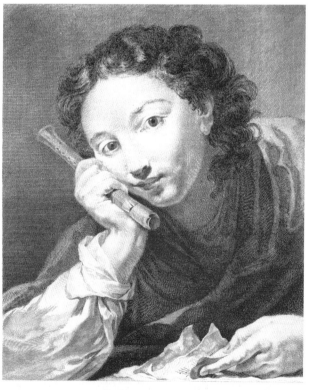

DAVIDDE FUGGITIVO

Et declinavit David a facie eius (nempe Saul persequentis).

Crespi and Genre Painting in Venice

As a young man, Crespi went to Venice to study one time, according to Zanotti, or twice, in the opinion of his son Luigi. There is only one known record of a painting that he probably made in Venice, the copy after Tintoretto which by 1708 had already entered the collection of Ferdinand de' Medici and was understood to be an original work of the sixteenth century.[96] (The painting is untraced but may be preserved somewhere in the deposits of the Florentine museums.) Zanotti, who is the more reliable biographer, describes a single trip to Venice immediately prior to Crespi's work in Pistoia in 1691.[97] It is interesting that Zanotti specifically states that Crespi had not yet been to Venice when, about 1686-1688, he painted his *Wedding at Cana* (cat. no. 1) in the manner of Veronese for Giovanni Ricci.[98] In point of fact, Crespi's "Venetian" banquet shows more affinity with the delicate tints of Federico Barocci if one compares it to a genuinely Titianesque picture such as Crespi's *Tarquin and Lucretia* (cat. no. 2). It is only reasonable to assume that a firsthand experience of Venetian painting was a prerequisite for the dense, broken brushwork that Crespi displayed about the year 1690 or not too much later. Although Venice did not affect the development of his genre painting, it led to crucial advances in his style and palette.

Since Venice had been a magnet for painters for two centuries before Crespi, and would continue to be so throughout the eighteenth century, it seems curious at first that Piazzetta, a promising Venetian artist, should leave home in order to complete his studies in Bologna. Yet, when Piazzetta sought out Crespi's school sometime after 1703 and before 1711, he was not taking an unprecedented step. Two decades earlier, Sebastiano Ricci, who went on to head the Venetian school, had graduated from his apprenticeship with Federico Cervelli with an uneasy feeling that he was not ready to assume the role of a master.[99] Ricci went to Bologna and for several years during the early 1680s he studied at the academy of Carlo Cignani. (He and Giuseppe Maria Crespi must therefore have sat before the same models, but neither seems to have paid any attention to the other.) It was the person of Cignani and the tradition of the Carracci that he represented which attracted foreign students. A brilliant draftsman, Cignani was also a proven master of historical compositions in the grand manner. None of the leading painters of the later seventeenth century in Venice — Antonio Zanchi, Antonio Molinari, Gregorio Lazzarini, among others — whatever their other talents may have been, could compose monumental multi-figured pictures, although not for want for trying.[100]

About 1695, the Dalmatian painter Federico Bencovich (1677-1753) is reported to have gone to Bologna in order to enter Cignani's still-active circle (the master had left Franceschini and Luigi Quaini in charge). The travels of this eccentric talent are shrouded in obscurity throughout his career, but in 1707, Bencovich is documented as working in Forlì, whither Cignani had moved in 1686. However much Bencovich learned from Cignani, he was at least as impressed by the dramatic chiaroscuro and prepossessing physicality of Crespi's more daring figurative compositions from this period. The paintings that Crespi made for Prince Eugene of Savoy in the mid-1690s typify this style (cat. no. 4), which greatly impressed both Bencovich and the slightly younger Piazzetta when he reached Bologna early in the eighteenth century. Indeed, the early works of both Bencovich and Piazzetta are only now being identified, and scholars often differ over attributions to the two of them, or confuse the works of Bencovich and Crespi himself at this age.[101] The impact of Crespi's monumental style of history painting can be detected as late as 1722 in the canvas

23. After Crespi, Sleeping Shepherdess Tickled by a Straw. *Etching by Giuseppe Camerata. British Museum, London.*

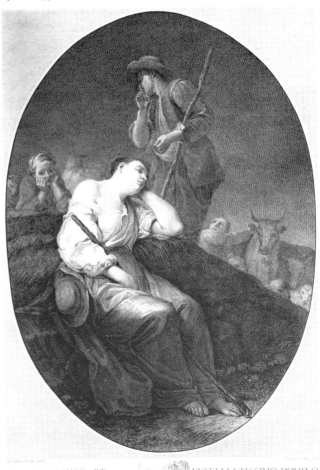

ILLUSTRISSIMO ET IOHANNI GEORGIO FRIDERICO SERENISSIMI ELECTORIS SAXONIAE

EXCELLENTISSIMO DOMINO S. R. I. COMITI EINSIEDEL MINISTRO ET SECRETARIO SERENISSIMI

that Piazzetta sent to the important cycle at San Stae, Venice, in which all of the best talents in Venice competed head to head.[102] Through the influence of Piazzetta, the contribution to the cycle by the young Giambattista Tiepolo represented still another resonance of Crespi's model.

The literary testimony for Piazzetta's studies with Crespi is scant but credible. None of Crespi's biographers claims Piazzetta as his pupil, but Moschini, writing in 1806, had access to extensive notes on the matter by Antonio Marinetti, one of Piazzetta's closest assistants during the 1740s and until the master's death in 1754.[103] Lanzi, in 1789, is actually the first author to state that Piazzetta worked with Crespi in Bologna.[104] Through the indirect testimony of Moschini/Marinetti, we are informed that Piazzetta went to Bologna with letters of introduction to several painters, among them Crespi. Piazzetta's most likely source of information about the situation of Bolognese painting at the time would have been the painter Antonio Balestra (1666-1740), who made an extensive voyage of study to Bologna, Modena, Parma, Piacenza, and Milan from 1700 to 1702. We know from Balestra's letter of 1716 to Cavalier Francesco Maria Gaburri in Florence that

Balestra was acquainted with the Bolognese painter G.G. Dal Sole and was promising to procure a drawing by Piazzetta for Gaburri's collection.[105] Having completed his apprenticeship with Molinari in 1703, Piazzetta at age twenty was hardly a novice; when he presented himself in Bologna, Crespi is reported to have good-naturedly declined to teach anyone so accomplished, and a friendship ensued. In view of his age, it is more likely that the Venetian was a welcome observer in the studio as opposed to a contracted apprentice or assistant. By 1711, Piazzetta was again home in Venice, now prepared to inaugurate his independent career. Unfortunately, there are no paintings by Piazzetta known to date from his years in Bologna: our present understanding of his chronology only begins with his return to Venice.

Federico Bencovich coincidentally arrived in Venice around 1710 and remained there until 1716. This early sojourn is the only likely period during which he and the younger Piazzetta would have collaborated on a painting called *The Flea Hunt* that was once in the collection of Francesco Algarotti.[106] One need not look farther than Bologna for the source of inspiration for this bambocciantesque subject.

24. Domenico Maggiotto, Sleeping Shepherdess Tickled by a Straw. *Kunsthalle. Hamburg.*

25. Giuseppe Angeli, Sleeping Shepherd Tickled by a Straw. *Location unknown.*

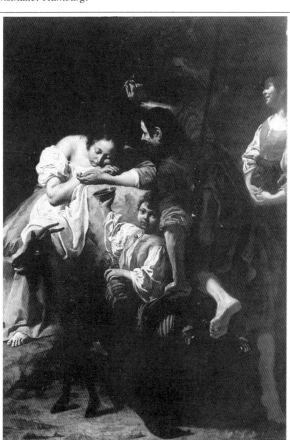
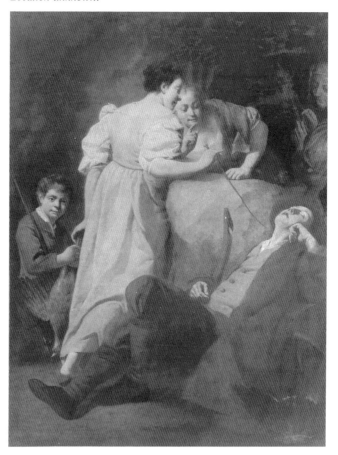

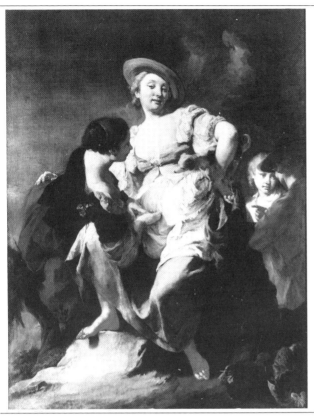

Although the Algarotti painting is lost, its character can perhaps be deduced from a pair by Piazzetta, *The Flea Hunt* and *Boy Counting Money*, which are commonly recognized as among his first Venetian works following his return (figs. 19 and 20). (These pictures, in the Museum of Fine Arts, Boston, are discussed below in relation to the similar, somewhat more mature, genre subjects in Salzburg, cat. nos. 34 and 35.)

Piazzetta's considerable production as a genre painter falls into two distinct categories. By far the most common type is that which represents half-length figures, sometimes little more than heads of youths holding simple attributes of the countryside — some fruit, a basket, a hat. There is an element of idealization in these works (they are hardly portraitlike) that was already present in the genre subjects of the late seventeenth century in both Venice and Bologna — especially in the latter city in the circle of Pasinelli. Crespi's masterpiece of this purely decorative sort of genre painting is his *Lute Player* (cat. no. 5), here dated to the 1690s, but so far as we know, not very different from his style in the

26. *Giambattista Piazzetta*, The Fortune Teller. *Gallerie dell'Accademia, Venice.*
27. *Giambattista Piazzetta*, Idyll on the Shore. *Wallraf-Richartz Museum, Cologne.*
28. *Giambattista Piazzetta*, Pastorale. *Courtesy of The Art Institute of Chicago, Charles H. and Mary F.S. Worchester Collection.*

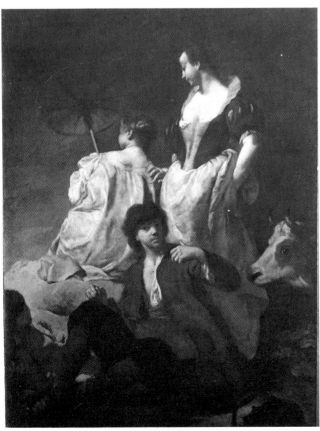

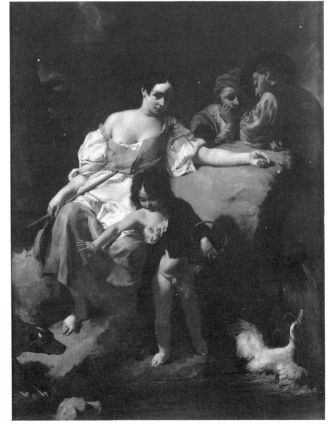

first decade of the 1700s. The *Handbook* of the Boston Museum of Fine Arts makes the point that the *Lute Player* is more in the style of Piazzetta than of Crespi (who would be expected to be more naturalistic).[107] The same might be said of Crespi's half-length *Boy Holding a Flute* (present whereabouts unknown, and difficult to date from a photograph), which he painted for the Faresini, clients of his in Venice for his genre paintings of the 1710s (fig. 21). This *Boy Holding a Flute* was subsequently acquired by Francesco Algarotti in Venice, who had it engraved (fig. 22) and endowed it with a biblical title, as Luigi Crespi ruefully observed in 1769.[108]

In Piazzetta's oeuvre, the *Girl Who Searches for a Flea* (Boston) and the *Sleeping Peasant Girl* (Salzburg, cat. no. 34), treat themes to which Giuseppe Maria Crespi gave artistic currency precisely during the time of Piazzetta's association with him, and the link is explicit. For example, the unpublished inventory, 1712, of the collection of Senator Francesco Ghisilieri, describes a painting of a sleeping hunter, life-sized in half-length. The attribution to Crespi is confirmed by Marcello Oretti, ca. 1769 (cf. cat. no. 36). It is characteristic of Piazzetta, and of the Venetian Rococo generally, that he should be attracted to the mildly erotic aspects of Crespi's genre painting, and not to his strongly personalized characterization, nor his Emilian celebration of the hardworking laborer. (The same is true, of course, for Pietro Longhi.) The vivid good humor of Piazzetta's early *Huntsman* (cat. no. 36) is, to return the compliment of the *Lute Player*, almost closer to the style of Crespi, than to Piazzetta's. In the 1690s, Crespi appears to have begun to paint prettily dressed nymphs sleeping soundly in fields, often in the company of mischievous *amorini*.[109] Crespi's experiences with collectors in Florence seem to have released the last fetters on his native instinct for the quotidian, and these nymphs may have evolved into simple shepherdesses about this time. Midway perhaps in the first decade of the new century, Crespi etched *A Shepherdess Tickling a Sleeping Shepherd* (fig. 7), a work that still breathes the rarefied air of Arcadia. He made for Prince Eugene of Savoy (therefore close to the time of Piazzetta's sojourn in Bologna):

a beautiful little painting on copper, in a magnificent gilt frame, representing a pretty shepherdess who is asleep, while a shepherd plays a trick, awakening her with a straw. At the same time he signals a young shepherd, who is laughing, to keep silent. There are other figures in the distance. This is one of the best things that *lo Spagnolo di Bologna* has painted.[110]

This picture, now lost, is fortunately recorded in a hitherto unpublished engraving by the Venetian Giuseppe Camerata (fig. 23). The same *Sleeping Shepherdess* came to Venice in 1736, when it was acquired by A.M. Zanetti the Elder. The Camerata

print also reveals for the first time that Crespi was the inspiration for two of the best works executed during the 1740s by Piazzetta's assistants Giuseppe Angeli and Domenico Maggiotto (figs. 24 and 25).[111] The motif is the same in all three, with the treatment by Giuseppe Angeli (signed and dated 1745) depending particlarly closely on Crespi's prototype.

The two paintings of shepherdesses by Angeli and by Maggiotto are sometimes considered to be pendants since they share the same ample dimensions, roughly two meters by one and one-half. Their size approximates that of three life-sized pastorals painted by Piazzetta around 1740-1743, two of them for Marshal Schulenburg (who was advised by Zanetti) (figs. 26-28).[112] The conception of these grand pictures is a brilliant improvisation by Piazzetta inspired by Crespi's precedent of painting genre in life size (so far as we know Crespi never translated his pastoral themes onto this scale). It is possible, too, that Piazzetta was inspired to cast his genre subjects

29. Giambattista Piazzetta, The Repentant Magdalen in a Grotto. *Private collection, Montreal.*

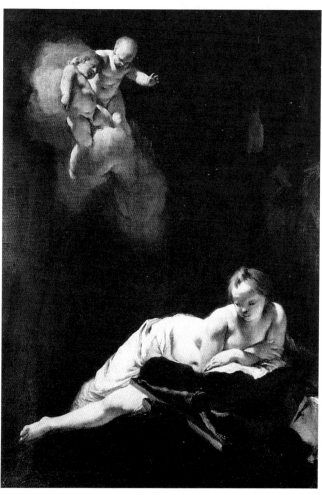

30. *Pietro Longhi*, The Reception of Frederick Christian, Electoral Prince of Saxony, by Representatives of the Doge at Trento in 1739. *Stair Sainty Matthiesen Gallery, New York.*

onto a large canvas by Giacomo Ceruti's contemporary paintings for the same patron. Finally, a relationship between Crespi's genre paintings and certain religious paintings by Piazzetta should be mentioned. Here, too, the Venetian deserves credit for finding new avenues of approach that the elder Bolognese did not himself explore. In Piazzetta's compact compositions of upright format depicting single figures in full length, the height of the figures is roughly equivalent to one-half the height of the canvas itself. The scale and, most notably, the impressive physicality of these single figures are directly related to Crespi's preferred format, around 1708-1710, for his genre scenes of laundresses, flea-hunts, and the like (cf. fig. 16). A particularly charming example from Piazzetta's brush is the *Saint Mary Magdalen* (Private Collection, Montreal) (fig. 29), datable on the basis of its blond tonality to about 1720.[113] The facial type of the Magdalen is clearly based on Crespi, and her kittenish charm is more suited to a lazy shepherd girl. The young Tiepolo imitated more than once this new mode of Piazzetta's in which a single religious figure was endowed with the spirit of genre, and it is clear that young Pietro Longhi must also have appreciated Piazzetta's evocations of Crespi's small canvases (and coppers) with single figures.

The earliest known genre canvases by Longhi represent single figures of shepherds and shepherdesses set against dark backgrounds: their oval faces and delicate features are painstakingly modeled on the familiar types of the Bolognese artist (compare cat. nos. 38 and 39 with cat. nos. 22 and 26 by Crespi. Unfortunately for purposes of comparison, the chronology of Longhi's work is not well understood. To begin with, his activity during the 1720s is completely unknown today. At the turn of the fourth decade, however, he began to receive commissions for altarpieces and other paintings of large scale. A.M. Zanetti mentions one such work by the fledgling artist in his guidebook published in 1733 (but compiled by August 1732, when the manuscript was passed on by the censors), and he identifies Longhi as a pupil of Antonio Balestra.[114] The apprenticeship

with Balestra is cited as well by Alessandro Longhi, writing during his father's lifetime in 1762,[115] and it is affirmed in unequivocal visual terms by his altarpiece of *San Pellegrino* (in the parish church of San Pellegrino), datable to 1732.[116] The absence of Crespian, let alone Bolognese, qualities in the *San Pellegrino* has indicated to some scholars that Longhi's sojourn in Bologna must have been brief, between 1732 and 1734; in the latter year he completed frescoes in the Palazzo Sagredo, Venice, in which some scholars have detected the influence of the Bolognese style of architectural decorations.[117] On the other hand, Pignatti and other scholars deduce from the sources that Longhi went to Bologna in 1719, following his time with Balestra, and spent "some years" with Crespi (according to Alessandro Longhi, whose nickname for Crespi, "Spagnoletto" [Jusepe de Ribera], does not inspire much confidence).[118] Further support of a kind for the early arrival of Longhi in Bologna can be deduced from a canvas that he later painted of *The Reception of Frederick Christian, Electoral Prince of Saxony, by Representatives of the Doge at Trent in 1739* (fig. 30),

which seems to evince direct knowledge of the paintings done in 1717 and 1719, respectively, by Crespi and his pupil Antonio Gionima of receptions given to James Stuart, "The Old Pretender."[119]

It is problematic, of cource, that neither Zanotti nor Crespi makes mention of Pietro Longhi, even though they both cite followers of considerably lesser attainment. Zanotti (1739) reports, moreover, that Crespi had not accepted any students in "*moltissimi anni*," which would appear to bar any direct association with Longhi during the 1730s.[120] As in the case of Piazzetta, the available evidence makes it doubtful that Longhi formally entered Crespi's studio, although perhaps he stated so himself in subsequent years, since his son and other Venetian sources beginning with Guarienti in 1753 had no difficulty with the story.[121] And Alessandro Longhi adds a detail that has a familiar ring, namely, that Antonio Balestra recommended Pietro Longhi to Crespi. Whether Longhi went to Bologna in the early 1720s, or a decade later, it would seem unlikely that his

31. *Giuseppe Gambarini*, A Peasant Girl. *Malcolm Waddingham collection, London.*
32. *After Crespi*, Laundresses, *Etching. City Museums & Art Gallery, Plymouth, England.*

Apud Ill et Rev D Gasparem de Nigris

34

earliest group of shepherds and shepherdesses à la Crespi date as late as about 1740, which is the consensus among scholars today.[122] In the first place, these modest, albeit charming, pictures (cat. nos. 38 and 39) are demonstrably less confident in their technique than are even the successive series of genre scenes that are considered to be early works (cat. no. 40).[123] Indeed, Longhi's first genre figures have hardly any narrative content at all, with the sole exception of the Crespian *Shepherd Girl* at Bassano (cat. no. 39). In this wise, they are more like details from Crespi's paintings, as opposed to fully realized subjects; specifically, they resemble Crespi's isolated figure studies (cf. fig. 30.1), and Giuseppe Gambarini's use of such studies pertains here as well (fig. 31).

The *Happy Couple* at the Ca' Rezzonico (cat. no. 40) belongs to a series of peasant subjects which are evidently early yet show marked progress over the Bassano shepherds with regard to the fundamental craft of painting. In these paintings, Longhi's own character comes for the first time to the fore: Crespian prototypes remain in evidence, but they are now used with greater intelligence, so to speak. The pigment is applied more densely than in the earliest examples and takes on an appeal in its own right, as is always the case in Crespi's works. Most significantly, among Crespi's works, especially the genre paintings of the 1710s, there are ample precedents for Longhi's peasant interiors. Longhi need not even have gone to Bologna to encounter such works by Crespi. Luigi Crespi provides a remarkable list of acquisitions by Venetian collectors that merits quotation; most of them are genre paintings:

for the noble Sagredo of Venice he [Crespi] painted two pictures, in one the Nativity of Our Lord, in the other a Mission: for the elder Faresini of Venice he painted a Market, and for its companion many pilgrims and poor people around a shrine [cf. figs. 16.1 and 16.2, cat. no. 16]: another picture in half length of a youth with a flute, and piece of music, which was then acquired by the late count Algarotti, who had it engraved, baptising it for a David [fig. 22]: two cypress panels, in one of which he painted the miserable life of a woman of ill repute, in the other three laundresses in the act of washing clothes, with a boy, and a donkey, and this panel then passed into the hands of monsignor Gasparo Negri, Bishop of Savenzo, who has had it engraved [fig. 32], in which the engraver has admirably imitated the character of the picture: and his own half-length portrait in the act of painting.[124]

Zanotti had previously cited Crespi's *Self-Portrait* in the Faresini collection, Venice,[125] which serves to confirm the apparent sense of Luigi's paragraph, namely, that all of the paintings other than those painted for the Sagredo were originally painted for the Faresini. At present, all of the paintings are untraced with the exception of the *Street Musicians* fragment (cat. no. 16) of the *Pilgrims and Poor People at a Shrine*, which is recorded in the print made by Giacomo Leonardis after it and its pendant, *Market*,

had passed into the collection of Consul Joseph Smith.[126] The style of these paintings suggests a date of about 1717, while the *Laundresses* which was later acquired by Gasparo Negri appears from the etching to have been of a slightly earlier date, perhaps about 1713. In many respects, the *Laundresses* qualifies as a proto-Longhian composition. Its subject might have been more appropriate somehow as the pendant to *The Miserable Life of a Woman of Ill Repute*, if by chance the lost picture of that title happened to be another version of *The Flea Hunt*.[127]

For the most part, the genre compositions of Longhi's maturity do not strictly depend on Crespi: the arrival in Venice in 1737 of the French printmaker Joseph Flipart is rightly regarded by scholars as a crucial medium for Longhi's introduction to the Parisian conversation pieces of Watteau and company. He is known to have copied figures from French engravings, and after the 1730s Hogarth's engravings would have made their way to Venice. Moreover, there were precedents for conversation pieces within Venice itself, including the several informal *Concerts* painted by Marco Ricci (1676-1730) later in his career.[128] Even so, it bears mention that Crespi too tried his hand at elegant interiors and social satire. Unfortunately, the early history of his *Concert* (*Scena galante*) in the Uffizi is unknown (cat. no. 24).[129] To judge from its style, Crespi's *Concert* could not have been painted earlier than the late 1720s; indeed, this scene of frustrated romance in the drawing room represents a far cry from the earthy bambocciate that Crespi had painted two decades before for the Grand Prince Ferdinand de' Medici.

1) The literature on genre painting in general is vast: for additional bibliography, and for a scholarly analysis of genre painting in a different school of European painting, see the catalogue of the recent exhibition, Sutton, ed., *Masters of Seventeenth-Century Dutch Genre Painting*, Philadelphia, Berlin, London, 1984.

2) The Campi have recently been studied *in extenso* in an exhibition and catalogue, *I Campi e la cultura artistica cremonese del Cinquecento*, Cremona, 1985.

3) Pieter van Laer and the Bamboccianti artists are the subject of a major monograph by Briganti, Trezzani, Laureati, *I Bamboccianti*, Rome, 1983.

4) For the most recent study of Sweerts, and for complete bibliography, see *I Bamboccianti*, cited in the precedent note. With regard to Sweerts's reputation, Chiarini (1979, fig. 54) has made the noteworthy rediscovery of Sweerts's *Self-Portrait*, documented in the collection of Cardinal Leopoldo de' Medici in 1675.

5) Malvasia, ed. 1841, II, pp. 179-181. Briganti *et al.* (*op. cit.*, pp. 352-362) have compiled a useful anthology of comments on the Bamboccianti by their contemporaries.

6) Ruffo, 1916, p. 174 (letter of May 22, 1665).

7) *Ibid.*, p. 186 (letter of January 24, 1670).

8) All the biographical data on Crespi in this section and below, unless otherwise credited, are derived from Zanotti's biography (1739, II, pp. 32-72), following Zanotti's sequence. For that reason, most footnotes to Zanotti have been suppressed with the exceptions of direct quotations and of his personal comments. In my opinion, the later biography by Luigi Crespi is essentially based on Zanotti's

account, without preserving, however, Zanotti's efforts to describe Crespi's works in chronological order. Luigi Crespi evidently made use of letters and other records preserved by his family, but Zanotti was an eyewitness to almost every event after 1686 that he recounts. Moreover, Zanotti (p. 65) explicitly states that he conferred with Giuseppe Maria Crespi concerning the paintings mentioned in the biography: "I have said about this man everything that I know, and that he himself knows. Certainly, he has made many more works besides, but he hardly remembers these other things."

9) Both forms of the name appear in contemporary documents, although "Crespi" is standard. However, "Cresti" appears to have been used by earlier generations of the family.

10) See Goldberg, 1983, pp. 34-38, for the Cospi and Ranuzzi families' service to the Medici in the seventeenth century.

11) Zanotti, 1739, II, p. 38.

12) *Ibid.*, p. 33.

13) This copy is mentioned in Crespi's letter of December 1, 1708. Cf. Appendix II, 20. This is presumably the same painting which had already become mistaken for an original Guercino by 1739, when Zanotti (p. 35) reports that Luigi Crespi made the necessary clarification during a subsequent visit to Florence. Luigi Crespi (1769, p. 203) tells the story with the added detail that the painting was shown to him by Grand Duke Gian Gastone de' Medici.

14) These frescoes in collaboration with Marcantonio Chiarini are illustrated in Roli, 1977, figs. 35a-d, 36a-d.

15) For Burrini's chronology, see *ibid.*, pp. 235-236. Indeed, the reader is referred to Roli's invaluable volume for documented chronologies and ample illustrations of all of the late Baroque and eighteenth-century Bolognese painters cited in this catalogue.

16) Zanotti (1739, II, pp. 36-37) describes the Chicago painting at length.

17) *Ibid.*, p. 36.

18) Crespi, 1769, pp. 204-205.

19) Zanotti, 1739, II, p. 37.

20) *Ibid.*, p. 37.

21) Cf. Roli, 1977, figs. 310b, 311a, 311c.

22) Johnston (1982, cat. no. 84) discusses an interesting genre drawing by Burrini and gives references to others.

23) Merriman, 1980, cat. no. 105.

24) Crespi, 1769, p. 207.

25) Zanotti (1739, II, p. 42) cites Crespi's denials, while Luigi Crespi (1769, p. 206) has no doubts of his father's authorship of the caricature.

26) In a letter of 1705 to the Prince of Liechtenstein, Crespi made this point in no uncertain terms. Miller, 1960, pp. 530-531.

27) Merriman, 1980, cat. nos. 148 and 149.

28) This paraphrases an apt comment by Roli, 1977, p. 182.

29) Cf. Appendix of Documents, I. This is the explanation as to why Ferdinand in 1708 did not display any previous acquaintance with Crespi or his works.

30) Marco Martelli's letter of August 6, 1701, from Vienna to Ferdinand in Florence discusses Crespi's commitments to a German count: Count d'Gios, Cameriere della Chiave d'oro, whom he describes as well versed in art and an advisor to the king of the Romans, i.e. Joseph, future Holy Roman Emperor. Unfortunately, Count d'Gios (undoubtedly an Italianization of the unpronounceable German) has thus far resisted efforts at identification. Wolfgang Prohaska has very kindly informed me that no nobleman of this name can be found in the Viennese retinue of Prince Eugene of Savoy.

31) The inventory of the contents of the Viennese residence of Enea Caprara in March 1701 lists eight paintings by Crespi, which confirms the later notices of Zanotti, Crespi and Oretti regarding the Caprara collection. See Appendix V, below. See Merriman, 1980, pp. 77-78 and 204, n. 2; also her cat. no. 255, a classically garbed *Shepherdess* in the Suida Manning Collection, which formerly bore the date 1698.

32) Bartsch, XIX, 404, 15. For illustrations of Crespi's collected prints, see Spike, 1982, pp. 216-259.

33) Ferdinand's known correspondence concerning Crespi is transcibed in Appendix II, below. For Crespi's relationship with Ferdinand, the best telling remains Haskell's (2nd ed. 1980, pp. 237-239). For further bibliography on Ferdinand, see Merriman (1980, p. 199, no. 13).

34) In 1736, Ludovico Mattioli copied Crespi's etchings in order to illustrate a deluxe edition of *Bertoldo* published by Lelio dalla Volpe in Bologna (for illustrations, see Spike, 1982, pp. 133-153). Scholars have been exercised since to reconstruct the sequence in which Crespi made his oil paintings, drawings, and etchings, and, moreover, whether Mattioli assisted Crespi with the earliest set, about 1710, since Mattioli's name appears on them together with Crespi's in more than one of the states (for illustrations of Crespi's, see Spike, 1982, pp. 239-258). However, both Zanotti and Luigi Crespi affirm that Crespi enjoyed giving Mattioli's career a boost through undeserved credits of this kind. Merriman (1980, pp. 320-326) collects all of the pertinent evidence (she includes in her consideration of the problem, however, a series of watercolors in the collection of the Cassa di Risparmio in Bologna which appear to me to be derivations from the prints). On the basis of Zanotti's generally greater reliability than Luigi Crespi's, his order of execution — drawings, prints, then oils on copper — is accepted here (cf. note 12, above). I agree also with Johnston (1982, p. 125), who attributes the first series of etchings to Crespi's hand unaided. Merriman (1980, cat. nos. 323-342) records the *Bertoldo* compositions in the Galleria Doria Pamphilj, Rome, and considers them Crespi's originals in poor state, heavily retouched or completely repainted (curiously, they are not all in the same direction as Crespi's etchings). Crespi's originals, as Luigi Crespi (1769, p. 211) learned from Count Giacomo Carrara, were acquired from the Pamphilj by a Bergamasque nobleman, Count Ignazio Barziza. Merriman (1980, p. 325) suggests that the Pamphilj then re-acquired the pictures at a later date. It is more than likely, however, that the originals were dispersed, and that one of them is the painting illustrated here as fig. 11 and listed by Merriman as cat. no. 343.

35) Crespi was already in contact with Cardinal Ottoboni since the end of 1707, since Antonio Sabaini in a letter from Rome, January 14, 1708, refers to two paintings made for him (cf. Appendix III, 6). Sabaini refers to his desire to make Crespi better known in Rome, which gives the impression that the painter had not been long in contact with Cardinal Ottoboni.

36) Crespi's skill in meeting this challenge was the most impressive aspect of the *Sacraments* for the author of Crespi's biography in the *Serie degli uomini i più illustri in pittura, scultura, e architettura...*, Florence, 1775, vol. 12, p. 142.

37) Crespi, 1769, p. 218.

38) See the discussion on Crespi and the Accademia Clementina in Merriman, 1980, pp. 30-32.

39) Crespi, 1769, pp. 226-231.

40) Zanotti, 1739, II, p. 70; Lanzi (3rd ed. 1809, pp. 193-194) indicts Crespi for worse faults besides, which are duly reiterated by Ticozzi (1830, I, p. 378).

41) Zanotti (1739, p. 164) writes 1718; Crespi (1769, p. 148) writes 1719.

42) They were commissioned by Senator Paolo Magnani: Roli, 1977, pp. 188-189, figs. 353a-b. The pair is listed in the unpublished inventory, 1765, of this collection, kindly traced for me in the Archivio di Stato, Bologna, by Tiziana Di Zio.

43) Evangelisti, 1981, p. 48.

44) See the documented chronology in Roli, 1977, p. 261.

45) For Ghirardini, see *ibid.*, p. 268, with many illustrations.

46) For Ubaldo, Gaetano, and Mauro (Gaetano's son) Gandolfi, see *ibid., passim.*

47) Zanotti (1739, II, pp. 46-50) tells this adventure in terms that are at least as melodramatic.

48) *Ibid., passim*, writes often of Crespi's gifts as racconteur.

49) The testimony of Crespi's friend Zanobio Troni, cf. Appendix III, 7.

50) See Note 33, above.

51) Merriman, 1980, pp. 103-105. Certainly Crespi's *Woman with Two Quarreling Boys* (private collection: Merriman cat. no. 286) pre-dates 1708.

52) Zanotti, 1739, II, p. 49.

53) Appendix II, 2.

54) Appendix II, 3.

55) Appendix II, 4.

56) Appendix II, 5.

57) Appendix II, 8.

58) Appendix II, 10.

59) Of this self-portrait (Merriman, 1980, cat. no. 181), Roli (1977, p. 169) comments, "it is not immune from *rembrandtismo.*"

60) Appendix II, 14.

61) Appendix II, 16.

62) Appendix II, 17.

63) Appendix II, 18.

64) Appendix II, 22.

65) Appendix II, 20.

66) See note 13, above. It might seem strange for Crespi to have sent a copy, but he probably wished to demonstrate the validity of his claim about the Tintoretto in Ferdinand's collection. The dell'Abbate was sent to Cassana in Venice for restoration: Appendix II, 21, 28.

67) Haskell, 2nd ed. 1980, p. 238. The small dimensions of *The Painter's Family* may have been suggested to Crespi by his knowledge of Ferdinand's *"piccolo gabinetto"* at the Villa Poggio a Caiano.

68) Zanotti (1739, II, p. 51) describes a satirical portrait of Don Carlo Silva which conforms with the painting depicted on the easel in the background of *The Painter's Family*. Since there is no other record of such a painting, it is possible that Zanotti has construed from his notes a distinct work that never existed.

69) Appendix III, 1, 7, 8, 9.

70) Appendix II, 24.

71) Appendix II, 27.

72) Appendix II, 32, 35 and 36; Appendix IV.

73) Appendix II, 33 and 34.

74) The black-frocked priest at lower right was apparently the butt of many jokes. Cf. cat. no. 9.

75) Zanotti, 1739, II, p. 54.

76) For the Magnasco, see the entry by Marco Chiarini in the exhibition catalogue, *The Twilight of the Medici*, Detroit and Florence, 1974, no. 163.

77) An interesting exception is a small painting, *A Man Teaching a Bird to Sing*, which patently derives from one of Magnasco's favorite motifs. Merriman (1980, cat. no. A9) suggests a date of 1710-1715.

78) For Helmbreker, see the detailed treatment with many illustrations and full biography by Laureati in Briganti *et al.*, 1983, pp. 340-349.

79) The 1706 Ughi inventory is published by Corti, 1980, pp. 69-79. Crespi could also have seen in this collection eight works by "Monsù Bernardo" [Bernhardt Keil (1624-1687)].

80) Quoted by Laureati in Briganti *et al.*, 1983, p. 341.

81) *Ibid.*, fig. 16.2.

82) Merriman, 1980, cat. nos. 223 and 224.

83) For a remarkable testimony to the humor perceived in the paintings of the Bamboccianti, see Baldinucci's elaborate discourse on a *Country Wedding* by Cerquozzi in the Gerini collection. The text is quoted and compared to the painting in Briganti *et al.*, 1983, pp. 358-359.

84) Zanotti, 1739, II, p. 54.

85) For Gerini, see Haskell, 1960, pp. 32-37; Morassi, 1962, pp. 3-10; Rudolph, 1972, p. 273; Ewald, 1976, pp. 344-358.

86) The observations that follow concerning the exhibitions at SS. Annunziata are based on the research of Borroni Salvadori, 1974, *s.v.* "Crespi."

87) Merriman, 1980, cat. no. A5. Not identified as the Gerini picture.

88) Ewald, 1976, fig. 15.

89) Recently the J. Paul Getty Museum has acquired one of a pair of Florentine commissions cited by both Zanotti (1739, II, p. 64) and Crespi (1769, p. 216). The painting on copper, *The Blessed Bernardo Tolomei Visiting Victims of the Plague in Siena*, is Crespi's prime treatment of a composition hitherto known only through studio derivations (cf. Merriman, 1980, pp. 138-141). This subject, together with a pendant, *Saint Francesca Romana Presenting the Infant Jesus to his Confessor* (likewise recorded only in a studio treatment), was commissioned by the "Olivetan monks in Florence" (Zanotti), specifically, the "Abate Corsi, Olivetano in Firenze" (L. Crespi). Zanotti discusses these pictures in the context of paintings datable to ca. 1730, which is confirmed by the style as well. The *Blessed Bernardo Tolomei Visiting Victims of the Plague* subsequently entered the collection of the Marchese Gino Capponi, Florence, who included it with the 59 paintings that he lent to the public exhibition in 1767 at the cloister of SS. Annunziata (cf. Borroni Salvadori, 1974, pp. 78 and 141). The painting was later described as in the Capponi collection, painted on copper and about a *braccia* in width, in the notes to the biography of Crespi in *Serie degli uomini i più illustri nella pittura, scultura, e architettura...*, 1775, XII, p. 143, n. 1.

90) See note 86 above.

91) Cf. Appendix I.

92) Zanotti, 1739, II, p. 63, adding that Crespi's own *Self-Portrait* in Gaburri's collection was used for the frontispiece for Zanotti's biography. The drawing must postdate 1722, since it did not appear in the inventory compiled in that year by the collector himself. In the 1722 inventory, a single drawing by Crespi representing a clothed man is listed: Campori, 1870, no. 173.

93) For Gaburri and the exhibitions at SS. Annunziata, see Borroni Salvadori, 1974, *passim*.

94) For Giordano in Florence, see Detroit and Florence, 1974, *sub vocem*.

95) The latest scholarship on Ferretti's training is Gregori, 1976, pp. 367-382.

96) Cf. Appendix II, 8 and 10.

97) Zanotti, 1739, II, p. 43.

98) *Ibid.*, p. 37: "Molto ancora lo Spagnuolo si era invaghito del modo della scuola Veneziana per quel poco, che n'aveva veduto..."

99) His admirer, the Florentine painter Giovanni Camillo Sagrestani, compiled some interesting biographical notes about Ricci, including the notice that Ricci was still far from formed when he arrived in Bologna, following his studies with Cervelli: Matteoli, 1971, pp. 201-202.

100) For the lives and works of the seventeenth-century Venetian painters, see the *magnum opus* by Pallucchini, 1981.

101) For example, Crespi's early altarpiece at Bergantino (Merriman, 1980, cat. no. 136; exh. cat. Venice, Civici Musei, no. 3) was previously attributed to Bencovich. The attribution of an *Adoration of the Shepherds* at Verona is contested between Bencovich and Piazzetta (Magagnato, 1978, no. 157; Martini, 1981, p. 502).

102) The San Stae pictures were recently exhibited in the Piazzetta exhibition in Venice, Civici Musei, nos. 15-18.

103) Moschini, 1806, III, p. 71. See also Ruggeri's summation of the historiography in *ibid.*, p. 58.

104) Lanzi, ed. 1795, p. 167. However, Mariuz, 1982, p. 67, refers to a reference in a slightly earlier manuscript by Bernardo Ziliotto.

105) Bottari, 1757, II, Letter LI, p. 100. In 1726, Gaburri acquired two drawings of heads by Piazzetta from Zanetti: *ibid.*, Letters LXX and LXXI, pp. 140-142.

106) *Catalogo dei quadri dei disegni e dei libri che trattano dell'arte del disegno della galleria del fu Sig. Conte Algarotti in Venezia* (A. Selva, ed.), 1780, p. 2.

107) *Illustrated Handbook, Museum of Fine Arts Boston*, 1975, p. 260.

108) Merriman, 1980, cat. no. 212, cites the Algarotti reference, but had not seen the print which secures the identification. This particular *testa di carattere* by Crespi is particularly close to the mode developed by Piazzetta, and there are many Piazzetta school paintings of similar boys holding recorders: the most recent addition is Martini, 1981, tav. XXIX.

109) Such subjects were in the collection of the Marshal Enea Caprara, who died in 1701. See note 31, above. See Merriman, 1980, pp. 77-78 and 204, no. 2; also her cat. no. 255, a classically garbed *Shepherdess* in the Suida Manning Collection, which formerly bore the date 1698.

110) Haskell (2nd ed. 1980, p. 341, note 4) first published this quotation from Zanetti's manuscript *Memorie* in the Biblioteca Marciana, Venice. See also Merriman, 1980, pp. 134-135; Romano in Turin 1982, pp. 7-8.

111) These paintings of sleeping shepherdesses by Maggiotto and Angeli are both described in Mariuz, 1982, nos. A3 and A37, respectively.

112) The literature on Marshal Schulenburg's collecting activity in Venice grows daily. Two recent contributions which cite the earlier bibliography are Gregori, 1982, *passim* (this book has no indices), and Bettagno in Venice, S. Giorgio Maggiore, 1983, pp. 83-88. As always, the most balanced account and the best outline can be found in Haskell (2nd ed. 1980, pp. 310-316).

113) Mariuz, 1982, no. 27. Most recently lent from a private collection to a benefit exhibition at Thos. Agnew & Sons, London, *Venetian Eighteenth Century Painting*, 1985, no. 20.

114) Zanetti, 1733, p. 433.

115) Longhi, 1762, *sub vocem.*

116) Pignatti, 1974, no. 1.

117) *Ibid.*, 1974, no. 7. See the biographical sketch for Longhi in the catalogue.

118) Pignatti, 1969, p. 14; Zampetti, 1969, p. 282. Pignatti (1974, p. 84) subsequently modified this position to "before 1734."

119) For the Crespi, cf. Merriman, 1980, cat. no. 188. Gionima's picture is illustrated by Roli, 1977, fig. 239.

120) Zanotti, 1739, II, p. 71.

121) Guarienti, ed., 1753, *sub vocem.*

122) The most compelling argument against such a late date for Longhi's juvenilia is the date of 1741 that he painted on his fully-mature *Concertino*, Gallerie dell'Accademia, Venice (Pignatti, 1974, no. 23).

123) This group includes several pictures closely comparable to the *Happy Couple* lent from the Ca' Rezzonico to this exhibition: cf. Pignatti, 1974, nos. 13, 14, 16-18, and 21.

124) Crespi, 1769, pp. 215-216.

125) Zanotti, 1739, II, p. 63.

126) For further information concerning these prints, see under cat. no. 16.

127) Jones (1981, II, pp. 27-28) is adamant in the view that the flea-seeker is to be interpreted as a prostitute.

128) For examples of informal concert scenes painted by Marco Ricci in England, 1709-1710, see the *Marco Ricci* exhibition catalogue by Pilo, 1963, nos. 28 and 29.

129) Merriman, 1980, cat. no. 284.

...the varied intercourse of country with country, interfusions, permeations, contacts of every sort, phenomena which, inexplicable when viewed apart, and in their own *milieu*, have to be integrated into the atmosphere of Europe as a whole before they can be readily understood...
— Paul Hazard

Up to the end of the seventeenth century, the artistic representation of ordinary scenes or events from contemporary daily life — scenes in which individual human figures play dramatic, central roles, but which have neither a literary base nor the heroic air of the deeds of history (in a word, genre painting) — had not occupied a very large part in the history of Italian art. Indeed, even in the eighteenth century, most of what materialized in the way of an independent, native tradition of genre painting in Italy is represented by the works of four Italian-born artists active in Bologna and the Veneto: Giuseppe Maria Crespi, Giovanni Battista Piazzetta, Pietro Longhi, and Giacomo Ceruti.

The four artists were connected either by direct contact or through common patrons or even through those tenuous conjunctions, sometimes second hand, that result when members of one small segment of a society share a certain intellectual and artistic sense of the direction in which the culture is tending. Stirring in this pre-Enlightenment society was a budding social consciousness and a responsiveness to new art forms, which, while firmly connected to the past, were asserting the primacy of the present — art forms that reveal the breakdown of the Renaissance (humanist) hold on the artistic imagination.

The grave truths and the playful insights into the human condition that hitherto had been satisfactorily exemplified in the literature and the history of the ancients, whether biblical or classical, now began to be clothed in the more specific fabric of actual experience. European traditions regarding issues of social class, behavior or the needs of the common populace began to be questioned; the modern, revolutionary consciousness began to take form and motivated these Italian artists to take the first halting steps in their new role as critics of the social order. Crespi (1665-1747), older by a generation than the other three, and thus also a source and precedent for them, matured as an artist during the phase of European intellectual history characterized by Paul Hazard as the years of crisis of the European conscience.[1] Beginning to paint professionally in 1685, by 1715 or 1720 Crespi had already produced the paintings that single him out as one of the first indigenous Italian artists of international standing who dedicated themselves in more than a casual or sporadic way to the production of subjects taken from contemporary life. If we are to understand fully how this development in Crespi's art took place, we must understand something of the intellectual history of the time. The thirty to thirty-five years in question

constitute what Hazard describes as a "dubious no-man's-land" between the perhaps too sharply-bounded territories of historical mapping known as the Counter-Reformation, on the one hand, and the period of the Enlightenment, on the other: the first represented a titantic attempt to reinspire through every modern means the values and the spiritual unity of the Middle Ages; the second represented the climactic repudiation of every tenet of the old order — man's declaration of intellectual independence.

What Hazard has put into focus is that the thirty years at the turn of the century were in fact years in which the potential for a new philosophy, swelling since the Renaissance, had finally exploded in all directions, producing an extraordinary intellectual upheaval. While the world had to wait until the generation beginning its work in the 1730s for the clear and unambiguous vision of the *philosophes*, already in the 1680s virtually all the ideas that would be deemed revolutionary in the 1760s were in place in Holland, England, and France, and were filtering down into Italy.

Doctrines of the divine authority of kings were, of course, not fully laid to rest until the French Revolution, but more than a century earlier, in 1673,

33. Crespi, Century Plant. *Private collection, Bologna.*

Pufendorf had identified natural law and reason as the real guiding forces in the evolution of social bodies, which were, by right, to be governed on the basis of common consent. In 1689, Locke argued that absolutism was incompatible with civil society, while concurrently James II was driven from the English throne for his presumptions. Where Crespi is likely to have stood on this question (at least as far as the pretensions of the Stuart line were concerned) may be guessed, as I shall argue later, from a curious painting commissioned in 1717 to commemorate the ceremonious welcome into the papal territory of James II's son, the peripatetic pretender, by a fawning Bolognese clergy and aristocracy.

At least in part, the rationalist revision of political theory rested on the rapid spread of knowledge of the successes of scientific thought. Fontanelle's *Entretiens sur la pluralité des mondes* (1686) became the prototype for subsequent publishing ventures intended to instruct ordinary readers in the mysteries of the new sciences and the true nature of the physical universe. Through the application of both observation and the descriptive powers of Newton's and Leibnitz's mathematics, astounding revelations regarding the clockwork regularity of the laws of nature were overthrowing the hitherto unquestioned authority of the ancients. Algarotti's 1737 Venetian version of that type of book, *Newtonianism for the Ladies* (with a frontispiece by Piazzetta), was a latecomer to the scene. But the excitement of Europeans beyond the Alps regarding this most powerful revolution of the human intellect was reaching Italy's scientists, writers, and artists long before. In 1691, the dissatisfaction with the stagnation of scientific studies — still mired in Aristotelianism at the University of Bologna — led Francesco Zanotti and Eustachio Manfredi (Arcadian poets and men of science) to establish the Academy of the *Inquieti* (the restless or anxious ones) in pursuit of experimental methods.[2] And the arrival from the Austrian wars in 1708 of General Ferdinando Marsili laden with optical instruments and books from Holland, the center of philosophical and scientific ferment, offered the enthusiasts of science and the artists of Bologna direct contact with modern inventions and thought.[3] Crespi, it may be noted, was the only one among the forty artists working with Marsili to establish an academy of art who responded with curiosity and interest by experimenting with the camera obscura, for the construction of which Marsili had brought lenses; and it says something of Crespi's proclivities, too, that it was his brush that we find recording, in the interest of knowledge, the botanical prodigy of a century plant in bloom (fig. 33). The inexorable progress of science and the sense of a changing intellectual panorama, which would bring the material world into sharp focus, was clearly finding its way into Bologna in the two decades at the turn of the century.

Along with the transformations which the new physical science was forcing on the image of God's created universe, there appeared also the unsettling *scienza nuova* of Giambattista Vico (born three years after Crespi). This was a new science of history, in the advancement of which Vico uncoupled the links between the history of the Church and divine revelation (the arenas of God's providence) and the actual history of human societies. Leaving the former to theologians and priests, Vico urged the application of reason to the study of the latter.[4]

But critical reason has a way of unraveling more than was intended. It set Antonio Muratori to work on an early history of Italy that was marked by a novel, encyclopedic historical realism, anthropological in its scope, which examined not so much the providential victories of this dynasty or that papacy, but rather the practical state of civilization — its arts, its production, its family structure, its recreations. Muratori, patient and industrious scholar that he was, was led from lucid examinations of the past to equally lucid examinations of the present, applying a moderate rationalist approach to the problems that beset the Italy of his time. He saw the need for reform in the distribution of wealth (*Della carità cristiana*), in the manner of wielding power, in the regulations of epidemics (*Governo della peste*), in the general conduct of the state and church in the interest of public welfare (*Della pubblica felicità*).[5] Crespi, whom we know to have corresponded with Muratori at least once, but in a way that suggests previous admiring contacts, could not but have been influenced by the tenor of these ideas. And while this period was not to see in Italy the skepticism that beset historians beyond the Alps, where investigations of biblical chronologies and of the myths and legends mixed with fact of ancient history led many to repudiate all intellectual authority, religious or otherwise, it certainly saw a shifting of the focus of the will beyond the status quo and towards a reform of those laws and institutions which had led to the endemic negligence by church and aristocracy of the welfare of the population. Mired in old systems and values, the established order with the church at its helm could no longer compete in the modern world of commerce or (more intangibly, but finally more importantly) of new ideas.

These same years also saw a crisis — much less explicit, of course — in art. It took the Franco-Flemish Watteau with his arch self-consciousness to produce finally in 1720 the image that on many levels commemorates the end of the Baroque. A genre painting of contemporary life, *Gersaint's Shop Sign*, is also a revery on love, taste, and art. In regard to art, the message is well known. The young woman welcomed into the rarefied world of the *cognoscenti* is distracted at the entrance of the gallery by a crate into which the official portrait of Louis XIV is at that moment being lowered, to be put

away along with the whole style and what it stood for. Something of this awareness seems to have begun to crystallize thirty years before in Italy. Literary dissatisfactions with *seicentismo* had surfaced during the foundation of the first Arcadia in 1690 in the meadows behind Castel Sant'Angelo in Rome. There, in a bucolic setting, a group of poets and friends founded the academy dedicated to recovering simplicity in poetry, ridding it of its feverish grandiloquence and the tyranny of a bombastic style.[6] Though not in itself very fruitful in works of more than passing interest, the Arcadia (which spread all over Italy and had an important chapter in Bologna) sounded the first note of rebellion against what had become empty and distasteful in the seicento's rhetorical style, as well as in its subject matter and the messages it conveyed. On the property donated to the group, named Bosco Paraiso (Paradise Wood), these new Arcadians idealized the more intimate experiences afforded by nature and the tender sentiments of pastoral love. The resulting poems thus constitute early counterparts of the *fêtes champetres*, which in Watteau's haunting images still readily evoke what we feel about the civilization of the eighteenth century. By the turn of the century, the Baroque had played itself out, and the style and content of the paintings that had embodied the

informing ideas of the seicento no longer had a currency or a life. The later complaint that they had become empty forms is probably correct; in any event, the ideas which these forms had served had lost their potency to generate anything new.
For lack of a clear sense of direction, the Italian painters of these years restudied the masters, relied on tradition and aligned themselves with different schools on the basis of taste or chance. Their works repeated the standard repertoire of subjects — the saints, the dramatic old testament stories, examples of virtues from ancient history, and allegories of the Olympian gods, such as those that embellished the walls and ceilings of palaces. The attention of collectors shifted to style and virtuosity. They bought examples from prominent practitioners, guided by taste rather than an interest in what was being represented. The collections of Prince Ferdinand de' Medici, Cardinal Ottoboni, and Eugene of Savoy reflected the ambition of the princely patrons to include in their galleries representative example (specimens) of all the modern *professori*.[7] Besides the undoctrinaire activities of the collectors (and collectors have a way of ignoring intellectual fashion), the signs are many that various artistic issues had lost their bite, even in official circles. And behind it all, even so, we sense a chafing for something new,

34. *Crespi,* Laundresses. *The Hermitage, Leningrad.*
35. *Crespi,* Scene in a Wine Cellar. *The Hermitage, Leningrad.*

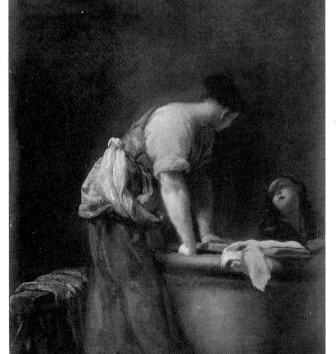

something piquant, something that would relieve the long line of Adorations, Holy Families, Saints, and standard subjects from Ovid. Yet, no strong voice was raised in rebellion or challenge. The mood, rather, was for tolerance, the broadening of taste, and an acceptance of what the academicians had polemicized against in the seventeenth century.

After the initial campaigns by Boschini (1660) in Venice and Rogier de Piles in Paris (1673) to vindicate *colore* in the face of the hegemony of *disegno*, and assert the excellence of the *moderns* over the *ancients*, an ever widening public, from the academy on down, was accepting modern, more natural imagery while agreeing to value Titian over Raphael, and Rubens over Titian. The result was that, while Poussin and Raphael were no less coveted than ever by those who could afford them, they began to share wall space and esteem with a hitherto largely disdained group of painters from Flanders and Holland — those unedifying realists of tavern and peasant life, Brouwer, Van Ostade and Teniers, not to speak of the Roman school of Netherlanders, Van Laer and his followers, known disrespectfully as the Bambocciati: Miel, Sweerts, Both, Lingelbach, and Helmbreker.[8]

The very feature of their appeal that once had been held against them, the fact that appreciation of their art did not require literary culture, or culture of any sort, at least one critic ventured to hold up as a sign of virtue. Writing in the 1680s, the Tuscan Baldinucci remonstrated against the snobbery that continued to obstruct the rightful appreciation and recognition of this type of art. Unpolished and unidealized representations from nature of the familiar appealed to every stratum of society; everyone could respond by virtue of a *puro lume naturale* (a natural understanding) when a painting was true to life.[9] What there was to be appreciated, Baldinucci maintained, was the skill of the artist in attaining variety and truth; as for style, he said, the painter needed only so much of an individual touch as to be recognizable. This was a tepid program for art, at best, and one, it must be pointed out, that was inspired by achievements already attained in Holland, and by Hollanders in Rome in the three previous generations. Still, considered along with all the other changes taking place in Europe, it represented a response of sorts, a lowering of intellectual barriers in Italy, to which a few very alert artists of the next two generations would respond.

The first to do so was G.M. Crespi in Bologna. His career might be viewed as a faithful reflection of the confused and changing state of affairs, the uncertain climate of this thirty-year period, when the old world was the matter-of-fact given (especially in conservative, papal Bologna), but the future was already stirring on every side. In his formative years, Crespi had been trained in an artistic ambience which one could scarcely have predicted would have led him to combine his career as a history painter with the practice of painting common subjects from life. His teachers, in so far as he actually had teachers, were Canuti and Cignani, both fresco painters. Each in his own way belonged to the full-scale, official, grand style of unexceptional Baroque pedigree going back to Reni and Albani, influenced along the way by Correggio and Tintoretto and more recently by Cortona and Giordano. Each had achieved that complex stylistic mixture that often heralds the end of an artistic era. There was not a whisper in their output of any impulse towards a lowering of their vision to the terrain of actual experience. Likewise, in the large circle of Bolognese painters, both older and contemporary (among them Pasinelli, Franceschini, Burrini, Gennari, Dal Sole, and Creti), there was virtually no sign of any interest in expanding the boundaries of art beyond the strict regimen, seemingly written in stone, which the exceptionally tight chain of descent of these Bolognese artists from the Carracci School had encouraged for over a century.

Neither can it be said, as is often done of artists who abandoned the prevalent high style (Caravaggio, Gambarini, or Pietro Longhi, for instance), that Crespi's early manner proved unsuitably awkward for a history painter, or that his turning to reality resulted from an inability to conjure from the imagination the requisite lightness and grace and compositional sophistication in arranging figures nobly related to each other, formally and emotionally. In fact, both the testimony of the sources and the actual works that survive clearly reveal how early Crespi had full control of the principles of classical proportion and that authoritative rhetorical movement which gave a high tone to Italian altars and history paintings alike. Likewise the suggestion that Crespi's activity as a realist genre painter was stimulated only in 1708 by exposure to the more worldly collecting tastes of Ferdinand de' Medici, whose galleries contained examples of Dutch genre painting and many Roman bambocciate, must be put aside in the face of Zanotti's unequivocally contradictory testimony.[10] While Crespi was winning laurels around 1690 for his powerful images of heroic figures in action, he was simultaneously producing and publicly exhibiting what his biographer called caprices, common subjects connected with the lowest trades of the working poor, which showed them forcefully engaged in their labors. Day laborers turning the wine presses with their strained backs and widely planted legs or laundresses with their powerful arms and graceful necks doubtless showed the same energy that the public admired in Crespi's heroic figures of Hercules and Cacus (figs. 34 and 35).[11] At a minimum, they would have made this point — that an Italian artist could wring art out of the most commonplace and humble experience. Certainly, if Crespi had been easily worried by the

opinions of the art writers, critics, apologists and biographers of the previous thirty years, he would not have sought to associate himself with "realist" subjects of low-class life. Indeed, apart from the recent voice of Baldinucci, who heralded the thawing of the frozen lines of Italian art theory looking ahead into the next century, the chorus of condemnation was well nigh universal. Foremost was the dignified and respected voice of Pietro Bellori, who articulated the classical ideal of art and spelled out the dangers inherent in the lessons that Caravaggio had taught (or, in any event, that most people seemed to think he had taught) as to nature's being the sole and necessary model for painters.[12]

A few years earliers, Salvator Rosa had raised a sneering and satiric voice against the subjects painted by the Bamboccianti, whom he accused of catering to the prurient, crude tastes of a public that enjoyed wallowing in scatalogical humor and spectacles of the lowest moral value.[13] In Venice, Boschini defended the Venetian tradition of *colore*, while repeatedly excoriating the use of low-class models, such as the porters and wrinkled old men whom painters employed to lend convinction to their images of hermit saints. That was too much reality. As for genre painters, while there were not any in Venice, Boschini made sure to voice his disdain for still lifes, which he called realistic *bagatelle* (trivia) in an ironic echo of Caravaggio's use of the same word to characterize painting not based directly on nature.[14]

Closer to home was Malvasia, the grand old man of the Bolognese art world, biographer of Bolognese painters in the *Felsina pittrice* (1678) and an early patron of the young Crespi. With unmistakable relish, he quoted in his Life of Albani an exchange of letters between the famous Bolognese painter and Andrea Sacchi, an intellectual artist in Rome, regarding the absolute loathing they both experienced at the sight of paintings showing low-born scoundrels such as beggars, vagrants, and other gutter subjects favored by the Bamboccianti. They regarded the growing popularity of this type of painting as an assault, a degradation of art itself — evidence of civilization in peril.[15]

In fact, the judgment against painting the lower classes in a style that depended on direct observation and transcription — without the mediating influence of good taste based on the classics, without, in short, the art of art in the familiar molds — was international in scope. It was echoed in France by Félibien in respect to the Le Nains, and even in Holland by a host of *nouveaux* art writers jumping on the cultural bandwagon.[16] On the eve of the new era, which the artists along with the philosophers, historians, scientists, and writers would help usher in by broadening the discourse of their art, the official opinion vis-à-vis the low-life mode was a solid phalanx of opposition.

Thus Crespi's decision to present himself publicly as a painter of *facchini* had an element of bravado in it. It was an act of innovation, of challenge to accepted values. What was modern about it was precisely his non-conformity, his lack of reverence for maintaining the subtle and elaborate structure of class which the current theories of art were at such pains to sustain. Where did this impulse come from? Did Crespi, who was somewhat sourly accused by the always impecunious Zanotti of invariably profiting from his bizarre behavior, read Baldinucci and follow the rising prices that the painters of those villified bambocciate were commanding?[17] Was this a case of being willing to hear a little abuse from the old fashioned contingent with an eye to a ready market? We cannot discount that altogether. Yet, to see that as the sole explanation would be to reduce behavior to one dimension. It would ignore a great deal of evidence that the non-conformity involved in Crespi's venturesomeness was but one feature of a complex personality oriented in a philosophical sense towards equalizing the disparities between the classes. Somehow, through a natural sympathy, he identified with the folk and was respectful to their labors; in contrast, he was largely unimpressed with the affectation and pretensions of their (and his) superiors.

In its totality, Crespi's life and work cannot be simply characterized as revolutionary or even clearly prophetic of an emerging new sensibility. An inchoate awareness of the poor would eventually call attention to the economic neglect and rapacity of the ideologically immobilized ruling class and to the harmful effects of its myriad privileges (as well as those of proliferating religious organizations of every sort) on the general welfare, both in town and country. In the years between 1685 and 1715 in Italy, however, the lessons of rationalist thinkers calling for reform tended to be applied within the given orthodoxies of class structure and the Church. This resulted in the peculiar mix of new and old that characterized Italian rationalists of this period, men who were not yet ripe for Spinoza or Locke, who avoided going to the roots of human contracts, but who, in Raimondi's words, were poking away from the inside at the old structure — stone by stone — until the edifice began to wobble or collapse.[18] What we can reconstruct of Crespi's life and thoughts fits just such a pattern.

Any serious consideration of Crespi's character must take into account his zealous and unquestioning piety within the Catholic Church. That piety had all the marks of having been formed in a clear Counter-Reformation mold, not unexpected in a Bolognese. We are told that Crespi attended mass and a sermon daily.[19] Such a frequent recourse to the sacraments went far beyond the obligations the church imposed upon its faithful, and, in fact, corresponded to practices common during the first fifty years after the conclusion of the Council of

Trent. The trend was towards stimulating a grass-roots devotion to the church's sacraments, a daily dependence on a round of pious rituals made vivid through both metaphors and concrete practices: the devotion to the sacred relics, the Rosary, novenas to the Virgin and the saints, and retreats sponsored by the religious orders and the various lay confraternities, the secular organizations that kept an open conduit between the priesthood and the laity.[20] The Counter-Reformation had also placed an overwhelming emphasis on works of charity, as exemplified by the acts of Saint Charles Borromeo, a Milanese famous for his compassion for the populace in time of epidemic, or Saint Francis of Sales and Saint Vincent de Paul at the beginning of the seventeenth century, both signally devoted to acts of mercy.[21]

In this regard, Crespi appears to have been equally assiduous, but especially in ways that impress one as being remarkably old fashioned and literal. He had, for instance, a lifetime dedication to the redemption of the souls of the dead through prayer and the buying of masses. His son Luigi saw receipts for over three thousand such masses, sometimes purchased, as we know, in exchange for paintings. Piety of this sort is certainly as distant from Enlightenment rationality as a religious practice could possibly be.[22] Not surprisingly, one senses in it a distinct correspondence with the religiosity of the altarpieces and smaller devotional works which made up such a large portion of Crespi's output as a painter. In them the visual language that Crespi used was unmistakably based on the models of early seventeenth century Counter-Reformation art, familiarly grim in its imaging of the swoons and ecstacies of the saints, and at the same time full of a sweet and genuine — if old fashioned — religious sentiment.

The Church, then, was the given in Crespi's life, just as the style of the Carracci and their followers, which he had absorbed with his earliest schooling, was the given in his art. The two — the Carracci style and his religious sentiment — went well together because, in fact, his religious understanding had remained untainted by any new thought that might have ruffled the certitudes of believers when the Church was in the full swing of its recuperation at the beginning of the seventeenth century.

In contrast, however, there was another aspect of Crespi's character and cultural identity that was far less orthodox and conformist; and in this aspect of his make-up we must seek out the impulses of his genre painting. A central feature of Crespi's character, revealed by both of his unusually detailed biographies, is his social irreverence. He was clearly a humorist, a man who perceived the world comically. He excelled in caricature of the particularly biting type that reduced human physiognomies to their animal counterparts. Such an image of a dead chicken that he circulated at a drawing school was

recognized by all as Count Cesare Malvasia, who was, in point of fact, remarkably scrawny. He was also much given to playing practical jokes designed to reveal human vices such as greed and dishonesty, and he seemed particularly impelled to play them when he was around important people at court. Even Zanotti, who was conservative, staid, and generally ambivalent about Crespi, could not resist his humor. Certain incidents, aimed at human folly and the deflation of vanity, were, he declared, worthy of Molière.[23]

Zanotti probably should have equated Crespi's pranks with the commedia dell'arte, the great repository of Italian humor. The commedia, with its improvisational humor, its standard situations, and its stock characters based on originals conceived in the sixteenth century, had developed in response to a changing and bewildering world when Italy was under Spanish rule and mercantile ventures were creating a new power class. Both were situations equally ripe with comic possibilities. The characters embody the various strata of society brought together by a loosely woven plot which permitted the famous comic actors to make *ad libitum* references to the social frustrations and woes that beset the Italian people. Thus there was the character of *Capitano*, a vainglorious braggart adventurer, villain of the Thirty Years War, and usually considered of Spanish origin. There was the Bolognese *Dottore*, the Latin-spouting travesty of the learned man and university pedant; and *Pantalone*, the nouveau riche Venetian or Genoese merchant, with his avarice, authoritarianism, and senile lechery. But above all, there were the *Zanni*, the clowns; foremost among them was *Brighella* from Bergamo, a side-splittingly gluttonous, uncouth, vulgar, lecherous scoundrel with beastly manners and given to prevarications. Brighella was a servant clown who spoke for the oppressed, unemployed, displaced, urbanized peasants and the other disinherited of society, who were always hungry and always at everyone's mercy. His weapons against those he served were lying, cheating, and scheming, and his success in dealing with his masters proved the peasant to be more aware, more cunning, and ultimately more sympathetic than all the bumbling fools who ran the world. In sum, the characters and the parts they played constituted a mirror of a society in which class distinction had come into the forefront of popular consciousness, a mirror which permitted comedy to sublimate despair, while it inevitably also subverted the existing order by laughter. One is not surprised that in 1687 Louis XIV banned the extremely popular commedia companies from Paris.[24]

There is much to suggest that Crespi's perceptions of society were cast in a similar comic mold and that some of his own personal adventures, which so amused Zanotti, were informed by a *topos* of commedia humor that had the artist himself playing the role of a Zanno — the shrewd manipulator

identified with the lower classes. Such an orientation would explain, for instance, Crespi's fondness for Cesare Croce, a popular Bolognese comic writer who had flourished in the time of the Carracci. Croce's most famous work, *Bertoldo e Bertoldino*, recounts the escapades of an astute peasant of the Brighella type who goes to court. Apparently, the characters of Bertoldo and his descendents struck responsive chords in Crespi, since, completely on his own, he elected to illustrate the book, eventually making three separate sets of twenty images, each in a different medium (fig. 36).[25] Croce had not belonged to the ranks of the learned poets of the courts. A contemporary of Marino, he represented the opposite pole to the sophisticated, learned, mannerist emblem writer. Croce's public bought his *Carnivale* plays, poems, announcements, and other *facezie* on the piazza in the form of cheaply printed broadsheets intended for the amusement of the common people.[26]

A child of the piazza himself, and of the commedia dell'arte, Croce wrote about what the populace knew best in those terrible days of endemic hunger, disastrous famine and general depression, when on winter mornings the citizens of many Italian cities had to gather up cartloads of rigid bodies of vagrants and beggars who had died during the night from cold and privation. The titles of many of his works reflect these grim realities: *A Letter brought once more by the North Wind, ambassaor of the Cold; to the poor, warning them that Winter is about to arrive...* (Bologna, 1610); *The Banquet of the undernourished. Comedy of the Academy of the Frusto. Acted by the Hungry in the City of Disaster, on the 15th of the month of Extreme misery. The year of the sharp and insupportable necessity* (Ferrara, 1601); *The true rules of staying thin with little expense; or the Argument between corn and bean bread* — the last, a doleful echo of the insufficiency of the peasant diet, which had been reduced to bread made of corn and bean meal instead of wheat flour.[27] In the story of Bertoldo, which Crespi found so appealing, a shrewd, sometimes mean, and always uncouth peasant confronts the world of the court. The peasant has his wisdom: to the king's question, "What is the longest day?" he replies "The one in which one has not eaten." Told hospitably by the king to make himself at home at the court, Bertoldo promptly prepares to relieve himself; checked, he defends this brutishness by observing that flies drop excrement into the king's soupbowl as readily as in that of a peasant. We are all made of clay, and clay does not bow to clay.[28] That is Bertoldo's philosophy, simple and redolent of the wisdom of the folk. Coming from those who have nothing to lose, it cuts through the conventions of social caste to the fundamentals — squalid, even at times scatological — to what is common to all humanity. Bertoldo is not a revolutionary, ready to destroy the social order; he does not want to stay at the king's court or take the king's place. The very food he is given in the palace is so rich that it destroys his stomach, accustomed as it is to a diet of beans and turnips.[29] He is, rather, a clown or jester, and as such he tells the truths that only jesters can tell to kings, because they are couched in humor and, in the end, do not overtly seek to uproot authority.

Thus Bertoldo's ethos — rustic, salty, and direct — appealed to Crespi, because in many aspects of his own character the painter was made of similar stuff and perceived society from a similarly alienated point of view. He clearly considered the scramble for social standing — especially the accoutrements of fashionable dress so important to the eighteenth century as a sign of status, and the social obligations of elaborate entertainment, participation in public ceremonies, and involvement in the grand occasions of the Academy — as unnecessary and foolish interference with the one thing that motivated his daily life, his painting. As a painter, he felt himself the equal of princes, bishops, and popes, whom like Rembrandt he greeted in his studio or in their palaces, nonchalantly dressed in the easy manner that Zanotti, a strickler for propriety, described disapprovingly as bizarre, "but convenient to himself."[30]

36. *Crespi,* Bertoldo on a Donkey Tormented by Flies. *Collezioni d'Arte della Cassa di Risparmio, Bologna.*

Zanotti's chagrin at Crespi's clothing (Luigi Crespi confided that his father wore some of the same garments for as long as forty years)[31] and at the artist's isolated and unpretentious style of life was more than a matter of personal distaste; he saw all these things as a hindrance to the long efforts (including his own as a faithful secretary to the new Academy of painters) to raise the status of the profession above its traditional associations with the humbler arts and crafts. What he did not understand was that Crespi's zeal far outstripped his own in regard to the real status of painting as the artist perceived it. Zanotti's judgment was clouded in Crespi's estimate by its emphasis on the merely external shows of status. Crespi, sensing the rarity of his own skill and the creative power coursing through him, saw himself in a social category all its own, liberated from the constraints of caste and class. He attributed his manners to something he identified as an "*estro pittorico,*" an artistic personality which clearly, he felt, gave him a special license in the world.[32] In the long run, as we know, his was the prophetically correct stance, foreshadowing as it did the time when artists would become the high priests of culture.

Clearly, then, the question of why Crespi was

37. *Crespi,* Woman with Two Quarreling Boys. *Private collection, Bologna.*

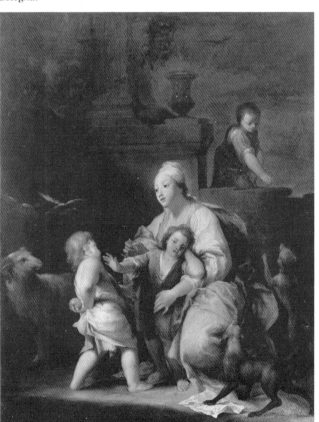

attracted to genre, a class of painting which bore the stigma of being vulgar, has a partial answer in his own sturdy independence of judgment and his conviction that great paintings, like great painters, transcend the class of their subject matter. Beyond that, his affection for the works of Croce suggests that he, a miller's son married to the daughter of a poultry butcher, retained a lifelong kinship with the working people of his city and felt a warm and entirely natural sympathy with those who pressed the grapes, worked the silk, scrubbed the pots, and ate the bread of the poor, when they could find it. It is that sympathy that lives in some of Crespi's most moving paintings.

As to the relevance of the bitter despair reflected in Croce's writing to the actual situation in the years at the turn of the eighteenth century, the answer which economic historians give is that the entire era was still tormented by an ongoing economic depression.[33] The countryside was drained of its population, unable to survive the irresponsible taxation imposed on it by the landowners and the city. The old industries had disappeared out of neglect and due to the indifference and laziness of the only class that could invest in their rehabilitation.[34] As a result, the cities were overrun by itinerant beggars, vagrants, and eventually charlatans and thieves of every sort, whose children also turned beggars, creating an enormous underclass that increasingly concerned the helpless authorities. For the thinking people of Crespi's day, with whom in one way or another we find him in contact, the social woes that had provoked the bitter humor of the clowns at the beginning of the century were as vivid as ever, but were no longer seen as intractable. The idea had dawned that rational remedies could be applied to the running of society and that reform was, in fact, possible and necessary.

A sadly mutilated painting by Crespi, now divided into two cut-down canvases, once showed (as an engraving of the work makes clear) a scene at one of the great gates of Bologna (cat. no. 16).[35] The street is lined with beggars, tired old men dandling children and sewing together their poor rags, old women kneeling or lying on the ground asking for help, ragged itinerant musicians, old and young — all the pitiable throng that clotted the narrow alleys of the city. They are the same wretched creatures who had attended Croce's grotesque comic banquet of the undernourished a hundred years before, creatures of whom the Bolognese writer had ruthfully exclaimed,

And if you could see how many warm themselves by the rays of the sun, miserable wretches, who from hunger suffer grave insults,
How many blind, how many widows and children, withered more thoroughly than anatomical specimens, prostrate on the ground, beggars and paupers.
The cries, the howls, which can always be heard along the streets, and knocks on the door, and the many and strange diseases,

The cheeks afflicted, discolored, and livid, which represent the very image of death.[36]

It is not easy to avoid the conclusion that the author of these words, who, after all, had set Crespi off on the long Bertoldo project, was also in some part the inspiration for his painting of the scene at the gate. Yet despite the pathos of both painting and poem, it is important to remember that insofar as Crespi was a genre painter, his contemporaries thought of him as a painter of comic subjects, just as they thought of Croce as essentially a comic writer. This classification depended in great part, of course, on the traditional view which automatically associated comedy with the lower orders of society. If Croce's subjects were characters of the lower classes, his work was by definition comic — the very accents of their speech gave the clue. Crespi's accent, to force a metaphor, was a faithful reflection of ordinary life (or so it seemed), a vernacular style, which automatically made him a painter of comedies.[37]

In fact, comedy, even in our sense of the term, abounds in Crespi's work. Considerably toned down from the burlesque of the commedia dell'arte, it retains elements of the popular drama's raw humor and its implicit awareness of class. It is, on the whole, very unusual visual comedy, differing from most other examples of comic imagery in a fundamental way.

Crespi did not resort to caricature in his paintings and did not, except in rare cases, employ strong facial characteristics or conspicuous expression and "telling" gesture to convey the comic import of the scene — unlike Hogarth, who was yet more than twenty years from creating his comic series, or Bartolomeo Passarotti and Vincenzo Campi, who had operated in Bologna a century before, or Gasparo Traversi, who would do so a half-century in the future. Nor did he, with one exception, employ settings filled with clues intended to illustrate specific proverbs in the tradition of the Dutch — from Bosch through Steen — of which Hogarth would avail himself.[38]

The unique example in Crespi's work of an emblematic moralizing painting, the *Woman with Two Quarreling Boys* (fig. 37), must have been derived from the widely circulated illustrations of Romeyn de Hooghe (1645-1708) in *Fourecourt of the Souls*, published in Amsterdam in 1668 (fig. 38). For the New Testament text "But they that will be rich fall into temptation and snare" (I Tim. 6:9), de Hooghe provides an illustration of a seated, well-to-do woman dangling a fruit and a jewel before a small child. The import of this image, elucidated by the commentary, is that children, uncorrupted by the false values of society, will spontaneously gravitate to a simple, God-given good having intrinsic value (such as a fruit) and will remain indifferent to what is useless but coveted by an illusioned world.[39] Such thoughts, of course, summon up the speculations then

current on human nature, natural law, and natural morality. These speculations, in conjunction with a moral weariness stemming from an increasingly complicated, ethically disunified — not to say incomprehensible — society, would flower in the middle of the next century into Rousseau's primitivism and the cult of sensibility. As yet, however, this was merely an expression of the brand of folk wisdom which Crespi appears to have admired, a pungent getting down to fundamentals. Yet, when Crespi undertook to paint the idea, he took only a slight direction from de Hooghe's etching. He retained the upper-class ambience, although he moved the scene into the open air and set is outside a noble house, avoiding the typical middle-class interior of his Dutch source. In so doing, he changed the atmosphere from a bourgeois setting to that of a pastoral — a comprehensible change, given Crespi's frequent reversion to that mode under the apparent influence of the Bolognese Arcadian academy. He made other changes, too, which rendered the scene narratively more active. Instead of one child, he has painted two: one who has obtained the apple and teasingly holds it behind his back, and another who, pouting and squirming in his displeasure, ignores the jeweled ring held up

39. Crespi, Peasants and Cattle Fording a Stream *(Detail). Private collection, Bologna.*

temptingly by the woman seeking to comfort him. Behind this group, as if to underscore the point about natural instinct, a boy lures a dog into taking some object he is holding. But Crespi's striking metamorphosis of his Dutch source derives mainly from his arrangement of the ensemble, ripe with the assimilated culture of Italian art going back to the Raphael of the Madonnas. A rich counterpoint of interrelated gestures in the central pyramidal group of mother and children, and the further currents of visual movement, lead the eye along the carefully calculated diagonal to the figure in the background, tying the action together. The result is a miniscule human comedy rendered with taste and well within bounds of the aesthetic norms of Italian art.

And therein lies the special quality of Crespi's comic mode: it never unmoors itself completely from the high-art origins of his training, nor from a fundamentally visual orientation. This orientation, while allowing him to explore quite a range of settings, sizes and compositional variations within a given format, nevertheless always led him to evolve an image which emphasizes the purely visual qualities of light, color, or abstract compositional dynamics while it tells its tale. The figures, moreover, never imitate the plain, unadorned body language of real life, especially that of the working poor. Baldinucci, who praised Cerquozzi at length for his fine descriptive grasp of peasant gestures, awkward and full of circumstantial detail, would have found little to commend in this respect in Crespi's peasants.[40] That is not to say that his figures look mannered, unconvincing, or conventionally idealized either. It is probably the secret of Crespi's appeal that he keeps a mysterious balance between the actual and the ideal, ultimately convincing us of both. A consideration of the *Peasants and Cattle Fording a Stream* (cat. no. 25) may begin to reveal the methods by which Crespi achieved this equilibrium. The central figure, for instance, is on close examination a body drawn with artful torsion (fig. 39). Her knees are oriented in the direction in which she is walking, but her head is turned almost 180 degrees in the opposite direction, while her body in between slowly rotates in accomodation. And that is not all. This torsion of the figure is further complicated by the thrust of the foreshortened shoulder and the arm that grasps the child, who is also posed complexly in relation to her. This is movement that Leonardo himself would have approved of as having escaped the woodenness he deplored, because it manages to attain a sense of kinetic energy — fictionalized, to be sure — but all the more convincing for that. It is, ideed, heightened reality. In addition, Crespi managed to preserve the figure's anonymity. She is materially there and has a certain realistic immediacy because of a few swiftly brushed-in descriptive details in her clothing — a lace loose here, a bit of petticoat there — but her

personality never materializes as a specific character with a particular face. The face remains turned away from us like that of the *Lute Player* (cat. no. 5) or that of the famous Uffizi *Woman Washing Dishes* (fig. 12). The aim is to attain a generalized impression (it is accomplished elsewhere by obscuring the face in a strong play of shadow and highlight). But, as in the *Workers in the Cellar*, there are enough clues here and there to indicate that these are indeed rough, uncouth members of the lower classes, and thus, by the critical presuppositions of the age, comedic figures *because* they are lower class. But the comedic effect, so understood, of Crepi's genre paintings is always mitigated by visual delights and artistic connivances — the traditional Bolognese combination of a jewellike, painterly surface (which Boschini extolled in Venetian painting) with the representation of the human figure as a sculptural form in the High Renaissance sense canonized by Raphael and Michelangelo.

It was, nevertheless, comedy that Crespi often intended. More often that not, the social commentary in his paintings resides in a piquant juxtaposition of the classes. This seems certainly to be the sense of the pair of ovals in the Hermitage (figs. 40 and 41), in the first of which a barefoot peasant and his lass display a lively sexual earthiness in their game of tag around a standing donkey (whose genitalia are the objects of their gestures and, presumably, rude jokes), while in the second oval an unwelcome upper-class lover makes a sudden and clearly brutish assault upon a startled lady of fashion. By contrast, the *contadini* seem positively innocent in their crude jollity.

A similar anatomizing of society seems to be subtly intended in the scene of the *Mission* from Detroit. The full significance of the by-play remains hidden to us until more specific knowledge can be had regarding the function and class implications of the rural missions, but an unmistakable polarity is set up by Crespi between the busy country folk and the two refined ladies eagerly directed to join in the event by a third, equally well-dressed woman. One of them makes a conspicuously aristocratic and mannered gesture directed out of the painting, as if to alert us to the content of the scene. Is the viewer being asked to distinguish, simply for variety's sake, as to a certain minimal dramatic content, or is this an allusion to some social judgment — for instance, approval of the simple piety of the rural poor in contrast to the gallant and Frenchified worldliness of the rich?

40. Crespi, Importunate Lover. *The Hermitage, Leningrad.*

41. Crespi, Peasant Flirtation. *The Hermitage, Leningrad.*

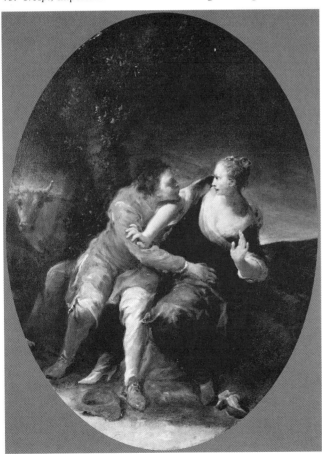

Further examples may perhaps serve as evidence.[41] This same type of contrast appears to have been intended in the work that Pope Clement XII commissioned Crespi to paint on the occasion of the welcoming into the Papal States of the exiled "James III," the Catholic pretender to the English Throne (fig. 42). For that event the entire aristocracy, as well as the ecclesiastical hierarchy, had turned out in a solemn ceremony, a type of activity in which the joint governing bodies of Bologna were considerably more practiced than anything else. To Crespi, who, as Zanotti said, had "his own lifestyle, strange and secluded," this kind of courtly ritual filled with panoply and oratory and followed by expensive entertainment must have appeared preposterously affected, considering that for himself he had woven a whole mystique of self-sufficiency around a simple life of work, prayer, and family. Such a view seems all the more probable when we consider the many insights Zanotti gives us into Crespi's personal style: for instance, in conversation, Crespi, unlike many of his contemporaries, "never stumbled into pomposity, being simple and explaining things without metaphors, leaving no one ever in doubt about what he meant to say."[42] It does not, therefore, seem farfetched to interpret what appears to be a deliberate

use of style to make a point as having an edge of political and social commentary. Crespi — a classical draftsman, as we have seen — certainly might have rendered the company of illustrious monarchists in a less rigid, doll-like manner, even given the constraint that the participants were to be able to recognize themselves in the group portrait. They might have been given at least as noble an air — as free of looking like stiff, powdered mannequins in buckled shoes — as the curious, lively, freely moving common folk watching the scene.

That a tacit edge of satire is involved here may, perhaps, be further confirmed by considering Crespi's most interesting comic undertaking, the intriguing series, described by Zanotti, which the artist invented to recount the life of an opera singer. This cycle of paintings has never been located, but we believe it is represented in part by surviving autograph replicas of two of the scenes. In them Crespi took on the latest craze that was turning the heads of fashionable people, the hysterical adoration of the current heroes and heroines of society — the opera stars.[43] This was the period when opera had come to displace the commedia dell'arte in popular enthusiasm. Comic opera, or the *burletta*, for the populace and tragic opera for the elite, with their stress on effects of audacious staging and electrifyingly brilliant voices singing music written solely as a vehicle for them,

42. *Crespi,* The Meeting of James Stuart of England with Prince Albani. *Národní Galerie, Prague.*

50

swept up almost everyone's imagination. There were, of course, a few too-serious classicists (among them the learned Padre Martini of Bologna, Muratori, Benedetto Marcello, and Gravina) who considered the modern melodrama set to music an absurdity, neither legitimate tragedy nor proper musical form — in a word, a monstrosity of mixed genres. But the rest of the world had surrendered itself to the magic of the new art, and even more than that, to the spell of the performers, who, like the famous Farinelli a bit later on, had become the pampered and spoiled darlings of society.

While we cannot be sure precisely when Crespi conceived the project to paint a comic cycle representing the career of such a singer, the evidence tentatively points to the early 1720s.[44] If the series was indeed painted then, it would coincide with another comic treatment of the subject written by the Venetian patrician and composer Benedetto Marcello. In his *Il teatro di musica alla moda*, Marcello ridiculed the entire motley crowd that surrounded the productions of musical drama, laying bare the follies of the pedantic writers, the vanities, jealousies, and vendettas of the singers, and the absurdities of their adorers. Other satires and denunciations would follow in later years. Padre Martini in *Il maestro della musica* pilloried the new emotional style of singing embraced by the virtuosi; Parini and Baretti denounced the singers as conceited imbeciles and corruptors of morals, while Goldoni, with gentler comic insight, gave comprehensible human motivation to the phenomenon in the *Impresario della Smirne*. The theme of the singer was clearly in the air.[45]

We lack any firm historical data regarding the nature of Crespi's connection with the musical world of Bologna. In his paintings, the presence of musical instruments and performing figures is conspicuous — from the *Lute Player* (cat. no. 5), to the portrait of the virtuoso instrumentalist Count Fulvio Grati (fig. 43), bursting with baroque brio, to the two humbler portraits of a painter and the silversmith Troni, in both of which musical instruments appear as part of the paraphernalia of an artist's studio. This may only reflect the fact that at this time in Italy music had become an almost universal pastime, that everywhere Italians were making music. There is, however, a notable trompe l'oeil still life showing a music library that suggests that he may have had a somewhat more intimate knowledge of and involvement with the sister art (figs. 44a and 44b). This work in two sections, clearly intended to serve as doors to a bookcase, echoes with delightful illusionism the contents that were stored behind. Neatly inscribed on the spines of the volumes are the titles that would form a complete humanist's collection of theoretical treatises, heavy on the ancients — Pythagoras, Euclid, Plutarch, Augustine, and Boethius — but also including some more modern authors such as Galileo

and Artusi.

The classical and conservative nature of the collection on the bookshelves is not out of harmony with the viewpoint of Crespi's opera singer cycle as described by Zanotti. Crespi, of course, approached the opera phenomenon not as a theoretician of music, irate that the musical theater was turning into a circus, but as an observer of the human comedy. From that standpoint, he appears to have found material for mirth. For one thing, the singers who strutted upon the stages of the theaters — idols of the whole society, rewarded with fortunes and position in the highest circles — almost invariably come out of the lower classes. Music was part of daily life in eighteenth-century Italy. Singing went on in churches, in orphanages, and in other charitable institutions; it was heard in the gondolas of Venice, from itinerant musicians on the streets; parents encouraged it in their children, hoping thereby to add something to the family income. And occasionally out of that whole singing world, the rare and perfect instrument

43. Crespi, Portrait of Count Fulvio Grati. *Salina Amorini collection, Bologna.*

would emerge in some humble youngster who, once discovered, would be on the way to fame. Such was the singer of Crespi's series, who, Zanotti tell us, began in a low and poor estate, but through her youth and beauty (and presumably her musical ability) arrived at a life of luxury and pleasure. Here was comedic material, indeed, with a ready audience richly predisposed to laugh. What titillating gossip must have accompanied the sudden rise to fame of such girls of humble background who now turned the heads of counts and married the dissolute sons of patrician houses! At the least they would be objects of lavish attention from a new species in the drawing room set (recently arrived from France and gaining admittance in Italy more readily than would Locke or Voltaire) known as the *cavaliere servente*, a sort of amorous lackey devoted to other men's wives and, barring that, to famous singers.

The two images in Crespi's surviving oeuvre suspected of once having been a part of the singer series focus on precisely this sudden class transformation. The first (which apparently standing alone was in great demand among purchasers of Crespi's comic pieces) is the *Woman Looking for Fleas*, now known in versions in the Louvre, Naples, and Pisa. It is a type of humble levee in which Crespi

worked hard to create a fully detailed ambience and situation. A slightly dissolute air pervades the scene, perhaps through the suggestion made by the presence of a baby in the care of people who seem too old to be its parents. The ingenue — in charming disarray — takes center stage, absorbedly looking within her bodice. She is indeed young, fresh and beautiful, and it is clear that her fortunes are on the rise, to judge from the small evidences of the gallantries of the preceding night. Her profession is indicated by the announcements on the wall and primarily by the presence of the musical instrument, wholly out of place in the otherwise unrelievedly lower-class scene of hanging garlic and clay pots.

In the second scene, she is at the pinnacle of her success. Of the two paintings of this episode that survive, one in the Uffizi (cat. no. 24) and the other (until now unpublished) in a private collection in Bologna (fig. 45, with detail), the latter is far superior and gives a fair indication of Crespi's most overtly burlesque style of comedy filled with commentary and innuendo. The setting is an aristocratic drawing room. Gold mirrors, sconces, and portrait frames twinkle on the walls, and the room is full of people. It is a gallant company, of which our completely transformed singer is the center of attention. She is now wholly artificial, mincing in gesture, pampered and powdered; coyly she receives the flattery of a bewitched admirer, a wealthy, sword-bearing

44a,b. Crespi, Music Library. *Pinacoteca Nazionale, Bologna.*

aristocrat, who offers her precious baubles, while the rest of the room virtually explodes with hilarity at his blind infatuation. To underscore and explicate the situation and leave the audience with no ambiguity, one of the male company holds what look like mounted horns over the lover's head. A second figure, presumably another suitor (a *cavaliere servente?*), seated near the singer's instrument which she has just been playing, makes a broad gester of finger to upper cheek known to Italians as the *furbo*, specifying that illicit doings are in course and that the signer is privy to them, perhaps from firsthand experience. The rest of the company are young women, servants, maids, and confidantes, who, as in so many Goldoni plays, have a livelier response to life and more common sense than the whole company of their illusioned masters.

As in the painting of the ceremony commemorating the crossing of the Panaro by "James III," the minor actors drawn from the *popolo* weave a lively wreath of fresh, free gestures and movement around the rigid and constrained figures of the protagonists. In both of these cases, as also in the contrast of the singer as a poor aspirant compared to herself in the high moment of success, the persons to whom Crespi felt a measure of contemptuous superiority he rendered in a subtly caricaturing manner. As we shall see, this had a formative influence on Pietro Longhi, the artist who best understood the substance of Crespi's attempt to establish the comic mode in painting and took up in the next generation where Crespi had left off. In the meantime, Crespi played a fluid and subtle game, mixing a little vulgarity with pity, irony, and occasional flickers of moral indignation. Like threads running through a fabric, he wove together in many of his paintings the connected themes of poverty, class contrast, the vitality of the working poor, and the lack of it in the idle rich. His works of this stripe all share the one quality which is entirely his own, a meditative evocation of the pure delights of visual perception. He differed from most of the Bamboccianti in that he did not train an unselective eye upon some corner of urban or rural reality, achieving their famous "view from the window," or unmediated slice of life. His selecting mechanism turned his comic pieces into criticism, but is was mild, measured criticism, without an excess of buffoonery, on the one hand, or bitterness, on the other. He might have said, as some fifty years later Goldoni would have Orazio say in his *The Comic Theater*, that comedy can be both good comedy and good criticism of society if it remains universal and is

45. Crespi, Singer at the Spinet with Admirers. *Private collection, Bologna.*

45. Singer at the Spinet with Admirers. *(Detail).*

not too specific — if, in short, "it remains criticism and does not fall into satire."[46]

We shall never know whether genre painting alone could have sustained Crespi financially or what would have happened if he had decided to cut himself loose from the past and to abandon the production of religious icons and other traditional forms of history painting in order to devote himself exclusively to modern themes, as Watteau, Hogarth, Chardin, or Pietro Longhi would do in the next generation. The evidence shows that his rare and strange inventions — as they were called — were greatly admired and that his audience laughed heartily either at the comic action that Crespi offered or, probably more frequently, because of the simple jolt of surprise at seeing a picture of something as unexpected and previously unobserved in paintings as a familiar corner of a musty parish church where a confession is taking place. We also know that some of the greatest collectors and connoisseurs of the day — counting among them Ferdinand de' Medici, Cardinal Ottoboni, Eugene of Savoy, and Zaccaria Sagredo — coveted precisely these examples of Crespi's art. The Faresini of Venice, about whom one would like to know more, owned not only a Crespi self-portrait, but also five of his genre pieces, among them a panel, now lost, with the subject of a prostitute.[47] Thus, the market might have materialized if Crespi had been firmly resolved to pursue such a course and had produced a consistent oeuvre with a wider range of subjects and other cycles in the vein of the opera singer. The more piquant of his ideas, like the morning toilet of the young girl known as *The Flea-seeker*, were certainly in hot demand, judging from the nine treatments from Crespi's own hand that have come down to us.

But speculation of this sort is, of course, not very useful, except as a stratagem for understanding more vividly the condition of the historical moment in which Crespi worked. All might have been in place for a full flowering of a new idea, but Crespi himself probably was not ready to shake off an internalized sense that it was permissible for him to take these flights of fancy and to indulge his sensibility and playfulness only so long as he remained well within the system in which he was recognized, with the full honors accorded to a history painter.

In the very years that Crespi was maturing in his vein of genre painting, during the fourth and fifth decades of his life (1700-1720), Watteau in France crystallized a new subject which would, as it proved, reflect the sentiments and the imagination of the intellectual, artistic, and fashionable society of Paris. He, like Crespi, found inspiration in the commedia dell'arte and in those general Arcadian longings for the rustic simplicities of nature which were pervasive in Europe and to which Crespi's response had preceded his by some ten to fifteen years. But unlike Crespi, Watteau took a complete and confident step and fixed his

subject early, developing it into a sophisticated and subtle anatomy of love poeticized by its Arcadian (romantic, one wants to say) setting. Watteau, of course, was younger than Crespi by almost two decades, and the steps he took toward inventing his new form were logical in Paris of 1702-1720. The longing for rural happiness, the weariness with wars and rationality, and the slowly advancing displacement of divine love by carnal and sentimental love between the sexes were well developed among the cultured of the city of Fontanelle and the Comte de Caylus.

In contrast, eighteenth-century Bologna, as Roberto Longhi said long ago, was excessively narrow and too provincial a center in which to launch a new direction in art.[48] The fact is that within the city Crespi's genius won no real followers save Gambarini, a Franceschini student who, according to Zanotti, settled into being a genre painter practically by default, and in that vein made pleasant but timid paintings guided, essentially, by Crespi's imagination.[49]

Still, Crespi was not without real progeny in the succeding generation of painters. The two historically significant artists who did receive indelible impressions from his work — G.B. Piazzetta and

46. *Crespi,* Sleeping Shepherdess. *Private collection.*

Pietro Longhi — were both Venetians. The details of the actual nature of the relationship they had with Crespi are not documented. But there is a widely shared conviction among scholars that the two either actually studied with the Bolognese master or in some other manner fell into his orbit. They came to Bologna some twenty years apart, Piazzetta first around 1703, just when Crespi was in the initial bloom of being an established, sought-after painter and teacher. Longhi, the best opinion says, arrived in the 1720s, when Crespi was at the height of both his powers and fame. In different ways, leading to truly distinct styles, trains of thought, and artistic solutions, Crespi's genre painting was a triggering agent for both of these enterprising young artists, who found in the Bolognese master's varied experiments currents that — in present historical judgment, at least — would carry them a long way toward being the most innovative and advanced figure painters of their generation in Venice.

When at the age of twenty Piazzetta went to Bologna upon the death of his Venetian teacher Molinari, he went, we are told by Albrizzi, who knew him well, to look at the Carracci and Guercino, the very same painters whom Crespi venerated and consulted, especially for his religious works.[50] The length of Piazzetta's stay in Bologna cannot be determined, but when he returned to Venice (and he is documented there in 1711), he began to produce, along with his regular production of altarpieces and other traditional subjects, images of popular life that suggest the unmistakable influence of what he must have seen coming out of Crespi's studio.

One of the earliest of such works, *Sleeping Peasant Girl with Turnips* in Salzburg (cat. no. 34), was based on a subject Crespi himself had repeated on various occasions. In Crespi's oeuvre, the several portrayals of sleeping shepherdesses, generally datable around 1700, still belonged to an Arcadian mode parallel to his *Sleeping Nymphs and Cupids* and hardly distinguishable from them (fig. 46). If there is any erotic suggestion in the paintings, it was of the kind that could be found in the light brushes with eroticism of such poets as Eustachio Manfredi, the founder of the Bolognese Arcadia in 1697 and, it will be remembered, a member of the scientific group of the *Inquieti* since 1691. The nymphs of this poetry, who are the objects of the endlessly wistful and disappointed longings of hapless shepherds, never become flesh and blood. They are described, but we get only an indefinite sense of their feminine graces, all veiled, as Crespi's maidens are always totally clothed, showing a "virginal modesty" here, a "white hand" there, "a warming graceful eye," "loosened hair," or as seen from a distance, nestled in the meadows of the countryside of Bologna's River Reno.[51]

Piazzetta's version of the subject shows that from the beginning the Venetian artist grasped elements from Crespi's works and tended to intensify them and to transform them into much more forceful psychological and physical experiences with a strong insistence on erotic innuendo. His first impulse, which would soon become a constant feature of his genre images, was to draw very near, to isolate the figure and cast it in a maximally sculpting light. Piazzetta tended also to focus on expression — in this case, a kind of insistent peasant slumber thrust out at one animalistically, like the breast falling out of the girl's bodice and mimmicked in shape and surface by the turnip, the crude root food, nourishment of the poor and a well-recognized symbol of peasant deprivation.[52]

While Crespi's images never had such physical thrust, Piazzetta might still have found in Crespi's *Lute Player*, for instance, or in miniature in such paintings as *The Laundresses* at the Hermitage (fig. 34), formal suggestions for his own adaptation of the classical-baroque style (in which, like Crespi, he was trained) to fit this new subject matter that he was launching upon the Venetian scene. If, as artists are wont to do, he was perhaps even unconsciusly in his early twenties looking around for a visual formula that had affinities with his own tendency towards powerful, solid form , he would have certainly found it in such examples of Crespi's painting. Particularly, he appears to have perceived a certain potential in the physical energy and grace of the foreshortened rendering of a beautiful neck or a tilted torso. If such a suggestive detail from Crespi were isolated and brought exceedingly close to the picture frame, it would answer to his own sense of drama and produce a wholly novel, monumental effect for what would become probably his most marketable product, his close studies of emotion-laden heads, the eventual *Iconae ad vivum expressae.*

The period of this rather direct Crespi inspiration was not, from all appearances, long-lived. In addition to the *Sleeping Peasant Girl*, it is exemplified by a *Woman Looking for Fleas* in Boston (fig. 19) and the pendants of both the female studies: a *Turnip Seller* in Boston (fig. 20) and a charming companion in profile to the contadina in Salzburg (cat. no. 35). The latter, facing in the direction of and seemingly moving towards the sleeping girl barring his way, would by implication stumble upon the recumbent form and perhaps play the satyr to her slumbering nymph. The extremely reticent erotic interplay suggested by the pairing of what must have been overdoors in an architectural setting, foreshadows Piazzetta's future direction. The preparatory drawings for the project point the way even more directly. The British Museum study for the head of the boy in the Salzburg painting, minus his hat, shows the aspect of Piazzetta which differed entirely from Crespi. Piazzetta was a draftsman who suffered when he painted and was known to be always dissatisfied and laboriously slow. Crespi, as has been frequently noted,

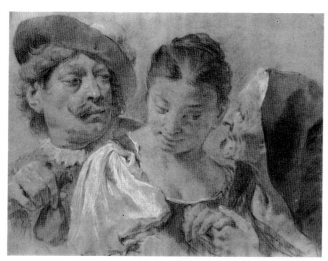

47. *Giambattista Piazzetta,* Bravo, Girl and Procuress. *Drawing. Royal Library, Windsor Castle. Copyright reserved. Reproduced by gracious permission of H.M. Queen Elizabeth II.*

suffered when he drew and was stiff and careful in comparison with the virtuosity that he displayed with the brush in his hand.

Piazzetta's great facility with the chalk, already fully in control in the British Museum drawing (fig. 35.1), was by 1717 appreciated even beyond the confines of Venice.[53] It was a talent that the artist learned to exploit early, thereby both creating and feeding a new fashion for drawings framed under glass and viewed as finished and prized works of art. Such works, intimate and requiring a sensitive responsiveness to the subtleties of effects achieved with an austere medium, first appealed to unusually passionate collectors like Zaccaria Sagredo or their middlemen — those busy, internationally oriented connoisseurs, agents, and gentlemen who made the literary and artistic life their business, and who were very much in contact with travelers and collectors from all over Europe.

It was among these and among foreign collectors with advanced tastes that Piazzetta found the audience for his images. One of the more fruitful relationships that he formed was that with Joseph Smith, a wealthy businessman in Venice and English consul from 1744. Smith's palace on the Grand Canal was, from the 1720s, the meeting place and a refuge from the prying eyes of the Venetian Inquisition for all of the inquiring and reform-minded nobles, writers, economists, philosophers, publishers, and connoisseurs within the city.[54]

They were drawn to Smith's hospitable house by each other and by his extraordinary library, which contained, besides rare volumes on architecture and archaeology, all the important publications of the Enlightenment which had been censored by the republic — from Locke and Montesquieu through, eventually, Rousseau and Voltaire. The reformers who

haunted Smith's palace were varied in their interests and programs. These ranged from Goldoni's reform of the theater to Padre Lodoli's reform of architecture, education, and science to Gianmaria Ortes's proposed economic reforms aimed at finding a working relation between the depressed countryside and the city. It was the same Abate Ortes who showed such a deep and melancholy realization of the exploitative nature of capital that a century later Marx commended him as the best economist in eighteenth-century Italy.[55] In Smith's immediate circle were: Algarotti, busy disseminator of the new sciences and enthusiast for Voltaire; the patrician Andrea Memmo, student of Lodoli and propagandist for an attitude of receptiveness to new ideas; and Canova, the vivacious and scandalous iconoclast who ran afoul of the inquisition on suspicions that he had joined the Masons. Beyond these was a network of men linked by correspondence and more practical connections: Muratori, whose work Smith and Pasquali were publishing; Scipione Maffaei, thundering against the superstitions of witchcraft and magic;[56] and Carlantonio Pilati, who, writing in 1767, admonished Pope Clement XIII:

You will see the countryside deserted and barren for the

48. *Giambattista Piazzetta,* Boy and Girl with Trap. *Drawing. Gallerie dell'Accademia, Venice.*

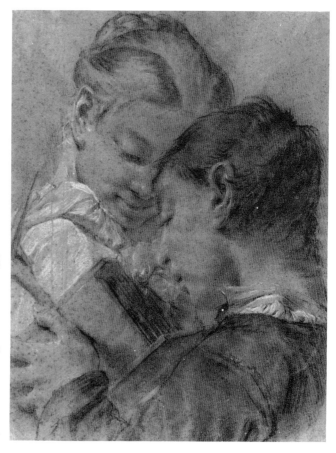

lack of men to cultivate it; you will find the men who work on the land reduced to the most abject poverty through the oppression of your ministers and powerful lords. You will find that crafts and manufactures have declined because they have not been protected and controlled...[57]

Smith, who drew to himself what Italians call the "strong spirits" of the day, was, not unexpectedly, also attracted to artists who were proposing a fresh and more contemporary imagery in painting. He represented a new kind of patron whom Mariuz described as priding himself on the originality of his taste — to differentiate him from conservative patrons trapped in the conventional assumptions of the preceding century.[58] Accordingly, Smith appears to have ignored almost totally one of the greatest artists of the era, the brilliant colorist and technician G.B. Tiepolo, the painter whose images embody both the past triumphs and the pathos of their irreparable loss in the twilight of Italian cultural supremacy. Not a single Tiepolo, outside the etchings of the *Capricci* of 1749 (which are, it should be noted, very original in conception), is cited in all the various inventories of Smith's collection or among his transactions, except for the mysterious *Banquet of Cleopatra*, which he appears to have sold to Algarotti just as soon as he had acquired it.[59] For a man of Smith's sophisticated

tastes, this is quite extraordinary, unless, perhaps, we are to interpret it as a personal or critical reaction against most artists of this category — among them Giordano, Amigoni, Pittoni, Pellegrini, and Diziani, whom Smith also ignored. Sebastiano Ricci, the one exception in Smith's affections, may represent a relatively early state of the Consul's taste, or even a personal commitment to an artist, reportedly himself cultured, gentle-mannered, a lover of music, and the uncle of Marco Ricci, for whose landscape *capricci* Smith had an unambiguous enthusiasm.[60]

A glance at Smith's inventories provides us with a roster of many of the modern painters who were experimenting with new techniques and new materials, or were working in a variety of genres which were at that moment establishing themselves on the art market and which Smith himself was instrumental in promoting. Besides Marco Ricci, there is a conspicuous holding of Rosalba Carriera, Canaletto, Zuccarelli, Pietro Longhi, Nogari, and even Crespi, who is represented in the inventory of the 1776 Christie's sale of Smith's estate by a *Country Fair* and its companion, attributed a little confusingly to "Spaniola," a mistaken rendering of "lo Spagnolo," Crespi's sobriquet.[61]

The element of novelty in the work of Piazzetta that

49. *Giambattista Piazzetta,* Young Woman and Man. *Drawing. The Curtis O. Baer Collection.*

50. *Giambattista Piazzetta,* Girl and Boy with Donuts. *Drawing. Gallerie dell'Accademia, Venice.*

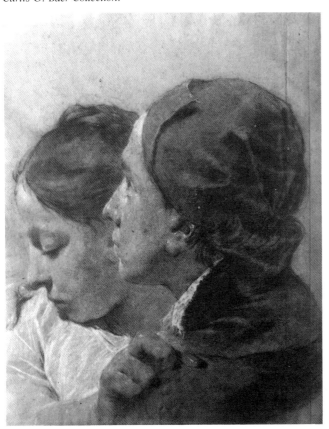

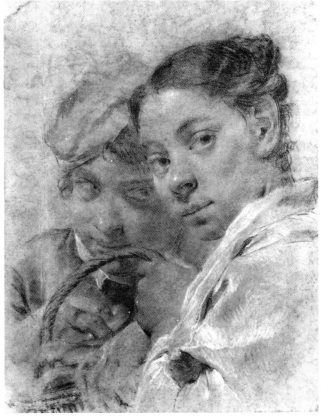

must have first attracted Smith and other like-minded *cognoscenti* to him, was his ingenious idea of reviving the concept of the presentation drawing. Not much in use since the sixteenth century, such drawings were revived by Piazzetta in a new format. His drawings are large, ranging from 15×10 inches to 20×15, with one or two heads filling almost the entire surface. This compositional mode renders the heads almost life size, inevitably giving them such proximity to the viewer as to lend weightiness and consequence to the characters in the drawing; Piazzetta often further underscored the feeling of nearness thus achieved by placing the two or three figures represented in the drawing in unusually close conjunction with each other, certainly closer than the talking distance dictated by Anglo-Saxon culture. The resulting sense of being crowded together with the subjects of the pictures probably accounts for our feeling forced to puzzle out the import of the mood, character, or emotions of the persons represented. For these ubiquitous features of Piazzetta's drawings, the works themselves, for the most part, provide no narrative explanation.

A certain number of drawings, however, are explicit enough, and we recognize here and there a conventional action or an emblem, which, more often than not, makes references to sexual transactions.

Such a drawing owned by Smith is the quite traditional one of a bravo offering money to a susceptible servant girl who is being persuaded by a pandering old hag (fig. 47). A similarly conventional example is the young couple with a trap or cage, teasing the captive creature inside (fig. 48). This particular theme seems to have been quite popular in the North, since we find it in Todeschini's paintings frequently.[62] To the Dutch painters, from whence it may derive, the bird cage and the trap were emblems of the captive heart or snared virtue, and that certainly is suggested in the Piazzetta drawing merely by the intimacy of the two heads, which seem virtually to breathe each other's breath, as we feel forced to breathe theirs.[63] Yet Piazzetta, too aesthetically acute to flatten the experience into a mere emblem, retains his ambiguity. The action alone suffices to motivate the intensity of the boy's engagement with the game and the girl's fascinated smile in response to his activity. Who is teasing whom? might well be the question.

While in most cases the situations and characters invoked by Piazzetta do not boast even such bare plots, they are nevertheless passionate and clearly intended to raise questions. Such, for instance, is the forceful drama in the drawing of a couple in a private collection (fig. 49). In it the figures are motivated by strong psychological states, about which the viewer is free to speculate. And speculate he does. The interpretations based on simple looking can be quite varied: is this holy matrimony on the point of being declared — the girl shy, fearful, and reluctant, the innocent spouse reassuring and full of pious hope in his upward glance? or, in an altogehter different vein, is this a kind of pre-nineteenth-century, Dickensian image of the noble, stoic, and gentle-hearted poor confronting the stings of fortune — she melancholy, soft, dependent on him, he still beardless, but full of manly faith? Or what are we to make of the drawing at the Accademia (fig. 50) in which a bewitching *popolana* glances out at us, while a young boy picks out a doughnut from her basket and, tilting his head next to hers, gives her a strongly directed, furtive or suggestive look? Are the two in collusion to steal a kiss or a doughnut? Or is this a seduction, to which she calls us to bear witness? Indeed, one could multiply the possible dramas indefinitely.

And that, probably, is the point. What Piazzetta had hit upon is the idea of narrative action without a narrative content. Algarotti compared Piazzetta's "character heads" to sonnets or madrigals,[64] perhaps finding the parallel not only in the drawing medium as opposed to the epic of the altarpiece, but also in the fact that sonnets (especially the Arcadian sonnets), like the drawings, generalized situations of love by presenting in the descriptive form of vignettes sudden erotic longings, fired by a chance glimpse of a

candid, bare neck or a sweet curl on the cheek. Piazzetta might have derived the concept from Crespi's mild pastoral comedies and harmless encounters, such as in a painting which in 1736 arrived in Venice, brought there from the collection of Eugene of Savoy by Anton Maria Zanetti. This work illustrated, as Zanetti tells us in his *Memoria*, "a delectable shepherdess asleep being tickled with a straw by a shepherd who signs silence to his laughing companions, with other figures in the background," and was a picture which the author of the *Pittura veneziana* judged to be one of the most beautiful paintings Crespi ever made.[65] There is little doubt that Piazzetta saw this work, as he must have seen other similar examples during his sojourn in Bologna. A few years later, while he was painting his great pastorals for Schulenburg, between 1740 and 1745, his students Domenico Maggiotto and Giuseppe Angeli were producing a pair of canvases in the same monumental dimensions as Piazzetta's, reusing the Crespi theme of a slumbering peasant tickled by a member of the opposite sex (figs. 24 and 25). Maggiotto's shows the peasant girl sleeping, as in Zanetti's Crespi, while Angeli's shows the reverse

situation with the sleeper a male.[66] Crespi, it appears, had already supplied the idea of the turnabout, as his etching of a sleeping shepherd being tickled by a maid clearly reveals (fig. 7).

But unlike his students, who took over Crespi's theme literally, Piazzetta seems to have preferred — especially when it came to large and important genre works for such special patrons as Marshal von Schulenburg — to avoid the obvious, trivializing actions (fig. 28). Stripped of their emotional motivation in recognizable, conventional exchanges, the same characters that we find in Crespi's or Maggiotto's paintings become in Piazzetta's pastorals mysterious and suggestive, a fact which has prompted some modern scholars to go far afield in search of meaning in the works.[67]

The intriguing effect of this mode of suggesting narrative content, which also appears in Piazzetta's illustrations for Albrizzi's editions of Bossuet and Tasso, has a further aesthetic dimension (fig. 51). It might be seen as an intellectual parallel to the optical effects achieved by those techniques of drawing and painting in which the artist is reticent of descriptive detail, leaving the actual form or texture sufficiently

52. *Crespi*, Man Drinking. *Private collection, Paris.*
53. *Annibale Carracci*, Head of a Man. *Drawing. Royal Library, Windsor Castle. Copyright reserved. Reproduced by gracious permission of H.M. Queen Elizabeth II.*

undefined as to allow the viewer's participation in completing what is perceived. The thrill of pleasure produced by such cooperation between the spectator and the artist has become a well-recognized aesthetic value in twentieth-century criticism. Piazzetta's invention of utilizing figures of the lower classes in formats that, like history painting, compell focus on their facial expressions and psychological states without providing specific content for them, avoids the problem of having the image reduced to vulgar anecdote, to too much clarity, and thereby gives an effect of suggestive indefiniteness that demands our participation and yet denies forever any simple resolution.

The success of such imagery necessarily depended heavily on the adequacy and appeal of the faces. Like a casting director for a modern cinema in which each face will be closely inspected, Piazzetta required a variety of facial types that would be uncommonly engaging. This was an old idea, indigenous to Venice: Giorgione in the sixteenth century had already launched the then equally enigmatic *teste di carattere* with their moody, poetic suggestiveness. When he was in Crespi's orbit, Piazzetta would have seen many examples of similar character studies, which, Luigi Crespi tells us, the Bolognese master produced in large numbers during his youth, making two or three a day. A painting which has recently surfaced in Paris gives us our first glimpse of that aspect of Crespi's activity (fig. 52). It is a character study in what may be called the toper tradition, full of life and individuality in both gesture and face. But the decidedly uncouth personality that gaily gazes out at us would hardly have provided the requisite appeal for Piazzetta's purposes.

However, while in Bologna and probably later in the house of Zaccaria Sagredo in Venice, Piazzetta must have studied Annibale Carracci's drawings.[68] What he learned from them was of immense importance for his final product. Annibale's fervent commitment to drawing from the model led to many examples of heads taken from life, such as the one in Windsor (fig. 53), which makes an interesting confrontation with Piazzetta's early drawing in the British Museum. The variety in the weight of the line and the distribution of middle-toned shadow are strikingly similar in effect. But beyond the purely technical lessons he absorbed from the Bolognese master's drawings, he apprehended Annibale's genius for taking common faces and infusing them with a frankness and a certain sense of their susceptibility to feeling and experience, which stirs the viewer with pleasure and longing.

Much of the audience Piazzetta was in great part addressing was already learning about this susceptibility, or sentiment, as it eventually came to be called. The lessons of Shaftesbury and the Marquise de Lambert, as well as those of Richardson and Rousseau to come, championed the view that nature was the source of all goodness and that nothing gave more happiness than feeling. What stirred the sensibilities was love — no longer a destructive force but a benevolent impulse that pierced the heart and suffused it with an inherent moral sense. Feeling, being a gift of nature, was furthermore likely to be the possession of simple people, found in purer form among the guileless and unspoiled lower classes, particularly those who worked in partnership with nature — the happy peasants of the countryside, in whom Rousseau so innocently delighted during his travels in Italy in 1743 and 1744.[69]

Such views, essentially of a literary nature, are obviously consonant with the transformations of the dour reality of actual peasant life into the idyllic pastorals of Watteau, whom Piazzetta, in fact, did not fail to study in engravings available to him in complete sets in Consul Smith's library.[70] These were most useful to him for the formulation of his exquisite illustrations, which are exceedingly elegant and, as scholars have noted, clearly French in their effect. But in the genre drawings and paintings by which he supported his family, "making a number of heads a day," he found his own formula, which, also like

54. *Giambattista Piazzetta,* Albrizzi and Piazzetta in a Landscape. *Drawing. Biblioteca Reale, Turin.*

Watteau's, crystallized the inchoate pastoral longings and the sentimentalization of the lower classes, that were slowly coming into vogue in the first half of the eighteenth century.

There were, to be sure, fewer idyllicized images of the peasantry available in Venice. Ceruti's harsh, rank images of peasants, known without any doubt to Piazzetta in Marshal Schulenburg's collection, were scarcely popular, and found no patron in Venice beyond the Marshal, who had a distinctly Northern taste for realism.[71] Ceruti's women and children, dressed in squalid rags with their pallid faces and puzzled, suffering eyes, were too grim a reminder of a reality that the bucolic, Arcadian fantasies veiled from consciousness. Much to be preferred was Piazzetta's wholesome new Eve in the Manning painting — dimpled, smooth-skinned, and gay-mouthed. Moving with a vivaciousness that is summed up in the pert turn of her hair, she promises delights with her apple and conjures up thoughts of lively games.

There are only hints as to how Piazzetta may have regarded this dialectical relationship between Ceruti's reality and his own playful one. Piazzetta was a man of considerable artistic culture. As the Schulenburg documents reveal, he was an accomplished connoisseur, whose attributions and expertise show a broad and subtle knowledge of all the artists, including those going back to the fifteenth century whose works were being traded on the market. He made distinctions between copies and originals, between prime works and mediocre ones, and showed a fervent and genuine enthusiasm for other people's art.[72] But in his own art, echoes reach us of a certain discontent. His remark to Algarotti that Holbein had painted faces, but that he himself painted masks seems to indicate his sense of something false, something external in his own works.[73] After all, his rural settings were an Arcadia, a background to the civilized world of reformers, salons, and the feverish collecting of amateurs.

How better could he have said this than in the closing vignette of the *Gerusalemme* (fig. 54), in which he represents himself and the publisher Albrizzi seated in a country scene? Albrizzi — fashionable in his embroidered breeches, ribboned shoes, loose country coat, and bobbed, curled hair — sits in a langorous, aulic pose, expounding to his friend Piazzetta, who counterpoises him by sitting in a position that echoes his so-called *Indovina*, a pose of showy dignity ultimately derived from mannerist sources. The artificiality of these two Venetian gentlemen is juxtaposed against a rural scene of charming reality. Quickly passing behind them, a milkmaid lifts her skirts as she prepares to follow her cows into a stream. The similarity of this small vignette of peasant existence to Crespi's *Peasants and Cattle Fording a Stream* (cat. no. 25) is quite striking. In the fifth decade of the century, around the time

when Crespi was already blind and soon to die, Piazzetta still evoked lessons he had learned in Bologna, but with a strange consciousness of disjuncture between his world and that of the peasant, which Crespi, somehow, never let us feel. Pietro Longhi (1702-1785), a slightly younger contemporary of Piazzetta, also began his career in the orbit of Crespi's ideas, and, when he returned from Bologna to Venice, he shared with Piazzetta the world of literati and nobility. His patrons formed the same group around which Piazzetta's artistic life revolved — the Sagredo, Consul Smith, Padre Lodoli, and Goldoni, to name a few. His artistic imagination, like Piazzetta's, always retained memories and seeds of ideas gathered in and around the Bolognese master's studio. However, it was not from the same aspect of Crespi's production that Longhi eventually found his starting point. The Crespi that sparked Longhi's subject matter (not unaided by French prints) was the Crespi of the opera singer cycle, which, if we are right as to its dating, was conceived about the time Longhi was in Bologna.

The difficult question of the dates of Longhi's sojourn in Bologna cannot be definitively answered. It seems reasonable to assume that he went there at the age of seventeen, around 1719, since his first teacher, the Veronese Balestra, left Venice in that year, recommending Longhi to G.M. Crespi upon his own

55. *Pietro Longhi*, A Girl Spinning. *Ca' Rezzonico, Venice.*

61

departure.[74] Whether Balestra dispatched the young Longhi to join Crespi because he felt that Longhi was more suited to a vernacular style, or whether Crespi in those years had become the most interesting teacher for Venetian art students is hard to say. Alessandro Longhi tells us his father stayed in the Papal city for several years, but just how many we do not know. The first we hear of him again is in 1730, when Longhi paints a typical martyrdom altarpiece for Venice's S. Pellegrini. In this work he showed his strong Venetian roots but with signs of having seen Crespi's martyrdoms being made for Bergamo, and included figures similar to his own shepherds in Bassano, which in turn are clearly derived from a Crespi mold. The influence of Bologna is still felt in 1734 in the Sagredo Palace *Fall of the Giants*, the last commission he executed as a history painter.[75] The format, with its heavy clouds and sparse figuration, recalls Crespi's Pepoli ceilings, while the falling giants strike poses redolent of Pellegrino Tibaldi's Ulysses frescoes. The ensemble is lugubrious and ungainly, so that it is no surprise that, as his son tells us, he became aware that he could not distinguish himself in this line of painting. With few commissions to go around in the 1730s — and Tiepolo, Piazzetta, and Pittoni eager to execute them — Longhi understood that he had to find a singular niche if he wanted to remain in Venice as a painter. As a solution, he seems to have launched a series of small cabinet-sized paintings along the lines of Crespi's and Piazzetta's pictures of *contadino* life. Quickly he developed a typology, a format, and a subject, which, as far as we can tell, he repeated many times with many variations. Like Piazzetta, Longhi ignored the Crespi whose eyes had been attracted to humble scenes of labor or simple, intimate interiors, and opted instead for Crespi's light, pastoral *scherzi* as a source. Nor did Longhi follow Piazzetta in depicting faces with character and emotion. The early scenes are all taken up with nubile peasant wenches caught flirting, drinking, and dancing in peasant tavern settings, leered at by their male companions, but meant to appeal to the appetites of a more sophisticated audience (fig. 55). Sparks dart from their teasing eyes, as their rotund, fetching bodies strike poses distilled from those of Crespi, but still reminiscent of them. And the light that Crespi used to give accents to entire scenes is now steadily beamed only on their slightly scandalous, sprightly and beguiling forms. Deriving the idea also from Crespi, Longhi furnished the settings with carefully chosen, single elements of peasant still life — a jug, a wash tub, or a clay pot, isolated and deliberately presented as a balancing form meant to draw attention to its own simple and shapely existence. The ensemble made for a charming combination, an Italian answer to the Dutch tavern scenes, purged of their unpleasant insistence on the ugliness and crudity of the merry-makers.

It is difficult to say how long this intermediate phase lasted and how popular it was, since all the comments by contemporaries refer to the later Longhi. In any event, at some point probably after 1735, Longhi once more changed his course, and, by 1741, when he dated *The Concert* in the Accademia (fig. 56), his new idea was fully formed. The startlingly novel concept was to turn the class focus entirely around, to train his lightly whimsical eye not upon the peccadillos and pleasures of the *popolo*, but upon the social scene of his own patrons, upon, in Alessandro Longhi's words, their "entertainments, conversations, arrangements, love games, jealousies," and masquerades. This was, the painter's son continued, "an untried path, trodden by no previous painter, either of the courtly or the modern stamp," and consequently quickly popular with the patrician class or "whoever," for that matter, "valued unusual works."[76]

Strictly speaking, this new subject matter was not entirely Pietro Longhi's invention. Crespi's scene of the opera singer's triumph goes a long way to establish the subject of upper-class flirtations and entertainments, and, even if Crespi did not produce other examples, by 1735 Hogarth's first series, the *Harlot's Progress*, was already on the market, as were

56. Pietro Longhi, The Concert. *Gallerie dell'Accademia, Venice.*

Jean de Julienne's engravings after Watteau.[77] In 1737, Charles Joseph Flipart had arrived in Venice from Paris, where he had been active in art circles as an engraver. He soon began to perform the same service for Longhi, so that it seems almost certain that the *scene de moeurs*, so much the rage then in England and France, had come to Longhi's attention and may account for his sudden conversion.[78]

The intent of Longhi's representations of aristocratic and upper-class life in Venice has been a matter of some argument over the years. The central question is whether Longhi was merely a mild-mannered chronicler of Venetian society's amusements or whether, instead, he should be classed among the reformers and critics whose works were meant to chide the shallow and frivolous customs of the irresponsible, morally bankrupt sectors of the Venetian aristocracy.[79]

A possible approach to the question is to turn to Goldoni's often quoted words from his occasional poem for the Grimani marriage in 1750, in which the playwright apostrophizes Longhi as "you who call my muse sister to your brush, which seeks the truth."[80] If Longhi indeed did call Goldoni's muse sister to his own, then we might take the words to mean something more than a conventional nod to the doctrine *ut pictura poesis*, the generalized association which had been drawn with particular frequency in the seventeenth century between poetry and painting as sister arts. The situation in Venice at mid-century would warrant such a view. The theatrical season 1750-1751 was the critical year in which Goldoni overwhelmed the theater audiences of the S. Angelo in Venice with his comedy reform, climaxing his sixteen new plays with the *Teatro comico*, a comedy that served as his artistic manifesto.[81] The reform consisted essentially of steering the comic theater away from the crude burlesque to which the commedia dell'arte had degenerated and replacing with his own fully-written dialogue the ad-libbed lines and often uncouth antics customarily supplied by the popular comic actors playing the various standard characters in masks. The intent of the reform was, of course, to establish comedy as a serious and respectable art like tragedy.

What Goldoni would bring to Venetian audiences during his career in the city was comedy based on nature. Not the extravagant and pointless slapstick of the commedia, nor the satirical attacks of Molière on conventional types and vices, nor fantasy, but plausible studies of contemporary social problems of the sort that involve old-fashioned fathers (*I rusteghi*), the country vacation mania (the *villeggiatura* trilogy), gambling (*La bottega del caffè*), harmful institutions such as that of the *cavaliere servente* (*La dama prudente*), or uneasy interactions between the classes of the community (*Il ventaglio*). With these plays, he brought before the eyes of his audiences the familiar encounters and enmities experienced by them in the social intercourse of their own day.

Goldoni pounded away at his reform on every available occasion in that crucial year of his mass assault. In the *Teatro comico*, his mouthpiece Orazio instructs an actor that "Drama is an imitation of nature, and in it one should do only what is plausible."[82] In his preface in that same year to the four plays published by Bettinelli, he explains the sources of his comic art. The "two books" from which Goldoni professes to be instructed are "*Il mondo*" and "*Il teatro*." "The world," he writes,

reveals to me many and various personality types, it represents them to me so naturally lifelike that they seem made on purpose to serve me with abundant plots of funny and instructive comedies; it represents for me the signs, the strength, the effects of all the human passions; it provides me with curious incidents; it informs me of the current fashions; it instructs me in the vices and defects common to our century and our nation.

The book of theater, in turn, he says, teaches him the art of presenting the material he has gathered in experience. Reverting to the vocabulary of the painter's studio, he claims that the art of other writers serves to instruct him

with what colors one should represent on the stage, the characters, the passions, and the incidents which one has read in the book of the world; how one should shadow them in order to give them greater relief; and which are the tonalities that will make them pleasant to the discerning eyes of the spectator.

In summing up, he exclaims, "I conclude that far above the marvelous and fantastic, what is natural and what is simple is victorious in the heart of man."[83] By 1750, Longhi had been painting the scenes of upper-and middle-class manners for over a decade. He too recorded the human passions, the curious incidents, the current fashions, and the vices and defects of his century and city, as his quotidian experience taught him. Calling Goldoni's muse a sister of his own, he naturally must have perceived himself as a painter of comedy who, like Goldoni, had substituted for the grandeur of the history painter and the burlesque of the Dutch tavern painter images that seek to present the social truth. These pictures represent an accurate picture of life turned into art by a brush trained in a long tradition. They instruct the viewer through recognition, delight and understanding.

The parallels that Longhi might have seen between his own introduction of a comedic parlor art and Goldoni's reform of the theather extend in still other directions. Like Goldoni's is the stylistic shift that Longhi effected in order to accommodate his images to his *idea* or vision of life. Among the most important features of Goldoni's reform was the version of the spoken language he brought to the stage. Besides purging his dialogue of gross and scurrilous language (favored by the commedia actors

for surefire laughter), he offered his audiences a clean, popular idiom appropriate to realistic conversation. He sought out regional dialects and characteristic speech defining the various classes, not so much in a spirit of derision as in that of imitating reality. This use of the contemporary vernacular on stage was so novel that it brought down upon him the ire of certain literati of the Granelleschi academy (founded 1747) who were devoted to preserving the "pure" style of earlier writers. For Goldoni's purposes, that style was much too stilted, much too rhetorical to serve.[84]

Equally unserviceable for Longhi's purposes in the treatment of the figure was the rhetorical high style of Venetian painters from Tiepolo to Piazzetta. A contemporary patrician, Pietro Gradenigo, who was obviously well aware of Longhi's abandonment of that style, characterized him as a *"Pittore per attitudini naturali e parlanti caricature."*[85] As Longhi's large corpus of drawings shows, he was a constant observer and recorder of people sitting, talking, reading, walking, or carrying various objects, all precisely and candidly caught in their habitual gestures. The prim poses of ladies in their *guardinfantes* (hoopskirts) and the reticent, polite movements and solicitous bows of their admirers and *cicisbei* (gallants), so precise and yet tactfully understated, are parallel to the vernacular of Goldoni. Gradenigo's characterization of Longhi's works as "speaking caricature" shows his understanding that the painter had departed radically from the noble style of the past and had found instead the essentials of actual gesture that permitted the identification of characteristic types.[86]

Hogarth, intent on defining his own new art, hotly contended in England "that there are hardly any two things more essentially different than character and caricature," and asserted that his figures were certainly not caricatures but careful representations of character and expression, more valid in the delineation of types and emotions than what academic artists of the past had achieved in history painting.[87] But as Antal noted, Hogarth had invented a "realist baroque idiom" for his serious bourgeois melodramas *cum* comedy which, in fact, does verge on caricature and satire in the sense of exaggeration and overstatement. On the other hand, Longhi's "rigid" and "static" poses, which have caused critics over the years to feel embarrassed and uncertain of his skill or intent, are caricatures only in the Italian sense of being sufficiently "loaded" with significant clues as to be amusingly recognizable.[88]

And how hard and intelligently Longhi worked for that familiar, recognizable, unstagey, but totally natural effect! So subtle is it that it requires careful scrutiny to read and comprehend — a requirement that Longhi even makes of his twentieth-century spectator because of the intimate size of his works (interestingly, all almost the same), which enforces proximity and close attention. Lacking both bold

formal effects and grandiloquent size, Longhi's paintings provide little to satisfy a quick *colpo d'occhio.* The Windsor *Morning Levee (Gentleman's Awakening)* of 1744 (cat. no. 41), originally in the collection of Consul Smith, is a brilliant case in point. One can easily imagine that Goldoni would have found in it a validation for his own conceptions when he returned to Venice in 1748, ready to spring his theatrical reforms on the city. Like the plays he was about to write, the painting suggests a contemporary domestic scene of manners, full of telling characterizations through facial types, postures, and the use of light. In the preparatory drawings for this canvas, we can witness the process of crystallization of the idea. The gentleman's attentive, even alert, seated posture was slowly defined in several sketches (now in the Correr Museum) showing a happy resolution to the rendering of his drawn-up knees under the coverlet. The woman, perhaps his wife but possibly a mistress, was at first conceived in a much more overtly suggestive pose, indecorously unwifelike, her legs bare, widely separated, with one slung casually across the corner of the man's bed (Correr 540r.). The final formulation, considerably more subtle and complex, shows her dressed in a soft morning robe, leaning against a pillow thoughtfully supplied to prop her elbow, as she muses with a

57. Pietro Longhi, Milord's Salad. *Benigno Crespi collection, Milan.*

certain willful reservation over whatever has just transpired to produce her consort's alert attention.[89] The actual event, or even the nature of the relationship, leaves us guessing. The milieu of a luxurious bedroom, however, with well-attended aristocratic types — as well as the fact that the sexual partners are sharing the morning chocolate (widely regarded at the time to be an aphrodisiac) — convinces us that this is an intimate scene to which, like the servants who see and know all in Goldoni's plays, we have been made privy. And again as in Goldoni's plays, Longhi's servants are not mere bystanders: significantly separated by shadow from the brilliant society pair they serve, they exchange glances, perhaps themselves inspired by the erotic intrigues of their masters. Are they amused by, or perhaps somewhat contemptuous of, the vacuous lives to which they are tied through service?

The social insights yielded by such tableaux convey no strident or urgent moral prodding, however. Like Goldoni, Longhi holds up a mirror that reflects the social scene without vilification or apparent anger. Neither the painter nor the playwright projects a militant, reformist attitute in his respective art. In displaying the moral weakness of his society, he maintains a critical tone without resorting to bitter judgment or a call to violent upheaval. At the end of Goldoni's plays, the illusioned characters are not condemned, and the social structure is not shattered. The peasants in the *Feudatario* do not call for revolution, being satisfied with having the ruling classes return to virtue and peace among themselves. Similarly, Longhi did not take sides obtrusively nor brandish, as Hogarth does, the inevitable and awful punishments attendant upon moral deliquency. Instead, in step with Goldoni's ethos rather than Diderot's, his method was to stimulate his audience into entertained self-knowledge.[90]

This gentle quality of Longhi's irony probably accounts for the fact that recent criticism, seeking in him the stronger medicine that would come with the revolutions of the next generation, has tended unjustly to deny him a place in the progressive ranks of the reformers, charging him with being "circumspect and reactionary," risking little, and sustaining the paternalistic image of the "happy peasant."[91] Yet, a close inspection of his paintings reveals frequent parallels between his and Goldoni's use of class contrast and class analysis as central thematic axes. And Goldoni, it is generally agreed, while not politically polemical, did concentrate his innovative efforts precisely on the presentation of the full cross-section of Venetian society, uncovering with laughter the indolence and arrogance of certain sectors of the aristocracy and the rigidity and materialism of the middle classes, while saving his warm affection for the common people.[92] Longhi's paintings also frequently reveal a similarly sharp awareness of the tensions, contrasts, and conflicts

between the various social classes when they are represented within a single painting. A canvas entitled *Milord's Salad* in the Benigno Crespi collection in Milan is a good example (fig. 57). It appears to poke fun at the practice, favored among the urban classes, of escaping into the country to eat presumably fresh, healthful food in a rustic setting among simple peasants in their simple dwellings. Salad, sausage, country wine, and a bit of unspoiled country music accented by a rude tambourine clearly allude to this pastoral ideal within the painting. For the occasion, Milord's companion has dressed up *a la contadinella*, that is, in the latest fashion decreed for country outings, but neither she, so clearly set off from the real peasant girls, nor the pompous, aristocratic male with her, can for a moment shed their stiff, self-conscious superiority. But of all the images that Longhi made, those that most seem to presage the inevitable end of the era are the late hunting scenes, a cycle of works painted in a moody, autumnal manner. Here there are no pretty peasant girls, no smiling milkmaids, no coquettish gestures. This is a man's world of dark, almost indistinguishable faces, of crouching, humble figures in service to the aristocratic sport. It is hard to imagine a painting more clearly articulating the

58. Pietro Longhi, The Master's Arrival. *Galleria Querini Stampalia, Venice.*

65

chasm between the peasantry and the patrician class than does *The Master's Arrival* at the Querini Stampalia, an image in which the lord, like a great general after a victory, grandly strides forward, acknowledging the dutiful, if not servile, bows of his young peasant beaters (fig. 58). Oddly, it is these late works, as well as Longhi's plebeian *Seven Sacraments* that remind us (if only in the choice of subject) of Crespi, in whose opera singer series Longhi had first recognized the comic possibilities in the use of class differences and social situations as artistic themes.[93] But in the generation of Piazzetta and Longhi in Italy, it remained for Giacomo Ceruti (1698-1767) to expose uncompromisingly the grim reality that lay behind the comedy. Of Milanese origin and formed in the Bergamesque-Brescian tradition going back to Moroni, Ceruti alternately portrayed the provincial aristocracy and middle classes in penetrating likenesses reminiscent of Ghislandi and painted what must be regarded as portraits also, but portraits of the disinherited — the most destitute, dispirited, sickly, deformed, and worn-down elements of eighteenth-century society.[94] The gallery of characters which Ceruti thus presents has astounded scholars since his rehabilitation in the 1920s after a long period of neglect. What jolts one to attention in the

59. *Giacomo Ceruti,* African Beggar. *Private collection, Turin.*

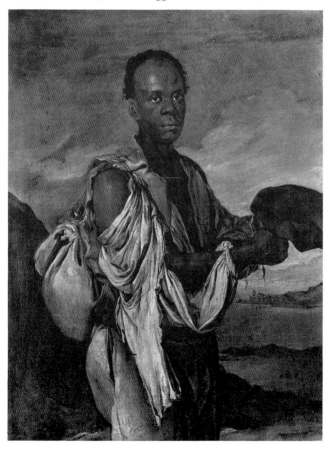

group of some fifty surviving works, which, according to the latest and fullest study by Mina Gregori, belong to the period around 1725-1740, is their insistent intent to expose, present, and keep in view a sector of society that nobody really wants to see, much less live with. We are, in these works, confronted with the detritus of the community: the displaced and homeless poor; the old and the young with their ubiquitous spindles, eloquent signs of their situationless poverty and unwanted labor; orphans in their orderly, joyless asylums plying their unpaid toil;[95] urchins of the streets eking out small coins as porters and wasting them in gambling; the diseased, palsied, and deformed; lonely vagabonds; even a stranger from Africa (fig. 59) — and all in tatters and filthy rags, almost all with eyes that address us directly, some squinted and dulled by deprivation, others (like the beggar from Hamburg) resigned and complaisant, still others stolid and accusatory.

With only a few exceptions, Ceruti presents these figures in large format, either singly or in pairs, such as the father and hungry child eating beans from one bowl; the two seated, deformed outcasts, one tenderly holding a kitten; or the mysterious, almost frightening duo in a shadowy forest, a crazed and grimacing man and a little girl in layers of rags standing silently before him (fig. 60). Generally the figures *do* almost nothing — after all, they have nothing to do. They turn to us and reveal their faces. The individuality we find there is explicable only if we assume that Ceruti posed them, as he posed the literally hundreds of parish priests, provincial *gentildonne*, doctors, scholars, and nuns, as well as the occasional count, for his magnificently characterized but rarely, it would appear, flattering portraits. Did he paint this anonymous and marginal element of society as a sequence of absolutely unique persons, each one singular in the way that his own bitter life has shaped and marked his face, because of a keen realization that this manner of presentation was the only way to make the point: that in the end, suffering is an individual matter, something that happens to a particular nervous system, that leaves marks on a particular face, distorts a particular body, and breaks a particular heart? To this end, generalization could have been of little use.

Ceruti's Italy provided the example of more than a little suffering. Scholarship is now slowly gathering the evidence of voices that were raised here and there, worrying about or denouncing the appalling state of affairs that had reigned for over a century — a situation broken by occasional moments of amelioration, but for the most part moving steadily downward as the torch of prosperity passed from Italy to other more vital economic centers and the Italian economy plunged ever deeper into stagnation. Within the territory controlled by Venice, the problems were especially grave, according to Scipione Maffei's advisory memorandum of 1736 regarding the

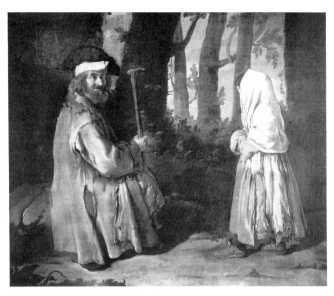

60. *Giacomo Ceruti*, Encounter in the Woods. *Private collection.*

disaffection of the terra firma. In this document addressed to the Concilio (and surpressed by that body), Maffei predicted that apathy in the nobility and consequent deterioration of the peasantry would continue to accelerate unless the *serenissima* gave some political representation to its mainland provinces.[96] The entire nation was running at a deficit, which had multiplied nineteen times in the two decades between 1719 and 1740. The service of this public debt amounted to forty percent of the entire income of the republic. Heavy taxes on salt and bread, as well as on every child born to the poor, increased the misery of the contryside without improving the government's situation. The hideous condition of much of the populace may be inferred from other bits of statistical evidence, such as a fifty percent growth in the numbers of *braccianti* (displaced day laborers) in the mainland town of Conigliano between 1723 and 1758 (in the latter year there were 2,462 persons who had lost the plots of land which had once supported them).[97] In a chain reaction, the craftsmen in the region were forced to flee the territory or resign themselves to being reduced to beggary. "Extreme hunger [and] shameful nudity," wrote a priest from the Brescian contryside, "torment and consume [the] trades."[98]

Prominent among the causes of these upheavals were the great changes in the landholding patterns of the Venetian nobility. Venice itself by 1727 had sold off one half of its holdings, presumably to pay debts, and the smaller bankrupt nobility saw itself forced to do the same. Land thus came to be increasingly concentrated in the hands of a few magnates who themselves had no interest in managing their holdings. The result was the development of a new class of middlemen interposed between the owner

and the peasant, who for many centuries had been symbiotically and paternalistically related. The land agents, having no such traditional ties, pitilessly squeezed the *villani*, who, in the end, were forced to abandon their huts and seek alms within the cities.[99] Most of these displaced paupers descended on the market places, the churches, and the charitable institutions of the capitals, straining their resources and filling the citizenry with squeamish apprehension, as well as a realistic recognition that such a weighty mass of hungry vagabonds constituted a serious danger for the city: "*Per Dio, che no saremo in sta invernada / segure in casa, se no basta in strada,*" wrote the not particularly liberal Angelo Maria Labia (1709-1775) at mid-century, voicing a general uneasiness at the sight of so much misery and destitution.[100]

Uneasiness, unfortunately, turned quickly to resentment, especially since the poor included many kinds, not only the innocent victims of economic changes, but also armies of thieves, charlatans, and ne'er-do-wells — the offspring of several generations of uprooted peasants. These, the *mali pauperes*, had, as early as 1698 in Rome, been segregated by Pope Innocent XII from the virtuous poor for the purpose of directing welfare support only to the deserving. But in practice the distinctions were difficult to make, and, according to Camporesi, all the poor began to look alike — all became *poveri viziosi*, the vice-ridden poor.[101]
Inadequate solutions to these problems evolved amidst a general confusion of motives — charitable impulses, rational desires to make distinctions, and selfish fear for the safety of the existing order. The work houses, orphan asylums, and hospitals established in response were severe and miserly in their management of the indigents. Bare subsistence diets, dour moralism, and long hours of labor — which for women included spinning, sewing, and laundry — were common features of such a life.[102] Eventually, foreign vagabonds were barred altogether from entering the city, and in 1752 Venice finally published a ban ordering all unregistered foreign paupers to leave within a fortnight or be subject to the "cord [i.e., the hangman's rope], prison, or the whip."[103]
Ceruti's head-on confrontation with these wretches, in which he captured their individual pain in some of the saddest pictures ever made, anticipated by over thirty years a wider recognition that Arcadian eulogies of bucolic life seriously distorted reality. Most artists and even the concerned, rationalist members of the intelligentsia and ruling class preferred in their art, as we have seen, an escape from the unpleasantness of such realities into good humor and Arcadia.
It was not until the 1760s in the *Osservatore Veneto*, that the topic began to be widely discussed in print. Gasparo Gozzi provides a revealing dialogue with a

peasant woman, who meets his innocent praises of country life with puzzled incomprehension. Her life, she tells him, is in fact one of unceasing toil in heat and frost, barefoot and lacking sufficient cover from the elements; the earth itself is niggardly, and the fruits it yields are all owed to the *padrone*. Nor was the much-vaunted freedom to love and marry a partner of one's choice (apparently an envied and romanticized liberty among those who lived under constraints of family and fortune) a recompense as Gozzi seemed to think. Poverty, she tells him, does not permit marrying, and, even if the peasants should do so, care and trouble reduce them in the space of a single year to dried, scrawny creatures, "black as coal."[104] A similar message is relayed by Carlo Gozzi, for once in agreement with his brother Gasparo, in his disillusioned mock–heroic poem, *La Marfisa bizzarra* (1761-1768). Here the peasants recall that, yes, at one time they did eat wheat bread, but now their bread is meagre and black, made of millet, because the devil takes away their harvest.

By now, we don't have strength or talent,
All our hopes are buried:
Look at our dried and singed skins,
And then judge our lives.
See us heading occasionally to the taverns,
So that the wine can lull us with its vapors,
This desperation that we have inside
Due to our state, our state of pain;
This misery extinguishes every light
And degenerates into traitorous vice.
So said the desperate peasants
Who, too, were philosophers of the enlightenment.[105]

But such literary recognition of the plight of the peasantry was a long time in the future when Ceruti was painting his scarifyng reminders of the victims of poverty in the 1720s and 1730s. His production of large numbers of such works and, perhaps even more difficult to explain, his apparent ability to market them readily in the provincial Brescia of those years raise a number of questions, still largely unanswered. What impelled Ceruti to take up such subjects? Under what ideological, psychological, or artistic promptings did the artist's profound response of conscience and empathy with the non-persons of his world emerge? And what was the audience for them? Who were the patrons and purchasers of these paintings which apparently seemed to ignore all other requirements of art except the one of provinding a bitter medicine of stark and uncompromising truth? The answers to these questions, as Roberto Longhi suggested, are best sought in careful examination of the concrete events and the actual, obscure persons of Brescian society of the settecento.[106]
Some of the sources that shaped Ceruti's art are possible to identify. The precedents for his subjects and the sources to which he seems naturally to have turned suggest a comprehensible pattern. In the first place, there is the mysterious but, one senses,

important presence of Antonio Cifrondi in Brescia between 1722 and 1730.[107] This artist, during the last eight years of his life, when he was between 67 and 75 years old, produced a series of paintings which prefigure Ceruti's subjects without being direct models. Employing a cursive, painterly style with which he succeeded in producing a light that emanates from the forms themselves, the aging Cifrondi painted a number of busts of old men — not the old men of prophetic gaze and wrinkled skin derived from the Caravaggio school, but whimsical, pitiful, senile and obsessive old men, brandishing hour glasses, taking snuff, and covering themselves against inclement weather with their bare hands (fig. 61). Then too, there are philosophical old men, who declare that those who do not know how to keep silence can never learn to speak well, or that all things are worthy of mockery — the stoic themes that had enjoyed popularity in the seicento and which Crespi also kept alive with his Democritus laughing and Heraclitus weeping over the foolishness of the world. Besides these, Cifrondi also produced a series of images of people at their work, which again recall Crespi's predilections, since Cifrondi revelled in his subjects' innocent absorption in their tasks. These

61. Antonio Cifrondi, Old Man in the Snow. *Pinacoteca Civica Tosio Martinengo, Brescia.*

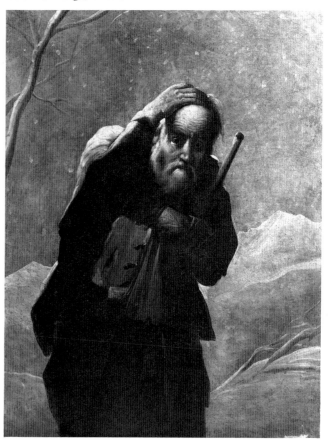

works directly communicate a passionate conviction of the goodness of work and of life itself. Such is the unforgettable figure of a young miller, dressed in white, studying a handful of wheat — the staff of life — with an amazed and meditative intensity (fig. 72). Or the white-robed youngster of a priest, holding the monstrance with a profound, trembling reverence in order to show the people that other, spiritual bread that sustains their poor existence.

The rapid, apparently somewhat untutored style and technique of Cifrondi's paintings are clearly outside the mainstream and belie the cosmopolitan breadth of his actual experience. He studied in Bologna (around 1670) in the Cignani circle with Franceschini and sojourned in Rome (1675-1680). By way of Turin, he made his way to Paris, where he was in contact with Le Brun, moving and working in court circles. Back in his home town of Clusone in 1686, he was a popular church painter in the territories around Bergamo until around 1722, when he settled down in Brescia in the Benedictine convent of S. Faustino, painting a large number of the genre works, already discussed, before his death in 1730.

The likelihood of there having been some kind of relationship in those eight years between the old and philosophically inclined but also wordly and experienced Cifrondi and the young Ceruti, who was just beginning his career, is very great. Cifrondi was a well-known painter in the area, and the small size of Brescia would have made at least some contact between the two artists almost certain. But beyond the simple presumptive evidence, there appear other correspondences of a more concrete nature. The convent to which Cifrondi retired in his old age (he appears to have stayed in religious institutions during the execution of commissions for their churches) is shown in later inventories to have owned a fair number of Cerutis too: five *pitocchi*, as well as four philosophers and a Saint John.[108]

Mina Gregori suggests that whatever affinities drew Cifrondi to the Benedictines here and in S. Paolo d'Argon in Bergamo might also have attracted Ceruti. Later, around 1740, Ceruti made other connections with the Benedictines, which remain to be investigated more fully, when he painted the portrait of Don Pellegrino Ferri, a scholar of moral law in the convent of Santa Giustina in Padua. Like S. Faustino in Brescia, S. Eufemia was a center of ideas with roots in seventeenth-century Jansenist thought, Venetian Gallicanism, and stoic ethical positions with pauperistic overtones.[109]

The possibility that there was a commonality, or at least an exchange, of ideas between Cifrondi and Ceruti is further fortified by the appearance in Ceruti's paintings in these Brescian years of images either influenced by, or directly copied from, such French artists of the first half of the seventeenth century as Callot and the Le Nain school, who dealt in pauperistic subjects during that earlier wave of

indigence and poverty that had come from the Thirty Years War and the subsequent depressions. Given Cifrondi's connection with France and the relative obscurity of the Le Nains at the beginning of the eighteenth century, as well as Cifrondi's own use of popular images from French prints, it seems probable that the untraveled Ceruti might have been introduced to this seminal iconography by the older artist.[110] And he might also have been encouraged by him, if they should have been friends, to transform his early experiments in genre painting, based on standard Caravaggesque scenes of card players and bravos in tavern settings, into images with greater philosophical and moral weight. At the least, it can be suggested that Cifrondi's role as an old man in the company of this brilliant young portrait painter was to provide a spiritual stimulus for moral seriousness and Christian concern.

Another presence in the Bergamo-Brescia cultural ambiance that must have been of some importance to Ceruti was that of Giacomo Todesco, or Todeschini, a painter of possible German origins who was active until around 1736.[111] The fundamental differences in their interpretations of their subjects must not obscure the fact that, upon Ceruti's arrival in Brescia, Todeschini was an established and extremely prolific painter of a whole gamut of genre subjects, a number of which Ceruti eventually took up as his own. Tavern scenes, street urchins, beggars, old couples eating, and women at their sewing were the themes that the two painters shared (figs. 62 and 63). The difference, of course, between Todeschini's street world of the poor and that of Ceruti is the difference between the latter's great artistic genius and depth of conciousness and feeling and the former's sturdy but shallow artistic vision that rarely goes deeper than a jolly, satirical sense that the world is a lark and most men are fools.

Todeschini's bumptious old folk, leering, jeering tavern dwellers, senile and vicious schoolteachers, pranksters with mousetraps, and jolly old women spinning while paupers display their begging permits might have suggested to Ceruti not only the viability of the subject range that he himself would pursue, but also the mark against which he could measure his own accomplishments. Indeed, he transformed Todeschini's comic vision into something entirely unprecedented, not even conceived of by the sober fraternity of the Le Nains, whose object, it would seem, was to give sentient expression to the evangelical idea of the dignity bestowed on the faithful poor through Christ's invisible presence among them.[112] Ceruti's poor seem stunned in the one life they know at this moment; they confront us as bare humanity, perhaps as an accusation, but more likely, as a mute reminder.

Those who wanted to be thus reminded, judging by the lists of collectors in Carboni's guidebook of 1760, were few; from other sources, however, we gather

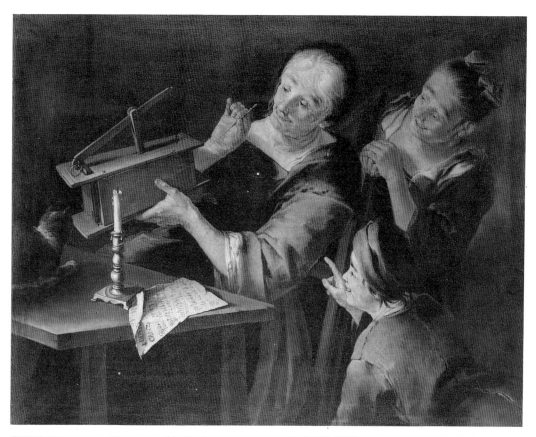

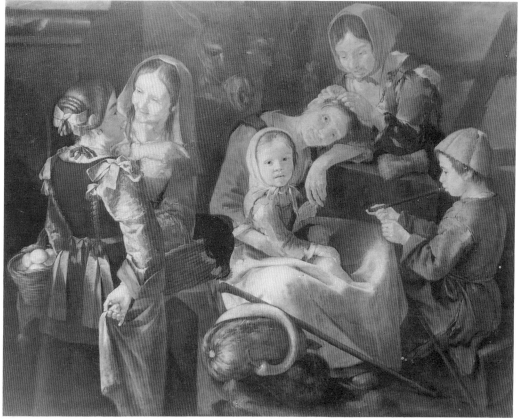

that the few who did were very passionate about Ceruti's work. Generally speaking, the major collections in Brescia did not favor genre subjects at all, though entire rooms could be dedicated to flower or kitchen pieces and landscapes. Collections, like those of Giovanni Molino, Bishop of Brescia, or those in the Palazzo Ugeri or Casa Gaifami, showed a distinct predilection for old masters and heroic subjects.[113] And while there must have been numerous smaller collections that did not merit a place in the Carboni guidebook, but which nevertheless might have included a Ceruti genre piece or portrait, we do know that two families in Brescia — the Lechi and the Barbisoni — acquired his paintings repeatedly. Moreover, the Avogadro and their heirs appear to have bought up almost everything of his in this vein that they could.[114] But until we have a more precise picture of the conflicts and alignments of indivuduals in regard to the religious, political, and economic, as well as artistic, issues that concerned the upper strata of Brescian society, it is difficult to interpret the significance of the exceptional enthusiasm that these few collectors had for Ceruti's works, especially in the face of an otherwise seemingly general indifference.

The possible explanations of this phenomenon are varied. One view would have it that such liking as Luigi Avogadro's for the paintings of Ceruti simply represented a connoisseur's enthusiasm. This is suggested wholly by the fact that under his and his young literary wife's guidance, the family collection grew in general at an astounding pace. Also, Avogadro's own taste for Brescian painters of the past, in particular for Moretto and Moroni, might account for his appetite for the soberness and Venetian facture of Ceruti's works. The undeniable superiority of Ceruti's virtuosity and the novel twist he gave to the Lombard tradition of realism could have been sufficient reason to collect a large number of his works.[115]
But the local loyalty that such activity suggests may have broader implications. The noble houses of the proud and active city of Brescia, along with the nobility of all the Venetian territories outside the capital itself — such as those of Padua, Vicenza, Bergamo, and Udine — were deeply aggrieved by the treatment of the provinces by the ruling city. Excluded from inscription among the Venetian nobility in the *Libro d'oro* (except at a high price when Venice needed money) and, as we have seen in Maffei's unheeded advice, denied any voice in the administration of the fiscal policies of their provinces, the provincial nobility were quick to note and protest

the ruination of their own people by the rapacity of the very government that dealt with them not as citizens, but as colonials. If Ceruti's paintings, magnificent works of art that they were, also made the bitter point for them that their political impotence was causing the destruction of the provincial economy, it might have made the paintings seem all the more important. Whether reformist ideas from the religious or secular enlightenment also came into play in the formation of such tastes is not possible to say with any certainty.
It is suggestive in this line of thought, nevertheless, that Ceruti did make connections with at least some members of the central group that made up the society of the Venetian Enlightenment. Already in Brescia in 1726, he had caught the attention of the serious-minded patrician and devoted servant of Venice, Andrea Memmo, then *podestà*, and was commissioned to paint a series of portraits of the previous governors of the city. Memmo's commission (the paintings are now lost) would not have concerned Ceruti as a genre painter, directed as it was to commemorating the past Venetian magistrates of Brescia, but it is suggestive of his liking for Ceruti's lack of high style that he did not select a more accomplished history painter from Venice. It was perhaps through Memmo or his nephew, Andrea

64. Giacomo Ceruti, Man and Child Eating. *Private collection.*

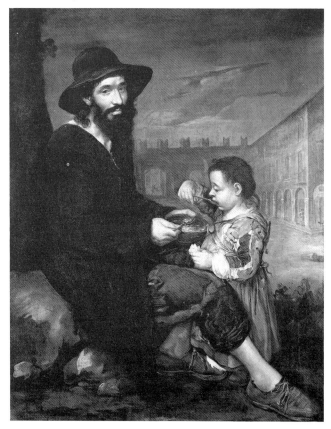

62. Il Todeschini, Woman Tickling a Mouse in a Trap. *Národní Galerie, Prague.*
63. Il Todeschini, Peasants with Woman Cleaning Lice. *Hampton Court.*

Memmo the Younger, both members of the circle of Consul Smith, that Ceruti came into contact with Padre Lodoli, the younger Memmo's teacher and gadfly of Venetian intellectual life. Lodoli's great contribution to those around him was to inspire in them an openness to new ideas, an ability too challenge authority and to apply reason to social problems. In any event, at some time while Ceruti was in Venice or in Padua he executed a portrait of Padre Lodoli.[116]

Lodoli had a fierceness of spirit, a mental clarity, and a caustic directness that made him a particular object of suspicion to the conservative upholders of tradition. In the biographical sketch that Andrea Memmo included in his book on Lodoli's unorthodox, functionalist architectural theories, we are treated to a vivid description of the figure that the now-lost Ceruti portrait depicted. Ceruti's talent must have been well-suited to the task, since the description conjures up an image not too distant from one of his own beggar paintings. The Franciscan robe that Lodoli wore, Memmo says, contributed to an exterior that ill conformed to any ideal of gallantry — especially in view of "the sanguinous blotches on his face, his unkempt hair, the thick, shaggy, multicolored beard, and fiery eyes, flashing sparks, all of which could put fear into souls that were somewhat delicate."[117]

Ceruti's character, to judge from the sparse clues that we have, appears to have been not only far from delicate, but also argumentative — even sticky — leading one to believe that the two unusual men might have found in each other a kindred spirit. The most revealing information that we have about Ceruti, besides the sense we get from his last will that he was a man of strong ethical convictions, is the response he made in 1745 to a parish priest in Piacenza for whose church, Sant'Alessandro, he had agreed to paint an altarpiece. When the priest — who had already been warned by someone who knew Ceruti better not even to bother to show the painter a sketch for the large project made by another artist — asked Ceruti to provide a sketch for the contemplated altar, the painter replied that no sketch could be expected from him, since he was born a painter, not made into one.[118] What the priest, who was probably artistically ingenuous and doubtless somewhat intimidated, made of this laconic response is hard to imagine. What Ceruti must have been saying was that he was not trained in academic method, with all its formulas for how to make preparations through drawings, developing an idea by means of orderly steps towards the finished work. Such painters, apparently, were in his mind "made," while he took pride in what he felt was his innate power to create directly on the canvas. These brief glimpses — along with the additional image that we get of Ceruti in his self-portrait as a pilgrim — permit us to image a fiercely independent

65. *Giacomo Ceruti*, Poor Family. *Private collection.*

66. *Giacomo Ceruti*, Carnival Scene. *Private collection.*

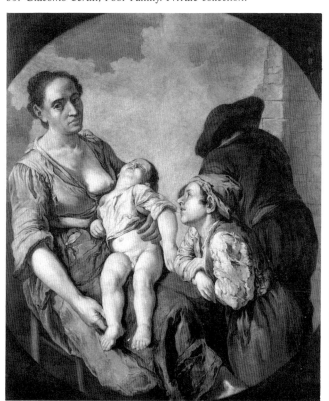

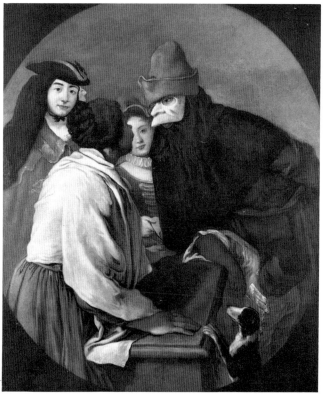

artistic personality for which the independent Padre Lodoli would have had particular sympathy, especially in light of his intense love of art and his habit of befriending artists and craftsmen and visiting them at their work.[119]

The fact that the portrait of Padre Lodoli was in Marshal Schulenburg's collection in 1741, along with twelve other paintings by Ceruti (among them three major canvases of beggars acquired in 1736), indicates something of the interconnectedness of Venice's enlightened thinkers and patrons. It also suggests that the old Field Marshal might have had a sensibility somewhat more complex than the picture we have of him otherwise as a comfortable old aristocrat settled in plush retirement on the Grand Canal, collecting paintings that show a predilection for realist Dutch and Flemish art. That the Marshal's character had other dimensions finds confirmation in the report that Schulenburg entertained a lifelong remorse for an action taken under his leadership against the inhabitants of the Val d'Aosta in 1699, when he, together with his German troops, was in the service of Duke Vittorio Amadeo II. The plunder and the loss of life among the civilian population that resulted from this attack filled him with guilt and led him to the extraordinary conclusion for an eighteenth-century military man that generals were responsible for the suffering they caused and that the only wars that were permissible were those waged in self-defense.[120] In the light of evidence of such a conscience, Schulenberg's patronage of Ceruti may perhaps be seen as the function of more than a mere taste for realistic painting. It would seem instead to be part of a larger, more enlightened spirit of compassion that emerges with the growing awareness of the misery of the poor, which artists such as Ceruti must have represented in order to lay their plight before the eyes of the powerful. Schulenburg's paintings of the three old beggars (cat. no. 46) — each one isolated in his own resigned and painful thoughts — or that of the young, bearded man of gentle face, with his small daughter in shreds rather than clothes, intently spooning a few watery beans from her father's bowl (fig. 64), as well as the Glynde Palace painting of a crowded family of peasants that so strongly recalls the work of Le Nains — all three deeply conscience-stirring canvases — represent the climax of Ceruti's exploration of this type of subject. In subsequent works, Ceruti turned his brush to more amiable imagery, such as in the North Carolina painting of a servant family in their quarters passing the time of day by playing cards, or the beribboned and brightly made-up shepherdess (cat. no. 50) who frankly stares out at us, full of confidence in her pastoral charms. These and other lighter glimpses of erotic pranks, seductions or smiling urchins which Ceruti painted at mid-century make the full circle and return us to the conception of genre painting as belonging in the comic mode.

If it was Ceruti's experience with the festive mode of Venetian painting that put an end to his unique gallery of peasant portraits, then a pair of tondi surely meant as pendants which he made during his Venetian period may represent a visual exteriorization of his artistic dilemma (figs. 65 and 66). In one he shows us, with a suggestive recall of Raphael's various Madonnas with the Christ Child and John the Baptist, a family in profound and hopeless destitution: the child, almost naked and asleep on his mother's lap, has just abandoned her worn breast, still apathetically uncovered, while she gazes out at us without expression. In the other tondo, masked and costumed young people in gay, hectic movement, full of energy and life, are engaged in some purchase at a stall. The grotesque *bautta* of the man and the beautiful young woman's fashionable tricorn hat whisk us into the world of pleasure, flirtation, and carnival delights. Perhaps, as has been said, the Enlightenment in Venice had given Ceruti a headier and more hopeful view of life. Perhaps he decided that such images as he had been painting simply constituted too much concentrated pain.

I want to thank The Wichita State University Research Committee for financial support during my travels in Italy.

1) See, Paul Hazard, *The European Mind* (1680-1715), trans. J. Lewis May (New Haven, 1953).

2) D. Porvenzal, *I riformatori della bella letteratura italiana* (Rocca S. Casciano, 1900), p. 7.

3) See Merriman, 1980, p. 210, n. 31.

4) Giambattista Vico, *The New Science*, trans. T.G. Bergin and M.H. Fisch (Ithaca and London, 1984), pp.XIX-XLV . The first edition came out in 1725.

5) *Della carità cristiana* was first published in Modena in 1723, the *Governo della peste* in 1714, and *Della pubblica felicità* in 1749. A very helpful analysis is Ezio Raimondi's, "La formazione culturale del Muratori: il magistero del Bacchini," *L.A. Muratori e la cultura contemporanea* (Florence, 1975). See also Bruno Brunello in the introduction to *Della pubblica felicità* (Bologna, 1941).

6) See Provenzal, *op. cit., passim.* Also Walter Binni, "Il petrarchismo arcadico e la poesia del Manfredi," *Storia della letteratura italiana*, VI, *Il settecento* (Milan, 1968). See also an excellent account of the Arcadian world in Vernon Lee, *Studies of the Eighteenth Century in Italy* (London, 1887), pp. 7-64.

7) For the inventory of Ferdinand de' Medici's collection, see: Marco Chiarini, "I quadri della collezione del principe Ferdinando di Toscana," *Paragone*, 301 (1975), pp. 57-98; 303 (1975), pp. 5-108; 305 (1975), pp. 54-88; M.L. Strocchi, "Il gabinetto d'opera in piccolo del gran Principe Ferdinando a Poggio a Cajano," *Paragone*, 309 (1975), pp. 116-126; 311 (1976), pp. 84-116. For Eugene of Savoy, see Alessandro Vesme, "Sull'acquisto fatto da Carlo Emanuelle III re di Sardegna della quadreria del Principe Eugenio di Savoia," *Miscellanea di storia italiana*, XXV (1886), pp. 163-253. For Ottoboni, see Haskell, 1963, pp. 164-165.

8) For this change in Paris, see Posner, 1984, pp. 13-15.

9) Baldinucci, 1847, V, p. 522. Speaking of Helmbreker: "*ed è, di affascinare, per dir cosi, in un tempo stesso, gli occhi degl'intendenti e de'non intendenti dell'arte, per modo, che non vi è alcuno, che imperito che sia, che, subito vedutele, non resti preso da gran diletto e maraviglia. La ragione di ciò si è, a mio credere, perché in quella guisa che tanto l'avveduto, lo studioso, il civile quanto il goffo, l'ignorante e'l plebeo, per pure lume naturale, ben conosce e prendesi diletto della cosa vera...*"

10) I belive the uniqueness of Ferdinand's patronage of Crespi and the role of Crespi's visit to Florence are somewhat exaggerated by Haskell (1963, p. 239).

11) Zanotti, 1739, II, p. 36. Also see Merriman, *op. cit.*, pp. 106-108.

12) Bellori, 1672, pp. 5, 213, 312-313.

13) G. Briganti, L. Trezzani, L. Laureati, *I Bamboccianti* (Rome, 1983), pp. 356-357. Rosa accuses the wealthy patrons who buy such works of hating the poor and loving the painting because at court all that is valued is fiction.

14) Marco Boschini, *La carta del navegar pitoresco*, ed. Anna Pallucchini (Venice-Rome, 1966), pp. 256, 273, 491.

15) Malvasia, 1678, Bologna ed., 1841, II, pp. 179-180.

16) Paris, Grand Palais, *Les frères Le Nain*, 1978 (text by J. Thuillier), pp. 61-62. In 1688, Félibien wrote "*J'ay veu, interrompit Pymandre, de leurs tableaux; mais j'avoüë que je ne prouvois m'arrester à considérer ces sujets d'actions basses et souvent ridicules. Les Ouvrages, repris-je, ou l'esprit a peu de part, diviennent bientost ennuyeux.*" The Dutch criticism of such art extends into the eighteenth century with Lairesse, who wrote in his *Groot Schilderbock* of 1707: "We hardly see a beautiful hall or fine aparment of any cost, that is not decorated with pictures of beggars, bordellos, taverns, tobacco smokers, musicians, dirty children on their pots, and other things more filthy and worse. Who can entertain his friend or a person of repute in an apartment which is in such a mess..." Quoted in Seymour Slive, *Rembrandt and his Critics 1630-1730* (The Hague, 1953), p. 161. See also pp. 170-171 for similar views by Ten Kate.

17) For the high prices, see Vincenzo Ruffo, "Galleria Ruffo nel secolo XVII in Messina," *Bollettino d'Arte*, X (1916), p. 289.

18) Raimondi, *op. cit.*, pp. 11ff. Interesting considerations on this subject are offered by Guido Quazza, "Il dibattito sul primo settecento," *Illuminismo e riforme nell'Italia del settecento*, ed. Gianni Scala (Bologna, 1970), pp. 152-166. Quazza says that in the period before 1750 the time was not ripe for a full encounter between ideas of the Enlightenment and the forces of power in society in order to provide action (p. 155).

19) Zanotti, *op. cit.*, p. 67.

20) For these developments see Émile Mâle, *L'art religieux de la fin du XVIᵉ siècle, et du XVIIIᵉ siècle* (Paris, 1951): Eucharist pp. 72-86.

21) *Ibid.*, pp. 86-96. Crespi's favorite charity was the liberation of prisoners from capital punishment or from captivity. Two incidents are recounted by the sources: Luigi Crespi, 1769, pp. 224-225; Zanotti, *op. cit.*, pp. 68-69.

22) For indulgences, see Mâle, *op. cit.*, pp. 58-65; for Crespi's practices, see Luigi Crespi, *op. cit.*, p. 224; Zanotti, *op. cit.*, p. 46.

23) *Ibid.*, pp. 68-69.

24) Dal Poggetto, 1975, p. 360.

25) Merriman, *op. cit.*, pp. 320-326.

26) For a modern edition of Bertoldo, see G.C. Croce, *Bertoldo e Bertoldino*, ed. P. Camporesi (Turin, 1978). The first edition was in 1606.

27) Piero Camporesi, *Il pane selvaggio* (Bologna, 1980), pp. 167-184.

28) Croce, *op. cit.*, pp. 52-53.

29) Camporesi (*op. cit.*, pp. 151-184) shows the connection that was made in 1587 between the "lower natures" of the poor and the appropriate food for their crude stomachs. The point was made by Baldassare Pisanelli, a Bolognese doctor who wrote the *Trattato della natura de' cibi e del bere...* (Bergamo, 1587), and was still maintained as a scientific truth by Vincenzo Tanara, *Economia del cittadino in villa* (Venezia, 1687). For obvious reasons, foods dear to the rich — such as pheasant and quail — were said to have deleterious effects on rustics in the form of asthma and tuberculosis. Efforts were also being made to find substitute foods for the poor in the wild grasses and roots: Ovidio Montalbani's *Pane sovventivo spontenascente* (Bologna, 1648).

30) Zanotti, *op. cit.*, pp. 66-67.

31) Crespi, *op. cit.*, p. 225: "*Piano nel vivere: modesto nel vestire, fino a portar gli abiti di 30 e 40 anni già fatti.*"

32) Zanotti, *op. cit.*, p. 66. "*Egli veste in casa in strana foggia, ma comoda a lui, ne di questo comodo si priva per qualunque visitazione riceva, e il fa con tal maniera franca, e piacevole, attribuendo cio ad un estro pittoresco, che non vuol soggezione...*" (my emphasis). Crespi, who admired Rembrandt, could have read similar reports about Rembrandt's attitudes regarding social proprieties in Baldinucci's Life of Rembrandt (Baldinucci, *op. cit.*, V, p. 307) and in Bellori about Annibale; see, Merriman, *op. cit.*, pp. 207-208, n. 13. What one sees in the making is a *topos* for artistic personalities.

33) Ruggiero Romano, *Tra due crisi: l'Italia del Rinascimento* (Turin, 1971), p. 191.

34) Enzo Piscitelli, "Le classi sociali a Bologna nel secolo XVIII," *Nuova rivista storica* (1954), PP. 79-118. Notable is the publication in the second decade of the eighteenth century by Domenico Maria Felice Gherlini, *Riflessi bisognevoli che si propongono per risorgimento e mantenimento dell'arti della seta, lana, e canape e loro esercenti e dipendenti da esse nella città di Bologna* (Bologna, 1714). Sixteen thousand people were out of work, out of a total work force of 70,000.

35) I am grateful to John Spike for sharing this information with me.

36) Quoted from G.C. Croce, *Banchetto de' Malcibati...* (Ferrara, 1601), p. 39, by Camporesi, *op. cit.*, pp. 183-184.

37) The literature on this subject is quite large. For art historical purposes, the following are very useful: Eugenio Battisti, *L'antirinascimento* (Milan, 1962), chap. X, "Dal comico al genere;" Bert W. Meijer, "Esempi del comico figurativo nel rinascimento lombardo," *Arte lombarda*, XVI (1971), pp. 259-266; Barry Wind, "Annibale Carracci's *Scherzo*: the Christ Church Butcher Shop," *Art Bulletin*, LVII (1976), pp. 93-96.

38) The painter Giovanni Domenico Ferretti (1692-1768), who studied in Bologna for five years (1714-1719) under Felice Torrelli and settled in Florence, appears to have brought from Bologna an idea of representing comedy in painting. He produced two scenes from the commedia del'arte (now at the Ringling Museum in Sarasota) showing Harlequin cooking and eating. These are clearly illustrations of stage action and provide a poignant note to the theme of hunger, since one of the favorite themes for the burlesque on the stage was the plight of the hungry Zanni. The paintings are published in Detroit / Florence, *The Twilight of the Medici: Late Baroque Art in Florence, 1670-1743*, 1974, nos. 135a-135b. *The Brazen Serpent* (1736) by Ferretti, in the Morton B. Harris collection in New York, shows strong affinities with Crespi's *Joshua Stopping the Sun* (Bergamo, Colleoni Chapel), dated 1737-1738, and with the *Brazen Serpent* of the Bologna Credito Romagnolo, attributed to Crespi by Carlo Volpe. The latter painting, in fact, looks like Ferretti's work but repeats a figure from Crespi's documented Joshua canvas. These are all puzzling interrelationships (for illustrations, see Merriman, *op. cit.*, nos. 12-14).

39) Boston, *Printmaking in the Age of Rembrandt*, 1981 (ed. Clifford S. Ackley), no. 177, pp. 257-58. For another possible exception, see *infra*, n. 63.

40) Baldinucci, *op. cit.*, IV, pp. 517-518.

41) For other examples, see Merriman, *op. cit.*, pp. 133 and 154.

42) Zanotti, *op. cit.*, p. 70.

43) A. Adamello, "Le cantanti italiane celebri", *Nuova Antologia* (1889), pp. 308-37.

44) See Merriman, *op. cit.*, p. 307, no. 250.

45) Benedetto Marcello's work was written in 1720. For a thorough study of *Il teatro alla moda* and an English translation, see R.G. Pauly, "Benedetto Marcello's Satire on Early 18th-Century Opera," *Musical Quarterly*, XXXIV (1948), pp. 222-223, 371-403 and XXXV (1949), pp. 85-105. For further studies, see Lee, *op. cit.*, pp. 67-139; F. Vatielli, *Arte e vita musicale a Bologna* (Bologna, 1974), pp. 71-75. See also Vittorio Malamani, *Il settecento a Venezia* (Turin-Rome, 1891), pp. 77-83; Pompeo Molmenti, *La storia di Venezia nella vita privata*, III (Trieste, 1973), pp. 376-377.

46) Carlo Goldoni, *The Comic Theater*, trans. John W. Miller (Lincoln, 1969), p. 75.

47) Crespi, *op. cit.*, pp. 215-216.

48) Roberto Longhi in preface to Bologna, *Mostra Celebrativa di Giuseppe Maria Crespi*, 1948, p. 16.

49) Zanotti, I, p. 390.

50) For a recent summation of scholarship, see Ugo Ruggieri in Venice, *Giambattista Piazzetta: Il suo tempo, la sua scuola*, 1983, pp. 44-46 and p. 58 under no. 4.

51) Eustachio Manfredi, *Rime* (Bologna 1732), pp. 29 and 74.

52) An important recent book adds to our conceptions of the origins of Arcadian subjects and suggests, again, the continual impact of Dutch art in Italy: Alison McNeil Kettering, *The Dutch Arcadia: Pastoral Art and Its Audience in the Golden Age* (Totowa, N.J., 1983).

53) George Knox, *Piazzetta: A Tercenary Exhibition of Drawings, Prints, and Books* (Washington, 1983), pp. 25-26.

54) See Haskell, *op. cit.*, pp. 297-310. Smith's life and salon are fully described in Frances Vivien, *Il Console Smith mercante e collezionista* (Vicenza, 1971).

55) For Padre Carlo Lodoli, see Andrea Memmo, *Elementi d'architettura lodoliana, edizione corretta ed accresciuta dall'autore nobile Andrea Memmo*, 2 vols. (Milan, 1834); G. Torcellan, *Una figura della venezia settecentesca: Andrea Memmo* (Venice-Rome, 1963), pp. 36-41; M. Brusatin, *Venezia nel settecento: Stato, architettura, territorio* (Turin, 1980), pp. 44-45.

56) Francesco Venturi, *Italy and the Enlightenment, Studies in a Cosmopolitan Century*, trans. Susan Corsi (London, 1972), pp. 103-133.

57) Quoted in *Ibid.*, pp. 238-239; see also Giovanni Tobacco, *Andrea Tron (1712-1785) e la crisi dell'Aristocrazia senatoria a Venezia* (Università degli Studi di Trieste, 1957), p. 19.

58) *G.B. Piazzetta, Disegni-Incisioni-Libri-Manoscritti* (Venezia, 1983), p. 50.

59) Vivien, *op. cit.*, pp. 39-40.

60) *Ibid.*, pp. 24-26.

61) *Ibid.*, Appendix A, B, C, p. 173ff; for Crespi, p. 220.

62) Luisa Tognoli, *G.F. Cipper, il Todeschini e la pittura di genere* (Bergamo, 1976), figs. 83, 86 and 87.

63) Mousetraps and bird cages were used by Dou and Adriaen van der Werff with amorous associations taken from Jacob Cats, who likened caged rodents and birds to the loss of freedom because of passion: Philadelphia, *Masters of Seventeenth Century Dutch Genre Painting*, 1984, no. 33, p. 184 and no. 125, p. 357. Scenes with a dead mouse being shown to a cat signify in Dutch art the passing nature of earthly enjoyment. See Mary Francis Durantini, *The Child in Seventeenth-Century Dutch Painting* (Ann Arbor, Michigan, 1983), p. 260. Crespi painted this subject twice; Merriman, *op. cit.*, No. 215, and in a painting recently on the art market.

64) Cited by Mariuz, Venice, 1983, p. 49.

65) Haskell, *op. cit.*, p. 341, note 4.

66) Venice, 1983, pp. 34-35 and 147.

67) In three articles, the authors D. Maxwell White and A.C. Sewter explicate the great pastorals — the two painted for Schulenburg now at The Art Institute in Chicago and in the Wallraf-Richartz Museum in Cologne, as well as the *Indovina* in the Accademia in Venice — as allegories intending social satire criticizing Venice: "Piazzetta's so-called Group on the Sea Shore," *The Connoisseur*, XLIII (1959), pp. 96-100; "Piazzetta's so-called 'Indovina' - an Interpretation," *The Art Quarterly*, XXIII (1960), pp. 124-138; "Piazzetta's Pastorals - An Essay in Interpretation," *The Art Quarterly*, XXIV (1961), pp. 15-32. There seems to be little agreement with this set of interpretations. See e.g., Haskell, *op. cit.*, p. 314, and Venice, 1983, pp. 23-24.

68) Haskell, *op. cit.*, p. 263. The Carracci drawings are now in the Royal Collection in England.

69) See Starobinski in Venice, 1983, pp. 11-12; also for general intellectual development: W. Roberts, *Morality and Social Class in Eighteenth-Century French Literature and Painting* (Toronto, 1974), pp. 62-63; J.J. Rousseau, *Discourse on the Origin of Inequality* (N.

Y. n.d.).

70) Smith owned four volumes of engravings after Watteau: Vivien, *op. cit.*, p. 29.

71) Mina Gregori, *Giacomo Ceruti* (Milan, 1982), p. 71.

72) See Alessandro Bettagno in Venice, 1983, pp. 85-88.

73) Quoted by Mariuz in *Ibid.*, p. 50.

74) Pietro Longhi's son Alessandro gives the original information connecting his father with Crespi in Alessandro Longhi, *Vite dei pittori veneziani* (Venice, 1762), no pagination. I follow Terisio Pignatti's dating in *Pietro Longhi* (London, 1969), p. 14.

75) There is one possible exception in the pendentive figures in San Pantaleon in Venice, *Ibid.*, p. 123.

76) Alessandro Longhi, *op. cit.*, n.p.

77) E. Dacier, *La gravure de genre et de moeurs* (Paris and Brussels, 1925), p. 8.

78) Pignatti, *op. cit.*, p. 28.

79) Two early studies already take opposing views: Longhi is seen as intending comedy and criticism by Ernesto Masi, *Studi sulla storia del teatro italiano nel secolo XVIII* (Florence, 1891), pp. 263-275; this interpretation is called fanciful and ingenious by Pompeo Molmenti, "Di Pietro Longhi e di alcuni suoi quadri," *Emporium* (January, 1908), pp. 31-38. In recent writing, Longhi has been characterized as a mild chronicler of Venetian life with a bite less sharp than that of Goldoni: e.g. Pignatti in *Longhi*, 1969, pp. 10-12, and Michael Levey in *Painting in Eighteenth Century Venice*, Rev. ed. (Ithaca, 1980), pp. 147-148. In Ronald Paulson *Emblem and Expression* (Cambridge, 1975), pp. 108-114), Longhi's works are analyzed as satirical and somewhat comparable to Hogarth. Haskell (*op. cit.*, p. 323) raises the question whether Longhi ought not to be regarded as a reformer like Goldoni, especially since his patrons were for the most part "men who were anxious to look more steadily at the actual circumstances of Venetian life than was usual for the time." The most suggestive and thoughtful study of the Goldoni-Longhi relationship is Philip L. Sohm, "Pietro Longhi and Carlo Goldoni: relations between painting and theater," *Zeitschrift fur Kunstgeschichte*, CLV (1982), pp. 256-273. My own ideas owe much to Sohm's view that the artist and writer shared thematic and stylistic concerns. For other bibliography on the question, see Sohm, pp. 256-258.

80) *Componimenti poetici per le felicissime nozze di SS. EE. il sig. Giovanni Grimani e la sib. Catterina Cantarini* (Venice, 1750), p. LXXXVII: "Longhi, tu che la mia musa sorella / chiami del tuo pennel che cerca il Vero..."

81) Carlo Goldoni, *Tutte le opere di Carlo Goldoni*, ed. Giuseppe Ortolani (Verona, 1954), I, p. LI.

82) Carlo Goldoni, *The Comic Theater*, trans. John W. Miller (Lincoln, Nebraska, 1969), p. 67.

83) Quoted in Giuseppe Ortolani, "Appunti per la storia della riforma goldoniana," *La riforma del teatro del settecento* (Venice-Rome, 1962), pp. 50-51. My translation.

84) Heinz Riedt, *Carlo Goldoni* (New York, 1974), pp. 27-28.

85) Quoted in Vittorio Moschini, *Pietro Longhi* (Milan, 1956), p. 62. Written by the Venetian patrician in 1760. "Painter of natural gestures and speaking caricatures."

86) For the drawings, see also Terisio Pignatti, *Pietro Longhi dal disegno alla pittura* (Venice, 1975).

87) Frederick Antal, *Hogarth and his Place in European Art* (London, 1962), p. 135.

88) *Ibid.*, p. 204.

89) The drawings are reproduced in Pignatti, 1968, nos. 56, 58, 59, 60, 61.

90) It is interesting that Crespi's opera singer did not come to a tragic or violent end either. Her punishment, according to Zanotti, was that she became old and religious. Zanotti, *op. cit.*, p. 59.

91) Pignatti, 1969, p. 10.

92) Riedet, *op. cit.*, p. 22. An excellent example of Goldoni's interest in the interaction of the classes is *The Fan (Il Ventaglio)*: it juxtaposes bankrupt aristocrats, a middle-class pretender and the

gentry in a villa, the professions in a pharmacist, a merchant in a general store, the crafts in a cobbler, and the lowest estate in two peasants — a brother and sister.

93) A print by F. Bartolozzi after a painting by Longhi shows an opera singer with a patrician protector. The verse underneath reads:"*Per impegno, perforza e con dispeto / Cantatrice gentil studia la parte / L'assiste il protettor, ma men dell'arte / Che della sua beltà prende diletto.*" Illustrated in Pompeo Molmenti, *La storia di Venezia nella vita privata*, III (Trieste, 1973), p. 376.

94) Gregori (*op. cit.*, p. 50) claims that Ceruti's women sewing and women with children are types not portraits. This seems to me impossible given the vivid individuality of the faces.

95) I propose that the two scenes showing young women in a sewing circle in Ceruti's work (Gregori 51 and 55) are scenes in girls' orphanages.

96) *Ibid.*, p. 48, n. 233; also Manlo Dazzi, "Testimonianze sulla società veneziana al tempo di Goldoni," *Studi Goldoniani*, I (Venice-Rome, 1957), pp. 49-53.

97) *Ibid.*, pp. 50, 76-77. In 1719, the deficit ran 3,723,000; by 1740, it was 71,000,000. One third was spent on the military and one third on debt service. Taxes, naturally, kept going up.

98) O. Marini, "Qualcosa per la vicenda del Pitocchetto: I. I committenti bresciani del Ceruti: Il Ceruti nella galleria Avogadro," *Paragone* (1968), p. 58.

99) Marino Berengo, *La società veneta alla fine del settecento* (Florence, 1956), pp. 89-95.

100) Quoted in Camporesi, *op. cit.*, p. 123. "By God, we will not be safe in our houses in winter, if there is scarcity on the streets."

101) *Ibid.*, pp. 193-194. Muratori in *Della pubblica felicità* (*op. cit.*, pp. 234-235) devotes a long passage to the problem of the fraudulent poor and pilgrims who are motivated by "*birbanteria,*" and not by piety.

102) Robert Navarrini, "Overi e pitocchi organizzazione e istituzioni benefico-assistenziali," *Aspetti della società bresciana nel settecento* (Brescia, 1981), pp. 116-122.

103) *Ibid.*, p. 118.

104) Cited by Marino Berengo, *Giornali veneziani del settecento* (Milan, 1962), p. XXXVI from Gaspare Gozzi, *Osservatore Veneto*, ed. Spagni (Florence, 1914), pp. 199-202.

105) Quoted in Dazzi, *op. cit.*, pp. 75-76: "*Non abbiam più né forza né talento, / ogni nostra speranza è ormai sepolta, / guardate pelli secche e abbrustolite, / e giudicate poi di nostre vite. / E ver che andiam talora alla taverna, / perocché il vin sopisce col vapore, / quella disperazion che abbiam interna, / del stato nostra, stato di dolore; / che la miseria spegne ogni lucerna, / e degenera in vizio traditore. — Così diceàno i villan disperati / che anch'essi eran filosofi svegliati.*"

106) In his preface to the exhibition *I pittori della realtà in Lombardia* (Milano, 1953), p. XVIII, Longhi predicted that if an answer to these questions is ever to be attained, it will be by studying in depth the lives of Ceruti's patrons. Two studies by O. Marini make the first attempts with investigations of two families which collected Cerutis: O Marini, "Qualcosa per la vicenda del 'Pitocchetto' I. I combattenti bresciani del Ceruti; a) il Ceruti nella galleria Barbisoni," *Paragone* (1966), pp. 34-42; Marini, *op. cit.*, pp. 40-58. Mina Gregori's recent monograph goes further in suggesting that Ceruti's patrons regarded his subjects as socially significant. I owe my understanding to the situation to these writers.

107) For Cifrondi, see Paolo Dal Poggetto, *Cifrondi* (Bergamo, 1975). Dal Poggetto denies any real relationship between Ceruti and Cifrondi, seeing them as pulling in opposite directions, the latter to silence and solitude, the former towards protest (p. 391). However, influence and possible sharing of interests does not predicate identical feelings or intentions in two artists.

108) Gregori, *op. cit.*, pp. 36, 61, 67, 477.

109) *Ibid.*, p. 67.

110) Mina Gregori discusses these possibilities (*Ibid.*, p. 64) but warns that direct knowledge of the Le Nain was not very likely in Brescia, given that no paintings by the French painters are known

to have been in Brescia, and the first engravings do not date before 1771.

111) For Todeschini see Louisa Tognoli, *G.F. Cipper, il "Todeschini" e la pittura di genere* (Bergamo, 1976). Tognoli suggests (p. 26) that Ceruti may have influenced the older Todeschini in pauperistic works such as the *Woman with Begging Permit* (fig. 150). It is interesting that Todeschini also painted paintings for Marshal Schulenburg (p. 22).

112) P. Deyon, "A propos du pauperisme au milieu du XVIIe siècle. Peinture et charité chretienne," *Annales-Economies-Sociétés-Civilisations*, XXII (1967), pp. 137-153.

113) G.B. Carboni, *Le pitture e sculture di Brescia* (Brescia, 1760). For the collection of Mons. Giovanni Molino, see pp. 145-147. No Brescian painters appear in his collection. For the Palazzo Ugeri, see p. 158; for the Casa Gaifami, see pp. 148-152.

114) Mina Gregori's catalogue indicates eighteen paintings with Avogadro-Fenaroli connections.

115) Marini, *op. cit.*, 1968, pp. 44-45.

116) The lost painting is listed in Schulenburg's inventories 1741, 1747, Gregori, *op. cit.*, p. 118. Other portraits of Lodoli by Nazari, Alessandro, and Pietro Longhi are mentioned by Memmo, *op. cit.*, p. 85.

117) Memmo, *op. cit.*, pp. 77-78.

118) For the last will and testament, see Gregori, *op. cit.*, p. 102. For the Piacenza incident in 1744, *Ibid.*, pp. 111-112.

119) Memmo, *op. cit.*, p. 78.

120) Haskell's portrait of Schulenburg (*op. cit.*, pp. 311-312) is that of a "good old man," who liked girls, was nosy about other people's affairs, and was tyrannical and proud — yet he paid his artists well. The report of his "conscience" is given by Bettagno in Venice, 1983, p. 83.

Giovanna Perini

Luigi Crespi, a son of the famous Bolognese painter Giuseppe Maria Crespi, nicknamed "lo Spagnolo," was a real jack-of-all-trades. Among his various activities, ranging from priesthood to art historiography and from accountancy to painting, he was also an art dealer.[1] The social status of his customers varied dramatically, from Augustus III, King of Poland and Elector of Saxony, in Dresden, to the Cardinals Silvio Valenti Gonzaga and Neri Corsini in Rome, down to minor provincial collectors of prints and drawings, such as Filippo Acqua in Osimo, Domenico Morelli in Spoleto, and Tommaso Francesco Bernardi in Lucca, to name a few.[2]

For some time, his most assiduous customer in Turin was Gaetano Chiabrano, a well-known musician at the Court.[3] He would buy pictures not only to decorate his house, but also for speculation, although he was unwilling to admit to it. It is probably for this reason that in his letters Chiabrano often seems to be far more concerned with the format, size, grade of finish, and attribution of paintings than with their aesthetic qualities or even their subject matter.[4] On the question of subject matter, however, he gave some general guidelines in his first preserved letter, dated June 8, 1774:

I see that you wish to offer me some paintings by your father, whom I have always held in high esteem. Now I shall say that I will eagerly buy them, provided they are not religious paintings, for my rooms are already almost entirely paneled with this kind of subject. If I ever had to sell them, either because of need or because I should decide to do so, it would be very difficult to find a buyer. Meanwhile, I shall eagerly buy the two oval-shaped bambocciate on copper...[5]

For these bambocciate he was not prepared to pay anything above ten sequins, since they were "too small, and of a slightly inconvenient format." In his subsequent letter of June 29th, Chiabrano expressed his views on art trade and on art collecting in Turin:

I must inform you that selling paintings in this country is very difficult, especially if they are expensive, because, to put it plainly, they are not sought after at all. With reference to the Court, we are very unlikely to succeed in selling them any, for they possess hundreds of pictures of very good quality which they do not hang. You can be assured therefore that the paintings I am trying to gather are not for trade, but for my own use. As evidence of this, I will tell you that all the paintings I have bought are still with me, and if I needed to sell them, I should not obtain a half of what they have cost me.[6]

More details can be gleaned from other letters:

I can well believe that it is easier to find altarpieces than profane paintings, since here I can buy as many religious paintings of excellent quality as I wish. This is exactly why I beg you to be so kind as to send me as many of the other sort as possible — profane stories, I mean: provided they are not sketches.[7]

I acknowledge receipt of your information on the quality of their subjects. I am concerned because of the two half-lengths: here that kind of painting is not in favor. The same with the pictures of animals.[8]

It will be difficult to sell those paintings at your prices, especially the two with animals, first of all because they are too big, and secondly because they are not very alluring subjects for our dilettanti. Here they have some wonderful examples of that sort of thing which find no purchaser, save for some country house. The two pictures representing Music and Painting are too large. At present nobody buys paintings of that size. What is more, all those who have seen them (that is, all those to whom I have shown them) agree that they are not originals by your father, but copies made by one of his sons.[9]

We cannot identify the paintings Chiabrano is discussing, but it is likely that his doubts and those of the connoisseurs in Turin were correct, for suspicions about and positive rejections of Luigi's attributions were common enough among his lesser customers, especially when the author of a picture was purported to be either his father or Guercino, a painter lo Spagnolo had often copied.[10] As a matter of fact, we know that Luigi did not recoil from sending a *Shepherdess* allegedly by Giuseppe Maria, but probably by Luigi himself, as a gift for the king of Sardinia, to whom it was never forwarded by his courtiers because of their suspicions aroused by its mediocre quality. Furthermore, one of the Giuseppe Maria Crespis which was already in the king's collection and which had been sent by lo Spagnolo as a gift in 1742 is nowadays generally considered to be a workshop replica, probably by Luigi.[11]

Most of the pictures offered to Chiabrano (whoever their author was) were landscapes, townscapes, portraits, and genre pieces, but they seldom met with his approval, either because of their poor condition, or because they were copies, or because they had been ineptly restored, or because they were mere daubs. They all belonged, however, to what in eighteenth-century art terminology would have been defined as "genre."[12] Our narrower, present-day definition of genre can nevertheless be applied to at last a portion of them, such as Spagnolo's picture of "washerwomen and donkey" and another of "workmen at the press."[13] In many cases, the subject is not specified, and the paintings cannot be traced. Yet it is obvious that a biblical story centered on Laban would probably have been treated by Giuseppe Maria Crespi more in the manner of a genre work than a history piece.

The Venetian Francesco Algarotti pointed out in his *Essay on Painting* (1756) that lo Spagnolo lacked the sense of decorum which is essential to history painting, that is, that he kept confusing the styles of two different kinds of painting, serious history and comic genre, possibly because he was not well advised:

Had Spagnoletto of Bologna consulted with men of this character [men of letters], he never would have represented, as he has done in a picture he drew for Prince Eugene, Chiron about to give Achilles a kick for not taking a good aim.[14]

Luigi could hardly reply to these charges. In his first published version of his father's life (a biography in disguise, for it was published as a letter addressed to Bottari in the third volume of his *Raccolta di lettere sulla pittura, scultura ed architettura* printed in 1759),[15] he ignored a similar remark. Ten years later, however, after Algarotti's death had put a brusque end to his relations with the Venetian, Luigi viciously attacked him in the new version of his father's biography published in his *Felsina pittrice - Tomo terzo*:

[lo Spagnolo] represented Achilles who, missing the target, was scolded by his instructor in a way that uncouth people would naturally use, that is, showing the Centaur about to kick him. This is a most pleasant invention, a new, natural and lively one. However, certain critics who criticize everything to show off their connoisseurship have found it distasteful...[16]

Luigi's text was also obviously an indirect reply to Giovan Pietro Zanotti, one of Algarotti's best friends, who had been the first to observe in his *Storia dell'Accademia Clementina* (1739) how lo Spagnolo's invention for this painting had been "in low taste, but new, its beauty being only in the graceful manner in which it was painted."[17] However such opinions may have inspired Luigi's indignation and resentment, Algarotti's low esteem for genre painting in general and Crespi's in particular is also very apparent in his own art collection and in another of his texts published as late as in 1792 (in the eighth volume of the Polese edition of his *Complete Works*): in his *Progetto per ridurre a compimento il Regio Museo di Dresda*, presented to Augustus III on October 28, 1742, Algarotti gave some advice on how to build up an outstanding collection of modern art.[18] Unlike Boschini's a century earlier, this project was most earnestly conceived as an imaginary gallery sooner or later to become a reality.[19]

In his projected gallery for Augustus III, Algarotti listed a number of contemporary painters and suggested one or more titles for pictures by each of them which he thought would be particularly suitable to their talents. In some cases he even added complete, detailed inventions to be executed by the artists. His choice of painters is extremely interesting: Pittoni, Piazzetta, Tiepolo, and Balestra were an obvious tribute to his native region; Boucher and Van Loo an homage to the international art world; the Neapolitan Francesco De Mura and his master Solimena were representatives of the greatest eighteenth century Italian school after the Venetian one; the comparatively modest Francesco Mancini was included as an acknowledgement of the albeit declining fame of the Roman school; finally, Donato Creti and Ercole Lelli represented the two most important, even if opposite, trends in contemporary Bolognese art. The very choice of these two latter painters evidently implied some sort of negative judgment of the activity of the other major Bolognese

painter, Giuseppe Maria Crespi.

All these artists were expected to contribute history paintings whose subjects came from Greek and Roman history or mythology, so that even Piazzetta could not show off his Crespian valences. As for the lesser genres, Zuccarelli was to be asked to decorate his landscapes with mythological events, and Pannini was to be required to portray real Roman buildings. The overall tone of graceful Rococo classicism seems to account for some major exclusions, both of painters (the Riccis, Canaletto) and of genres (still lifes, *vedute*, genre pieces).

Another Italian adviser of Augustus III was the Bolognese physician Giovanni Ludovico Bianconi.[20] Both in Dresden and, later, in Rome he was to be the strongest supporter of a more orthodox neo-classic revival based on Greek models. The somewhat tormented, ambiguous romantic neo-classicism created and fostered by the Venetian Giovambattista Piranesi, who took inspiration from the extraordinary magnitude of the architectural Roman ruins, was for Bianconi a hideous heresy to be eradicated at any cost. No doubt about this is left by the biography he wrote of Piranesi, first published by installments in a literary periodical he had founded, the *Antologia romana*, in 1779.[21] While discussing the artist's early training as an academic painter, Bianconi displays the full force of his terrible sarcasm. In order to strike in one blow both the dead painter and genre painting as such (in both the present-day and the eighteenth-century sense of the term — that is, both in its strong and in its weak sense), he adapted a passage from Bellori's Life of Caravaggio and turned it into a sarcastic caricature:[22]

Instead of studying the nude or the most beautiful statues of Greece that we have here, and which alone provide the only true way of learning, he started drawing the most ramshackle cripples and hunchbacks he could find in Rome during the daytime, for Rome is always the most charitable lodger of every most elegant item of this sort in Europe. He also enjoyed drawing legs covered with blisters, broken arms and faulty bottoms. Whenever he found such an exhibit in a church, he felt as if he had found a new Apollo Belvedere or a new Laocoön. Therefore he would immediately run home to make a sketch of it (...). When he wanted to upgrade himself and reach almost heroic levels, he protrayed edible stuff, such as a piece of meat, the head of a pig or of a kid. It must be confessed however that he could represent this sort of thing marvelously well.[23]

Piranesi as a genre painter is virtually unknown; nor, according to the extant published documents, is Venice the best area to find records on and evidence of the diffusion of genre painting (in its strong sense), either in private collections or in workshops. Despite this, Rodolfo Pallucchini has strongly made the case for a widespread presence of genre pieces in Venetian art collections by the second half of the seventeenth century.[24] Pallucchini applies the weak, that is, the eighteenth-century concept of genre, however, and not the presentday one. If going through inventories

we exclude landscapes, *vedute*, portraits, and battle scenes, we are left with very little indeed, for in the seventeenth century only two collections can be singled out as possessing enough genre pieces (in the strong sense of the phrase) to justify his assertion: they are Gasparo Chechel's (inventoried in 1657) and Giorgio Bergonzi's (inventoried in 1709, but formed in the previous century and already known to Ridolfi).[25]

Gasparo Chechel was apparently a foreigner, possibly from the Low Countries, since most of the paintings in his collection were Flemish.[26] As for Bergonzi, his family of silk merchants was originally from Bergamo, a provincial town then in the State of Venice. Both his social status and his geographical origin explain very well the reason why he did not share the preference for sixteenth-century religious and history painting that was typical of the Venetian aristocracy.[27] Out of a total of 459 pictures, he possessed only 28 genre pieces, including two pictures attributed to Pieter van Laer, 14 Flemish or Dutch ones, two by Domenico Fetti, and three by Matteo de' Pitocchi.[28] Only 6.2 percent of his collection was therefore devoted to genre: however low this percentage is, it is nonetheless one of the highest among the inventories of Venetian art collections published by Simona Savini Branca and Cesare Augusto Levi.

It is unfortunate that Levi's edition of eighteenth-century Venetian inventories is neither thorough nor very accurate, so that the information we can gather from his book can scarcely be considered reliable.[29] Nevertheless, it is interesting to observe from this source that at virtually the same date as Bergonzi's inventory (1708), Francesco Querini, a member of the Venetian aristocracy, possessed 25 genre pieces in a collection which was half the size of Bergonzi's.[30] In 1785, however — that is, almost 80 years later — another Querini, Antonio, possessed only 21 anonymous genre pieces out of several hundred pictures.[31] In the meantime, at least two major Venetian painters, Pietro Longhi and Giovan Battista Piazzetta, had devoted a smaller or larger share of their activity to genre painting, but, extraordinarily enough, this fact does not seem to have deeply affected Venetian art collecting as a whole.[32] While most of the paintings of this sort listed in the eighteenth-century inventories published by Levi are anonymous, those which do bear the name of an author belong to Bassano, Matteo de' Pitocchi, Joseph Heinz, or some other Flemish or Dutch painter. Longhi's name never occurs; Piazzetta's does only once, in the house of Alvise Morosini in San Cassian (1756).[33]

Despite Piazzetta's activity as a genre painter, he was better known for his religious and history paintings and for his position in the Venetian academy. Even so, Luigi Crespi omitted to list both his name and Pietro Longhi's among Giuseppe Maria Crespi's students.[34] In a sense, Piazzetta's inclusion would have indirectly confirmed and enhanced Crespi's reputation as a universal painter (not just a genre one), and as a good teacher with a successful school. Pietro Longhi could have been of little use to this end, because his activity consisted mainly in Modern Moral Subjects or Comic History Paintings, to borrow from categories used to describe Hogarth's work. He practiced a very special kind of genre painting: instead of depicting the miserable conditions of the contemporary Italian country — or town — *Lumpenproletariat*, Pietro Longhi portrayed the social life of the Venetian upper classes with an objective eye. This was closer, if anything, to Goldoni's than Parini's view of society, for like Goldoni (though less often than he), he too might be critical, but was never indignant. He was obviously too delicate to share Hogarth's bold, mocking criticism of contemporary society and to turn it into scraping sarcasm. Nevertheless, the influence of English and French prints on his work (especially those after Hogarth and Watteau) has often been suggested.[35]

On the contrary, Longhi's son Alessandro stressed the novelty of his father's themes and their fortune in contemporary collections; he also correctly emphasized the importance of his apprenticeship in Crespi's workshop, which had been first remarked by another student of Crespi's, Pietro Guarienti, in his edition of the *Abecedario*:[36]

Pietro Longhi, Venetian, was born in 1702, the son of a silver founder who, seeing him model, fostered his inclination and encouraged him to draw. He then had the good fortune to be aided by Antonio Balestra of Verona, the famous painter, who after several years sent him to Bologna with a recommendation to Giuseppe Crespi called the Spaniard, also a famous painter; and after several years of study he returned to Venice: but seeing that it would be difficult to distinguish himself as a painter of History, he altered his aim, and being a whimsical and brilliant spirit he set about painting small pictures of everyday matters such as conversations and entertainments; with scenes of love and jealousy which, since they were faithful portrayals of reality made a great impression. He then painted also pictures of masked figures which were so realistically depicted in their natural attitudes that they were recognisable even behind the mask. And as this was a way not trodden nor sought by any before him, it gave great pleasure, so that his paintings are desired not only by all the patrician families but by whomsoever esteems singular works of art; and thus they are sent even to the courts of Europe; and because the same merit is apparent also when they are printed, they are engraved on copper by the most famous engravers. He lives at home in Venice, applauded and loved by all the Venetian nobility.[37]

Until a new, systematic study of Venetian art collections in the eighteenth century is carried out, it will be difficult to supply documentary evidence to corroborate Alessandro Longhi's statement. It is unfortunate for the historian today that in a city like Venice, where art collecting had a longstanding tradition and where the first systematic record in

Italy of the contents of private art collections can be found (Michiel), no eighteenth-century written source (be it published or manuscript) is known that provides a detailed overall survey of local private collections. Naturally enough, references to important collections in guidebooks are too brief to give us much of an idea of the contents of a gallery. In the first place, guidebooks tend to mention frescoes rather than easel paintings for the very obvious reason that frescoes are more permanent in their locations. Secondly, such books generally record only the masterpieces in a collection or the group of choice pictures which best represents its character.[38] Citations of pictures in private hands occurring in biographies of artists are also too occasional to be very helpful in a quantitative study. These general remarks are valid not only for Venice, but also for virtually all the North Italian cities that will be dealt with in this essay (Turin, Genoa, Milan, Brescia, Bergamo), with the notable exception of Bologna, where some manuscripts by Marcello Oretti provide a general, though incomplete, survey of the aristocratic and bourgeois collections in the city in the second half of the eighteenth-century.

Nevertheless, there were at least two eighteenth-century collections in Venice on which we are definitely well informed: they both belonged to foreigners, the English Consul Joseph Smith and the German Marshal von Schulenburg. As for the former, it is very difficult to have a precise idea of the whole of his collection, since no exhaustive catalogue exists. According to what can be gleaned from the extant partial catalogues and inventories, however, it seems that he possessed only 11 genre pieces out of 374 Italian paintings. These included two "character heads" by Rosalba Carriera and two by Giuseppe Nogari, a painting by Grechetto with animals and shepherds, a "concert" by Bernardo Strozzi, three pictures by Pietro Longhi — two of which must have belonged to his early years, for they represented pastoral subjects (A Shepherd with a Girl and A Spinning Girl) — and two paintings by Magnasco showing religious ceremonies taking place in a square. The proportion of genre pieces was much higher in Smith's collection of Flemish and Dutch paintings: there were 38 out of a total of 149.[39]

As for the Marshal, he certainly possessed quite a few genre pieces in the eighteenth-century meaning, including many battle scenes, as would be expected. If we take into consideration the strong sense of genre only, however, it is important to observe that Schulenburg was the patron in Venice of Giacomo Ceruti, considered nowadays as the most famous and possibly the greatest genre painter of his time.[40] Oddly enough, no contemporary printed source gives any biographical or critical account of this painter.[41] Despite earlier partial rediscoveries, the credit for placing Ceruti in the limelight of today's critical esteem is Roberto Longhi's, who in his exhibition on "The Painters of Reality in Lombardy" (1953) raised some fundamental questions on the central issues of Italian genre painting in general and on Ceruti's in particular. After observing that the subject matter of Ceruti's paintings is the poor, "that very populace that will seem irredeemable even to the intelligentsia of Enlightenment" (like Voltaire), he made some further remarks that it is perhaps worthwhile quoting at length:

At that date (1760) Ceruti had already portrayed them [the poor] without a hint of irony, without any bumptious detachment. On the contrary, he showed humane sympathy that seems to be a miracle not only for the standards of those days, but even for today's. All this, mind you, was not painted in those small pictures only a few inches high, that might easily have gone unobserved as minute furniture in a sitting room: it was on enormous canvases, with life-size figures, as if the painter thought he had discovered the most important subjects in the world (...). I cannot tell who and how many were the patrons for his big canvases. For sure, they cannot be found amongst beggars and washerwomen. Some years ago I happened to suggest that 'the great and serious Ceruti had been compelled to entrust his masterpieces on popular life to the entertainment of the Brescian noblemen in their villas on Lake Garda.' Nowadays I do not feel that such a hypothesis does justice to the possibility and likelihood of a relationship between Ceruti and his patrons. Entertainment, great fun indeed! For here it was not a matter of buying condescendingly some small painting every now and then from an extravagant painter (and yet a talented one!). It rather meant filling up houses in town and in the country with these scornful gigantic memoranda.[42]

After ruling out the possibility that Ceruti's fortune depended on the lure of his brushwork — in fact it lacks both polish and sensuous appeal — Longhi states:

If we ever manage to obtain a truthful answer, it will be the fruit of steady research on the events and most hidden feelings of society in Brescia in the eighteenth century: provided they will not be supported by class abstractions, but by the rediscovery of sure facts and living characters (were it even only one person).[43]

After over thirty years, Italian art historiography is still revolving on the same questions; yet, in the meantime, some partial answers have been found. We now know the names of some of Ceruti's patrons: Schulenburg in Venice; Don Giulio Barbisoni, Luigi Avogadro, and possibly Pietro Lechi in Brescia; Pier Maria Scotti in Piacenza. It is not a distorting sociological abstraction to point out that they were all noblemen and that, be they famous warriors or peaceful landowners, none of them was known as a radical — rather the contrary.[44] We also know that Ceruti's paintings in the Avogadro collection were hung partly in the Countess's boudoir and partly in the flat for the guests: surprising settings indeed![45]

It is well known how desperate the situation of the poor was, especially in the Lombard countryside, in the years when Ceruti was active. In this context, it is significant to note how well paid the artist was for his

pictures, even better than the famous portrait painter Fra Galgario. His paintings in Brescian and Piacentin art collections were also more highly valued than Tintorettos and Romaninos. We know that the godfathers of some of his children were noblemen. Thus, he can hardly be described as a bohemian. Even Ceruti's itinerary from Milan to Brescia to Venice, Padua and Piacenza, and back to Brescia and Milan, was suggested more by the events of war (the Succession Wars of Poland and Austria, fought also on North Italian battlefields) than by some romantic wandering instinct of his supposedly restless soul.[46] From these facts we should be able to draw some valid conclusions and begin to suggest some tentative answers to the longstanding questions: was it a form of Christian charity, or social concern, or perhaps of enlightened morality that led Ceruti's patrons to support him, or was it rather fear and contempt, exorcism of perceived impending social upheavals, or,

even worse, a pure sadistic pleasure? Were Ceruti's patrons sympathetic to the cause of the poor, or did they feel relieved and even cheered by a comparison between their own lot in life and that of the poor? On the one hand, Roberto Longhi's followers have tended to opt for the first set of conclusions, adhering for the most part to a somehwat romantic and certainly very ennobling interpretation of art and social history in which Ceruti becomes a harbinger of Courbet. A promising and original contribution to this point of view is Mina Gregori's recent suggestion of possible intriguing relationships between Ceruti's patrons and the fortunes of certain heterodox religious currents in Brescia, such as the Erasmians and the Jansenists. This opens up a possible level of understanding that is deserving of further study, and it must be hoped that some more conclusive evidence can be gathered in its favor.[47] On the other hand, Luciano Anelli, in his book on Antonio Cifrondi and Giacomo Ceruti, and Pier Luigi Fantelli, in an article on the seventeenth-century

67. *Giacomo Ceruti.* Two Beggars. *Pinacoteca Civica Tosio Martinengo, Brescia.*

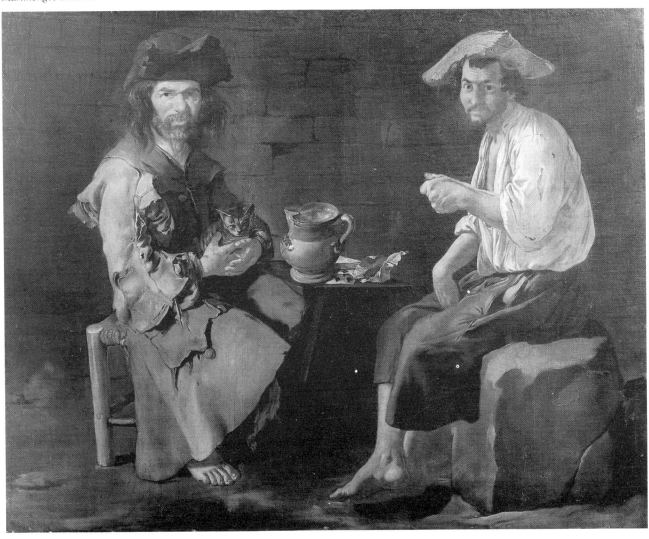

81

Paduan genre painter Matteo Ghidoni, called "de' Pitocchi," dismiss any social concern on the part of the artists' patrons and emphasize the traditional *satira del villano* to explain the significance of the works they illustrate. Even if their statements sound equally biased, they may be somewhat closer to truth.[48] It must be agreed that both Pietro Lechi in Brescia (who possessed 19 pictures of peasants and beggars in his two houses in the country) and the Ferris in Padua (who first patronized Ghidoni, and, some decades later, Ceruti) were busy achieving rapid economic growth and social self-promotion: it is hardly likely that they harbored much concern for their peasants, who were just necessary tools for their aims. No evidence survives to prove that the Avogadros were more tender-hearted; as for Giulio Barbisoni, his being a member of the clergy may not have led to any more benevolent a social attitude than the prevailing one.[49] Even without mentioning the considerable documentary evidence found in popular and literary texts which has been collected and used by Pietro Camporesi, and even without referring to the lamentable state of the Italian countryside as reflected in eighteenth-century agronomical studies, art literature provides examples that are quite to the point.[50]

In 1685, a member of the ducal court in Mantua, hiding himself under the penname of Albino Arpaio, explained the allegorical meaning of a painting by Pietro Bellotti (*Lachesis*) which in modern times has been considered "the portrait of an old peasant woman with the attributes of some mythological personification of the classic world" and a good example of "caricaturized realism."[51] Albino Arpaio, who simply put on paper what Bellotti had explained to him ("as soon as you explained to me verbally and in writing the above mentioned emblems..."), tells us instead that the picture is in fact the portrait of an old jolly at the court and was meant both as a jest at her and as the carrier of a deep moral truth, because it is an allegory of the frailty and unhappiness of the human condition.[52] One of the symbols she carries is a reed around which three threads (a woolen, a golden and a silver one) are twisted, as if it were a spindle. The threads represent the three different social and ethical stations of men: the poor (the woolen thread), the heroes (the golden one), the rich (the silver one).

The first thread is straighter and higher, but thicker than the others, to suggest that a poor man has no worries, nor the doubts that haunt the minds of others, for he has no chance of interfering with the aims which are most sought after by men of some status. Since Poverty leaves no room to ambition, she makes men live in rectitude, which cannot be preserved amidst riches (...) Poverty is a solace to the soul, for she takes it away from those fears to which all the rich are subject (...). If the above-mentioned woolen thread is thicker than the other two, as I have already pointed out, this is only to suggest that the poor generally have much less subtle and penetrating minds than the rich: either

because they are made with less refined clay, or because what they eat generates much less pure blood, or because they have no chance of becoming subtler by attending schools or reading books or meeting learned men; or finally because even if they had the brains of Aristotle, the scarcity of their means would be a big obstacle to their promotion in the public opinion.[53]

While extolling the abstract, Arcadian aspects of Poverty, as if they were a perfect blessing, this passage cannot hide the intellectual and moral contempt for the poor which comes to the surface here and there. It is hard, indeed, to make such an outlook agree with the twentieth-century art historian's characterization of Bellotti's "programmatic naturalism," "crude realism," "desecration of classical myths," or even with the title of "painter of reality" deeply concerned about, if not sympathetic to, his models.[54] Bellotti is not Ceruti, of course, nor is mid-eighteenth-century Northern Italy the same as the late seventeenth-century one (after 1710, for instance, Mantua was ruled by Austria and, in 1714, Lombardy was handed over from Spain to Austria, so that in 1737 Mantua officially became a part of Lombardy), but very little, if anything, had changed in the social and economic structure of the country, or in the attitude of aristocracy towards the poor and the laborers.[55] It was to the ranks of town aristocracy and landed gentry that most art partons and collectors belonged: although there were quite a few bourgeois art collectors, Italy was by no means comparable to seventeenth-century Holland.[56]

The origins of genre in Italy can be traced back to the International Gothic and the splendid autumn of Feudalism, when Michelino da Besozzo created a genre work with comic overtones in the late fourteenth century.[57] Genre survived in tapestries throughout the fifteenth century and flourished again in painting in the sixteenth century, during a period of refeudalization: thus the development of genre can be seen as closely linked to crucial moments in the history of the aristocracy.[58]

We often know little or nothing at all of the original purchasers of the famous extant genre works of the sixteenth-century artists who are often viewed as the precursors of modern genre painting — Campi, Passarotti and Carracci. Nevertheless, relying on documents and literary sources, we can safely conclude that these painters who reintroduced genre in Italy did not have the kind of social awareness that we associate with post-industrial societies. Bartolomeo Passarotti was concerned with one social problem only — his own social status: he tried to behave like a gentleman, gathering and boasting of a precious art collection. Annibale and Agostino Carracci, who were less concerned with their own social status and decorum and who loved making rude jokes, found it funny, for example, to evacuate in the boots of sleeping peasants.[59] Vincenzo Campi, moreover, painted five pictures with greengrocers and

fishmongers for the German banker Hans Fugger, in which sexual rather than social implications are detectable, and it has been suggested that the same is possibly true for Annibale's *Butchers*.[60] Even taking into consideration eighteenth-century North Italian genre painters, there is no doubt that artists like Todeschini, Cifrondi, Crespi, Beccadelli or Gambarini reveal an ironical, satirical or, at best, patronizing, rather than sympathetic, attitude towards their subjects.[61]

If, therefore, we are not misreading Ceruti's sympathetic concern for his models, it must be admitted that it was virtually unique among his contemporaries and was probably not shared by his patrons, who very likely misapprehended his intentions. Whatever their real feelings were, it was surely they rather than the painter himself who were interested in images of beggars and tramps. Ceruti's originality, therefore, requires some further comment. Ceruti's iconographical sources have been admirably treated by other scholars. It should be emphasized here, though, that the Spaniard Murillo was one of them. Some decades later, Murillo's genre works also inspired those of the English painter Thomas Gainsborough: thus the very same source engendered

two completely different results. Gainsborough's representations of tattered English children are suffused by a somewhat mannered sympathy. His English peasants tread or plod or ride or drive in the dark side of the English landscape, whereas Ceruti's beggars and laborers stand towering in the often sunny center or foreground of his pictures.[62] Since quite a few of them were *soprafinestre* (paintings to be hung over the window high up on the walls), their general effect must have been somewhat less impressive than it is nowadays, when pictures are displayed at eye level according to modern museological criteria.[63]

The jug on the small table between the *Two Beggars* in the Tosio Martinengo Gallery in Brescia, for instance, has been drawn with a blatant mistake in perspective (fig. 67). If this picture was ever a *soprafinestra* or *soprabalcone*, its original, high location might have corrected in part its overturning effect. The fact that other "painters of reality" like Todeschini indulged in similar perspective mistakes does not alone explain Ceruti's fault, however: it only goes to prove how ambiguous and probably misleading it is to label these painters as realists.[64] What modern installation practices have changed most about the *Two Beggars*, however, is the painting's psychological impact. If the picture were

68. Alessandro Magnasco, Synagogue. *Uffizi, Florence.*

placed in its presumably original location at a certain height on the wall, the two mendicants would simply have looked down upon the beholder with a forlorn gaze, instead of confronting him in a distant, eye-to-eye look suggestive of reproach and defiance. Looking up, the noble owner (possibly Giulio Barbisoni at first, certainly Paolo Brognoli later) would only have met the blinking eyes of the harmless kitten resting in the lap of the beggar on the left.[65] A further implication of the painting's original location would be that the image of the two men would simply have mirrored the actual poor men down in the street, sitting opposite the same window or balcony. Such a dialectical relationship should suggest that what was customary, taken for granted, and hardly disturbing in everyday life could scarcely affect or upset the aristocratic collectors when they viewed it imitated on canvas.

Examining closely Ceruti's amazing reportory of hopeless dropouts, we find a few more hints that lead us to question the current notion of his realism: for instance, at the 1953 exhibition, there was the image of a tired and tattered peasant leaning heavily on the handle of his spade in front of a poor house.[66] Despite all his weight, he cannot make the tip of the spade pierce the ground, as if the soil were as hard as ice. When compared to George Stubb's notorious, smartly dressed and shod *Reapers* and *Haymakers* of 1785,[67] it should probably be deduced that Ceruti's "reality" is more apparent, but not necessarily truer. Ceruti's message is not the same, of course, for his ambiguity and ambivalence towards his subjects are not confined to the visual details or content of the works, but are invested in their function as well. The *Sitting Beggar* which was once part of Paolo Brognoli's collection is a case in point: his raggedy cowl suggests that he is a mendicant friar, probably a Capuchin.[68] It is telling, however, that modern eyes tend to overlook this suggestion. The problem is once more what the owners of such a painting would read in it. Was this image a serene praise of evangelical poverty, an evidence of the very sad contemporary situation of their own country folk, or rather, as I tend to suspect, a warning against the devilish deceptions by which tramps and dropouts of different sorts survived? Would they not be reminded of the contents of those seventeenth-century treatises on tramps and beggars which were so often reprinted

69. *Alessandro Magnasco*, Gathering of Quakers. *Uffizi, Florence.*

well into the nineteenth century and which exposed all their deceptive techniques and tricks, including camouflage as mendicant friars, which was typical of the *affrati*?[69]

On the other hand, the Capuchins — the true ones, with clean, tidy cowls — were a fashionable subject for genre and certainly one of Alessandro Magnasco's favorite ones. The Genoese Magnasco was easily the most original and gifted genre artist of his time. Unfortunately, Lanzi's misleading equation of Magnasco and Cerquozzi does not lead to a correct appreciation of the former's merits, aims or style, for the only element they shared was the great vogue they had in Italian private collections.[70]

Unlike Ceruti's, Magnasco's fame was widespread in his lifetime, and his works were actively sought after, both in the North (from Milan to Genoa and from Turin to Venice) and in central Italy (Florence). Unlike Ceruti, a lot is known about Magnasco through contemporary literature. Unlike Ceruti, his direct concern with religious and ethical reform is clear, although it was probably confined to a small, elitist circle of still unknown patrons.[71] This concern does not affect the bulk of his production, which includes the usual gatherings of gypsies, soldiers, beggars, and tramps in the streets and squares of some Italian town or in the woods invented for him by Peruzzini, Spera or Tavella. According to Carlo Giuseppe Ratti, who was later on paraphrased by Lanzi, Magnasco was particularly renowned for his graceful representations and whimsical inventions of convent schools with young girls busy learning or doing needlework; hermitages of Carmelite or Carthusian monks who scourge themselves or do other acts of mortification and penance; chapters of friars, religious processions, monks in a library, missionaries who preach; robbers who assault travelers; shops of barbers, knife grinders, carpenters and similar artisans; urchins playing; quacks who show magic lanterns to children; guardrooms with soldiers who do military exercises or practice mechanical arts and the like. But his favorite subject matter, which he often had to repeat, was the Synagogue of the Jews [cf. fig. 68].[72]

Despite being a friend of the neo-classicist Mengs, Ratti was a sympathetic and appreciative critic of Magnasco's work, possibly because he was the son of a minor genre painter, Giovan Agostino Ratti, who made a name for himself as a painter and engraver of *pulcinellate*, that is, of pictures featuring Punchinello, more or less in the same years when Gian Domenico Tiepolo drew and painted his carnival scenes full of Punchinellos.[73]

Notwithstanding his taste for Magnasco, Ratti failed to mention the typical pendants of the painter's Synagogues, namely the Gatherings of the Quakers (e.g. fig. 69). It has been argued that the diffusion of these themes was related to the little-studied underground currents of enlightened libertinism officially persecuted by the Catholic church. It has also been stated that Magnasco must have relied on Dutch engravings, both for the Quaker scenes and even when allegedly portraying the Synagogue in Livorno, since the Catholic grand dukes of Tuscany had organized a strict apartheid regime.[74]

Magnasco's skilled, refined and mannered brush was totally innocent of realistic concerns, yet it managed to make an important contribution in a crucial battle for new ideas under the pretext of fiddling with a new and peculiar theme in genre. No wonder, therefore, that the very conservative aristocracy of his native city (Genoa) did not feel very attracted by his work, much to Ratti's chagrin.[75] Although some Magnascos must have belonged at least to the richest

70. *Alessandro Magnasco,* Party in a Garden at Albaro. *Palazzo Bianco, Genoa.*

collections in town (where else can the splendid *Party in a Garden at Albaro* (fig. 70) have come from?), the total absence of his name in Ratti's detailed guidebook of Genoa is further evidence of how little this artist was thought of at home. This is indirectly confirmed by the archival inventory of the collection of Giacomo Filippo Durazzo, a member of a most rich and powerful family in Genoa which included some well-known connoisseurs like Girolamo, to whom the second edition of Ratti's guidebook was dedicated.[76]

This is all the more remarkable because genre painting (in the weak sense of the phrase) is known to have been very popular in Genoa, due to the city's longstanding commercial contacts with the Netherlands and its cultural relations with Venice; yet scenes of everyday life (genre in its strong sense) were not particularly favored, as a quick glance at Ratti's guidebook proves. All the major Genoese collections are mentioned there, and abridged catalogues given. Very few genre paintings are recorded, but since no list of paintings is complete and genre works occur only in the most detailed ones, it is obvious that also in Genoa genre was regarded as hardly representative of the highest quality of a collection. Ratti mentions 12 galleries that contain at least one or two genre works. These belong to various branches of the Gentile and Durazzo families and to members of other noble families, such as the Spinola, Balbi or Brignole. The artists mentioned are local seventeenth-century painters like Luciano Borzone, Domenico Fiasella, Bernardo Strozzi, and Sinibaldo Scorza, or Flemish painters like Cornelius De Wael, who settled down in Genoa for fifteen years, or David Teniers, by whom Giovan Battista Cambiaso possessed "a painting with a great many little figures representing a kermis in the country (...) This is one of the most beautiful and rare pictures by this author. It is extremely difficult to find one that can match it."[77] To finish the list of the artists, a handful of anonymous painters, Caravaggio and some Caravaggesque adherents (Bartolomeo Manfredi, Jusepe de Ribera) should be added.[78] This quick survey indicates a preference for an entertaining kind of genre, completely removed from any contemporary social, ethical or religious concerns, and where strictly pictorial values are more important than matters of content. It certainly cannot be a coincidence that no living painter is recorded. This choice is almost as symbolic of the attitude of the Genoese oligarchy towards social problems as was the secluded location of the huge building for lodging the poor which had been erected outside the old city walls. In Turin, the capital of the neighboring kingdom of Sardinia, the trends in art collecting must have been slightly different. Despite Chiabrano's biased point of view reported at the beginning, it is often assumed that genre was thriving, especially insofar as landscapes and scenes of crowded markets and

squares were concerned. At the end of the century, Lanzi could draw the attention of his readers to at least one successful local painter of bambocciate, Domenico Olivieri: "In the galleries in Piedmont his pictures with funny caricatures after Van Laer and other good Flemish painters are well known."[79] Moreover, Lanzi knew vaguely of the existence of a follower, Giovan Michele Graneri. Also, Count Felice Durando di Villa had already remarked on Olivieri's whimsy and the apparent Flemish influence on his works, a fact that Lanzi placed in relation to the royal acquisition of Prince Eugene's prestigious collection, so rich in Flemish paintings in general and genre works in particular.[80] It should be noted, however, that Prince Eugene's collection had been bought in 1741, whereas Olivieri had already been summoned to the service of the court in 1724.[81] His payments, especially for works in the castle of Rivoli, continued until 1753.[82] It is obvious, therefore, that his "Flemish" style derived from different sources: it should never be forgotten, for instance, that Jan Miel had lived in Turin from 1659 until his death in 1664 and had worked for the court.[83] Although it is generally assumed that Miel's activity in his last years concentrated on the higher genres (such as history, mythological or religious painting), Alessandro Baudi di Vesme observed in his survey of art in Piedmont that "in Piedmont many private families possess easel paintings by Jan Miel: those that I have seen look as if they had been done in Rome instead of Piedmont."[84] This means that Piedmontese collections included bambocciate, for the association with Rome is more likely to refer to the nature of their subject matter than to their style. It is indeed significant that among the very few genre works listed by Francesco Bartoli in the first volume of his *Notizia delle pitture, sculture ed architetture d'Italia*, where he describes Turin and Piedmont, there were some by Jan Miel and by Domenico Olivieri in the possession of the royal family.[85] (Other artists whose genre paintings are mentioned are Gerrit Dou, Jacopo Bassano — who is usually considered the founding father of pastoral genre — and the Genoese Grechetto, another painter devoted to the pastoral mode.)[86]

The popularity of genre in Piedmont is further proved by the products of local china manufacturers, who made quite a few small statues of peasants, chimney sweeps and other artisans. These objects met with a considerable success, so as to be copied later and produced in England as well during the nineteenth century.[87] Such widespread popularity depended on the lighthearted, entertaining aims of genre in Turin, where, significantly enough, landscape was the most appreciated and widely practiced kind of painting, though at an amateurish level.

The situation and intellectual atmosphere in nearby Lombardy was quite different: there had always been thriving centers there for the production and

collecting of genre painting, both in the Austrian (Milan, Cremona) and in the Venetian (Bergamo, Brescia) parts of the state, since at least the time of Michelino da Besozzo and, later on, Vincenzo Campi. The case of Milan is particularly interesting, as a number of facts suggests. It has recently been discovered that Giacomo Ceruti was from Milan; the Milanese nobleman Francesco Londonio was also a minor genre painter who deserves at least a mention for his Arcadian interpretation of genre, even if in Lanzi's *Storia pittorica* he is registered only as a painter of animals. Last but not least, the Genoese Alessandro Magnasco found his patrons and a small number of followers in Milan: their names can be gathered from his *Life* by Ratti. Among his patrons, it is worth recalling aristocratic families like the Arese and the Casnedi, and a middle-class collector, the postmaster Ignazio Balbi.[88]

The Arese patronage of Magnasco is confirmed by the eighteenth-century inventory of Giovanni Francesco Arese's collection, where 23 pieces by him are listed, together with other genre works by Salomon Adler (Fra Galgario's master), Leandro Bassano, Lucas van Leyden, Daniele Crespi, Michelangelo Cerquozzi, Giovanni Benedetto Castiglione, and David Teniers. It is possible that Arese's short stay in Flanders as a military commander (1679-1680) contributed to excite or confirm his interest in genre.[89] It is clear, however, that in Milan, as in Genoa, close trade and political relations with Flanders must have encouraged the diffusion and evolution of genre painting.[90] As in Genoa, also in Milan very few published records of noble collections are available.

In his 1787 guidebook of Milan, the Bolognese Carlo Bianconi, following the example of earlier guidebooks of his native city, supplies the name of the principal galleries, scattering them amongst the various churches. The works of art treasured in these collections are hardly ever mentioned, partly due to Bolognese tradition (paralleled in Milan by equally reticent guidebooks by Lattuada and Gallarati) and partly because of the practice of making detailed descriptions of the collections readily available to visitors on the premises.[91] However, even when one or two choice paintings from a gallery are recorded, their selection follows neo-classical criteria or adheres to the interest of local historiography: Mantegna, Leonardo and his followers, or Mengs are among the artists often mentioned. Given the (neo)classicist contempt for genre, it cannot be expected to find references to such paintings.

While most of the printed and manuscript catalogues of collections which Bianconi mentions have long disappeared, a few archival inventories have been found and published which give precise information on the private galleries of the D'Adda, Arese, and Melzi families.[92] Furthermore, Carlo Bianconi's sale catalogue of Carlo Firmian's collection has been recently reprinted.[93]

Oddly enough, Count Firmian's collection reflects the pattern of its contemporary Milanese counterparts rather accurately, a fact which is remarkable inasmuch as the count was not from Milan, but from Tyrol, Austria. In Tyrol there was an active group of good genre painters who have been recently rediscovered, but no trace of them can be found in Firmian's gallery.[94] Although he had traveled extensively throughout Europe and Italy, and had been to the Low Countries, he did not possess more Flemish paintings than, say, Giacomo Melzi or Giovanni Francesco Arese: his collection seems to have borne no relation whatsoever to his biography. Most of his Flemish paintings were either allegories or landscapes, but there were a couple of genre paintings (*Stables* with hostlers, horses, riders, etc.) by Philip Wouvermans, and two small pictures with hermits reading holy books, by Gerrit Dou.[95] As for the Italians, apart from two landscapes with shepherds and fishermen by Magnásco, there were only two *teste di carattere* by Pietro Bellotti, two half-lengths by Giuseppe Maria Crespi and Jusepe de Ribera, and a *Washerwoman* by Stefano Polazzo. Some of these paintings (the Riberas, the Dous, and the Bellottis) were bought by Giacomo Melzi in 1784-1785, after the count's death.[96]

In Melzi's collection, Italian and Flemish landscapes, seascapes, and townscapes prevailed, but there were 13 genre paintings in all: besides the five paintings from the Firmian gallery, there were two Dutch pictures attributed to the school of Lucas van Leyden (a *Wedding in the Country* and a *Dance of Peasants*), one by Pietro Tempesta (*Coming Back from the Market*), two by Sebastien Vraux [Vranx] (*Robbers Assaulting Travelers* and *A Scene from Army Life*), a *Young Woman Playing the Flute*, by Francesco del Cairo (which might also have been a portrait) and, finally, two pictures of old men, one of them holding a cat and the other one holding a dog, which in the 1802 Melzi inventory were given to the Venetian Giuseppe Nogari, but which have been recently attributed to Giacomo Ceruti.[97]

If this new attribution to Ceruti is correct, then the logical conclusion is that at the end of the eighteenth century, only a few decades after his death, his name and work were unknown or meant nothing to either a refined Milanese collector like Giacomo Melzi or to the mediocre painter Antonio Schiepati, who wrote the inventory for and together with him.[98] *Nemo propheta in patria*, but one may wonder whether Ceruti's oblivion was linked to a lack of appreciation of his style, or to his attitude towards his subject matter. It is very possible that in 1802, during the period of the Napoleonic Kingdom of Italy, following the events of the French Revolution which had swept away so many noble landowners (in France at least), people were particularly sensitive to the issue of the urban and country poor. It might be argued that if

Ceruti had been famous during his lifetime in Lombardy for his paintings, then times had probably changed enough in 1802 to make his name sound awkward and embarassing in the art market, just because of his standard subject matter, for which he had been so sought after, especially outside Milan. While the Melzi inventory seems to have hidden Ceruti's name, whatever its reason for this, the inventories of Girolamo Maria D'Adda's private collection supply the first name of a painter who is totally unknown both to Lanzi and in the various editions of Orlandi's *Abecedario*. Among a few paintings by either anonymous or Flemish authors, the 1704 inventory records "A small picture of porters by Sebastianone, 25 (...) high, 27 (...) wide, with a carved gilt frame." In the 1705 inventory, there is "a picture by Sebastianone with three peasants having their meal at a table in the kitchen, 1.23 braccio long, 1.28 braccio wide, with a carved gilt frame, valued £ 100." Finally, in a different inventory compiled in 1759 for D' Adda's heirs, item no. 824 is described as a "Picture with poor people having their meal at a table, in a carved gilt frame by Sebastianone... £ 18."[99] All these entries may refer to the same picture, despite some discrepancy in the descriptions between the first and the other two. The drop of its value from £ 100 to £ 18 over a period of 54 years is as dramatic as it is puzzling. It should be interesting to know whether the mysterious artist was alive at either or even both dates, so as to determine whether this fact is part of a wider trend involving genre painting or is linked to other circumstances. If we cannot determine Sebastianone's chronology and family name, we can at least make a guess at his nationality, for in the inventory of Giulio Barbisoni's collection in Brescia there was a "picture with two laughing heads, by Bastianone from Milan."[100] This is listed immediately after two paintings by Magnasco with nuns and capuchin friars, and four portraits of young porters by Ceruti.

The recent discovery of one more unknown Milanese artist devoted to genre reinforces the view that in Lombardy the interst in genre painting was widespread. Such hints are numerous, although it is becoming more and more evident that inventories of private art collections do not seem to reflect accurately the actual trends in art production as empirically witnessed by the quantity of extant paintings. The blatant paradox of this situation can be analyzed in greater detail in the case of Bologna, where many more documents of different sorts are available for cross reference and comparison. Here it can be pointed out that not all inventories are equally reliable: legal inventories preserved in state or family archives are to be supposed complete, whereas manuscript or printed catalogues supplied to visitors or compiled for sales must not have been, nor did they need to be, exhaustive. The process of selection involved in their compilation was affected by a

number of external factors, including current fashion in art, which may well account for the few genre paintings cited.

In the case of Brescia, the manuscript catalogues of seven private collections were reprinted by Giovan Battista Carboni in an appendix at the end of his town guidebook. The proportion of genre works varied greatly depending on the collection: if the Gaifami, who possessed 132 paintings, did not have any, the Archbishop Giovanni Molino had six genre works out of 30; the Maffei had five out of 87: the Ugeri ten out of 46; the Arici one out of 41; the Barbisoni 16 out of 284; the Avogadro five out of 195.[101] Earlier on, Giulio Antonio Averoldo, in his Brescia guidebook published in 1700, had described one gallery only, that of Count Pietro de Tertio Lana, where 124 pictures were hung, of which 12 were genre pieces.[102] Moreover, in the manuscript catalogue of Count Faustino Lechi's collection, which can be found among Marcello Oretti's papers in Bologna, only six genre works could be counted out of 142: towards the end of the century, however, the same collection included 586 pictures, of which 22 represented "scenes of everyday life" or bamboccíate.[103] Yet, according to the inventory of 1768-1769, his father Pietro had ten genre pictures out of 99 which decorated his house in town; but 19 more portraying beggars were preserved in his houses in the country, where it seems that no other paintings were hung.[104] It is indeed possible that genre works were bought mainly for country houses and villas, which would explain their scarcity in city galleries and the fact that many extant genre works are preserved in or come from the countryside.

Most of the Brescian collections cited above contained a fair balance between foreign and Italian genre paintings. "Foreign" usually stood for Flemish, which, in eighteenth-century Italian would have meant Dutch as well. Faustino Lechi possessed three anonymous French paintings too, whose summary descriptions remind us of Chardin; no German or Austrian pictures are ever referred to. Among the Italian pictures, besides various Cerutis and Magnascos, we can find many Venetian painters of the sixteenth, seventeenth and eighteenth centuries, as would be expected in a town which was then part of the Venetian republic. Oddly enough, Bassano is not present, but there are works by Giorgione, Pietro della Vecchia, Domenico and Francesco Maggiotto, Giuseppe Angeli, and Matteo de' Pitocchi. Archbishop Giovanni Molino had three paintings by Michelangelo Cerquozzi, a painter who was comparatively rare in North Italian private art collections. Conversely, the presence of Gaudenzio Botti, a Brescian artist who specialized in kitchens with people busy cooking or eating should be fairly predictable, yet specimens of his works are cited only in Faustino Lechi's galleries. Nevertheless, kitchen interiors seem to have been a favored subject in

Brescia: quite a few such pictures are recorded both in Lechi's and Pietro de Tertio Lana's galleries. Some of them are anonymous, others are attributed to Bonanni.[105]

The most common genre painter in Brescia was Faustino Bocchi, the inventor of a special kind of bambocciate whose protagonists are funny dwarfs busy dancing, playing, fighting, and working (fig. 71). Unlike Ceruti's and Magnasco's, his pictures lack both realism and social or ethical concern. They were painted simply for the entertainment of their owners and were used mainly for the decoration of country houses.[106] Bocchi's fame was not confined to his hometown or nearby Bergamo: he also had the patronage of the Medici in Florence, where he had gone some time before 1700. The earliest source on Bocchi is perhaps Averoldo, who, applying the critical *topos* of works of art mirroring their author's character, described him as a jolly good fellow spending most of his time in merriment and jokes.[107] A similar concept can be found in Lanzi's page on Giovanni Agostino Ratti.[108] On the contrary, Francesco Maria Tassi, in his *Vite de' pittori, scultori*

ed architetti bergamaschi, somehow manages to combine the same *topos* with its very opposite (i.e. the melancholic artist fighting his own gloomy temperament by painting cheerful pictures) in the life of Enrico Albricci, one of Bocchi's most successful imitators and followers in Bergamo.[109] Both Averoldo and Tassi emphasize the unintellectual, thoughtless pleasure provided by Bocchi's and Albricci's pictures. It is certainly remarkable, or perhaps rather depressing, that their silly works met with such a success as to cause their names and biographies to pass down to posterity, whereas painters like Ceruti or the Bergamasque Antonio Cifrondi have had to wait for a late, equivocal revival during this century. To the eyes of his contemporaries, Antonio Cifrondi was a facile, mannered painter of altarpieces that nowadays look hopelessly mediocre. As for his interesting genre works, which have often been misleadingly related to Ceruti's, there is only a passing reference to some of them in the seven-page biography which Tassi wrote of him:

In the house the Mapelli have in the countryside, near Ponte San Pietro, you can see twelve pictures or more where some crafts have been expressed in half-length figures, in a very lively way and with a very bold, whimsical outline. Their attitudes are so difficult that they catch the attention.[110]

71. Faustino Bocchi, The Spoil-sport. *Pinacoteca Civica Tosio Martinengo, Brescia.*

While praising Cifrondi's technical ability, Tassi shows complete indifference to the peculiarities of his genre style. This seems to confirm the spirit of social and moral detachment which alone could make the depiction of the working classes and the poor palatable or even welcome and entertaining in the eyes of the landed gentry (fig. 72).

Even so, no genre painting by Cifrondi or Ceruti can be found in Giacomo Carrara's rich and varied collection. His was the most important, but by no means the only private picture gallery in Bergamo. A detailed inventory of its contents was made in 1796 by its keeper, the painter and restorer Bartolomeo Borsetti.[111] Out of a total of 1,271 pictures, genre works accounted for only 47, inclusive of some 20 pictures on the borderlines between the strong and the weak definitions of genre, such as the *Seasons* by Francesco Bassano or the crowded, snowy landscapes by David Teniers and other Flemish artists.[112] 18 of those 47 paintings were by foreign painters, be they Flemish, Dutch, or German. As for the remaining pictures, seven were by Faustino Bocchi, one by Albricci (but Tassi, who was certainly informed by Carrara, says there were three),[113] six by Magnasco, and the rest by various artists from or active in Venice — like Francesco and Jacopo Bassano, Bernardo Strozzi, and Domenico Fetti — or by those deeply influenced by the Venetians, like Grechetto. It has been observed elsewhere that Carrara did not aim to have an exhaustive collection of paintings, but rather a highly representative selection of all the main trends in Italian and European art from the sixteenth century onwards, with a special emphasis on local (that is Bergamasque), Venetian and Lombard art.[114] Within this general framework, the absence of Cifrondi as a genre painter (but his presence as a religious one), the absence of Lombard and Venetian painters like Ceruti, Todeschini, Londonio, Matteo de' Pitocchi, or Antonio Carneo and, conversely, the many pictures by Bocchi, his follower Albricci, and even his master (il Fiamminghino) show a deliberate, clear-cut choice in favor of disengaged entertainment. From other documents, we know how deeply unsympathetic with the economic and social problems of his dependents Carrara was: he may even have avoided buying pictures portraying the life of the humble because of a guilty conscience.[115] It is worthwhile noting, however, that in his father's much smaller collection there was only one genre painting, a *Shepherdess* by an anonymous Frenchman.[116] This picture is not recorded in Borsetti's catalogue; therefore it may be inferred that Giacomo Carrara got rid of it. This may indicate how little he cared for genre.

Magnasco's works seem to have faired better in the context of such collections, but whatever the artist's intentions, his paintings could easily be appreciated for their brillant brushwork alone, without taking their content into consideration. Furthermore, they dealt with moral and religious considerations, rather than social ones, and thus may have been less disturbing.

We know very little about contemporary Bergamasque collections and art patronage besides the names of the families that distinguished themselves in this arena. Records on Bergamasque collections are extremely random. In 1720, Angelini could count 32 art collections, whose contents he did not describe. In 1799, during a big religious festival, 23 private collectors exhibited some of their possessions. The only genre paintings on show were a *Kitchen Interior* by Grechetto from Count Zanchi's collection and Flemish genre works from Count Mozzi's.[117] We also know of other examples of Flemish genre painting in the collection of Count Sottocasa at a somewhat later date, and also of some fresco decorations by Bocchi in Marenzi's palace.[118] From letters that Count Carrara wrote to Luigi Crespi in 1767, we know that Count Ignazio Barzizza had 20 pictures by Giuseppe Maria Crespi illustrating the stories of Bertoldo, Bertoldino, and Cacasenno. According to Carrara, these were the same oils on copper that Giuseppe Maria Crespi had sold to Prince Pamphilj in Rome. Luigi Crespi took note of this piece of information and used it in his *Felsina pittrice - Tomo terzo*, but, as Merriman has already remarked, it is very strange that the same 20 oils are nowadays again in their original location, the Doria Pamphilj Gallery, from which there is no further evidence that they were ever removed to be returned later on.[119]

Giuseppe Maria Crespi is by far the most important painter to have devoted a large part of his activity to genre. It has already been observed that "his occasional rise to pure poetic eloquence in his treatment of the lowly and the poor was not the expression of a fully aware social conscience which deemed it important to represent a consistently positive image of the subject."[120] Crespi's alternately Arcadian and humorous interpretation of genre bears ample witness to this. Mira Merriman has also pointed out how local figurative and literary culture could stimulate Crespi to look probingly at the activities of the lower classes in order to portray them.[121]

In any survey of the development of genre painting, it is customary to cite, apart from the sixteenth-century works by Bartolomeo Passarotti and Annibale Carracci, Annibale's engravings of the *Arti di Bologna* and their later imitations by Giuseppe Maria Mitelli, Giuseppe Maria Crespi himself, and Giovanni Maria Tamburini.[122] Nevertheless, Annibale's *Arti di Bologna* found its most important successors in eighteenth-century Paris and Venice. Rather than Bouchardon's *Cris de Paris* (1737), Gaetano Zompini's elegant *Le arti che vanno per via nella città di Venezia* is relevant to the present survey. It was published in 1785, after the deaths of the artist and

of his patron, Antonio Maria Zanetti the Elder, a famous collector of prints in close touch with a number of Bolognese artists and connoisseurs, *in primis* Giovan Pietro Zanotti and Luigi Crespi.[123] The *Arti per via* which Zanetti ordered from Zompini did not just follow or emulate Annibale's example; it was radically different in spirit. Whereas Annibale had focused his attention on the figures of various Bolognese and Roman peddlers, the actual protagonist of Zompini's plates is Venice herself, as the emphasis on the everyday life of the Venetian urban setting and the rhyming captions in charming Venetian dialect show.[124] Even so, Zompini's plates and Dr. Questini's captions reveal a degree of social awareness that is very far from Annibale's detached study of picaresque characters considered merely as types. In this sense, Annibale's sketches could be considered "idealized." Idealization, however, was also an important feature of certain Bolognese genre paintings during the eighteenth century: in its most banal, Arcadian sense, it certainly characterizes the works of Giuseppe Gambarini, Stefano Gherardini, and Antonio Rossi.

72. *Antonio Cifrondi, A Miller. Pinacoteca Civica Tosio Martinengo, Brescia, Vitale Bandini collection.*

This kind of inferior idealization was not enough to make genre acceptable to most academic theoreticians, however. Giovampietro Zanotti, a *maître à penser* in Bologna for the whole first half of the eighteenth century and one of Algarotti's closest friends, shared the Venetian penchant for a sort of elegant Rococo Classicism. As we have already pointed out earlier, he also shared, or more probably inspired, Algarotti's criticism of Giuseppe Maria Crespi's *Chiron Teaching Achilles to Draw the Bow*, but his lack of sympathy was not confined to Crespi alone. It extended to genre as such. This is particularly evident in his *Storia dell'Accademia Clementina*. His biography of Giuseppe Maria Mitelli is written in a constant apologetic tone that betrays, and even underlines, his unfavorable opinion of Mitelli's artistic achievements and standards.[125] His life of Giuseppe Gambarini is short and hasty, but his disparaging attitude of dimissal towards his production is explicit:

Gambarini was very diligent in everything he did and portrayed everything from life. Sometimes or rather too often he stuck too much to the model he had in front (...). This slavish imitation of life increased even more after he got married (...). Since he knew he was too much inclined to this, he started painting small pictures with low and humble subjects, dealing with popular themes, such as women who weave, embroider, teach boys and girls how to read or to make lace, and do other childish or female jobs. Sometimes he aslo added begging friars, who receive bread and wine and everything they need out of Charity; or other such folk. In sum, he started painting this kind of subject, and portrayed them from life with so much verisimilitude that people started liking them, and almost nothing else was required of him. In fact he painted a great many pictures like these. Many houses of noblemen and middle-class people possess them and hold them in esteem. His fame had already started spreading outside Bologna, so that he received orders from abroad (...).[126]

Zanotti's book includes only those artists who were or had been members of the Accademia Clementina by the time of its publication. Therefore, Antonio Beccadelli and Stefano Gherardini (to name two genre painters) are not mentioned. Antonio Rossi is present, but there is not the slightest reference to his genre paintings. Luigi Crespi, who is the other major biographer of Bolognese artists in that century, does not add a single piece of information to Zanotti's, save for some factual corrections and critical adjustments in his own father's life.[127]
As can be seen, discussion of genre painting in eighteenth-century art literature is rare and not very thorough. Most of the debates on this issue had already taken place in the previous century, and they had often been very heated ones.[128] In Bologna, Malvasia had supplied a remarkable documentary contribution to the historical and theoretical debate by publishing Albani's and Sacchi's private opinions on the issue. He avoided, however, to take any clear-cut, personal position against or in favor of

genre like Bellori, Baldinucci, Boschini, or Passeri. In the end, the official condemnation of genre sanctioned by most critics must have affected art trade and patronage far less than it did the selective records of private galleries that have survived.[129]
The case of Bologna is particularly interesting because it provides extraordinary opportunities for a systematic study of art collecting, even if — or possibly because — her guidebooks are fairly reticent on this issue (the various re-editions of Malvasia's guidebook, in fact, tell little more than the names of some of the most famous aristocratic and bourgeois collectors in the city). This fact may have prompted Marcello Oretti, a local dilettante, to compile four important manuscripts, recording the collections of paintings and frescoes in the possession of aristocratic families (MS. B 104), of middle-class ones (B 109), in noble country houses (B 110), and on display in the streets during some special religious festivals (B 105). It is generally assumed that all these manuscripts were written between 1760 and 1786.[130]
The information he collected seems to be fairly homogeneous, at least on a superficial level, and, although it has shortcomings and pitfalls, these are common to all archival inventories, the only alternative source available for a general survey of Bolognese art collecting. Both Oretti's manuscripts and any series of archival inventories are deficient: the latter in that they contain inevitable casual gaps, either because of accident (mislaid or missing documents) or because of historical vagaries (documents that are theoretically necessary to a foolproof, systematic study, but which are not to be found, for they never existed); the former in that they are not complete, nor is there a pattern of logic to justify and neutralize the effects of their flaws. Another problem which both categories of document share concerns the validity of the attributions given in them (when they are given). In a quantitative study, these attributions must be taken at their face value, without checking, even when we are aware that in some particular cases they are no longer tenable, because any alteration would jeopardize the cultural integrity of the data. This is particularly true in the case of Oretti's manuscripts, for, unlike private family inventories compiled by different people at different times and with different criteria, Oretti's personality is their unifying factor.[131] In his prefatory note to B 104, Oretti states:

On various opportunities I had of visiting the palaces in my native town, I took a fancy to making a list of them [the works of art. For their attributions] I relied on the authority of the owners of the paintings, on the most expert professors and on the catalogues of the family collections.[132]
Besides authoritative oral and written sources, Oretti also relied on his ability as a connoisseur, as is confirmed by his statement that he had discovered many copies which were generally regarded as original and by his frequent rejection of

attributions.[133] Such apparently confident statements can give the misleading impression, however, that all of Oretti's assertions were checked by him against the factual record; yet often enough it can be proved that his entries derive from his personal readings only. Sometimes he does quote his sources, but more often he hides them, and they may well be as old as Malvasia, as in the case of the Cospi collection.[134]
This problem can be more serious than the preceding ones, but it cannot deter us from a quantitative study, for the aim of such a study is not so much to describe a single set of empirical circumstances or to portray phenomena, as it is to identify their underlying trends and patterns of logic: under many circumstances, it might be more important to ascertain the presence of a certain kind of painting, or of artists belonging to a certain school, than to be too fussy about the time and place of their presence in the city. In sum, the problem of Oretti's reliability does exist, but is not sufficiently serious as to make a quantitative study of Bolognese art collections untenable, once we have acknowledged that his assertions reflect the subjective point of view of a contemporary witness, as imperfect as anybody else.[135]
Oretti was less imperfect than many others, actually, for some of his apparent contradictions represent an accurate reflection of real contradictions. Thus, it might be argued that the social divisions of art collectors, as proposed in manuscripts B 104 and B 109, are not consistently adhered to: well-to-do, middle-class families can be found in B 104 (Belloni, Piastra), whereas a few aristocratic families have intruded into B 109 (Oretti, Carrati). A closer look at the histories of these families, however, proves that Oretti made his distinctions with an eye to the actual possibility of living *more nobilium*, rather than to the formal registration in the golden book of aristocracy. After all, the merchants Belloni had been the Old Pretender James III's hosts in Bologna.[136]
In the end, even if Oretti's information may be somewhat deficient in its details, the raw figures which can be extracted from it are impressive and provide an interesting touchstone for any quantitative study based on archival documents. In B 104 and B 109, Oretti lists 346 private collections containing a total of 6,919 pictures — inclusive of frescoes. Such numbers are impressive, especially when we consider that they are rounded off to the lowest possible figure: in fact, whenever Oretti uses phrases like "many paintings by...," "a number of paintings by...," or simply "pictures by...," it is necessary to remember that each reference is equated to one for statistical purposes.[137] Moreover, it is very unlikely that Count Francesco Bentivoglio possessed only three pictures, as Oretti's notes state; it is also certain that Filippo Hercolani had more than twice as many paintings as Oretti states.[138] Thus it is clear that the number of paintings in Bolognese art collections was well above the nearly 7,000 units recorded by Oretti; however,

they were not evenly distrubited. The 164 collections listed in B 104 possessed 4,353 works vs. 2,566 paintings in the possession of the 182 collections in B 109. This means that, on average, aristocratic collections were fewer but larger than middle-class ones.

Family patronage of individual artists, which is typical of the aristocracy, may account for an intriguing fact: although the absolute number of artists listed in noble galleries (386) is higher than that in bourgeois collections (335), the ratio between the number of artists and the number of attributed works is slightly higher in the latter than in the former (335:2,344 $>$ 386:3,998 — a ratio of .14 $>$.096). This ratio is naturally confirmed by the opposite trend of the inverse proportion (2,344:335 $<$ 3,998:386, or 6.99 $<$ 10.35) and means that, on average, fewer artists were represented by more paintings in aristocratic collections.

Anonymous paintings are present in a higher percentage (9.93 percent vs. 8.15 percent) in bourgeois houses (although in absolute values they are more numerous in noble ones — 355 vs. 255). From this datum, however nothing can be inferred as to the qualitative standards of the collections, because anonymity may depend more on foreign or unfamiliar styles, and possibily on so-called "stylistic anonymity," than on quality as such. In bourgeois collections, for instance, 33 anonymous works out of 255 are identified as foreign (one as French, 4 as North European, and 28 as Flemish, which may mean Dutch as well); as for the remaining 222 pictures, 86 are granted brief appreciative remarks ranging from good (43) to excellent (38), whereas only five are classified as mediocre. Apparently, even quality cannot guarantee the survival of an artist's name, especially in middle-class families, where family archival records were naturally less extensive than in noble ones.[139]

Oretti's manuscripts confirm that foreign artists were remarkably rare in Bolognese collections of either social class: even using "foreign" in its eighteenth-century meaning of "non-Bolognese" and including, therefore, all the other Italian schools, Bolognese paintings represent over 79 percent of the total.[140] As can be seen from Tables I-IV and as evidenced by Graphs 1-3, the ratio of foreign painters to Bolognese ones differs in the two groups of collectors, even if it follows similar trends. In particular, the number and percentage of foreign painters is higher in the aristocratic group. In both classes, the ratio between works and painters is naturally much lower for non-Bolognese artists: both facts are consistent with the apparent rarity of foreign pictures on the Bolognese art market.[141]

It must be stressed, however, that despite the prestige and high quality of the Bolognese school, local collections were not totally devoid of foreign works: in particular, some foreign genre pieces were available in the city, which might explain Crespi's early interest in genre, even before his stays in Florence.[142] Of course, it was much easier to study Flemish paintings in a city like Florence, where quite a few specimens were hung side by side in the Grand Duke's gallery, but it was not impossible to learn something about Flemish genre painting even in Bologna.

Oretti lists 15 relevant entries, but we can assume that others must have existed. The 1698 catalogue of Annibale Ranuzzi's collection, for instance, records two small paintings by "Monsù Bambozzo" (Van Lear) with figures and animals (valued at £ 400) and two "bambozzate" on copper by "Monsù Cornelio" (De Wael?): they belonged to a lot of 16 paintings by the same author, valued at £ 180.[143] From Oretti we know there was a market scene by an anonymous Flemish author in the Palazzo Orsi in San Vitale, where a famous Van Dyck could also be seen;[144] another market scene was in the Sampieri gallery; besides, there were four bambocciate in the Palazzo Zagnoni and a painting contrasting two heads of philosophers (one laughing and the other one crying, surely representing Democritus and Heraclitus) in the Palazzo Caprara. Seven more pictures could be found in various bourgeois collections: two bambocciate in Bertelli's house, two more in Predieri's, a winter market scene in Gaetano Gandolfi's, and, last but not least, two pictures attributed to Jan Miel in Jacopo Bartolomeo Beccari's — one representing a bambocciata, the other one called *Soldiers Playing Cards*. It is perhaps worthwhile looking a bit more closely at one of these collections, to see in what context Flemish genre could be found.

Jacopo Bartolomeo Beccari (1682-1766) was a very famous physician and esteemed scientist teaching at the University and at the Instituto delle Scienze. His collection was not huge, but was very choice: it contained 32 pictures and various drawings, including Domenico Maria Fratta's copies of the Carracci and Carraccesque frescoes in the cloister of San Michele in Bosco and of Niccolò dell'Abate's frescoes in the Palazzo Torfanini.[145] Save for Jan Miel's paintings, a landscape by Titian, and a religious painting by Giovan Domenico Ferretti, all the works in Beccari's collection were Bolognese of the seventeenth and eighteenth centuries. The latter period prevailed, with 22 paintings by Donato Creti, Ercole Graziani, Francesco Monti, Giovan Gioseffo Dal Sole, Giuseppe Marchesi, Candido Vitali, and a few others. All the pictures had either biblical or religious subjects, with the exception of four paintings by Nunzio Ferrajoli and five still lifes by Candido Vitali. The structure of Beccari's collection does not hint at any special interest in either foreign or genre paintings; therefore, it provides no clue to explain the presence of two pictures by Miel. As a matter of fact, if there was some kind of bias, it must rather have been against genre, as suggested by the

TABLE I
Foreign Schools in Bolognese Aristocratic Collections

Schools		Artists		%	Paintings		%
Venetian		40		10.36	151		3.46
Emilian	Ferrarese	8			41		
	Parmesan	11	25	6.47	44	109	2.50
	of Romagna	6			21		
Roman		20		5.18	89		2.04
Non Italian	Flemish	9			58		
	French	4	17	4.40	9	82	1.88
	Others	4			15		
Tuscan		14		3.62	38		0.87
Neapolitan		6		1.55	30		0.69
Lombard		8		2.07	15		0.34
Genoese		3		0.77	16		0.36
Umbrian		1		0.25	1		0.02
Others (unidentified)		7		1.81	24		0.55
Total		141		36.48 (36.52)	555		12.69 (12.74)

TABLE III
Foreign Schools in Bolognese Bourgeois Collections

Schools		Artists		%	Paintings		%
Venetian		28		8.38	86		3.35
Emilian	Ferrarese	5			19		
	Parmesan	9	16	4.79	25	51	1.98
	of Romagna	2			7		
Roman		10		2.99	25		0.97
Non Italian	Flemish	6			46		
	French	2	12	3.59	7	67	2.61
	Others	4			14		
Tuscan		9		2.69	15		0.58
Neapolitan		5		1.49	16		0.62
Lombard		7		2.09	12		0.46
Genoese		6		1.79	12		0.46
Umbrian		1		0.29	1		0.03
Others (unidentified)		4		1.19	8		0.31
Total		99		29.59 (29.64)	293		11.37 (11.41)

TABLE II
Bolognese Painters and Pictures in Bolognese Aristocratic Collections

Schools	Artists	%	Paintings	%
Bolognese	245	63.47	3443	79.09

TABLE IV
Bolognese Painters and Pictures in Bolognese Bourgeois Collections

Schools	Artists	%	Paintings	%
Bolognese	236	70.35	2051	79.73

GRAPH 1

GRAPH 2
Schools in Bolognese Aristocratic Collections
1) Artists

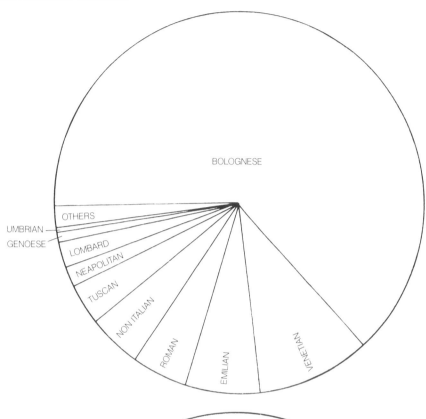

2) Paintings

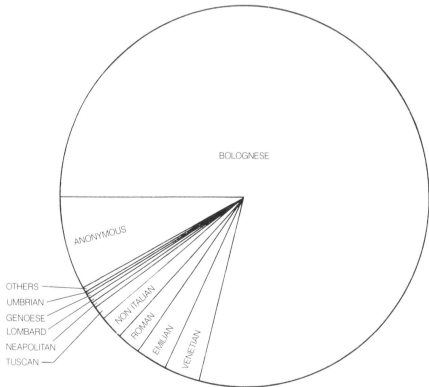

GRAPH 3
Schools in Bolognese Bourgeois Collections
1) Artists

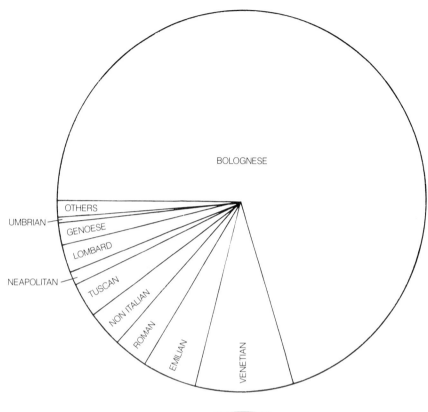

2) Paintings

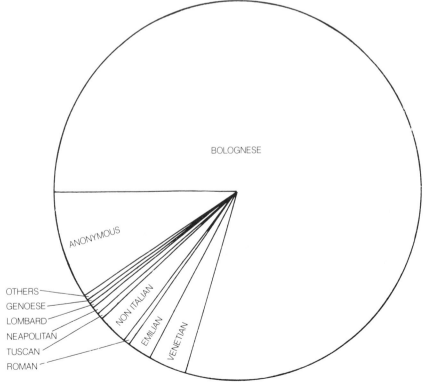

TABLE V
Schools and Subjects in Bourgeois Collections

Schools:	Unknown	Bolognese	Emilian	Lombard	Venetian	Roman	Neapolitan	Non Italian	Tuscan	Umbrian	Genoese	Uncertain	Total	%
Subject matters:														
Religious	82	727	20	5	29	10	10	6	5	1	2	1	898	34.99
Biblical	18	153	3	—	10	1	1	2	1	—	1	—	190	7.40
Mythological	8	97	3	—	8	5	—	—	—	—	—	3	124	4.83
Allegorical	12	71	1	—	1	—	1	1	1	—	—	—	88	3.42
Historical	2	40	3	—	—	—	—	—	—	—	—	—	45	1.75
Unspecified	9	88	—	—	2	—	—	—	—	—	—	1	100	3.89
Genre	4	44	2	—	2	—	—	9	—	—	2	—	61	2.37
Portrait	32	167	6	—	14	1	1	8	1	—	1	—	231	9.00
Landscape	15	301	9	1	16	—	3	33	4	—	6	—	388	15.12
Still life	23	96	—	6	1	3	—	8	3	—	—	2	142	5.53
Perspective	11	185	—	—	—	3	—	—	—	—	—	1	200	7.79
Others	6	82	6	—	3	2	—	—	—	—	—	—	99	3.85
Total	222	2051	51	12	86	25	16	67	15	1	12	8	2566	99.94

TABLE VI
Schools and Subjects in Aristocratic Collections

Schools:	Unknown	Bolognese	Emilian	Lombard	Venetian	Roman	Neapolitan	Non Italian	Tuscan	Umbrian	Genoese	Uncertain	Total	%
Subject matters:														
Religious	130	1084	60	6	89	28	11	8	14	1	2	3	1436	32.98
Biblical	46	228	4	—	8	8	2	4	2	—	3	1	306	7.02
Mythological	21	293	4	—	8	4	3	2	—	—	1	—	336	7.71
Allegorical	19	126	3	—	—	—	3	—	—	—	—	4	155	3.56
Historical	12	98	6	—	2	12	4	—	—	—	—	—	134	3.07
Unspecified	16	378	7	—	8	—	4	5	3	—	—	1	422	9.69
Genre	5	47	2	—	1	6	—	8	—	—	—	—	69	1.58
Portrait	45	302	5	3	18	—	2	25	3	—	1	—	404	9.28
Landscape	24	230	2	—	2	5	—	22	5	—	6	15	311	7.14
Still life	8	56	2	2	—	10	—	—	9	—	1	—	88	2.02
Perspective	5	205	—	4	—	—	—	—	—	—	—	—	214	4.91
Others	24	396	14	—	15	16	1	8	2	—	2	—	478	10.98
Total	355	3443	109	15	151	89	30	82	38	1	16	24	4353	99.94

GRAPH 4
Subjects and Schools in B 109

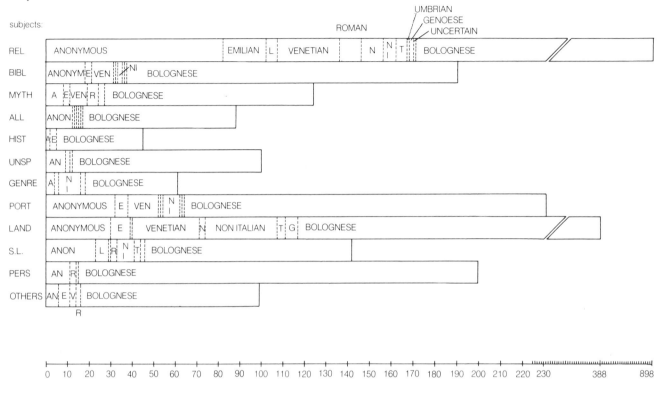

GRAPH 5
Subjects and Schools in B 104

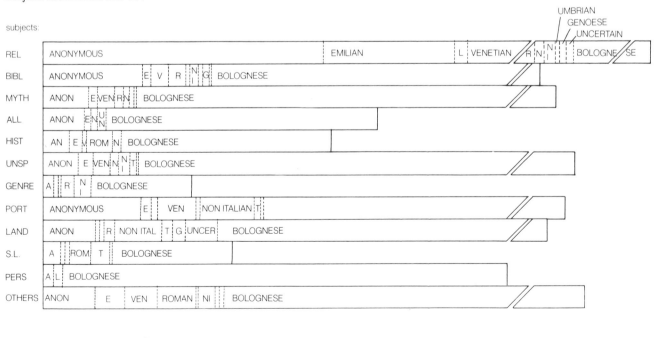

predominance of such well-known contemporary classicists and, conversely, the total absence of works by Giuseppe Maria Crespi, his followers and imitators. It might be mentioned that the source of Miel's paintings could possibly have been a gift: what remains certain is that Beccari had many illustrious correspondents in cities like Turin or Milan, where it was not difficult to find pictures by Miel.

In any event, genre painting does not seem to have been popular in Bolognese collections, notwithstanding the number and fame of local genre painters. Tables V-VI show the distribution of pictures in middle-class and noble collections by school and subject matter; Graphs 4 and 5 chart this information.

Following our analysis of Oretti's data, genre works in Bolognese collections amount to a total of 129 pieces, equal to 1.86 percent of all the paintings. It must be pointed out, though, that since these data derive from manuscript sources and cannot be checked against surviving works, it is sometimes difficult to deduce how the subject matter of a given picture should be classified, for borderline descriptions are not uncommon, and no general rule can be fixed and followed. The difference between a *testa di carattere* and a portrait is sometimes not obvious even when looking at real works of art, but it is impossible to tell the difference from a half-line description by Oretti. A *concert* can be anything from a group portrait, or conversation piece, to pure genre; a "figure" might be an allegory, a portrait, a genre work, or something else altogether; in the case of "figures in a landscape," it is hard to decide whether the emphasis was on the action of the figures or on their natural setting. What is known of an artist's production generally supplies the best guidelines by which to arrive at a conclusion, but when no choice is possible, pictures are forced into the miscellaneous category.[146]

Bearing these considerations in mind, the classification of genre according to schools supplies some material for analysis. First of all, it is certainly remarkable that the Lombard school, which included so many famous genre painters, is not represented at all in this field and is scarcely mentioned even in other areas of subject matter. Unlike Naples, which was equally inclined to genre painting and equally unrepresented in this field in Bologna's galleries, Lombardy was close enough to Bologna. In this case, however, the short geographical distance between Lombardy and Bologna may have been stretched by growing cultural differences, depending on different political administrations. None of these factors, however, would have been significant enough to make that distance unbridgeable. If the Lombard school was one of the least important components in Bolognese art collections and if Neapolitan art was somehow represented in fields other than genre painting, the lack of any Roman genre piece in

bourgeois collections, and their scarce presence in the aristocratic ones (four bambocciate by Andrea Locatelli and two reading girls by Domenico Fetti in the Palazzo Paleotti), is even harder to understand.[147] Rome had very little in common with Bologna in terms of its culture, but it was the capital of the Church State to which Bologna belonged: these close, or stifling, political links are reflected in the comparatively high percentage of Roman pictures in fields other than genre, especially in noble collections. It is rather curious, however, that no Cerquozzi is ever mentioned.

As for other central Italian schools, like the Tuscan and the Umbrian ones, they are of lesser relevance in the Bolognese cultural context anyway; thus it is hardly surprising that no genre works of this origin were found in Bolognese collections. The Genoese school, however slight its relative importance may have been, was represented by two pieces by Giulio Benso (*The Fortune Teller* and an *Assault*) in the bourgeois Fabii collection. It is curious that Genoese genre, which included the works of first-class artists like Grechetto and Magnasco, should be represented by a minor artist who is better known for his religious paintings and *quadrature*. It does not seem farfetched to suggest that the acquisition of his works might have been in connection with some special circumstance in the history of the Fabii. On the other hand, the chance exists that the author of these two paintings was not Genoese at all, but rather an equally unimportant Bolognese artist, one Giulio Benzi from the school of Carlo Cignani. Like his Genoese homonym, he is known for frescoes with religious stories, but genre works by him were recorded by a seventeenth-century source, Antonio di Paolo Masini.[148]

As for the non-Italian schools, four more pictures must be listed in addition to the 15 Flemish ones mentioned earlier on: they are two kitchen interiors by an anonymous European painter in the house of a lesser Bolognese artist, Pietro Donati, and two pictures by an anonymous German artist active in Tintoretto's workshop (he might be the Dutch painter Lambert Sustris) in the aristocratic Bonfiglioli collection. Oretti does not explain their subjects clearly, nor is it possible to identify these pictures with any of those listed in the 1757 catalogue of this famous Bolognese gallery. Conversely, the catalogue records two pictures ignored by Oretti which represent card sharps. One is attributed to Callot, the other one to Brueghel.[149]

This is one more of evidence that North European art was known in Bologna, although these attributions of paintings to first-class foreign masters may be unreliable. Nevertheless, it would be interesting to know how easy it was for younger local artists to visit these collections and study in them, because this might be crucial to understanding the opportunities that Bolognese painters like Crespi or Beccadelli had

to broaden their scope.

Giuseppe Maria Crespi is by far the most famous Bolognese genre painter, even if genre was not his sole concern. It has been observed that "genre painting represents approximately one third of the extant oeuvre" and that "originally it must have represented an even larger proportion of Crespi's production, given the tendency for such works to be lost in the shifting tides of taste more easily than altarpieces and portraits."[150] At first glance, the data we can gather from the Oretti manuscripts do not confirm this impression. Out of 96 works of his which were dispersed in 46 different noble and bourgeois houses, only 13 can be classified as genre, whereas 37 were religious ones. Somehow it looks as if devotion was still the largest source of private patronage, immediately followed by history painting and portraiture.

One might almost wonder whether Crespi's genre works were painted mainly for export, but apart from Florence and, later on, a few minor provincial towns in Northern Italy, it is impossible to imagine where his production could be sent to. It might be even more tempting to suppose that, since genre was particularly suitable for the decoration of country houses, Oretti's survey of such places in B 110 would be rich in genre works by Crespi or others. Once more, the facts are disappointing: save for the bambocciate by anonymous Flemish artists in the Casino Biancani Tazzi at Meldola and a picture of players at various games by Sebastiano Santi, nicknamed "il Rodellone," in the Casino Grimaldi, there is no further mention of genre paintings. Of course, it is possible that the easel paintings of unspecified subjects by Stefano Gherardini in Villa Albergati, Zola Predosa, were genre pieces, because the artist was a fairly well-known genre painter, but there is no conclusive evidence for this.[151]

Obviously we cannot tell how thorough Oretti's survey of the countryside was. From his town census we know that, occasionally at least, he could be quite accurate even in matters of detail. Checking his description of the Sampieri gallery, for example, against the printed *Descrizione italiana e francese di tutto ciò che si contiene nella galleria del Signor Marchese Senatore Luigi Sampieri* (Bologna 1795), it must be granted that the two catalogues are remarkably similar. Although the *Descrizione* lists some additional paintings which might well have been bought after Oretti's death in 1787, it records only one genre piece, namely Dosso's *Players of Sleight-of-Hand Tricks*, which is also mentioned in Oretti's manuscript.[152]

In the collection of the Hercolani family, Oretti cites only two genre pictures, Ercole Roberti's *Concert* and Grechetto's *Shepherd with Sheep*. The same two are mentioned in Jacopo Alessandro Calvi's selective catalogue printed in 1780. After going through Luigi Crespi's handwritten catalogue of this collection, which lists about 250 pieces, only four *teste di carattere* by Burrini can be added. Interestingly enough, neither Luigi, who worked for the Hercolani portraying some members of the family, nor his father, Giuseppe Maria, is ever mentioned in either compilation.[153]

Nevertheless, from Oretti's data we should infer that Crespi's work was appreciated in Bologna by both the middle class and the aristocrats. The pattern of its distribution, however, followed two opposite trends: 55 of his pictures were dispersed among 30 different aristocratic collections, whereas 41 pictures were the property of only 16 middle-class families. This means that in the latter case fewer families possessed a higher share of specimens of his works. This suggests that their interest in his work may have been more genuine, less a matter of some dutiful completion of their collections.

Whereas the noble Palazzo Caprara contained nine paintings by Crespi (two of which were extravagant *capricci con figure*), the bourgeois Marchesini possessed five works, three of which were genre (a *Butcher's Shop*, a *Woman Playing an Instrument* and an *Amosteria [sic] fatta da villani*). Another branch of the same family living in Strada Maggiore had ten pictures and various drawings by him. Only two of the pictures were genre: like their relatives, they possessed a *Butcher's Shop* and an *Amosteria [sic] fatta da villani*.[154]

It is not clear what Oretti means by "*Amosteria*," a word unknown in the dictionaries of both the Italian language and the Bolognese dialect. Since it is here specified that peasants are involved in the activity, and the word sounds enough like *mosto* (must), the pictures might possibly have illustrated something like the *Scene in a Wine Cellar* now in Leningrad — that is, the pressing of grapes. There was another "*Amosteria*" listed in the collection of the Taruffi, a fairly prosperous family of publishers: in this case, however, the painting was by a Bassano, probably Jacopo.[155] Although the Venetians were the most numerous non-Bolognese artists represented in Bolognese collections, the Taruffi Bassano was a rarity, for in Bologna there were only two more Venetian genre works, a beautiful *Capriccio con figure* by Magnasco's most gifted student, Sebastiano Ricci, and a kitchen interior by Leandro Bassano. The former was in the house of Antonio Buratti, a Bolognese merchant involved in trade with and in Venice; the latter was in the noble Palazzo Aldrovandi. There was no Piazzetta, no Longhi, no Maggiotto, no Marcuola.[156]

Even fewer works can be found from the Emilian school — only two bambocciate by the Ferrarese Scarsellino in the Palazzo Marescalchi — but then the Emilians were not particularly famous for genre painting. As for the obscure painters whose incomplete or missing names do not allow for the

identification of their schools, there appear two kitchen interiors in the house of the wealthy merchants Rizzardi, a *Girl Holding a Candle* in Predieri's house, a *Gathering of People* in Santelli's, a kitchen interior in the Palazzo Caprara, a *Grape Harvest* in the Palazzo Aldrovandi, and a picture with a group of people whose actions are not described in the Palazzo Barbazzi.

Returning now to the Bolognese artists, and to Crespi in particular, we must consider certain assumptions which have become common. It has been noted that

under the broad rubric genre, the range of Crespi's subject matter was unusually wide, showing a continuous experimental interest that went far beyond a few ready-made models that he might have seen in this or that gallery of his patrons and settling on no single type of low life scene to be repeated as a stock in trade. On the contrary, some of Crespi's most creative and inventive efforts were directed to the exploration of the variety of possibilities in painting low life scenes, whether conventional or taken from life.[157]

The data from the Oretti manuscripts do not contradict this general statement, yet they provide only inadequate evidence to support it, owing to the few pictures by Crespi they record. Besides the seven paintings noted earlier on, there were: one picture of porters and one called *Women Doing Some Housework* in Mazza's collection, a *Female Pilgrim* in Doctor Gabriele Brunelli's, and, in the aristocratic palaces, a market scene in Conti's and a picture entitled *A Hunter with Dogs* in the Palazzo Ghisilieri. Moreover, Zanobio Tron, a well-known goldsmith and jeweler who was on very friendly terms with Crespi, had eight pictures by him, mostly portraits, but there was also a *Woman Playing a Musical Instrument*, most probably a genre piece.

Defining a typology of genre painting in Bologna according to Oretti's data would hardly lead us beyond the fairly narrow limits of the various subjects mentioned so far. It is more useful to take a closer look at the artists and collections cited by Oretti, since this will also lead to minor additions to the group of subjects.

Some artists' names mentioned in this context are fairly unexpected. This is the case with Prospero Fontana, for instance, whose picture *An Old Man Embracing an Old Woman* in Palazzo Berò sounds as if it had been inspired by some German or Netherlandish iconographical source. Unlike Bartolomeo Passarotti and Annibale Carracci, Fontana has never been thought of as a painter interested in genre. On the contrary, however, the scene cited above most probably had comic or satiric, rather than realistic, implications.

Another Bolognese painter whose name is not generally associated with genre is Donato Creti, yet Oretti records a picture of his showing *A Greengrocer amidst Fruits and Flowers* in the Palazzo Fava. Count Pietro Ercole Fava was Donato Creti's first and most important patron, as we know from Giovampietro Zanotti's *Storia dell'Accademia Clementina*. No genre painting is ever mentioned by Zanotti, nor later by Luigi Crespi, in Count Fava's possession or elsewhere, but if we go through the 1745 legal inventory of Count Fava's properties, we can find three genre works by Creti: an *Old Beggar*, a *Woman Looking at Herself in a Mirror*, and *Two Women Spinning*. It seems logical to attribute these products to the early part of his career, when he was somewhat influenced for a short time by Giovan Antonio Burrini, whose activity in genre is documented by literary sources rather than extant works.[158] Oretti's census confirms the existence of seven genre pieces by him in noble galleries (the palaces of two different branches of the Albergati and the Palazzo Scarselli) and one (*A Woman Peasant Working in the Fields*) in the bourgeois house of Covelli.

Admittedly, it is unusual that Oretti records almost as many genre works by Burrini, who is not now known as a genre painter, as he does, say, by Crespi. Specialists like Antonio Rossi, Antonio Beccadelli, Stefano Gherardini or Giuseppe Gambarini hardly account for as many.[159] Antonio Rossi, for instance, is mentioned only once, as the author of a series of three paintings with stories of Bertoldo and Bertoldino in the bourgeois house of Tondelli: they are now lost, but it would be intriguing to know if and to what extent the artist was influenced by Crespi's famous series and engravings. Antonio Beccadelli is represented by only four paintings, all of them concentrated in the house of Doctor Gabriele Brunelli. They included two bambocciate, a *Banquet*, and a story with monks.

Stefano Gherardini is the best represented, even if by no means the best genre painter. Five works by him were concentrated in a single middle-class collection, Graziani's (a *Washerwomen*, a *Cellar*, a *Schoolteacher*, a *Singing Master*, and a *Singer*), and four of his bambocciate were in three noble houses (Amorini, Ranuzzi and Albergati). To Giuseppe Gambarini, Gherardini's teacher, are ascribed only eight pieces unevenly distributed in four palaces (a bambocciata in the aristocratic Palazzo Ranuzzi; two more in the house of a merchant, Gabriele Cermasi; two similar ones in the house of Giovanni Pellegrino Savini; a *Forge* and two stories with monks in the collection of Giuseppe Belluzzi).

Truly classicist academic painters like Giuseppe Marchesi, called Sansone, Ercole Graziani and Aureliano Milani made occasional contributions to genre. Ercole Graziani combined a group of youngsters with a still life of fruits for the Casa Vitali (a residence possibly related to the still life painter Candido Vitali); Aureliano Milani was the author of a market scene in the Palazzo Magnani; Sansone painted a group of soldiers playing cards (Casa Medici) and another genre piece in the Palazzo Conti. To complete the list of genre painters and works

listed by Oretti in his manuscripts B 104 and B 109, we cannot omit a handful of minor artists like Pier Paolo Varotti (two paintings in the house of the publisher Longhi); Giuseppe Antonio Caccioli (*Hunters with Dogs* and *A Girl Playing an Instrument* in the Palazzo Orsi); Leonardo Sconzani (two bambocciate in the Palazzo Ranuzzi); Francesco Calza (a *Dance School* in the Palazzo Caprara); and Domenico Grossi, a native of Naples (an *Old Woman with Children* and a *Young Boy with Fruit* in the Palazzo Boccadiferro Marulli).

Save for Prospero Fontana, all the painters mentioned so far are eighteenth-century artists. This reflects both the century's vogue of genre painting and the indisputable preponderance of eighteenth-century painters in Bolognese art collections as witnessed by Oretti's record. Nonetheless, a few instances of earlier genre paintings can be found in the Palazzo Tanari (*A Girl Playing an Instrument* by Agostino Carracci and another one by Annibale) and the Palazzo Angelelli (*Harvesters* by Annibale Carracci).

Seventeenth-century painters were not numerous either: Giovanni Maria Galli Bibiena (two pictures in the Palazzo Scarselli); Francesco Ghelli (four market scenes, three of which were in the house of the lawyer Giovanni Magnoni, while the other one was the property of the merchants Rizzardi, who also possessed a *Tavern Interior* by the same author); Lucio Massari (*Players* in the Palazzo Armi); Flaminio Torri (*Women Doing Needlework* in the Palazzo Malvasia); Francesco Brizio (*Soldiers Playing Cards* in the house of the Arnoaldi); Leonello Spada (one picture in the collection of Domenico Landucci); Carlo Cittadini (four works in the house of an art dealer named Mazzanti); Pier Francesco Cittadini (a *Greengrocer* in the Palazzo Aldrovandi, a bambocciata in the Palazzo Zagnoni, two more genre works in the Palazzo Legnani); Leonardo Ferrari (six caricatures and a *kermesse* in the Palazzo Bonfiglioli). From what has been observed so far, it can be concluded that Bolognese art collectors were not too keen on genre painting, or, if they were, they did not like to show it. Further reinforcement of this conclusion is found in the lists of pictures displayed during the annual exhibitions called *Addobbi* (that is, decorations). These were (and still are) religious festivals which each city parish would celebrate every ten years, in groups of five parishes per year. Each parish would organize a procession through the main streets of its precinct. Precious damask hangings were put at the windows of the houses along the procession route, colored silk and gauze veils stretched across the streets or under the arcades of the palaces, pictures and, less often, statues, tapestries and drawings were exhibited in floral settings under the shade of those very arcades or of the vaulted passageways leading from the streets into the private courtyards of the noble palaces. Sometimes the exhibits belonged to the owners of the palaces,

sometimes to proud collectors from a different area of the city, or to professional art dealers who exploited this opportunity to make their goods known to the public. It is conceivable that some artists who wanted to make a name for themselves or exhibit their latest production also took advantage of the same facilities.[160]

In the nineteenth century, brief printed catalogues of such exhibitions were available, and many have come down to us. In the eighteenth century, similar printed leaflets might have existed but have perished.[161] For the lists of the paintings, it is therefore necessary to rely once more on Marcello Oretti, who diligently took note of them year by year from 1759 to 1786, save for 1760, when he happened to be ill, and 1764, when he missed one of the five exhibitions.[162] The number of exhibits could vary a great deal from parish to parish and, within the same parish, from decade to decade. There could be as few as four (as in the parish of San Michele Arcangelo in 1771, against ten in 1761 and 18 in 1781) or as many as 273 (as in the parish of San Giuliano in 1783, against 13 in 1763 and 125 in 1773). Of course we cannot exclude the possibility that Oretti may have omitted to make note of some exhibits, either deliberately or by accident, but, since in one case he does state that that particular list is incomplete, it is reasonable to assume that all the other lists are not, unless stated otherwise.[163]

Although the *Addobbi* were religious festivals, the pictures on show were not necessarily religious. Virtually all sorts of pictures were hung, and the different kinds of subjects were quantitatively in the same rough proportions to one another as they were in private collections. Obviously, religious authorities, namely the Holy Inquisition, did check the exhibits and occasionally had some removed, but on the whole this fact must not have seriously affected the selection of the works to be hung.[164]

Genre painting in particular was not likely to catch the censors' attention, especially in its special Bolognese interpretation, with comic overtones or Arcadian formalisms. Most of the genre pieces on display were in fact Bolognese, or at least Italian; yet there were some notable exceptions. Anonymous Flemish pictures were fairly common. Although most of them were landscapes, there were also some genre paintings, roughly described as bambocciate, market scenes, *capricci di figure*, and so on.[165] In 1764, however, three anonymous Spanish paintings representing a *Peasant*, a *Peasant Woman* and a *Chimney Sweep with Cats* were hung outside the church of San Giovanni Battista dei Celestini.[166] They were next to a Velázquez and a Rubens, both the property of Farinelli, a very famous opera singer who had traveled extensively. His unusual biography can probably account for his equally unusual selection of paintings.[167]

Among the Italian artists, two at least deserve

mention: Caravaggio and Pier Francesco Cittadini. A painting attributed to Caravaggio and representing a *Woman with a Basin* was first exhibited in 1773 in the parish of San Vitale by its owners, the noble Orsi. It was exhibited again in 1783, but this time Oretti records it as anonymous. In 1780, when it had been given on loan to the chemist at Santa Maria del Carrobbio for that year's *Addobbi*, Oretti had already doubted its attribution. He was probably right in rejecting it, but this gives an interesting hint of the attitude noble art collectors had towards their possessions: a Caravaggio in Bologna was pretty rare (only three collections, including the Orsi, could boast one). According to manuscript B 104, however, the Orsi Caravaggio represented "a female figure, possibly Herodiades." Although the protagonist of the picture in both references to it is female, and although Herodiades could well carry the Baptist's head in a basin, it is difficult to understand how Oretti could mistake her for "a woman who carries a basin to wash herself." Apparently, however, he did not use the notes taken at the *Addobbi* to compile his manuscripts B 104 and B 109.[168]

As for Pier Francesco Cittadini, the presence of his paintings is fairly constant: virtually all middle-sized to large *Addobbi* had some of his works on display. Interestingly enough, many of these were genre works. Despite his practicing all kinds of painting, in the eighteenth century he seems to have been valued most for his genre pieces. The subjects of his genre pictures are not identified in precise terms: they are generally referred to as bambocciate or *baccanali di villani*, but, on a few occasions, captions are more accurate and refer to *Tavern Interiors* (1772, parish of San Benedetto); *Peasants Having their Meal* (1771, parish of San Niccolò degli Albari); *School Teachers* (1769, Santa Maria della Mascarella); and so on.[169] This "Lombard" side of his activity was not so clearly emphasized in B 104 and B 109.

Eighteenth-century Bolognese genre painters outnumber the representatives of earlier centuries or of different schools. Oddly enough, Giuseppe Maria Crespi's genre works are very rarely recorded, nor is he regularly mentioned in inventories. It is easier to find copies after his genre works exhibited; although they are generally unattributed, it can be assumed that they were probably by one of his sons. Both Luigi and Antonio Crespi are occasionally recorded among the artists whose works were exhibited, and their contributions sometimes included bambocciate.[170]

According to Oretti's records, the two protagonists of genre in Bologna seem to have been Antonio Beccadelli and Stefano Gherardini. Their presence is fairly regular and is not generally limited to one single exhibit. Most of their works are labeled as bambocciate, but there are paintings with friars too. A picture by Beccadelli representing a man who sharpens his pen is recorded in the parish of San Benedetto in 1762. It is worth pointing out that a Flemish painting with the same subject existed in Bologna and was exhibited in 1773 in San Niccolò di San Felice. As a matter of fact, Beccadelli's favorite source of inspiration must have been Flemish rather than Italian genre, at least as far as subject matter is concerned. This was surely true in the case of the man counting his gold coins, or of the "figures of men after the Flemish style" that Oretti saw in San Niccolò di San Felice in 1783.[171]

Going through all the lists of parish exhibitions systematically, it is possible to gather further information and to make a few additional remarks. Thus it can be observed that, although Venetian genre paintings are quite rare, there is at least one interesting addition to the very few of them recorded in private collections, namely the *Beggars* by Niccolò Bambini exhibited in the parish of Sant'Agata in 1776. As far as subject matter is concerned, descriptions in these lists are usually so vague that it is difficult to extract much useful information from them. Amidst the variety of vague bambocciate, kitchen interiors, market scenes, peasants, greengrocers, and old people of either sex, Gambarini's *Forge*, exhibited in the parish of Sant'Isaia in 1773, or Marchesi's *Tanners*, exhibited in various parishes, strike us as very original subjects.[172]

An analysis of single bits of information is bound to be less rewarding than a survey of the general trends in Bolognese art collecting. The data on the quantity, diffusion and quality of genre available in Oretti's manuscript B 105 are not inconsistent with what can be ascertained from B 104 and 109, although there are some discrepancies. In general, it is fair to say that they confirm and complete the overall picture of Bolognese art collecting: they confirm that genre was not particularly favored or appreciated in the city, and that the presence of foreign works was rare and virtually irrelevant, save for Flemish paintings, which did exist and must have been more numerous than is generally believed. Obviously, the quantity and quality of Flemish painting in Bologna cannot be judged by Milanese, Genoese, Florentine or Roman standards, but then we should not forget that Bologna had no particular political or commercial links with the Low Countries, therefore the presence of Flemish art can never be considered accidental or occasional: it implies some specific artistic motivation.

As for the contemporary reputations of individual Bolognese genre painters, they do not tend to reflect our expectations; we might, however, question whether our expectations were correct, or if they were not based on a distorted perspective. I do not simply mean to imply that taste changes (whatever the word "taste" may be taken to mean); I would rather stress the fact that historians work with incomplete sets of data and that their perceptions of

historical events are colored by their own research experience and by popular beliefs. The empirical evidence of so many eighteenth-century genre pictures preserved in today's public and private galleries naturally leads us to expect that many more once existed and were destroyed or disappeared at some time or other. The "readability" of a painter in terms of our modern vision leads us to prefer him and to wish him better success than he did in fact have. The compatibility of genre paintings with modern intellectual, social or political concerns forces us to think that such was always the case.

In the case of genre painting, it was and is a matter of fact that the eighteenth century made this particular kind of painting acceptable and even sought after in Italy, without the passionate, radical rebuttals or total devotion that the heated seventeenth-century theoretical discussions had urged. Yet Italy was not Holland: the importance and significance of genre in Italy was always relative, subsumed in a social, political and cultural context in which history painting was always prevalent, where academies could switch from baroque classicism to rococo classicism and neo-classicism, but would not accept anything totally "untraditional" and "unconventional." Reflecting Bolognese taste, Zanotti did not like Crespi: what disturbed him the most about him was his unclassical bias — which was quite another thing than being unconventional or untraditional.

In this perspective, Crespi's rare presence in Bolognese private collections and public exhibitions becomes understandable and less surprising; the inflated reputation of the mediocre but "correct" paintings of Gherardini becomes less inexplicable. The discrepancy between written documentary evidence (art literature in all its aspects — from inventories to biographies and correspondence) and visual evidence is no longer so strange or unintelligible: it is almost obvious. If we accept the logical and historical reality that genre works were not so much more numerous than the extant ones and that, conversely, documentary traces of them are partial (meaning both incomplete and biased, or partisan), we must admit that the data finally find some satisfactory though precarious balance. Genre *was* an inferior kind of painting, not so much inferior as educated classicist dilettanti would have liked, but not so "equal" as twentieth-century bias would suggest.

1) On L. Crespi, cf. R. Roli in DBI, vol. 30, pp. 718-22; G. Perini, 1981/82, and Ead., 1985, pp. 235-61 (this article, which is marred by a number of nasty typographical mistakes, will be hopefully reprinted soon in a collection of essays).

2) Cf. Bologna, Biblioteca Comunale dell'Archiginnasio (hereafter BCB), MS. B 15 and B 162, *passim*.

3) For Chiabrano, see DBI, *ad vocem Chiabrano Francesco*; and Grove (ed. Sadie), 1980, vol. 4, pp. 218-19.

4) Cf. BCB, MS. B 162, letters nos. 124, 125, 127, 130, 140, 142, 149, 150, 151, 157, 160, 161, 163, 167, 168, 168 bis, 169, 171, 178. In letter no. 151, dated January 25, 1775, Chiabrano finally admits that he is buying paintings for investment and speculation.

5) BCB, MS. B 162, letter no. 124: "*sento che Vostra Signoria si compiace propormi quadri del suo Signor Padre quale veramente ne ho fatto sempre una gran stimma, ora le dirò che volentieri ne farei aquisto se non fosero quadri sacri, mentre tengho le camere quasi tutte copperte de tali soggetti e che in caso fossi costretto o per necessità o volontariamente, resta molto difficile il trovare il compratore; intanto io fare volentieri l'aquisto dele due bambocciate dippinte sul rame di forma ovale (...).*"

6) BCB, MS. B 162, letter no. 125: "*le dirò che per esitar quadri in questo paese è cosa molto difficile, masime quadri di un certo prezzo, che a dirliela schietta non li amano niente afatto. In riguardo alla Corte non vi è la menoma probabilità di potter esitar quadri, mentre ne anno de li centinaia e molto buoni, che non se ne servono, onde si acerti che li quadri ch'io procuro di avere non è per farne un negozio, ma ben sì per mi uso, e per prova di questo le dirò che tutti li quadri chio ho fatto venire, li ho ancora tutti e se per disgrazia io fossi in nesità (sic) di venderli, non ne tirerei la mettà di quello che mi costano.*"

7) BCB, MS. B 162, letter no. 151: "*credo benissimo sarà più facile il rittrovar quadri sacri che proffani, mentre qui de quadri sacri ne posso avere quanti ne voglio e ancora molto buoni, onde la prego di farmi la finezza (...) di procurarmene in quela maniera cioè proffani in qualsisia genere, mediante non siino abbozzetti o schizzi.*"

8) BCB, MS. B 162, letter no. 177: "*Sento pure la qualità de' sogetti e quello ch'io temo si è che li due di mezze figure, qui tali generi de' sogetti non li amano troppo, come pure quadri di animali.*"

9) BCB, MS. B 162, letter no. 169: "*sarà cosa difficile di esitarli a tali prezzi, masime li due di animali, im primo per essere troppo grandi e in secondo che non sono sogetti troppo piacevoli a nostri dilettanti, mentre qui ve ne sono deli stupendi in tali generi che non si trovano a venderli, eccetto per qualche casa di campagna, li due rappresentanti la Musica e la Pittura sono pure troppo grandi, che presentemente nessuno compra più quadri di tal grandezza, e poi quelo che di più si è che a tutti queli che li hanno veduti, cioè fatti da me vedere, dicono che certamente non sono originali del suo Signor Padre, ma ben si coppiati da qualche suo figlio.*"

10) For Spagnolo's copies after Guercino, cf. Merriman, 1980, pp. 41, 58, 74, 163, 165-167, 213, 265, 267 and 299. For the complaints of Luigi's customers, see BCB, MS. B 15 and B 162, *passim*.

11) For the *Shepherdess*, cf. Luigi's correspondence with Carlo Emanuele Cavalleri, Count of Groscavallo, in BCB, MS. B 15, letters nos. 62, 63, 159 and 191. For the *Adoration of the Shepherds* sent as a gift in 1742, cf. Bologna, Biblioteca Universitaria (hereafter BUB), MS. 1932, *Lettere di vari personaggi scritte al Padre Abate Paolo Salani ed alcune scritte da lui medesimo*, year 1742; letters partially published in L. Frati, 1916, pp. 279-283; BCB, MS. B 15, letter no. 88 by Claudio Francesco Beaumont; and for its attribution to Luigi, cf. Merriman, 1980, p. 241, entry no. 24.

12) For an outline of the history of genre, see G.B. Washburn, 1954, and Id., 1981², V, col. 659-670; F. Abbate, 1971, pp. 184-227; E. Battisti, 1962, pp. 278-313; and marginally also C. Gilbert, 1952, pp. 202-216. For the evolution of genre in Italy, cf. N. Spinosa, 1982. For the history of the term "genre" and its definition, cf. more specifically H. Osborne (ed.), 1971, pp. 465-467 and W. Stechow-C. Comer, 1975/76, pp. 89-94. For a comparison between Dutch and Italian genre, cf. M. Friedländer, 1943, pp. 97-99.

13) For the definition of genre, cf. *supra*, note 12. For the two paintings by Spagnolo, cf. BCB, MS. B 162, letters nos. 140 and 142.

14) F. Algarotti, 1756 (quoted from English e., 1764, p. 143).

15) G. Bottari-S. Ticozzi, 1822, III (first published in 1759), letter no. CXCIII, pp. 443-470.

16) L. Crespi, 1769, pp. 207-208. On this painting, cf. Merriman, 1980, pp. 276-277, entry no. 150.

17) Zanotti, 1739, part II, pp. 43-44.

18) Cf. Algarotti, 1792, VIII, pp. 351-388, and *Catalogo*, s.l., s.d.

19) Cf. M. Boschini, 1966, pp. 623-637.

20) For G.L. Bianconi, cf DBI, *ad vocem*, and G. Perini, 1984, pp. 797-827.

21) Cf. *Antologia romana*, 1778-1779, V, no. XXXIV, pp. 265-267; no. XXXV, pp. 273-275; no. XXXVI, pp. 281-284.

22) Cf. G.P. Bellori, 1976, pp. 211-233, especially pp. 213-215.

23) *Antologia romana*, 1778-1779, V, no. XXXIV, p. 266.

24) For Piranesi's interest in drawing cripples and beggars, cf. J. Wilton-Ely, 1978, pp. 11, 31, and note 14, p. 129. For genre works in Venetian collections, cf. R. Pallucchini, 1981, pp. 313-324, especially p. 313.

25) Cf. S. Savini Branca, 1965, pp. 140-147 and 165-178. These inventories had already been published in a less correct form by C.A. Levi, 1900, pp. 33-39 and 159-169.

26) Cf. Savini Branca, 1965, pp. 140-47, 200, and K. Pomian, 1983, pp. 542-543.

27) Cf. Savini Branca, 1965, pp. 43-44, 165-78, 188-91. For a discussion of the major trends in Venetian aristocratic collections, see *ibid.*, pp. 9-38, and K. Pomian, 1983, especially pp. 533-547.

28) Savini Branca, 1965, pp. 170-171, 173-175, 178, and K. Pomian, p. 543.

29) C.A. Levi, 1900, II, pp. 117-269.

30) C.A. Levi, 1900, II, pp. 151-158.

31) C.A. Levi, 1900, II, pp. 260-269.

32) For Piazzetta's and Longhi's activity as genre painters, cf. A. Longhi, 1762, biographies nos. IV and XII. On Piazzetta, cf. also D.M. Federici, 1803, part II, p. 123, where interestingly enough, "genre" is identified with "caricature." For modern monographic studies on these two painters, see T. Pignatti, 1969, especially pp. 8-26 and 32 (for Longhi's followers cf. *ibid.*, pp. 28-31, and V. Sgarbi, 1982, pp. 13-14); and *G.B. Piazzetta* (exhibition catalogue), 1983, especially pp. 15-40 (R. Pallucchini), and 43-53 (U. Ruggeri).

33) C.A. Levi, 1900, II, p. 229: It is not clear whether the "copies" listed herein are after or by Piazzetta.

34) For Piazzetta's activity in the Academy, cf. *G.B. Piazzetta* (exhibition catalogue), 1983, pp. 215-216 (G. Nepi Sciré). For a list of Giuseppe Maria Crespi's students, cf. L. Crespi, 1769, pp. 231-232.

35) For the influence of Hogarth and Watteau on Longhi, see T. Pignatti, 1969, pp. 14-17. For his relations with Goldoni, see *ibid.*, pp. 1 and 12; for his lack of concern with the conditions of the lower classes in a town which counted over 25,000 registered paupers in the years of his activity, see *ibid.*, p. 10.

36) P.A. Orlandi-P. Guarienti, 1753, p. 427.

37) Cf. A. Longhi, 1762, biography no. XII (English version from T. Pignatti, 1969, p. 60).

38) Cf. A.M. Panni, 1762, pp. XIII-XIV, where he explains the reasons why he will not mention pictures in private collections in Cremona: *"io di quelle [pitture] non farò punto parola, che stanno alla celata riposte nelle private Case, perocché, mutando esse tuttora Padrone, o potendo mutarlo, sarebbe stato per avventura impossibile il rinvenirle o rinvenute, passando poscia in decorso di tempo ad altre mani, e cangiando eziandio Paese, avrei gittato a perder l'opera e zappato, come suol dirsi, nell'arena."* Similar remarks had been made in 1648 by C. Ridolfi (cf. C. Ridolfi, 1965, I, p. 7), who meant to justify in advance possible inaccuracies or mistakes concerning the locations of pictures that he might make in the future.

39) For Joseph Smith's collections, see F. Vivian (1971, especially pp. 173-211 and 215-224) where the available catalogues are reprinted. On Joseph Smith, cf. also F. Haskell, 1980, pp. 299-310.

40) On Marshal Schulenburg, cf. F. Haskell, 1980, pp. 310-315 (for Ceruti, see p. 314). On his collection, cf. M. Levey, 1958, p. 221, and E. Antoniazzi, 1977, pp. 126-134. On his patronage of Ceruti, see M. Gregori, 1982, pp. 47 and 70.

41) On the reasons for this silence, cf. M. Gregori, 1982, pp. 8-10.

42) R. Longhi, 1953, pp. XVI-XVII.

43) R. Longhi, 1953, p. XVIII.

44) For a fairly recent repetition of the same questions put by

Longhi, cf. F. Zeri, 1976, pp. 91-92. For Ceruti's patrons, see O. Marini, 1966 and 1968; G. Fiori, 1974; L. Anelli, 1982, p. 30; and M. Gregori, 1982, pp. 10-11, 47, 70-71, 80-82. Cf. also *supra* note 40; and, for Pietro Lechi, F. Lechi (1968, p. 63), who is corrected by M. Gregori (1982, p. 16).

45) For the disposition of Ceruti's paintings in the Avogadro collection, see O. Marini, 1968, pp. 46-47. For the desperate conditions of the population, see *ibid.*, pp. 52-58, and also *infra*, n. 55.

46) For the value of Ceruti's paintings, see O. Marini, 1968, p. 50. G. Fiori (1974) and L. Anelli (1982, pp. 27-31) argue against a bohemian interpretation of Ceruti's work. For his itinerary, cf. M. Gregori (1982, *passim*, but especially p. 80), where his peregrinations are related to contemporary historical events; on p. 67, however, the same author seems to adhere to the earlier Romantic interpretation — some restlessness and undocumented penchant for bohème in Ceruti's mind.

47) One of Longhi's followers is obviously G. Testori (1967). M. Gregori (1982) adds some new and valuable suggestions to the classic Longhian interpretation: for Ceruti's contacts with heterodox religious movements, for instance, see pp. 23, 46, 67-68, 71.

48) Cf. L. Anelli, 1982, p. 30, and P.L. Fantelli, 1978/1979, pp. 159-164. On Matteo de' Pitocchi, cf. also, for a different perspective, R. Pallucchini, 1981, I, pp. 287-289.

49) For Pietro Lechi, cf. *supra*, note 44. For the Ferri's patronage of Ghidoni, see P.L. Fantelli, 1978/1979, p. 161; for Ceruti, see M. Gregori, 1982, p. 71. On Giulio Barbisoni, see O. Marini, 1966.

50) Cf. P. Camporesi, 1973 and 1985.

51) Cf. R. Pallucchini, 1981, I, pp. 284-285.

52) Cf. A. Arpaio, 1685, pp. 4-5 and following.

53) Cf. A. Arpaio, 1685, pp. 34-37.

54) Cf. R. Pallucchini, 1981, I, pp. 284-285, and M. Liebmann, 1969, pp. 263-264.

55) On the social and economic situation of the Italian countryside during the seventeenth and eighteenth centuries, cf. E. Sereni, 1972, I, pp. 193-196; B. Geremek, 1973, 5, pp. 694-698; B. Pullan and S.J. Woolf, 1978, I, pp. 981-1078; L. Faccini, 1983, pp. 651-670. For the economic and political history of Italy, see G. Candeloro, 1978, I, especially pp. 44-54 and 75-109.

56) On Dutch art collecting, cf. A. Hauser, 1951, I, pp. 456-470; and F. H. Taylor, 1954, pp. 259-305.

57) Cf. B.W. Meijer, 1971, p. 264; B. Wind, 1974, pp. 28-29; and. G. Romano, 1978, p. 40.

58) Cf. G. Romano, 1978, pp. 40-42.

59) On Bartolomeo Passarotti, cf. C.C. Malvasia, 1841, I, p. 187-188; on Annibale and Agostino Carracci, cf. *ibid.*, p. 343.

60) On Vincenzo Campi, cf. B. Wind, 1977; for Annibale, see *Id.*, 1976.

61) On Todeschini (or Cipper), cf. L. Tognoli, 1976, and R. Wishnevsky, in DBI, vol. 25, especially p. 728. On Cifrondi, cf. L. Anelli, 1982; P. Dal Poggetto, 1982, especially pp. 368-396; L. Ravelli, 1983; for the Bolognese, cf. R. Roli, 1977, pp. 181-193, and E. Riccòmini, 1979, pp. 9-39.

62) For Ceruti's sources, cf. M. Gregori, 1982, pp. 45, 49-66, 74, 83. On Gainsborough, cf. J. Burke, 1976, pp. 211-221, but especially p. 217, and J. Barrel, 1983, pp. 35-88.

63) For Ceruti's paintings used as *soprafinestre*, cf. O. Marini, 1968, p. 47. It is obvious that *soprafinestre*, *sopraporte* and *soprabalconi* could not be looked at and relished at their best, owing to their awkward location: in fact, it was not infrequent to find paintings of lesser merit in those positions, where their blemishes were less conspicuous. A letter by Chiabrano to Luigi Crespi proves this: Chiabrano, after complaining of the poor quality of some pictures bought from Crespi, exclaims: *"li altri [quadri] non sono buon ad altro che di servirsene per sopraparte, ma che siino molto alte!"* (cf. BCB, MS. B 162, letter no. 161). It is therefore intriguing that we find a number of Cerutis in such unfavorable positions.

64) For the perspective mistakes and indifference to spatial

relationships detectable in some "painters of reality," namely Todeschini, cf. R. Wishnevsky in DBI, vol. 25, p. 728; O. Blazicek, 1966, I, p. 774.

65) For the provenance of the *Two Beggars*, cf. M. Gregori, 1982, pp. 9-10. For the catalogue of Paolo Bagnoli's collection, see P. Guerrini, 1926 (the *Two Beggars* are item no. 386, p. 239). The catalogue of Giulio Barbisoni's collection is published in G.B. Carboni, 1760 (the picture that could be identified with the *Two Beggars* is on p. 174).

66) Cf. R. Longhi, 1953, plate no. 124: now reproduced also in M. Gregori, 1982, plate no. 112.

67) This "puzzling series of farming scenes" is discussed in J. Barrell, 1983, pp. 25-31; such discussion has been ignored by J. Egerton, 1984, pp. 166-169.

68) Cf. M. Gregori, 1982, p. 41 and plate no. 43.

69) On these treatises, cf. E. Raimondi, 1966, pp. 73-86, and P. Camporesi, 1973. For an example of these treatises and some information on the *Affrati*, cf. *Trattato*, 1828, pp. 11-19.

70) Cf. L. Lanzi, 1974, III, p. 230.

71) Cf. F. Franchini Guelfi, 1977, pp. 36-43 and 71-73.

72) Cf. C.G. Ratti, 1797, p. 157.

73) On Giovanni Agostino Ratti, cf. L. Lanzi, 1974, III, p. 231, and F. Alizeri, 1864, I, pp. 251-252.

74) Cf. F. Franchini Guelfi, 1977, pp. 39 and 71.

75) Cf. C.G. Ratti, 1797, p. 160.

76) Cf. D. Puncuh, 1984, pp. 196-201.

77) Cf. C.G. Ratti, 1780², p. 286.

78) *Dice Players* by Caravaggio are in Giacomo Gentile's collection (C.G. Ratti, 1780, I, p. 131) and in Marcello Durazzo's (*ibid.*, p. 211). Bartolomeo Manfredi is present in Card. Giulio Raggi's gallery (*ibidem*, p. 236). For Jusepe de Ribera, cf. Marcello Durazzo's palace (*ibidem*, p. 183).

79) L. Lanzi, 1974, III, p. 257.

80) Cf. L. Lanzi, 1974, III, p. 257. On the most important items in this collection, see R. D'Azeglio, 1862, and *Per una storia del collezionismo sabaudo*, 1982, p. 17ff.

81) For the date of the acquisition of Prince Eugene's collection, cf. A. Vesme, 1887, p. 166; for Olivieri's contacts and contracts with the court, cf. G. Delogu, 1931, pp. 242-246.

82) Cf. G. Delogu, 1931, p. 240.

83) On Jan Miel's stay in Turin, cf. G. Briganti, 1980, II, col. 299, and Christopher Brown in P. Sutton ed., 1984, p. 254.

84) A. Baudi di Vesme, 1932, p. 363.

85) Cf. F. Bartoli, 1776, I, pp. 39 and 53-54.

86) *Ibid.*, I, p. 37.

87) Cf. S. Pettenati, in E. Castelnuovo and M. Rosci ed., 1980, I, p. 120, entry no. 138.

88) On F. Londonio, see C. Pirovano, 1973, p. 170, and N. Spinosa, 1982, p. 71. Cf. also L. Lanzi, 1974, II, p. 346. For Magnasco's patrons in Milan, cf. C.G. Ratti, 1797, p. 158.

89) On Giovanni Francesco Arese's collection, cf. F. Arese, 1967, pp. 128 and 129-141.

90) For about two centuries Milan was ruled by Spain; therefore it was often linked to the Low Countries and Flanders by a common political fate. Relationships with the Low Countries and Northern Europe in general are essential to explain a lot of Lombard art, even in minor towns like Cremona, for which see B.W. Meijer, 1985, pp. 25-32, but especially pp. 28-29, where the influence of Flemish painters on Vincenzo Campi and the evolution of Lombard genre is discussed.

91) Cf. C. Bianconi, 1787, p. 73.

92) For the Arese, cf. F. Arese, 1967; for the D'Adda, cf. E. Bertoldi, 1974; for the Melzi, cf. G. Melzi D'Eril, 1973.

93) Cf. G. Melzi D'Eril, 1971, pp. 64-84.

94) On these painters from Tyrol and their relations to Todeschini and Ceruti, cf. M. Gregori, 1982, p. 45, and R. Pallucchini, 1981,

I, pp. 264-265.

95) The pictures by Wouvermans are entries nos. 135 and 136 in Bianconi's catalogue; Gerrit Dou's are nos. 63 and 64.

96) Bellotti's paintings are nos. 7 and 8; Giuseppe Maria Crespi's is no. 117; Jusepe de Ribera's is no. 115; Stefano Polazzo's no. 95. On the paintings bought by Giacomo Melzi, cf. G. Melzi D'Eril, 1973, pp. 61-62, 100 and 137-138.

97) For the Cerutis originally attributed to Nogari, cf. G. Melzi D'Eril, 1973, p. 128. For some affinities between Ceruti and Nogari, cf. M. Gregori, 1982, p. 76.

98) On the compilation of the inventory, cf. G. Melzi D'Eril, 1973, p. 55.

99) Cf. E. Bertoldi, 1974, pp. 199, 200 and 202.

100) Cf. G.B. Carboni, 1760, p. 170.

101) Bruno Passamani, 1981, p. 24, draws totally different conclusions from the data provided by G.B. Carboni, 1750, pp. 145-185: according to him, in the same seven galleries there were at least 300 genre works: this figure, however, takes into consideration also 110 pictures of animals, 42 landscapes, 16 seascapes, eight still lifes, 32 *vedute*, 32 battle scenes — that is, it refers to genre in its broadest sense. Passamani is perfectly consistent with some earlier essays of his (cf., for example, 1961, III, pp. 619-622 and 661-676) where the term "genre" was used in its eighteenth-century meaning: I wonder, however, whether a use of this term inconsistent with present-day standards cannot partially account for the already lamented discrepancies which often, if not regularly, occur between the present analysis of the fortune of genre in private art collections and the traditional ideas on the vast popularity of genre in the seventeenth and eighteenth centuries. In other words, it is very likely that, regardless of the common present-day meaning of "genre," some art historians feel entitled to adopt its original sense when dealing with art collections of past centuries. From a theoretical point of view, this is perfectly acceptable, or even more correct, but it is certainly misleading when general conclusions are drawn. It favors building up wrong expectations against which the results of a more coherent survey are bound to clash. By saying this, I do not wish to imply that all the problems of contradictory data derive from verbal misunderstanding only: I simply want to draw attention to this factor. Others have already been pointed out and still others will be given presently: nevertheless, verbal misunderstanding is not to be overlooked, and it clearly explains the apparent disagreement between the data I take into consideration and Passamani's.

102) Cf. G.A. Averoldo, 1700, pp. 243-247.

103) Cf. BCB, MS. B 97, ff. 268r-271r, published in C. Boselli ed., 1962, pp. 33-39. For the later inventory, cf. F. Lechi, 1968, pp. 123-164.

104) Cf. F. Lechi, 1968, pp. 61-63.

105) For Lechi's collection, see F. Lechi, 1968, pp. 125, 128, 129, 134, 135, 142, 143, 146; G.A. Averoldo, 1700, p. 245, 246.

106) Cf. M.A. Baroncelli, 1965, p. 11.

107) G.A. Averoldo, 1700, pp. 253-254.

108) L. Lanzi, 1974, III, p. 231.

109) F.M. Tassi, 1793, II, pp. 110-114, and M.A. Baroncelli, 1965, pp. 65-83.

110) F.M. Tassi, 1793, II, p. 40.

111) On Giacomo Carrara's collection, cf. A. Pinetti, 1922 (Borsetti's inventory is published at the end of this booklet, pp. 68-158); R. Paccanelli, 1976/77; M.E. Manca, 1983/84, pp. 16-21; G. Perini, 1986 (in press).

112) R. Paccanelli (1976/77, I, p. 393) gives a table on the composition of the gallery dividing the various items according to their subject matter (labeled as follows: "sacred history", "Virgin and Child," "saints," "profane history," "genre," "portraits," "heads"). In that table, "genre" includes 284 pictures out of 1,271 (22.34 percent): but obviously Paccanelli, like Passamani, includes landscapes, battle scenes, etc. (cf. *supra*, note 101).

113) Cf. F.M. Tassi, 1793, II, p. 113.

114) Cf. R. Paccanelli, 1976/77, I, pp. 390-393.

115) Cf. G. Perini, 1986 (in press).

116) Cf. Bergamo, Biblioteca dell'Accademia Carrara, file XX, folder no. 3 (inv. no. 1068/3), f. 14.

117) On Bergamasque collections of the seventeenth century, see R. Paccanelli, 1976/77, I, pp. 23-64. For the eighteenth century, see *Pinacoteche*, 1917, pp. 32-33; and A. Locatelli Milanesi, 1928, pp. 29-42.

118) Cf. A. Locatelli Milanesi, 1928, p. 37, and M.A. Baroncelli, 1965, p. 70.

119) Cf. BCB, MS. B 15, letters nos. 153-154; Bergamo, Biblioteca Civica Angelo Mai, MS. λ - 5 - 33, letters nos. 40 and 45; L. Crespi, 1769, pp. 211-212. For a detailed survey of this problem, see A. Emiliani, 1973, pp. IX-XXXVII, and Merriman, 1980, pp. 147-153 and 320-326.

120) Merriman, 1980, p. 137.

121) Cf. Merriman, 1980, pp. 107-112.

122) Carracci's, Mitelli's and Tamburini's *Arti* have been recently reprinted in A. Molinari Pradelli, 1984; for Carracci, see A. Marabottini, 1979; for Mitelli, see F. Varignana, 1978, pp. 205-220; for Tamburini, cf. D. C. Miller, 1972, and G. Roversi, 1984. On Crespi's *Arti*, see M. Pajes Merriman, 1980, p. 110 and figs. 60-64.

123) On A.M. Zanetti the Elder, cf. A. Bettagno, 1969, pp. 11-26 (especially pp. 18 and 21, where the *Arti che vanno per via* is mentioned).

124) Zompini's book has been recently reprinted (G. Zompini, 1980). As for Annibale's peddlers, they are generally supposed to be Bolognese, partly because of the collection's title (*Le arti di Bologna*) and partly because some sketchy backrounds have an unmistakably Bolognese air (cf. especially plates 60-61). Also some of the captions show the influence of Bolognese dialect (e.g. *Brendatore, Solfaroli* and *Marletti*), but others show the Roman influence (*casio*, or *cascio*, instead of *formaggio* for cheese is used in central and southern Italy, not in the North; *mondezza* is another typically Roman word: its equivalent in the regional Italian of Emilia would be *rusco*).

125) Cf. G.P. Zanotti, 1739, I, pp. 181-184.

126) *Ibid.*, pp. 390-391.

127) Cf. L. Crespi, 1769, pp. 208, 217, 223 and 226-231.

128) For a quick anthological survey of seventeenth-century discussions of genre, see G. Brigantti, 1950, pp. 17-26. Boschini should be added to the sources quoted by Briganti; for his opinion on genre (in the weak sense of the term), cf. R. Pallucchini, 1981, I, p. 313. On Baldinucci, cf. M. Pajes Merriman, 1980, p. 207, n. 6.

129) It has been observed earlier on (cf. *supra*, pp. 88, 92-93 and n. 101) that some quantitative discrepancies exist between our assumptions concerning the diffusion of genre in private collections and the documentary evidence on the same issue. Without wishing to linger too much on this topic here, I want to stress that our disappointment at the meagre evidence on the diffusion of genre is caused mainly by our opposite expectations. Although documents are not exhaustive and the data we can gather from them are not complete (save for legal inventories), we must admit that, in the case of Bologna, figures are not so low if considered in their absolute values (see *infra*, p. 92). 129 genre paintings would be enough to furnish various museum rooms; besides, this figure is only slightly smaller than the one which can be obtained by adding up all genre pictures listed in R. Roli (1977, pp. 225-299): in fact, that total is *only* 153. Obviously what is really perplexing is the ratio between genre paintings and the whole of the works of art recorded. However, we have no real evidence to justify the assumption that their ratio or percentage should be higher: first of all, very few artists were full-time genre painters (in the case of Bologna, neither Crespi, nor Gambarini, nor Rossi were such); secondly, part-time and full-time genre painters were but a small portion of the whole of painters. It is perfectly logical that their works cannot outnumber history paintings, altarpieces and so on.

130) On Marcello Oretti, see G. Perini, 1983. For his manuscripts on art collections and an analysis of the data in B 104, see G. Perini, 1978/1979. The four manuscripts quoted in the text are all preserved in BCB. MSS. B 104 and B 110 have been thoroughly

and accurately indexed (cf. E. Calbi - D. Scaglietti Kelescian, 1984, and D. Biagi, 1981). An index of B 109 is in preparation. In the light of this fact, I have not deemed it necessary to give the exact page reference for each single datum taken from either of these three manuscripts that I discuss. The printed indices mentioned above can be used to find quick reference to the page number in Oretti through the artists' names. Since B 105 has not been indexed, I have given the reference to the manuscript.

131) Correcting one or more attributions which modern research has proved wrong would mean making a major methodological mistake, for instead of making it more accurate, such occasional corrections would mar the homogeneity of the text. It is not so important to ascertain which painter had made the pictures, but which painters the collectors or their contemporaries thought were represented in their galleries.

132) Cf. BCB, MS. B 104, prefatory note, f. unnumbered by Oretti (anastatic reprint in E. Calbi-D. Scaglietti Kelescian, 1984, p. 17).

133) For his discovery of copies regarded as originals by their owners, cf. BCB, MS. B 104, prefatory note. For changes in attributions, cf. BCB, MS. B 104, part II, f. 15 (Oretti's paging): "*è di Bartolomeo Passerotti benché dicono che è di Tiziano.*"

134) For Oretti's use of local art literature in compiling B 104, cf. G. Perini, 1981, p. 222, note 85, and E. Calbi-D. Scaglietti Kelescian, 1984, pp. 8-9 and 13.

135) It is my intention to discuss these methodological issues in greater detail in a forthcoming essay on art collecting in Bologna in the eighteenth century. The following pages rely on the data gathered for that study.

136) For the Belloni, cf. A. Caracciolo, 1982. For the Piastra, their palace was bought by the Duchess of Modena, therefore their bourgeois name is simply a remainder of past times. For the Oretti and their precarious economic conditions, see G. Perini, 1983. As for Baldassarre Carrati, his enrollment in the Bolognese nobility was fairly recent.

137) Since it is impossible to determine the exact number of paintings, and since two indicates a plural quantity, but a definite one, the only possible way of using the datum consists in giving it a wholly symbolic value devoid of any precise quantitative determination.

138) For Bentivoglio's three paintings, see BCB, MS. B 104, part I, ff. unnumbered between ff. 69 and 70 (Oretti's paging) and also f. 94. For Filippo Hercolani's collection, see BCB, MS. B 104, part I, ff. 104-105 (Oretti's paging has almost totally disappeared, probably rubbed out when the three pages were removed from their original location and put at the very beginning of the manuscript); ff. 59-65 and 135-138. Oretti's list includes 128 pictures. Some of them are registered in more than one list, for the three lists derive from at least three different partially overlapping sources: L. Crespi, 1769, p. XIX; *Id.*, in G. Bottari-S. Ticozzi, 1822, VII, letter no. X, pp. 94-105; and finally J.A. Calvi, 1780, where 50 paintings are described. None of these sources is as complete as L. Crespi, 1774, unpublished (BCB, MS. B 384, part II), where over 250 paintings are recorded and discussed: this manuscript was certainly unknown to Oretti, who for his second list must have relied on a different manuscript source. A more detailed description of Oretti's records on this collection is found in G. Perini, 1978/79, pp. 221-224.

139) Similar data on anonymous paintings in aristocratic collections are discussed in G. Perini, 1978/1979, pp. 236-238.

140) The sums of the paintings of Tables I and II, and of Tables III and IV, do not coincide with the total number of paintings in aristocratic and bourgeois collections respectively, because anonymous paintings have not been taken into consideration. They are 222 in B 109 and 355 in B 104. If they are added to the totals, the accounts are balanced: i.e. (555+355+3443) + (293+222+2051)=4353+2566=6919.

141) It is likely that foreign paintings were more common in aristocratic collections because noblemen were often sent on diplomatic missions abroad and might well have taken home some "souvenirs" of their journeys. Moreover, it was probably more expensive to buy works from abroad than on the local market.

142) For a survey of different interpretations and dating of G.M. Crespi's interest in genre, cf. Merriman, 1980, pp. 104-106 and p. 207, n. 2, and p. 208, n. 21.

143) Ranuzzi's catalogue is published in G. Campori, 1870, pp. 409-419.

144) The Orsi Van Dyck was nicknamed *La Balia* and is now known via prints, especially one by Ludovico Mattioli (cf. G. Gaeta Bertelà, 1974, entry no. 466).

145) On J.B. Beccari, cf. DBI *ad vocem*, and G. Fantuzzi, 1782, II, pp. 31-41. For his collection, cf. BCB, ms. B 109, ff. 54-56.

146) In the miscellaneous category, I have included battle scenes, concerts and hunting scenes, plus anything else that cannot fit into the other categories.

147) Actually, in the Palazzo Paleotti there were two paintings of *Beggars* by Giovan Battista Barca, a painter from Mantua who was active mainly in Verona. L. Lanzi (1970, II, p. 151) classifies him as Venetian, but it is difficult to place him because he is also supposed to have been a student of Fetti's. This might be confirmed by the presence of two pictures by Fetti in the Palazzo Paleotti: if Barca was a student of his, his two paintings might have been bought together with his master's, and the presence of the works of a fairly obscure foreign painter would no longer be puzzling.

148) On the Genoese Benso, cf. R. Soprani-C.G. Ratti, 1768, pp. 279-285; for the Bolognese Benzi, cf. L. Crespi, 1769, p. 110, and R. Roli, 1977, p. 229.

149) For the Bonfiglioli catalogue, cf. G. Campori, 1870, pp. 616-628.

150) Merriman, 1980, pp. 206 and 103.

151) These data can be checked in D. Biagi, 1981.

152) On the Sampieri gallery, cf. *Descrizione*, 1795, and BCB, MS. B 104, part II, ff. 42-47.

153) For the catalogues of the Hercolani collection, cf. *supra*, n. 138. On Crespi's in particular, cf. G. Perini, 1985, pp. 250-252.

154) It seems a strange coincidence that two different branches of the same family possessed two paintings by Crespi with exactly the same subjects: a *Butcher's Shop* and "*Amosteria*". It almost gives one the impression that the same two paintings were dealt with, the more so because the Marchesini had inherited the Crespis with the collection of Giovanni Ricci, one of lo Spagnolo's most important patrons (see Merriman, 1980, p. 203, n. 28). It is true that Oretti states that the two *Butcher's Shops* are different (cf. BCB, B 109, part I, f. 8), but, in the following line, he admits that both the *Butcher's Shop* and the "*Amosteria*" in the house of Filippo Marchesini "have gone missing."

155) For Crespi's *Scene in a Wine Cellar*, cf. M. Pajes Merriman, 1980, p. 309, entry no. 260, and color plate XIV. As for Bassano's "*Amosteria*", it was exhibited in the parish of San Gregorio in 1767 during an "*addobbo*" (for which see *infra*, p. 101): cf. BCB, MS. B 105, f. 60.

156) Antonio Buratti had patronized the edition of Zanotti's *Le pitture di Pellegrino Tibaldi (...)*, published in Venice by Pasquali in 1756, and for this reason he had been associated to the Accademia Clementina in Bologna: cf. Bologna, Biblioteca dell'Accademia di Belle Arti, *Atti*, I, f. 203.

157) Merriman, 1980, p. 103.

158) For the legal inventory of the Fava collection, cf. G. Campori, 1870, pp. 602-615. Incidentally, it may be observed that the expert appointed for the compilation of the inventory was Donato Creti himself. For the relations between Donato Creti and Burrini, cf. R. Roli, 1977, pp. 116-117.

159) On these painters, cf. R. Roli, 1977, pp. 181-183, and E. Riccòmini, in *L'arte*, 1979, pp. 9-41.

160) For artists showing their pictures during religious festivals, namely the *Addobbi* (which coincided with the holiday of Corpus Domini), cf. G.P. Zanotti, 1739, I, p. 388 (in the life of Giuseppe Gambarini). As for the rest of the above information, it is taken from a careful reading of Oretti's manuscript B 105.

161) For the nineteenth-century catalogues, cf. A. Emiliani, 1972, 1972, pp. 49-50. For earlier publications, usually poems or general descriptions of the decorations, without lists of the paintings on show, cf. L. Frati, 1888, I, pp. 314-22, nos. 2590-2656. For a partial list of iconographical sources, showing the processions and decorations in the streets, cf. A. Frabetti, 1982, p. 155.

162) Cf. BCB, MS. B 105, f. unnumbered and 10.

163) For incomplete lists, cf BCB, MS. B 105, part I, ff. 102, 223, etc. For San Michele Arcangelo, cf. BCB, B 105, part I, ff. 13, 126, and part II, f. 28; on San Giuliano, cf. *ibid.*, part I, ff. 28-29, 169-70, and part II, ff. 57-61.

164) Cf. BCB, MS. B 105, part II, ff. 71-78 and 124.

165) For anonymous Flemish paintings, cf., for instance, BCB, MS. B 105, part I, f. 156, part II, ff. 11-12, 18, etc.

166) Cf. BCB, ms. B 105, part I, f. 37.

167) On Farinelli, cf. A. Bettagno, 1969, p. 46.

168) BCB, MS. B 104, part I, f. 88, and B 105, part I, f. 161, and part II, ff. 13 and 53. In B 104, after suggesting the identification of the biblical theme, Oretti notes that the Orsi called it *La lavandara*: it is interesting to observe that the owners considered it a genre painting (like their Van Dyck, which they thought represented a wet nurse: cf. *supra*, n. 144), whereas the dilettante tried to find a "historical" subject in it.

169) For genre paintings by Pier Francesco Cittadini, cf., for instance, BCB, MS. B 105, part I, ff. 90, 126 and 157.

170) Cf. BCB, MS. B 105, part I, f. 31.

171) For Beccadelli's *Man Sharpening His Pen*, cf. BCB, MS. B 105, part I, f. 26; for the Flemish painting, cf. *ibid.*, part I, f. 171; for Beccadelli's figures *alla Fiamminga*, cf. *ibid.*, part II, f. 68.

172) For Niccolò Bambini, cf. BCB, MS. B 105, part I, f. 133; for Gambarini, cf. *ibid.*, part I, f. 168; for Marchesi, cf. *ibid.*, part I, ff. 38, 216 (with a change in attribution: Gionima with the help of Marchesi), and part II, f. 107.

1 The Wedding at Cana
Oil on canvas, 118×248.5 cm.
The Art Institute of Chicago, Wirt D. Walker Fund

Merriman cat. no. 51.

Early Provenance
Giovanni Ricci, Bologna; Alessandro Marchesini, Bologna;
Dr. Giacomelli, Bologna (1769); (?) Palazzo Sampieri,
Bologna (1789).[1]

Sources
ZANOTTI (1739, II, pp. 36-37): In this time [1686-90] he
painted... for Ricci a large picture of a feast in Cana in
Galilee, depicting Our Lord at table with many people, as
is told in the Gospel. This work brought great fame to *lo
Spagnuolo*. It is painted with indescribable spirit and
bravura.
Certainly, to accomplish so much at such an early age was
the result not only of his native talent, but also of the
guidance he had from Canuti, and from the example of
Burrini, another lively and instinctive painter on a par with
anybody. *Lo Spagnuolo* was also attracted by the style of
Venetian painting, that is, by as much of it as he had seen,
and he used it in his work as much as he could. In short,
all these things combined to make him bolder and more
skilled. I remember that I was about twelve years old at the
time when he asked me to act as a model for the head of
Christ, especially as regards the hair, and I was amazed to
see the speed with which he worked; it seemed as if he
didn't paint the figures so much as they grew out of the
canvas.
CRESPI (1769, pp. 205-206): Among the pictures owned by
Ricci were three that were acquired a few years ago by
Doctor Giacomelli... The third represents the Wedding at
Cana in Galilee conceived and composed according to the
taste of Veronese. Certain of the figures, particularly that of
the Redeemer, are painted in the manner of Barocci,
thereby demonstrating the attention, wisdom, and profit
with which the master studied these painters. There is no
one who has seen this picture and has not remained
astonished and has not overflowed with praise for it.
ORETTI (ca. 1769, B. 104, [b], 48/4): The Wedding at
Cana in Galilee, Palazzo Sampieri, Strada Maggiore.
ORETTI (B. 109, [pt. 1], 7): According to Merriman, cites
two large canvases of the Marriage at Cana in the collection
of Alessandro Marchesini.

Additional Bibliography
Bologna, 1979, no. 9.

The subject of the Wedding at Cana is from John II:
1-10. Christ, at far left in Crespi's painting,
performed one of his first miracles in the company of
Mary, his mother, when he transformed water into
wine at a wedding celebration. At right, the steward
in festive dress hands a glass of the new wine to the
governor of the feast.
The early sources are agreed that *The Wedding at
Cana* was the first major work of Crespi's career;
there is reason to think that the artist himself
considered it as such. The picture was painted for his
new patron, Giovanni Ricci, who had been

introduced to Crespi in late 1686 or soon thereafter
by Giovan Antonio Burrini, with whom Crespi was
sharing a studio. The date of *The Wedding at Cana*
can be established to this epoch with some precision
due to the extraordinary coincidence that G.P.
Zanotti (1674-1765), Crespi's principal biographer,
had posed as a model for this painting when he was
about twelve years old.
Zanotti comments that Crespi painted *The Wedding
at Cana* in the Venetian style but had learned as
much from his former teacher, D.M. Canuti, and his
contemporary, G.A. Burrini; Luigi Crespi specifies
the influence of two masters of the previous century,
the Venetian Paolo Veronese, and the Umbrian
Federico Barocci. All of these references are
appropriate, especially these last two: they testify to
the force of Crespi's artistic personality, that he was
able to range far and wide in his studies without
losing himself in imitation.
Banquet scenes derived from the New Testament
became a hallmark of the late Renaissance in Venice
through the examples created by Paolo Veronese in
the 1560s and 1570s. There is a tendency in
Veronese's compositions for the sacred stories to
become swallowed up in the midst of the mob of
merrymakers, musicians, and servants. In Veronese's
time, his attention to ancillary detail was considered a
tour de force of naturalism. This legacy is duly
respected in Crespi's *Wedding at Cana* by the curious
prominence afforded the musician who kneels,
viewed from the back, at the very center of the
picture. Crespi adopts Veronese's lighthearted
approach as an appropriate style for the miracle of
this wedding celebration, but he seems at pains not to
disrupt the clarity of the narritive. Notwithstanding
his playful sense of humor, to which he gave free rein
on many occasions, Crespi invariably interpreted his
religious subjects with unambiguous seriousness.
Another artist of Crespi's generation, the Venetian
Sebastiano Ricci, revived the Veronesian banquet in
purely decorative terms that became definitive for the
eighteenth century.

Notes
1) Lanzi (1st edition, 1789), 3rd ed. 1809, V, p. 194, cites an
important *Cena* in Crespi's "more solid style" in the Palazzo
Sampieri, which could well be the present picture. This same
notice is given by Ticozzi, 1830, I, p. 378.

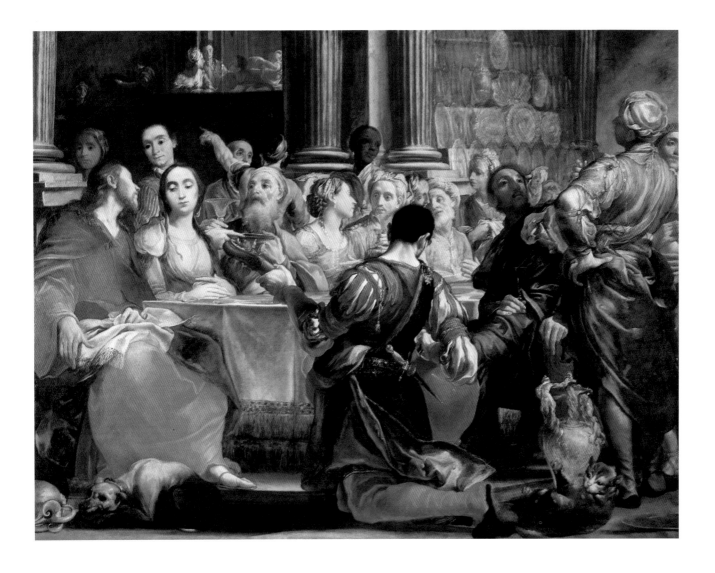

2 Tarquin and Lucretia
Oil on canvas, 195×172 cm. (inclusive of ca. 30 cm. addition at top)
National Gallery of Art, Washington, Samuel H. Kress Collection

Merriman cat. no. 177.

Early Provenance
(?) Senator Barbazza, Bologna.

Sources
ZANOTTI (1739, II, p. 58): Senator Barbazza has two paintings by him — Queen Thomyris and Tarquin.
ORETTI (ca. 1769, B. 104, [b], 105/6-9): Casa Barbazza: Thomyris, Queen of Syria, who in the presence of her victorious army immerses the head of Cyrus, whom she has defeated in battle, in a basin of blood. Tarquin who attempts to murder Lucrezia with the intention to violate her.

Additional Bibliography
Matteucci, 1965, no. III; Shapley, 1979, pp. 147-149.

The story, told by Livy (I, 58), Ovid (Fasti II, 761-812), and others, is one of several anecdotes of Roman stoicism and feminine virtue which enjoyed great popularity in the sixteenth and seventeenth centuries. Lucretia, a Roman matron, was raped by Sextus Tarquinius, son of the king of Rome. To preserve her honor, she later took her own life. Lucretia's death was avenged by her family, leading to the downfall of the monarchy and the establishment of the Republic.
The theme of Lucretia's violation was treated more than once by Titian. The vertical format and disposition of the figures in Crespi's picture are loosely quoted from Titian's most famous *Tarquin and Lucretia*, painted in 1571 for Philip II of Spain and engraved by Cornelius Cort. The comparison with Titian is apt because the expressive brushwork in Crespi's painting immediately calls to mind the late style of the Venetian, as in, for instance, Titian's *Tarquin and Lucretia* in the Akademie der Bildenden Künste, Vienna.
If we compare the Venetian qualities of Crespi's *Tarquin and Lucretia* with those of the earlier *Wedding at Cana* (cat. no. 1), it is clear that Crespi's study voyage in 1690 to Venice has occurred in the meantime. In the earlier picture, Crespi painted a Veronesian conception with the delicate tints of Barocci. The Titianesque *Tarquin and Lucretia* could not have come into being without Crespi's firsthand experience of the Venetian school. Crespi's iconography departs from that of his illustrious prototype inasmuch as he has discarded Tarquin's traditional gesture (dagger held on high). Instead, Tarquin's hand is raised as if he had first tried to argue his case with words, but now resorts to violence.
Scholars have generally dated Crespi's *Tarquin and Lucretia* in relation to his paintings for Prince Eugene

of Savoy (cf. cat. no. 4) and the *Hecuba Blinding Polymnestor* (Musée Royal, Brussels).[1] A dating to the 1690s appears reasonable for this group; the *Tarquin and Lucretia* can probably be dated to the beginning of this decade, while the others would belong to the middle years of the decade. The influence of Giovan Antonio Burrini, Crespi's erstwhile partner, can still be discerned in the shaded profile of Tarquin's face. Lucretia resembles the females in Crespi's frescoes in the Palazzo Pepoli, Bologna, which were probably painted during the early 1690s.
Zanotti's reference to a painting of this subject in the Palazzo Barbazza is of no help as regards its date but raises the possibility that the *Tarquin and Lucretia* originally had a pendant painting representing *Queen Thomyris Presented with the Head of Cyrus*.[2] A pairing of Lucretia and Thomyris would be unprecedented but has a certain logic: both are stories of strong-willed ladies who were undaunted by demonstrations of mortality.

Notes
1) Shapley and Merriman suggest a date of ca. 1700 for the *Tarquin and Lucretia* and the Brussels *Hecuba Blinding Polymnestor* (Merriman cat. no. 158).
2) The story of Thomyris is told by Herodotus (I, 214). No representation by Crespi of this subject has come to light.

3 Girl Holding a Dove
Oil on canvas, 62.8×48.3 cm.
Birmingham Museum and Art Gallery, Birmingham,
England

Merriman cat. no. 216.

Early Provenance
(?) Cardinal Tommaso Ruffo, Ferrara (1734).

Sources
AGNELLI (1734, pp. 18-19): Two pictures, each with a
half-length figure, painted by Giuseppe Crespi, called
Spagnuolo, each one the same size, about four palmi by
three. The first represents a beautiful young girl who has in
her hands a bird. A more refined beauty can hardly be
found nowadays than in this work by Spagnolo, done with
his accustomed skill and enlivened with a graceful and vivid
expression.

Additional Bibliography
Matteucci, 1963, no. II; Bologna, 1979, no. 14.

Crespi has painted a pretty girl who apparently offers
an enticement to a pet dove. The hand that supports
the bird rests lightly on her breast. Dimly seen in the
background is a woven basket which is perhaps the
bird's cage. Presumably, this quiet scene alludes to
feminine wiles and to the pleasant entrapments of love.
The painting appears to date from the 1690s and is
therefore representative of the artist's early genre
style. The half-length format and emblematic
overtones of this genre painting have ample
precedents in the work of contemporary Bolognese
painters, especially Lorenzo Pasinelli and Giovan
Antonio Burrini. On the other hand, even in his early
style Crespi seeks to imbue his genre subjects with a
sense of actual time and place. His figures are
imposingly substantial, and they are wrapped in a
palpable atmosphere of shadow and air.
Merriman was the first scholar to observe that a
painting of this subject is described in the 1734
catalogue of the collection of Cardinal Tommaso
Ruffo. Because Ruffo commissioned many works from
the local artists during his tenure as Papal Legate in
Bologna, 1721-1727, she proposed to date this *Girl
with a Bird* to the artist's full maturity. However, an
early dating is likely for reasons of style, as Volpe,
Matteucci, and Emiliani[1] have already suggested. The
picture is executed with the dense brushstrokes of
Crespi's Venetian-inspired style (cf. cat. nos. 2 and 4),
while the girl's face is not yet portrayed with the
features preferred by Crespi in the 1720s.[2]
An attractive *Girl with a Rose and a Cat* in the
Pinacoteca Nazionale, Bologna, has been proposed by
Emiliani[3] as a possible pendant for the Birmingham
Girl with a Dove, and Merriman suggested that the
pair might be the two pictures cited in the Ruffo
collection. However, the picture in Bologna appears
to be later in date, and Riccòmini has discovered,
moreover, that the pendant in the Ruffo collection

represented "a man tuning a lute."[4] A repetition of
the *Girl with a Dove*, of lesser quality, is in the
Museum of Art, Columbia, South Carolina.[5]

Notes
1) Volpe, 1957, p. 37, n. 10; Emiliani in Bologna, 1971, no. 26.
2) The girl's heavy-set brow and cheeks are closely comparable to
those of Christ in another "Rembrandtesque" early work by Crespi,
namely the *Resurrection* in Raleigh, North Carolina, reasonably
dated to ca. 1690 by Merriman (cat. no. 64).
3) Emiliani, *op. cit.*, no. 26.
4) Riccòmini in Bologna, 1979, no. 14, citing Oretti B. 131, c. 364
(MS., Biblioteca Comunale, Bologna).
5) Merriman cat. no. 217.

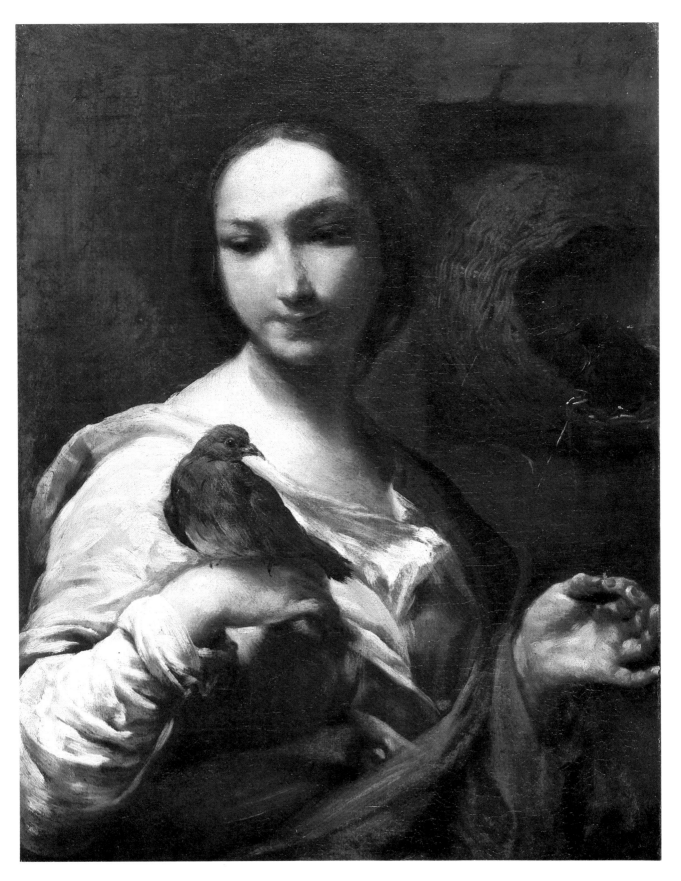

4 Chiron Teaching Achilles to Draw the Bow
Oil on canvas, 129×125 cm.
Kunsthistorisches Museum, Vienna, Gemäldegalerie

Merriman cat. no. 150.

Early Provenance
Commissioned by Prince Eugene of Savoy for his city palace in Vienna. At his death (1736), acquired for the Imperial Collections, Vienna.

Sources
ZANOTTI (1739, II, pp. 43-44): By order of Prince Eugene of Savoy, Senator Davia commissioned from him a picture representing the centaur Chiron, who instructs Achilles in the art of drawing a bow. This picture was intended to accompany three others by excellent masters, Benedetto Gennari, G. Dal Sole, Antonio Burrini. *Lo Spagnuolo* with his usual imagination, has pretended the young Achilles has shot an arrow and missed his target, so that the centaur is portrayed in the act of reproving him with a kick; a conception that is rather uncouth, but novel, the beauty of which lies in the grace with which it has been expressed. The Prince was very pleased with it, so much so that *lo Spagnuolo* had occasion to work for him for more than five years.

ZANOTTI (post 1739, in a marginal note to p. 44, line 4): an idea fit for a beast.

ALGAROTTI (1762, p. 211): Concerning the advantages of consulting with a friend... If *lo Spagnuolo* of Bologna had had men of this kind to advise him, he would never have represented, as he did for Prince Eugene, Chiron in the act of giving a kick to Achilles for not having hit the mark in his archery. The painters of the Venetian school would never take such license in their paintings, and with counselors at their side they would never have sinned so much against custom.

CRESPI (1769, pp. 207-208): For Prince Eugene of Savoy he painted in competition with Benedetto Gennari, Gio. Gioseffo Dal Sole and Antonio Burrini, a picture representing the centaur Chiron, when he instructed Achilles in drawing the bow. He pretended that Achilles, having missed his shot, was reproved by his teacher; in the manner, however, in which a coarse person would naturally make a correction, that is, he shows that the centaur is about to give Achilles a kick; a thought, as pleasant, natural, vivid, and novel as it proved to be distasteful, however, to certain critics, who, in order to show themselves as connoisseurs of the best, find it necessary to ridicule, and in their essays[1] they make note of these frivolities, without reflecting, that the painter heeds his amusing inspiration, and that suffices for him, and as for execution, if it is executed by a master, then it doesn't matter whether it accords with the fable in every respect... Notwithstanding that it was not a thought, in the opinion of the scrupulous, of the nobility that they might have desired, it was nonetheless much applauded, both for its novelty as for its grace, and expansiveness, with which it was painted; it was judged superior to the other artists', and garnered other assignments for the ensuing five years from the same Prince...

1) *Saggio sopra la Pittura*, 1756, p. 34.

The Greek hero Achilles was the son of the divinity

Thetis, who sought to protect him by immersing him in the magical waters of the river Styx; she held him by the heel, which remained dry (and vulnerable). The young Achilles was consigned to the centaur Chiron for his conditioning and training in the arts of war.[1]

At the end of seventeenth century, Senator Davia, on behalf of Prince Eugene of Savoy, commissioned four Bolognese painters to execute works for the decoration of the Prince's city palace under construction in Vienna. Crespi was about thirty years old at the time and the youngest artist by a decade to be invited to participate in this commission from Prince Eugene, whose discrimination as a collector was nearly as celebrated as was his valor in battle. Although the four painters, Crespi, Benedetto Gennari, G.G. Dal Sole, and G.A. Burrini, received their assignments at the same time, it is not immediately clear whether their paintings were intended to comprise a series, since they represent diverse episodes from Greek mythology and Roman history. Crespi subsequently painted a pendant to his *Chiron and Achilles* representing Aeneas and the Sibyl Embarking with Charon (fig. 4.1). Heinz discovered a drawing by Salomon Kleiner (1700-1761) that shows Crespi's pictures hanging as paired overdoors on either side of a bed.[2] Since the painting by Gennari was untraced, it has been frequently suggested by scholars that Crespi's *Aeneas* (which is not mentioned by the early sources) may have replaced Gennari's unexecuted contribution. However, Wolfgang Prohaska has kindly informed me

4.1. Crespi, Aeneas and the Sibyl Embarking with Charon. *Kunsthistorisches Museum, Vienna, Gemäldegalerie.*

that Gennari's painting has been rediscovered in the Kunsthistorisches Museum, Vienna; moreover, Prohaska has established that Crespi's paintings were hung in an audience chamber, the *Parade-Zimmer*, which contained an ornamental bed (*Prunkbett*), but was not in fact the Prince's bedroom.[3] The *Parade-Zimmer* could accommodate only three overdoors which would indicate that the Bolognese pictures were not intended to hang in this room alone.

Merriman proposes to date Crespi's works for Prince Eugene of Savoy to the period 1695-1700, with the recognition that the *Chiron and Achilles* is the earlier of the pair. Roli has pointed out that the Bolognese painter Marcantonio Chiarini was called to Vienna in 1697 in order to work in Prince Eugene's palace (acquired in 1694), and he hypothesizes a connection between this event and the commission given in Bologna.[4] However, these writers have overlooked Volpe's demonstration that Zanotti places G.G. Dal Sole's contribution to this group in the period 1692-1697.[5] In fact, the *terminus ante quem* for this commission must be 1697, by which time Dal Sole was no longer in Bologna. In 1697, Zanotti paid a pleasant visit to Dal Sole in Verona, where he was already ensconced in the house of Count Ercole Giusti.[6] Zanotti similarly indicates that Crespi began his five years of activity for Prince Eugene during the early 1690s, as he raises the subject immediately following his notation of Crespi's work in Pistoia in 1691.[7]

When Crespi addressed himself to the theme of Achilles' apprenticeship with Chiron, he would not have felt too constrained by precedent: earlier painters had shown Achilles learning not only archery, but also horseback riding and the use of the lance. Crespi chose archery, and typically for him, the action is cast in terms that are borrowed from real life: for having missed his target, the no-nonsense teacher chides the pupil with a kick in the seat. However, the classicist mentality, here represented by Zanotti and Algarotti, did not take to the notion of the ancients cavorting like roughnecks. Zanotti's private comment in the margin of his own book ("an idea fit for a beast") is quite a bit stronger than his published opinion. Algarotti shows no hesitance in criticizing the license taken by Crespi, and he precipitated an extended defense on the part of Luigi Crespi.[8] Algarotti says rightly enough that the painters of his native Venice never violated decorum in this way. On the other hand, they never tried, as Crespi did, to capture the motivations and emotions of the human heart.

Notes

1) Ovid (Fasti V, 385-386); Statius (Achilleis II, 381-452).

2) Heinz, 1967, fig. 28.

3) Prohaska, *Prinz Eugen*, forthcoming 1986, no. 5.4.

4) Roli, 1977, pp. 21 and 105.

5) Volpe in Bologna, 1959, no. 81.

6) Zanotti, 1703, p. 77. Dal Sole may even have arrived in Verona a year or two earlier than 1697, since he took students, and Zanotti (1769, I, p. 303) reports that he lived in that city "a long time." From a notice in Dal Pozzo (*Vite de' pittori Veronesi*, 1718, p. 202), we can deduce that Dal Sole had returned to Bologna around 1700; Dal Pozzo writes that the minor painter Francesco Comi transferred to Bologna to study with Dal Sole when his first master, Alessandro Marchesini, moved to Venice, which happened in 1700 (L. Rognini in Magagnato, 1978, p. 286).

7) Zanotti, 1739, II, p. 43.

8) Merriman assumed that Zanotti was the author of the critical remarks in a *Saggio sopra la pittura* (1756) that Luigi Crespi cites and attempts to rebut. However, the book in question was the work of Francesco Algarotti, Venetian connoisseur, who is quoted above.

5 The Lute Player
Oil on canvas, 121×152.5 cm.
Museum of Fine Arts, Boston, Charles Potter Kling Fund

Merriman cat. no 213.

The early history of this captivating picture is not known, nor does it seem to have attracted the attention of any writers from Crespi's own time. Crespi's good friend, the silversmith Zanobio Troni, owned a half-length figure of a woman playing a lute, which was an allegory of music and was paired with a half-length allegory of painting. Zanotti, however, mentions these pictures in the context of Crespi's works of the 1730s.[1] Merriman reports that in the latter half of the century, the writer Marcello Oretti saw in the house of Giacomo Marchesini nelle Lame a painting by Crespi of a half-length figure, life-sized, playing a lute in a horizontal canvas.[2] However, Oretti proceeds to identify the model as the famous singer Vittoria Tesi, which establishes a *terminus post quem* of 1716 for the painting, the year in which the sixteen-year-old Tesi gave her first performance in Bologna. If Oretti correctly identified the sitter, then the Boston *Lute Player* could not be the Marchesini picture, as it is an early work roughly datable to 1695-1705, as Merriman has pointed out. For the moment, these scattered references to unidentified paintings serve only to confirm that Crespi painted lute players, and that, on one occasion at least, he treated the subject as an allegory of music.

This exhibition includes four genre paintings by Piazzetta, each of which in its way bears testimony to the significance that Crespi's genre paintings like this *Lute Player* had for Piazzetta and the emerging Rococo in Venice. Piazzetta traveled to Bologna in order to study with Crespi, and it is possible that he arrived as early as 1703.[3] The Boston *Lute Player* by Crespi seems almost to have more of Piazzetta's typical manner than of his own, because the picture has a romance and a verve that immediately call to mind Piazzetta's tendency to "polish his apples," that is, to embellish his models. Crespi's *Lute Player* is the exception to the rule that his great genre paintings were not conceived in terms of decorative appeal.

Notes

1) Zanotti, 1739, II, p. 64. Troni acquired the pictures from a certain Antonio Comastri. Cf. Crespi, 1769, pp. 216-217. Troni testified in support of Crespi in the suit brought by Don Carlo Silva. Cf. Appendix III, .

2) In Oretti, MS. B 109, pt. 2, 5. See Merriman for a complete consideration of the various references to lute players painted by Crespi.

3) For more information, the reader is referred to the introductory essay to this catalogue, specifically to the chapter entitled "Crespi and Genre Painting in Venice."

6 The Continence of Scipio
Oil on canvas, 222×157.5 cm.
Chrysler Museum, Norfolk, Virginia, Gift of Walter P. Chrysler, Jr.

Merriman cat. no. 178.

Early Provenance
Two alternative possibilities are raised by early sources:
1) Count Ercole Giusti, Verona (1718)[1] or 2) Count Antonio di Colato, Bologna (1739).

Sources
DAL POZZO (1718, p. 297): In the house of Count Ercole Giusti at SS. Apostoli [Verona]... There follow four large pictures. In the first, P. Scipio, who restores to Lucillus his wife who was captured in the expulsion of the Carthaginians from Spain, ordering that the gold and gems offered for her ransom should serve to enrich the girl's dowry. The history is taken from Titus Livius. By Giuseppe Crespi, called *lo Spagnolo Bolognese*.
ZANOTTI (1739, II, p. 63): Before he made the portrait of [the singer] Tesi he painted that of Coralli, and he made it for the Count Antonio di Colato, for whom he also painted his self-portrait... One should not omit mention that for the same nobleman he also made two very beautiful pictures, namely, Brutus, who kisses the earth, and Scipio, who restores the prisoner to her husband...

The Roman general Scipio Africanus demonstrated his magnanimity in victory by restoring unharmed to her parents a beautiful Celtiberian princess who had been captured in the fall of Carthago Novo. Scipio decreed that the gold and silver offered for her ransom was instead to be her dowry (Livy 26.50). Crespi's depiction of *The Continence of Scipio* is unusual in that he has reduced the number of principal actors to three: Scipio, the Carthaginian princess, and her grateful fiancé who rushes in from stage left. The most significant deletion is that of the father of the princess, who has, after all, brought the ransom. Instead, and with great originality, Crespi has shifted the dramatic focus from Scipio, who gained fame for his self-restraint, to the touching reunion of the young lovers.
In all, Crespi's *The Continence of Scipio* is a masterpiece of spirited painting, rendered in splendid colors and animated by vivacious action. Previous scholarship had dated *The Continence of Scipio* to the 1720s, a period in Crespi's career that is notable for its felicitous colorism (cf. cat. no. 19),[2] but it is here proposed that this picture represents a major achievement of Crespi's first maturity, about 1700. The compositions of the 1720s are characterized by the elegance of the incipient Rococo; the figures are typically set back from the foreground in order to show more of the ambient. *The Continence of Scipio* is more closely comparable to Crespi's altarpiece of *Saint Margaret of Cortona* (fig. 6), dated 1701. In both paintings, the canvas seems barely large enough to contain the expansive forms of the life-sized

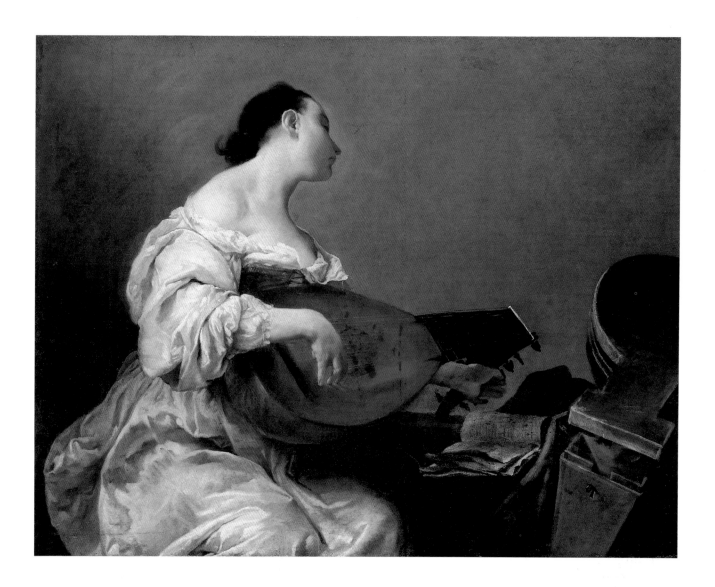

figures, and in both there is a compelling sense of movement along the diagonal axis from upper left to lower right. The Cortona altarpiece and the Norfolk *Continence of Scipio* represent significant advances over Crespi's paintings of the 1690s, but all of these pictures have in common their inspiration from High Baroque precedents. In fact, the figures in these paintings resemble one another more than they do the definitive facial types that Crespi settled on towards 1710. At the upper right, one sees a pretty girl in a turban who could have been painted by Burrini.

An early dating of *The Continence of Scipio* helps to clarify the picture's provenance (and *vice versa*). Merriman was the first to point out that a painting of this description, of specifically large size, was in the collection of Count Ercole Giusti, Verona, before 1718; this notice had to be discounted so long as Crespi's painting was believed to date from the 1720s or later. By contrast, a later date would be consistent with the little we know about Crespi's commissions from Count Antonio di Colato, the alternative collector of this subject.[3]

There exists other circumstantial evidence in favor of the identification of the Chrysler picture with the *Scipio* described by Dal Pozzo in 1718 in the collection of Ercole Giusti. This nobleman from Verona was one of the most astute private collectors in Italy at the close of the seventeenth century. Giusti specialized in the painters of his native city and of Bologna: he even persuaded one of the ranking Bolognese masters, G.G. Dal Sole, to come and take up residence in his house for several years at the close of the seventeenth century.[4] Earlier in that decade, Dal Sole was one of the artists, along with Crespi, who had been favored with a commission from Prince Eugene of Savoy, and he would therefore have been a likely informant to Giusti about Crespi. It is notable, too, that the 1690s is the only period in which Crespi painted classical subjects with life-sized figures (cf. cat. nos. 2 and 4). Historical subjects are practically non-existent in his oeuvre after 1706: *The Continence of Scipio* is more likely to conform to this pattern than to be an anomaly.[5]

Notes

1) Merriman notes that Crespi's *Continence of Scipio* in Verona is cited also by Oretti (ca. 1769, MS. B 131, c. 367).

2) The dating contemporary to the Ruffo commissions in the early 1720s was first proposed by Miller in Detroit, 1965, no. 118.

3) Antonio di Colato commissioned from Crespi a portrait of the singer Tesi, who first performed in Bologna in 1716 (Zanotti, 1739, II, p. 63).

4) Zanotti visited Dal Sole in Verona in 1697. See note 6 of the previous catalogue entry, no. 5.

5) Mythological subjects only appear in Crespi's later career as occasions for pastoral or Arcadian paintings (cf. cat. nos. 22 and 26).

7 Cupids at Play
Oil on copper, mounted on panel, 30.8×44.2 cm.
El Paso Museum of Art, Samuel H. Kress Collection

8 Cupids at Play
Oil on copper, mounted on panel, 32×45 cm.
El Paso Museum of Art, Samuel H. Kress Collection

Merriman cat. nos. 165 and 166.

One of Crespi's characteristic outlets for his good humor and native instinct for informality was the painting of cupids (*amorini*) and nymphs cavorting in sunny landscapes. As in the present pair, Crespi usually conceived these subjects as cabinet pictures more suitable for the private recesses of a collector's house than for the more formal audience chambers or picture galleries. As Merriman points out in a valuable essay, Arcadian landscapes were a favorite theme for Bolognese painters, especially Francesco Albani.[1]

In the eighteenth century, as now, cupids stood for a special combination of innocence and playful eroticism. One of Crespi's major pictures in this mode, likewise painted on copper, is in the National Gallery of Art, Washington (fig. 7.1). In the larger format, he painted a host of cupids who tickle and perform other kinds of mischief at the expense of a company of slumbering nymphs. In other pictures,

Crespi reversed the situation and painted nymphs who take advantage of sleeping cupids, breaking their bows or otherwise disarming them of their powers of erotic persuasion. The cupids in the El Paso pair are shown frolicking in the midst of goats and rabbits: the latter, of course, have always enjoyed a certain renown for their amorous proclivities.

Zanotti records that Crespi painted nymphs and cupids for the Marshal Caprara in Vienna.[2] Following Caprara's death in 1701, his collections were transferred to the Caprara palace in Bologna.[3] As a result of this notice, Crespi's Arcadian comedies have generally been assumed to have been executed during the 1690s, but Merriman rightly points to such pictures that must be considerably later. The two paintings catalogued here are painted in delicate hues that would seem typically early in date: Merriman suggests that they were executed shortly before 1700; a slightly advanced date — into the next decade — is here proposed, since the facial types are those of Crespi's mature style.

Notes
1) Merriman, 1980, pp. 77-101.
2) See Appendix V for the collected documentation on the Caprara collection.
3) *Ibid.*, pp. 44-45; Oretti, ca. 1769, MS. B 104, (b) 138/18-20.

7.1. *Crespi,* Cupids with Sleeping Nymphs. *(Deatil). National Gallery of Art, Washington, D.C.*

9 The Fair at Poggio a Caiano
Oil on canvas, 116.7×196.3 cm.
Galleria degli Uffizi, Florence

Merriman cat. no. 270.

Sources

From the *Inventario dei Mobili, e Masserizie della Proprietà del Ser.mo Sig.r Principe Ferdinando di Gloriosa Ricordanza, ritrovate dopo la di lui morte nel suo appartamento nel Palazzo de' Pitti... 1713*, c. 30v. [Chiarini, 1975, p. 76.]: A [painting on canvas] 2 br. in height, 3 1/3 br. in breadth, whereon, by the hand of Giuseppe Crespi called *lo Spagnolo*, there is painted a Fair, where many figures, animals, and merchants of goods, and others are seen, and a stage with various saltimbanques on it, one of whom is the portrait of Antonio Morosini, called *Scema*, with a view of landscape in the distance, and buildings, with framing similar to the above [wood, entirely gilt].

ZANOTTI (1739, II, p. 54): Crespi had need to return more than once to Florence, called there by the Grand Prince, and he painted a thousand things there, so that one could say that there is not a house, villa, nor palace where many, many works by *lo Spagnuolo* cannot be seen, and of every kind. There is a large painting with innumerable figures in which he painted *lo Scema*, buffoon of his Highness, when he pretended to be a saltimbanque at the fair at Poggio a Caiano. Wearing a ridiculous disguise, he fooled everybody, no one recognized him, and he played an amusing joke on the priest of that place, so that the Prince split his sides with laughter, even though he had made a bet with the buffoon that he would not laugh on any account. Everything was so well done, and so vividly expressed in this picture, that all the people could recognize themselves in it, even the Prince, who stood at a window to observe the antics of *lo Scema*. For such beautiful and amusing works, the love and respect that the Prince held towards *lo Spagnuolo* grew ever greater.

CRESPI (1769, p. 211): Crespi promptly applied himself to various commissions received from that Prince, and completed them, all of pleasant subjects, which he sent there, and they were so regarded, that he was ordered to go with his family to Florence, where he resided in the palace at Pratolino. He stayed there some time, painting many works, which are seen in those palaces: among others, he painted the fair at Poggio a Caiano, where he portrayed Morosini, agent of his Highness, who disguised himself one year as a saltimbanque, and he portrayed as well the priest of that place.

Additional Bibliography

Chiarini in Detroit/Florence, 1974, no. 118; Chiarini, 1975, pp. 76, 103, n. 190; Riccòmini in Bologna, 1979, no. 19; Uffizi cat. 1980, no. P474.

A noisy, cheerful sea of humanity has engulfed the countryside: it is the annual market and fair at the Medici villa at Poggio a Caiano. In the foreground, the farmers are trading donkeys, cows, and other livestock. A peasant woman leans over to assist a lady customer with her selection of earthenware pots and pitchers. At left, a handsome peasant pulls out a flask of chianti and gestures to the viewer with his forefinger and eye — to indicate that he has specific intentions for the girl who asks him to share his wine. Above the crowd, the figure of a performer stands out: this is the saltimbanque or charlatan, who entertains the crowds with hyperbolic speeches and fantastic claims to healing powers.

The *Fair at Poggio a Caiano* is Crespi's most famous genre painting, and the chief legacy of his patronage by Grand Prince Ferdinand de' Medici. He evidently executed the work during his extended visit to Florence, from February to October 1709, when he and his family were guests at the Medici villa at Pratolino. Such scenes of popular gatherings or activities, fairs, carnivals, weddings, and the like, were the stock-in-trade of the Roman school of low-life genre painters called the Bamboccianti. With the encouragement of Grand Prince Ferdinand and his circle, the taste for the bambocciate of Theodor Helmbreker and other Northerners in Italy became one of the most particular aspects of Florentine collecting in the early eighteenth century.[1]

This tradition had not previously been taken up by Crespi, but he found it sympathetic and proceeded to paint bambocciate throughout his career, long after his contacts with Florentine collectors had diminished in importance. Crespi's fairs and markets (cf. cat. no. 17) have a distinctively Bolognese character, rather as if they were painted compendia of the trades and street criers that had been favored subjects among Bolognese genre painters since the time of Annibale Carracci: the participants in Crespi's depictions are notably more industrious than the hangers-on who populate the archetypal bambocciate.

Chiarini has noted that the Medici interest in pictorial records of popular fairs under their purview extended at least as far back as the famous etching *The Fair at Impruneta* by Jacques Callot one hundred years before. Callot's print had been a deliberate tour de force of the etcher's craft. The Medici, as is well known, had an impressive record in inspiring artists to surpass themselves. In the hope of attracting Ferdinand's patronage, Crespi had outdone himself by filling his *The Massacre of the Innocents* with more than a hundred figures (fig. 8). He undertook to succeed on these same terms with his *Fair at Poggio a Caiano*.

Zanotti informs us that Crespi filled his composition with portraits of court personalities, an obvious improvement upon the anonymity of the usual bambocciata. No more than three years earlier, Alessandro Magnasco, another artist employed by Ferdinand, had captured on canvas a high-spirited hunting party in which the Grand Prince and one of his retainers had enacted a memorable farce (fig. 15).[2] Crespi's *Fair at Poggio a Caiano* similarly records an historical event, namely, the time that Antonio Morosini, nick-named *lo Scema*, "the Fool," entertained the court with his impersonation of a provincial charlatan. The local priest was the principal butt of the jokes, and his disgruntled figure

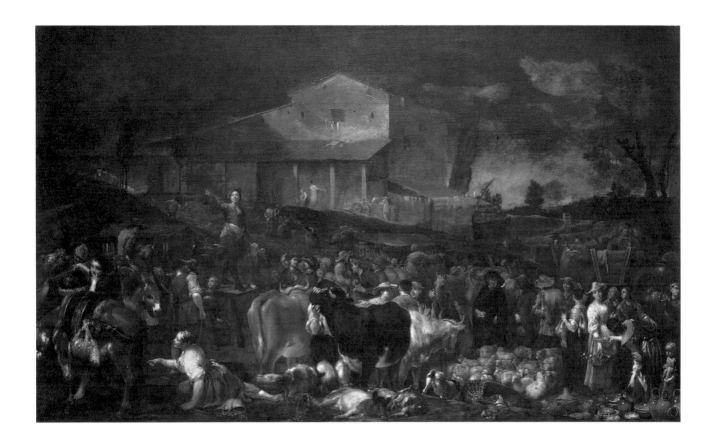

in dark robes and hat is evidently that seen in the right foreground. The disguised portraits amongst the crowd set a precedent for genre paintings that Crespi soon repeated in his series of the Sacraments and became standard practice for Pietro Longhi after the 1740s.

Crespi must have kept his preparatory drawings or perhaps a *ricordo* of the entire composition of his *Fair at Poggio a Caiano*: twenty years later, he and his sons painted at least two repetitions in collaboration. The farmhouse and foreground cattle recur in a canvas in the Pinacoteca Nazionale, Bologna,[3] while most of the figures were used again in a version now in the Musée de Caen, first published by Rosenberg.[4]

Notes

1) See the section "Crespi and Genre Painting in Florence" in my introductory essay above.
2) See Chiarini in Detroit/Florence, 1974, no. 163.
3) Merriman cat. no. 272.
4) Rosenberg, 1980, pp. 825-886, fig. 73; Merriman cat. no. 271.

10 Peasants Playing Musical Instruments
Oil on canvas, 100×50 cm.
Sir Denis Mahon Collection, London

11 Peasants with Donkeys
Oil on canvas, 93.5×53.5 cm.
Sir Denis Mahon Collection, London

Merriman cat. nos. 261 and 262.

These extraordinary paintings are composed as if they were glimpses into the street through the crack of a door. Denis Mahon and all subsequent writers have conjectured that these genre paintings may be fragments of a larger canvas, perhaps an Old Testament subject, that was cut into several smaller pictures. Crespi's paintings have always been susceptible to mutilation because of his distinctive way of isolating figures in darkness (cf. cat. no. 16). However, the sources do not mention a likely candidate for a lost picture of these dimensions with genre elements.

This is not to say that contemporary documentation for these pictures is altogether lacking. Roli made the critical observation that two paintings in Stuttgart by Giuseppe Gambarini (cf. cat. nos. 31 and 32) borrow Crespi's figures from both of the Mahon canvases. A number of conclusions can be drawn from this fact. In the first place, it seems evident that these paintings by Crespi were already paired when Gambarini drew from them, almost certainly before 1716. Gambarini began to paint genre scenes in the style of Crespi about 1710. This is the same period to which scholars assign to Crespi's execution of these two paintings of peasants. But Gambarini's two pictures tell us even more, if we look closely at the use he made of Crespi's figures. Gambarini has cropped his figures along exactly the same lines as one finds in Crespi's original pair: for instance, he shows only the forequarters of the donkey — which he also copies (in reverse) in his *Monks Receiving Alms* (cat. no. 32) — and in his *Dance in the Country* (cat. no. 31). Gambarini scatters Crespi's peasants (he does not add any) among the more genteel figures of his own invention. If we conclude from Gambarini's evidence that Crespi's pair were already in this format at about the time that they were made, it becomes less likely that anyone other than Crespi himself cut these canvases into these shapes. One wonders why Gambarini, a younger but already independent artist, felt so free to plagiarize another painter's inventions. The simplest explanation is that he did so with Crespi's consent, that is, that Crespi had retained these paintings in his studio, to which Gambarini must have briefly had access about 1710. Gambarini must have made careful drawings, because he reused these figures for the remainder of his career (cf. cat. no. 33). Neither Zanotti nor Luigi Crespi states that Gambarini was ever associated with G.M. Crespi,

but, for that matter, neither of these writers makes any mention of Crespi's potent influence on Gambarini's genre paintings.

These two representations of peasants at work (including the musicians, since they labor while others celebrate) display an extraordinary sympathy for unvarnished reality. They are genre subjects in the style of Annibale Carracci, at a remove of more than a century. In the typical spirit of Bologna, Crespi sees the common worker as embodying an uncomplicated good humor. The child porters painted by Ceruti are perhaps more moving expressions (cf. cat. nos. 48 and 49). Yet Crespi, Ceruti, and Goya alone among the painters of the eighteenth century envisioned humble humanity with such dignity and in such monumental form.

12 A Peasant Family with Boys Playing
Oil on copper, oval, 39.4×30.5 cm.
Harari & Johns Ltd., London

13 Peasants with Donkeys
Oil on copper, oval, 39.4×30.5 cm.
Harari & Johns Ltd., London

Unpublished.

These intimate scenes of humble life resonate with a sense of immediacy. A mother prepares a simple supper, while the boys finish their game. A ten-year-old muleteer poses next to his docile companion; he has all the simplicity and earnestness of the passers-by in a nineteenth-century photograph by Alinari. Crespi trained his brush on incidents so commonplace that none of his compatriots could see their potential as art. Indeed, his contemporaries did not seem to notice much difference between his paintings of peasant life and the average bambocciata painted by the ragtag followers of Pieter van Laer. As a rule, the classicists disapproved of the very idea: Zanotti's praises of Crespi's genre paintings are always slightly incredulous, and Luigi Crespi pointedly de-emphasizes this aspect of his father's oeuvre. It is precisely this attention to everyday life, however, that constitutes his most lasting contribution to the history of art.

This pair of pictures can be dated with some confidence to 1710, or thereabouts, on the basis of comparison with Crespi's earliest version of *The Flea Hunt* (Uffizi), also painted on copper (fig. 16). As in Crespi's other pictures of this time, these works are painted with marvelous contrasts between dense pigments and liquid shadows. It is curious how differently he composed the two pictures within their oval frames: the *Peasant Family* is a study in disguised geometry; the composition of *Peasants with Donkeys* conforms in no way to its oval format.

This is the period of Crespi's deepest involvement in genre painting — immediately following several months' residence in Florence in 1709, when he was encouraged to study paintings by the Bamboccianti. It was also during this period that Crespi decided to etch illustrations to the comic epic *Bertoldo, Bertoldino, and Cacasenno* (figs. 9 and 10). All of these works are devoted to representations of peasant life, but the *Bertoldo* series is as satirical of rustic life as these pictures are sympathetic to it.

 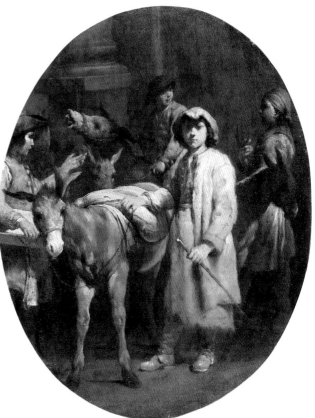

14 Confirmation
Oil on canvas, 125×93 cm.
Staatliche Kunstsammlungen, Dresden,
Gemäldegalerie Alte Meister

Merriman cat. no. 291.

Early Provenance
Commissioned by Cardinal Pietro Ottoboni (1667-1740),
Rome, ca. 1712; at his death, acquired for Augustus III,
King of Poland, Elector of Saxony, Dresden (inv. 1747).

Sources
ZANOTTI (1739, II, pp. 53-54): As I have already said, *lo
Spagnuolo* is a man who is full of cleverness and
imagination, and who willingly treats common and amusing
themes. One day in the church of S. Benedetto he saw a
man inside a confessional, telling his sins to a priest; on the
head of the man, and on his shoulder, there lit a ray of
sunlight from a broken window, and reflecting in that little
cell, it made the most beautiful chiaroscuro in the world.
He paid close attention to this, and as soon as he had
returned home, he made a little drawing of it. Then he sent
two porters to bring at once a confessional, and placing it
in his room, in a selected light, he put inside it Ludovico
Mattioli, who happened to be there, in the act of
confession. And he portrayed him [Mattioli] so well, that he

was recognized by everyone, as was the priest also, who
was the same who had lent the confessional. The
imagination and the accurate representation made everyone
laugh, while at the same time, the picture was admired as
something very beautiful of its kind, and worthy of a good
price. Some of our gentlemen desired it, but none of them
could agree with the painter on the reward, so that finally
lo Spagnuolo resolved to make a gift of it to Cardinal
Ottoboni. The Cardinal accepted it with extreme pleasure,
and named this picture, the "picture of Confession;" he
gave the order to [Crespi] to paint for him the other six
Sacraments in this manner. Whoever knows the humor of *lo
Spagnuolo* can imagine whether he had pleasure in a
commission such as this. However, he painted the other
Sacraments, in the same tenor, and I remember that the
Matrimony consisted of a husband who appeared about
eighty years old, while the wife did not seem older than 14.
[In this picture] there were two witnesses who, while taking
tobacco, were secretly laughing over this mismatched union
almost as if they were predicting what would come of it.
Then the priest with the guardian of the church stood apart
counting the money of the offering, and giving to the
guardian his due, who makes a face however showing that
he wished to have more than he received. The others [of
the *Sacraments*] were all expressed in similar manners, and
to speak of each would be too long an undertaking. When
these pictures arrived in Rome, they were the pleasure and
delight of not only the Cardinal, but of the whole city, who

14.1. Crespi, Baptism. *Staatliche Kunstsammlungen, Dresden,
Gemäldegalerie Alte Meister.*

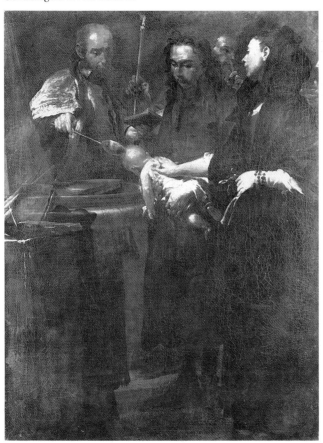

14.2. Crespi, Communion. *Staatliche Kunstsammlungen, Dresden,
Gemäldegalerie Alte Meister.*

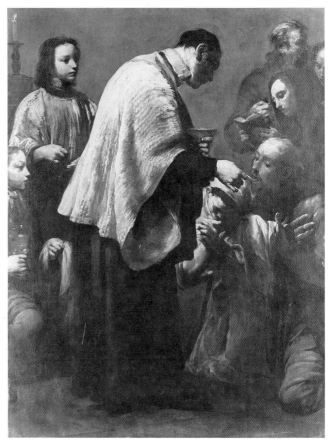

competed to see them, and it is indescribable how much these paintings endeared Crespi to the Cardinal, who paid for all of them with a single great gift.

CRESPI (1769, pp. 212-213): One day while in the church of S. Benedetto de' frati Paolotti, our painter noticed by chance that a penitent who was making his confession was gracefully illuminated by a ray of sun that passed through a broken window, and was reflected from his head onto his confessor and into the confessional. Delighted by these accidental reflections, when he arrived home, he sent for a confessional, and with his imagination stimulated by what he had seen, he positioned it in a similar light, and painted it on a canvas, which, as it happened, was not very large, adding a confessor and a penitent, such as he had seen. The picture was a success due to the novelty of its idea, but more for the truth which it expressed, so beautiful, so pleasing and brilliant, that it is impossible to say how satisfying it was to everyone who had the fortune to see it. And since Cardinal Ottoboni had written to him whether he was making anything exceptional that he could acquire, our painter sent it to him as a gift. Words fail to describe the pleasure of that prince and the reception that this painting received in Rome. The Cardinal named it the *Picture of the Confession*, sending a gift of 200. scudi to the artist, and commissioning him to paint the other six Sacraments in the same dimension. He made the same gift for each of them.

Then *lo Spagnuolo* regretted that he had painted that subject on such a small canvas, in which it was easy to place two persons, one sitting and the other kneeling, since he knew that it would not turn out so well for the other subjects. Nevertheless he set to the task, and made the other six pictures of the same taste, lighting, and painting, and even with as much wit as the gravity of the subjects would allow. For example, he painted in the sacrament of Matrimony an octogenarian being wed to a girl 14 years old, and to one side the guardian with the priest, who divide the offering between them, while the others laugh over the difference in their ages, predicting a less than happy future for the tender maiden. For the Extreme Unction, a poor Capuchin who lies on top of a miserable pallet of straw, has received unction from one of his companions by the light of a small tallow candle, which drips down the hands of the man holding it. For Confirmation, a Bishop, bent over in order to annoint a little boy with chrism. All of these pictures, in sum, designed in an extravagant manner, so as to accommodate them in such a small dimension; and in this truly, *lo Spagnuolo* was admirable, placing into a little space many large figures, so well conceived and drawn, and in foreshortenings as if they were in ample spaces.

All seven of these pictures were the delight and the pleasure not only of the Cardinal but of all Rome, which treated [Crespi] to his deserved applause... After the death of the Cardinal the seven Sacraments were bought by his Majesty King Augustus of Poland, Elector of Saxony, and I have seen

14.3. *Crespi*, Matrimony. *Staatliche Kunstsammlungen, Dresden, Gemäldegalerie Alte Meister.*

14.4. *Crespi*, Ordination. *Staatliche Kunstsammlungen, Dresden, Gemäldegalerie Alte Meister.*

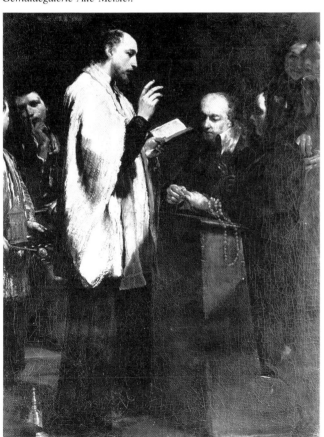

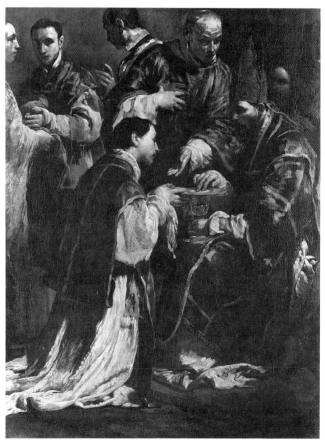

them in the superb gallery of Dresden, and I saw in a chamber in the Palazzo Albani in Urbino the excellent copies that were made before the Sacraments left Rome."

Additional Bibliography
Matteucci, 1965, pl. X-XI; Bologna, 1979, no. 22.

The Sacraments, or holy rites of the Roman Catholic Church (baptism, communion, confirmation, matrimony, ordination, penance, and unction), have rarely been the subjects of art. The notable exceptions prior to Crespi's seven paintings of the Sacraments were the two monumental series which Nicolas Poussin had painted in Rome in the seventeenth century — archeologizing works that were acclaimed for their piety, high-mindedness, and scrupulous reconstruction of Roman antiquity. It comes as no surprise that the idea for Crespi's Sacraments came from a Roman collector, Cardinal Pietro Ottoboni.[1] As the patron of Francesco Trevisani and Sebastiano Conca, Ottoboni was a noted exponent of classicism: it is a tribute to the scope of his taste that he would commission the anti-academic Crespi to design seven Sacraments of unprecedented naturalism and informality.

Zanotti and Luigi Crespi both devote lengthy discourses to the Sacraments, and they raise issues that seem at variance with our appreciation of these pictures today. For his part, Zanotti hints that Crespi may at first have been miffed that he had been induced by Ottoboni to create such a cycle of sacred subjects. Zanotti, who is anyway appalled that the Holy Sacraments should be enacted by real persons, not Romans in togas, takes the position that the series can only be justified in the sense of an extraordinary joke. He makes the most of the ill-matched couple portrayed in Matrimony (fig. 14.3) and manages to remember a vignette of money changing hands which is not, in fact, depicted in the painting. Luigi Crespi duly repeats Zanotti's misstatement about Matrimony and goes in search of other comic elements in the series. He describes incidents in two other pictures, Extreme Unction (with the comment that the cheap tallow candle drips) (fig. 14.6) and Confirmation (that the bishop must bend forward in order to anoint the child).

Viewers of the late twentieth century have an advantage in that they do not labor under the prejudices of subject matter and decorum that prevented Zanotti and even Crespi's biographer-son

14.5. Crespi, Confession. Staatliche Kunstsammlungen, Dresden, Gemäldegalerie Alte Meister.

14.6. Crespi, Extreme Unction. Staatliche Kunstsammlungen, Dresden, Gemäldegalerie Alte Meister.

from seeing beyond the novelty of his series of the Sacraments. Granted, *Matrimony* depicts the impertinent humor of some young men, but neither this scene nor any of the others is the burlesque that Zanotti supposes it to be. For instance, there is nothing to laugh about in *Confirmation*. It does not seem strange to us that an artist could conceive of a sacred subject in contemporary terms — without recourse to saints or antique costumes. Some of the participants in this rite appear to be portraits of Crespi's friends, as was true of the first work, *Confession* (fig. 14.5). At the left, the father of the young confirmant places his hand on his son's shoulder with touching solicitude. Behind them are another father and son, the boy's face tinged with nervousness as he awaits his turn. The inclined posture of the bishop imparts motion to what could otherwise have been a static image.

Crespi's seven *Sacraments* are commonly dated to about 1712, since this date was once legible on *Baptism*. From Zanotti's account of the commission, the inaugural painting of *Confession* must have been executed at least a year earlier. A *terminus post quem* of January 1708 can be deduced from a letter of that date to Crespi from Antonio Sabaini in Rome, who was beginning to obtain pictures from the artist for Cardinal Ottoboni.[2]

Notes
1) Ottoboni was a Venetian by origin, the cardinal-nephew of Pope Alexander VIII. For more on him, see Haskell, 1980, pp. 164-166.
2) Appendix III, 6.

15 The Birth of Arcas (or possibly The Infant Moses Reunited with his Mother)
Oil on canvas, 94×74 cm.
Staatliche Museen Preussischer Kulturbesitz, Berlin, Gemäldegalerie

Merriman cat. no. 153.

Additional Bibliography
Bologna, 1979, no. 32.

This enchanting if enigmatic picture came to light in an auction in 1900, attributed to the early seventeenth-century painter, Domenico Fetti. In time, Crespi's authorship was universally recognized, but the theme has remained a mystery. The literature to date presents two alternative explanations for this representation of a lady (a divinity?) who prepares to bathe and a nursing mother and child. Hermann Voss proposed that the lady was Callisto, Diana's nymph, who gave birth to Arcas. The bow and quiver at her feet are indeed suitable attributes for a wood-nymph. On the other hand, Callisto was an outcast as the result of her pregnancy (and she was metamorphosed into a bear): Callisto would not have been served by the other nymphs nor dressed in finer cloth than they. Merriman recently suggested that the babe might be Adonis nursed by Diana and her nymphs, but it hardly seems possible that the most striking element of the story, the myrrh tree that has borne him, should be omitted.

As Voss observed, the subject must be difficult to recognize because of its rarity. There is another possible interpretation, however, that has not been proposed. The tenderness with which the wetnurse holds the infant suggests that she must in fact be the mother of the child, rather than the lady in white, who bares her breast for a different purpose. The alternative interpretation is that Crespi has painted *The Infant Moses Reunited with his Mother*. When the Pharaoh's daughter went down to the Nile to bathe, and discovered Moses in his raft of bulrushes, she had compassion on him. This much of the story was a very popular theme in post-Renaissance painting (cf. cat. no. 19). No artist, except perhaps Crespi in this painting, has ever depicted the action that ensued (Exodus 2:7-9). The sister of Moses was present at the scene of his rescue, and she said to Pharaoh's daughter:

Shall I go and call to thee a nurse of the Hebrew women, that she may nurse the child for thee? And Pharaoh's daughter said to her, Go. And the maid went and called the child's mother. And Pharaoh's daughter said unto her, Take this child away, and nurse it for me, and I will give thee thy wages. And the woman took the child and nursed it.

In accordance with this reading of Crespi's picture, Pharaoh's daughter thereupon addressed herself to her original purpose in going to the river that day. The date of this picture is somewhat controversial as well. Merriman compares it in style to the *Finding of*

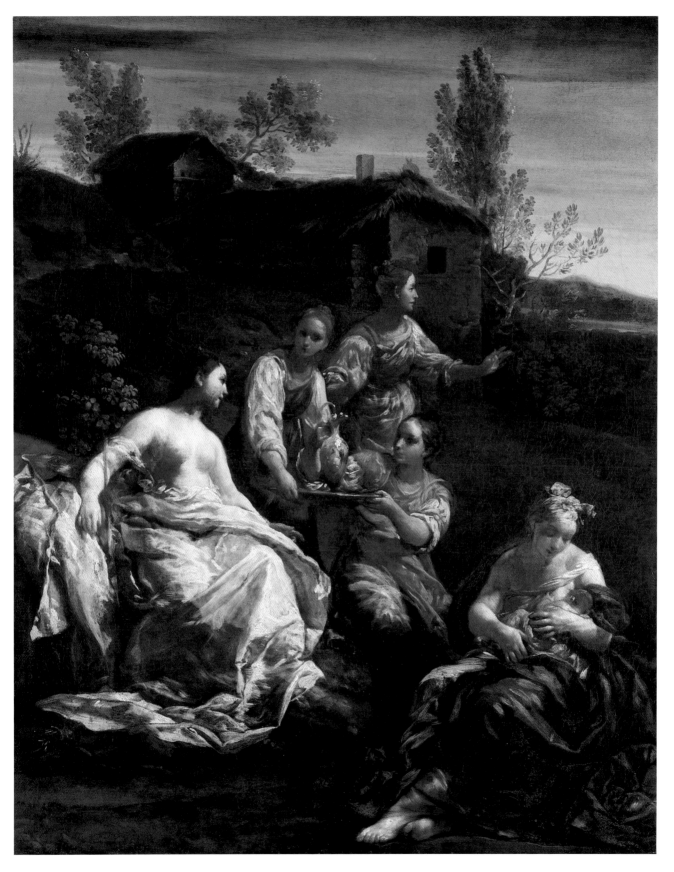

Moses (cat. no. 19 below) painted for Cardinal Ruffo between 1721 and 1727. Schleier has proposed a tentative dating of ca. 1710.[1] Riccòmini also considers Merriman's dating to be too late.[2] The dense brushwork and heavy folds of drapery in this picture do seem closer to Crespi's style during the 1710s — later than the *Sacraments* of ca. 1712 but earlier than the Brera *Fair with a Dentist* datable to ca. 1718 (cat. no. 17).

Notes
1) Schleier, 1975, p. 124.
2) Bologna, 1979, no. 32.

16 Street Musicians
Oil on canvas, 48×32 cm.
Pamela Askew, Millbrook, New York

Merriman cat. no. 263 [fragment of cat. no. 265].

Early Provenance
Painted for the Faresini family, Venice; Consul Joseph Smith, Venice (1762); the sale of his collection, Christie's, London, 17 May 1776, lot 29 ("Spaniola 29 A Country Market and its pendant").

Sources
ZANOTTI (1739, II, p. 62): But which city, which region of Italy does not have some work by this painter? Whoever has been able to procure one, has done so; certainly everyone has wished to have them. In Venice, the Sagredi, and the Faresini, and some other noble personages have them.
CRESPI (1769, p. 215): For the greater Faresini of Venice, he painted a Market and, for its companion, many pilgrims and poor people around a shrine.

16.1. After Crespi, Mendicants around a Shrine. *Etching by Giacomo Leonardis. British Museum, London.*
16.2. After Crespi, Country Market. *Etching by Giacomo Leonardis. British Museum, London.*

This small painting of a hurdy-gurdy man, his boy, and a mother nursing her baby was originally part of a larger canvas depicting a forlorn collection of beggars and pilgrims near a shrine outside the gate of a city. The appearance of Crespi's original composition is recorded in an etching made in 1762 in Venice by Giacomo Leonardis (fig. 16.1). The print allows us to identify a painting entitled by Merriman *Scene at the Wall of a Cathedral* (present location unknown) as the missing portion of Crespi's picture (fig. 16.3). Even in the photograph, one can discern at right the vertical cut in the canvas where this present *Street Musicians* was detached. It is not known when the canvas was divided: the etching by Leonardis reveals that the upper third of the original painting was discarded in the process, so that neither fragment conveys any semblance of the place where these indigent people have assembled.

In 1762, the printmaker Leonardis inaugurated a series of etchings based on paintings in private collections in Venice.[1] The first two numbers in this *Raccolta di dipinti da Collezioni Veneziane* represented paintings by Crespi: the present *Mendicants around a Shrine* was No. 2; its pendant, a *Country Market* (fig. 16.2), was No. 1. Both bear the date 1762 and indicate that the owner was the British Resident in Venice. The pairing of these two subjects permits the conclusion that these are the two paintings that Luigi Crespi informs us were made for the Faresini in Venice.[2] The likely date for the commission would be between 1715 and 1720, since they compare closely in style to the Brera *Fair with a Dentist* (cat. no. 17), which is usually dated to that period. By 1762, they had entered the fabled collection of Consul Joseph Smith.[3]

Crespi's *Mendicants around a Shrine* and *Country Market* (the actual canvas is untraced) present drastically differing visions of the everyday life of common people. As a pair, these pictures were evidently intended to illustrate an Arcadian theme of wide currency (if debatable accuracy) in the eighteenth century: to wit, the virtues and happiness of rural life as opposed to the squalor and deprivation of the urban poor. It is not at all clear that peasants led lives as comfortable as the *Country Market* would seem to indicate. Even the women are all pretty. Their smiling faces and voluminous dresses evoke the thousand shepherdesses that would be painted in the ensuing decades by Francesco Zuccarelli (1702-1778), who, of course, could have seen this picture in Venice.

An Englishman named Edward Wright, who made a trip to Italy in the early 1720s, published later a volume of his travel notes. Wright's impressions of Bologna speak of this same disparity between the impoverished city streets and the comparative riches of the countryside. His remarks point up the sad conditions that lay behind Crespi's paintings of homeless denizens of the street:

I observ'd more poor naked Boys in Bologna than in any other City whatever that we were in. The Reason I was told is, that they are turn'd out of the *Pietà* at six or seven Years old, and no care taken of them afterwards.* When I have gone out early in a Morning I have seen them lying in heaps by the Dozens, nestling together as close as they could, like little Pigs, having no other Covering than the sorry Rags they wear all day, nor anything under them, except perhaps a little straw, upon the cold Stones under the publick Porticoes, and the Winters there are at least as cold as Ours.
[* In the Pieta's at Milan and elsewhere they are entertained till fourteen years.][4]

On the other hand, Wright gives an optimistic account of rural life, although his mention of subsistance on *biscotti* seems to indicate that the peasants did not retain the wealth that the earth had fostered:

The Grounds about it are very rich,* not only in the vast abundance of Vines, Olives, chestnuts, and other Fruits, but likewise in Corn, and good Pasturage, which fills the Markets with great Plenty. The Beef they have there is (I think) the finest I ever tasted. The poorer sort (tho in so rich a Country, that abounds almost with everything that even luxury can desire or wish for) do in a manner subsist upon the *Biscotti*, as they call there the roasted Chestnuts, which the Hucksters roast in the streets all about the town.
[* Bologna la grassa, Bologna *the fat*.][5]

The dichotomy between town and country is likewise the theme of descriptive verses that appear in the lower margins of the second edition of these prints by Leonardis after Crespi's pair of paintings.[6] Of course, these verses have no direct connection with Crespi, but it is pertinent to know that the paintings were interpreted emblematically within his same century. Crespi's market and street subjects were influenced by the earlier paintings of the so-called Bamboccianti. At the present time, historians are not agreed as to whether or not allegorical or social content can be discerned in the genre paintings of the Bamboccianti.

16.3. *Crespi,* Scene at the Wall of a Cathedral. *Location unknown.*

Notes

1) The Leonardis prints after Crespi are catalogued by Le Blanc (vol. 2, nos. 16 and 17). The unsigned print of *Laundresses* after Crespi's painting in the collection of Gasparo Negri (fig. 32) is plausibly attributed to Leonardis in the catalogue of the Cottonian Collection of Venetian prints in the Plymouth City Museum and Art Gallery. Le Blanc (vol. 2, p. 3), cites a Leonardis print after a *Resurrection* by Antonio Gionima, which constitutes further evidence of the diffusion of Crespi and Crespi school designs in Venice. The entire activity of Leonardis has been expertly treated by Annalia Delneri in the recent exhibition catalogue at the Museo Correr, Venice, *Da Carlevarijs ai Tiepolo. Incisori veneti e friuliani del Settecento*, 1983, cat. nos. 225-263.

2) Luigi Crespi (1769, pp. 215-216) lists the Faresini as major patrons for works that we can date to the 1710s. Zanotti (1739, II, p. 62) mentions multiple works belonging to the Faresini, and specifically (p. 63) Crespi's *Self-Portrait*, which would attest to the mutual esteem between artist and patron.

3) As Delneri (*op. cit.*, no. 225) points out, the inscription on the Leonardis prints in the first state of 1762 ("Dalla Raccolta del Residente Britanico in Venezia") clearly refers to Consul Joseph Smith, although it is usually reported that Smith never received the sought-after title of British Resident (Delneri reports that he did for a few months in 1766). It is noteworthy, by the way, that Giambattista Tiepolo refers to Consul Smith as "Sig. Residente" in a letter of April 4, 1761, to Francesco Algarotti (Levey, 1978, p. 421). Be that as it may, No. 3 in the Leonardis *Raccolta di dipinti da Collezioni Veneziane* reproduces a Carpioni *Offering to Venus*, again in the collection of the "Residente Britanico in Venezia," and the Carpioni was demonstrated by Vivian (1971, pp. 143 and 217) to belong to Joseph Smith. Vivian (1971, App. C, 220) was unaware that the "Market and its companion" in the Smith sale in 1776 were pictures by Crespi, since she assumed that the sobriquet, "Spagniola" referred to Jusepe de Ribera.

4) Wright, 1730, p. 451.

5) *Ibid.*, p. 434.

6) The inscription for the *Mendicants* reads: "*Squallida turba in nauseanti spoglia/ Ristoro attende alla pietosa soglia.*" Rather more optimistic is that of the *Country Market*: "*Di sparsi merci ond'e ripieno il prato/ Bisbigliando i villan fanno mercato.*"

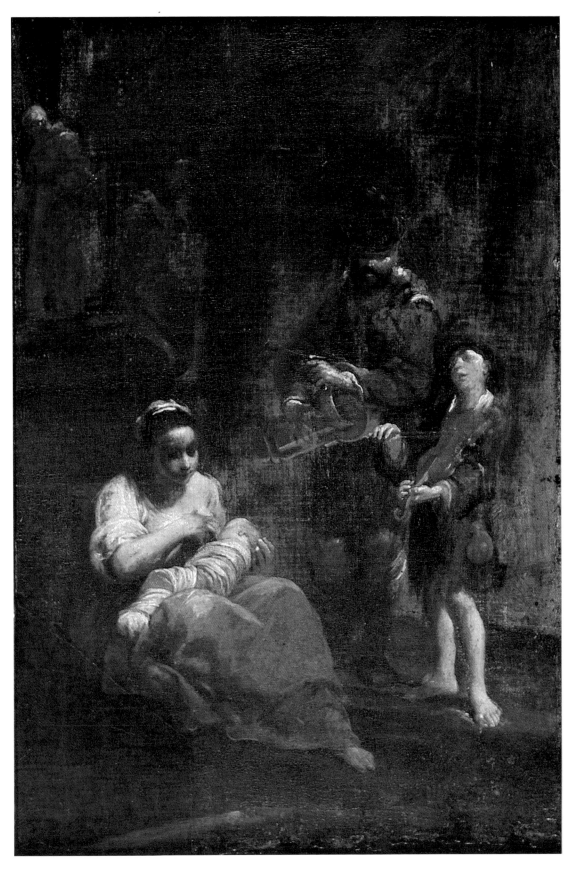

17 A Fair with a Dentist
Oil on canvas, 76×87.5 cm.
Pinacoteca di Brera, Milan

Merriman cat. no. 275.

Additional Bibliography
Bologna, 1979, no. 20.

During the second decade of the eighteenth century, Giuseppe Maria Crespi painted several pictures of fairs, markets, religious missions, and similar public gatherings in the out-of-doors. His interest in these subjects, which were closely associated with the seventeenth-century genre painters called the Bamboccianti, had been provoked by his visit to Florence in 1709. In response to the collecting tastes of his patron, Grand Prince Ferdinand de' Medici, the *magnum opus* of Crespi's Florentine sojourn was, significantly, not a religious or historical theme, but rather an elaborated bambocciata, *The Fair at Poggio a Caiano* (cat. no. 9).[1]
Without the impulse of his Florentine contacts, it is debatable whether Crespi would ever have tried his hand at the genre style of the Bamboccianti, who were mostly Netherlandish artists working in Rome. From the outset of his career, Crespi had been deeply influenced by his native Bolognese tradition of naturalism applied to the representation of laborers and the trades. The Bamboccianti had typically set their compositions in landscapes. Prior to 1709, and for the most part thereafter, Crespi's landscapes with shepherdesses and the like were inspired by local sources, specifically the Arcadian landscapes invented by Francesco Albani in the mid-seventeenth century.

The favorite subjects of the Bamboccianti were mainly random gatherings of humble people, outside a tavern, for instance, or at an inn by a roadside, or caught up in a mob at carnival time. Crespi's paintings of fairs and markets conform to this pattern, and they incorporate many favorite Bambocciante motifs — among them the comedy of a dentist plying his trade in public, as is featured in the Brera *Fair.* It is notable, however, that Crespi has no sympathy for the undercurrent of listless behavior or social rootlessness that is a common element in the Netherlanders' world view. The populace in a picture by Crespi is always engaged in some sort of activity, sometimes as frivolous as flirting, often as passive as begging, but never utterly aimless as so many of the loungers in the Roman bambocciate appear to be.

The *Fair with a Dentist* in the Brera is a major example of Crespi's version of genre painting in the manner of the Bamboccianti, but it is equally valuable as a well-preserved example of Crespi's distinctive style between about 1715 and 1720. This is the period of his sharpest contrasts, in which highlights are applied only sparingly but to telling effect. The figures in the background seem often to glide about like spectres touched only here and there with the tip of the artist's brush. On the basis of similar effects in two dated works,[2] the *Meeting of James Stuart of England with Prince Albani* (Prague) of 1717 (fig. 42) and the *Flowering Aloe Plant* of 1718 (fig. 33), Merriman has reasonably dated the Brera *Fair with a Dentist* to these same years. From this period also dates a pair of important genre pictures that Crespi painted for the Faresini in Venice, a *Country Market* and *Mendicants around a Shrine*, which are recorded in prints and in a fragment of *Street Musicians* (cat. no. 16). The early provenance of the Brera *Fair with a Dentist* is not known, but the picture was presumably not painted for a Venetian client since it includes at the lower left the same group of cattle that are offered for sale in the lower right foreground of the Faresini *Country Market* (fig. 16.2).[3]

Notes
1) See in my essay above the section entitled "Crespi and Genre Painting in Florence."
2) Merriman cat. nos. 188 and 301.
3) Riccòmini (Bologna, 1979, no. 20), points out that a "*quadro per traverso con un mercato*" by Crespi was noted by Oretti (MS. B 104, c. 27, Biblioteca Comunale, Bologna) in the Conti collection, S. Gregorio, Bologna.

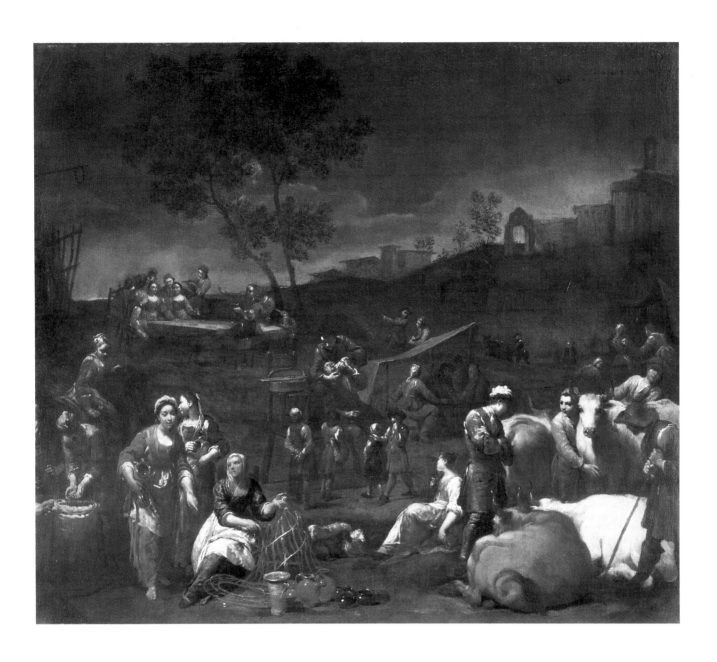

18 Self-Portrait
Oil on canvas, 95×81 cm.
Pinacoteca Nazionale, Bologna

Merriman cat. no. 182.

Sources

ZANOTTI (1739, II, p. 63): He has painted his self-portrait more than once. The noble Faresini of Venice have one, and another can be seen in the Medici gallery in one of those rooms devoted to portraits of the ancient and modern painters, made by their own hands. Cavalier Ughi in Florence has another, painted with a capricious design... He has made another one in a drawing which Cavalier Francesco Gaburri in Florence has in his beautiful collection of artists' self-portraits, and from this was taken the frontispiece of this biography... Before he made his portrait of [the singer] Tesi, he did that of Coralli, on behalf of Count Antonio di Colato for whom he also painted his self-portrait.

CRESPI (1769, pp. 212, 215, 216): He made a close friendship with the lawyer Benazzi, who had lent him assistance in the case against the aforesaid priest [Don Carlo Silva], and he often painted for him... in his country house... and many pictures for his house in Bologna, including his self-portrait... [215] For the greater Faresini in Venice he painted... his self-portrait in half-length in the act of painting... [216] In addition to the self-portraits cited above, one for the greater Faresini in Venice, one for the Ughi in Florence, and the third for the Count di Collalto,

he painted his own portrait for the Medici gallery. He also drew it for the late Cavalier Gaburri in Florence, who had a beautiful collection of them.

ORETTI (ca. 1769, B. 104, [a], III/33): The portrait of Giuseppe Crespi painted by himself, half-length in life-size, Casa Ercolani, Strada Maggiore [Bologna].

Additional Bibliography
Bologna, 1979, no. 31.

Six *Self-Portraits* by Giuseppe Maria Crespi are known today. Evidently the earliest of these is an oval in the Hermitage in which he holds a tablet and a chalk pencil (fig. 18.1). The Hermitage *Self-Portrait* appears to date from the end of the seventeenth century and is not likely to be the picture "in half-length in the act of painting" that he made for the Faresini in Venice, as Merriman suggests, since it can be demonstrated that Crespi's other works for this patron were executed during the second decade of the eighteenth century.[1] It is easier to date Crespi's self-portraits on the basis of style than from his owlish features, which seem to have changed little after about 1715, the period of his *Self-Portrait* recently acquired by the University of Kentucky Art Museum in Lexington (fig. 18.2).[2] The Lexington *Self-Portrait* accords with the description as well as the probable date of the painting once in the Faresini collection in Venice.

18.1. Crespi, Self-Portrait. *The Hermitage, Leningrad.*

18.2. Crespi, Self-Portrait. *University of Kentucky Art Museum, Lexington, Kentucky, Gaines Challenge Fund.*

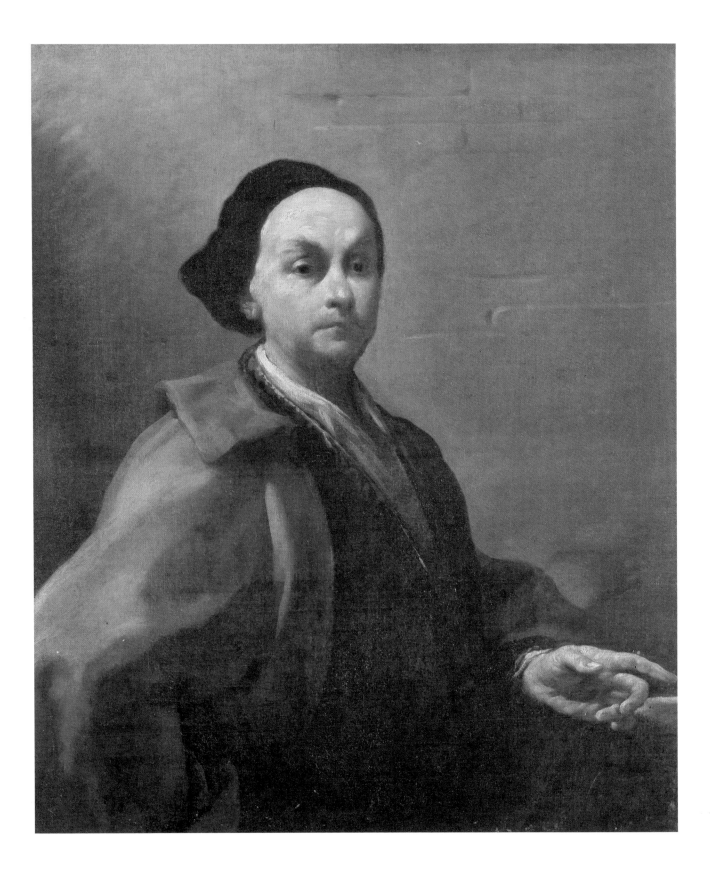

The early history of the self-portrait now in Pinacoteca Nazionale, Bologna, is not known. The painting is clearly based on the *Self-Portrait* in Lexington, although its smoother technique suggests a date of about five years later, as Merriman has also suggested. Riccòmini concurs in date of 1715-1720.[3] Merriman has called the Bologna *Self-Portrait* "one of the masterpieces of Crespi's mature years." Crespi was working in this period for the Count Antonio di Colato, who acquired his *Self-Portrait*.[4] Oretti saw some forty years later Crespi's life-sized self-portrait in half-length in the Ercolani collection, which is not mentioned by either Zanotti or Luigi Crespi.[5]

Notes

1) Merriman cat. no. 180. For the Faresini commissions, cf. cat. nos. 16 and 17 above, and, in my essay above, the section "Crespi and Genre Painting in Venice."

2) Merriman cat. no. A6, with the same estimate of its date.

3) Bologna, 1979, no. 31.

4) This can be deduced from the career of the singer Vittoria Tesi, who first performed in Bologna in 1716: see Merriman cat. no. 213.

5) Riccòmini (Bologna, 1979, no. 31) cites a self-portrait that Oretti saw in the house of Crespi's heirs (ca. 1769); however, this notice is not found in the published text of Oretti's MS. B 104.

19 The Finding of Moses
Oil on canvas, 120×165 cm.
Museo del Palazzo di Venezia, Rome

Merriman cat. no. 5.

Early Provenance

Commissioned from the artist by Cardinal Tommaso Ruffo, Papal Legate to Bologna (1721-1727); Cardinal Tommaso Ruffo, Ferrara (Agnelli cat. 1734); by descent to Prince Fabrizio Ruffo di Motta Bagnara, by whom bequeathed to the state of Italy in 1915.

Sources

ZANOTTI (1739, II, p. 56): While Legate to Bologna, Cardinal Ruffo wished to have some pictures by the local painters; he therefore commissioned two from *lo Spagnuolo*: Abigail, who offers to David, who was angry with her husband, ample gifts of bread, wine, sheep, and whatever else he requires in order to placate him; and the other was the finding of Moses in the river Nile. Having made these pictures, he was entitled to request two favors of the Cardinal, and he was granted them. One was to liberate a malefactor from the galleys, and the other was to free a man from the noose; and the Cardinal not only granted these favors, but he publicly said that he would not have done them for anyone but *lo Spagnuolo*.

CRESPI (1769, p. 214): For Cardinal Tommaso Ruffo, at that time Legate of Bologna, he painted two pictures, in one Abigail who placates David with Gifts, in the other Moses found in the Nile by Pharaoh's daughter.

The story of the Finding of Moses (Exodus 2:3-5) gained currency in seventeenth- and eighteenth-century painting after Paolo Veronese and other painters of the Venetian Renaissance had brought to light its potential for the representation of pretty maidens in festive dress. Crespi's *The Finding of Moses* respects this tradition: the mood is lighthearted.

19.1. Crespi, David and Abigail. *Museo del Palazzo di Venezia, Rome.*

The provenance of this painting and of its pendant, *David and Abigail* (fig. 19.1) are known in an unbroken succession from the time of Crespi. They were left to the Italian state in 1915 by a direct descendent of Cardinal Tommaso Ruffo, Papal Legate in Bologna (1721-1727), who commissioned them from the artist.

The Finding of Moses and the story of Abigail who assuages David's wrath against her husband (1 Samuel 2:14-35) are unexpected subjects for pendant paintings, but an explanation of the pairing is suggested by the compensation that Crespi requested for these works. As Zanotti relates on this occasion and elsewhere, Crespi felt keenly his Christian duty to deliver prisoners from captivity, and he often negotiated with persons in authority to obtain this favor. For Cardinal Ruffo, the Papal governor of Bologna, Crespi painted two stories in which a head of state or his surrogate — David and Pharaoh's daughter — chose to be merciful in the exercise of their powers over life and death.

20 The Massacre of the Innocents
Oil on canvas, 128×177 cm.
National Gallery of Ireland, Dublin

Merriman cat. no. 39.

Additional Bibliography
Bologna, 1979, no. 29.

After the wise men had departed from the Holy Family in Bethlehem, an angel appeared to Joseph in a dream, saying, "Arise, and take the young child and his mother, and flee into Egypt, for Herod will seek the young child to destroy him." When Herod saw that he had been deceived by the wise men, he was exceedingly angry, and he sent his soldiers to Bethlehem to slay all the children of less than two years of age. Thus was fulfilled the saying of the prophet Jeremiah: In Rama was there a voice heard, lamentation, and weeping, and great mourning (Matthew 2:13-18).

The tragic story of the Massacre of the Innocent Children of Bethlehem occupied the imagination of Giuseppe Maria Crespi throughout his career. There are numerous citations in the writings of Zanotti, Luigi Crespi, and Marcello Oretti of his paintings on this theme; all but one of these early references can be identified with paintings other than that in the National Gallery of Ireland. The exception is found in Zanotti's notice, "The Boccherini in Prato have one of his beautiful pictures of the Massacre of the Innocents." In the present state of our knowledge, it is impossible to know whether the ex-Boccherini picture is that in Dublin, or the closely related version in the Pinacoteca Nazionale, Bologna, or none of the above.

20.1. Crespi, The Massacre of the Innocents. *Pinacoteca Nazionale, Bologna.*

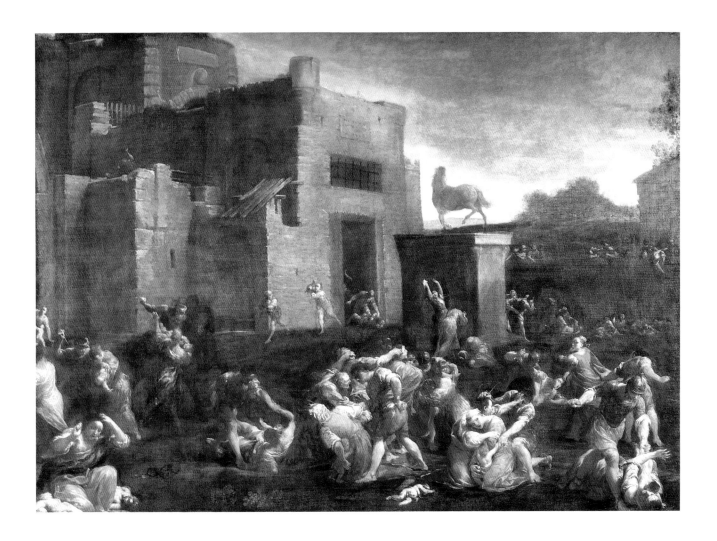

As the sources make clear (Haskell was the first historian to draw upon all the available evidence to reconstruct this episode), Crespi's career was brought to a crossroads during the period 1706-1708 by the controversy surrounding his *Massacre of the Innocents* (fig. 8), which he eventually gave to Grand Prince Ferdinand de' Medici (and is now in the Uffizi).[1] (It was not his first treatment of the subject, since it appears that Crespi had previously treated it in microcosm, so to speak, using the front and back of a small copper plate.[2]) The Uffizi *Massacre of the Innocents* was intended from its conception to be a kind of tour de force, since the original patron, a querulous priest named Don Carlo Silva, had intimated that the picture was to be a gift to Ferdinand de' Medici.[3] The Uffizi picture evidently created a stir in the artist's studio during the time that he waited for Silva to make good on his promise. When Giovanni Ricci brought Giorgio Raparini, advisor on art to the Elector of Palatine, to visit Crespi in 1706, the *Massacre of the Innocents* was nearly finished.[4] In 1707, Raparini sent Ricci three letters from Düsseldorf in the hope of acquiring the picture: in the end, he was sent a drawing of it, and he placed an order for a different picture of the same subject.[5] The drawing is probably the large sheet in the Metropolitan Museum of Art;[6] the canvas was not completed until 1715 and is now in the Alte Pinakothek, Munich.[7]

The *Massacre of the Innocents* in Dublin has been dated to the early 1720s by Merriman, and it was probably Crespi's last major consideration of the subject. The Pinacoteca Nazionale, Bologna, acquired in 1971 a similar composition (fig. 20.1) which is very likely an autograph derivation of some years later.[8] The most telling difference between the paintings in Dublin and Florence lies not so much in the scale of the figures (which are small in both), as in the treatment of spatial perspective. Although Crespi was forty-one years old in 1706, he was not as yet in complete command of his technique. The choked groupings in the Uffizi *Massacre of the Innocents* are signs of his inexperience in composing with many figures: he had already solved the problem by 1715 in the picture for the Elector of Palatine, and compositions of this complexity were second-nature to Crespi by the time of the Dublin canvas.

Notes

1) Haskell, 1980, pp. 327-239, 390-391. See also in my essay above the section "Crespi and Genre Painting in Florence." The known documentation for the relations between Crespi and Ferdinand de' Medici and the dispute of the *Massacre of the Innocents* is transcribed below in Appendices I-IV.

2) Zanotti (1739, II, p. 45) and Luigi Crespi (1769, p. 206) cite pictures of this subject for the Marshal Caprara, who died in 1701. The copper plate, recto and verso, in a Roman private collection (Merriman, cat. nos. 34 and 35) is reputed to have a Caprara provenance. See Appendix V.

3) We can imagine Crespi's frustration over Silva's prevarication, since one of the artist's assistants, Lorenzo Manzini, testified that Silva used to visit Crespi while he was working on the picture in order to chide him with remarks such as, "Signor Crespi, I advise you to make sure that the painting is well composed, since you know into whose hands it must go." (Appendix III, Doc. 8).

4) Giovanni Ricci testified to this visit in the course of Crespi's lawsuit with Silva: the notice is interesting and records Ricci's activities on behalf of Crespi twenty years after their first meeting (Appendix III, Doc. 1). Merriman misread this document to mean that Antonio Ricci (Giovanni's father) was the person who brought Giorgio Raparini to Crespi in 1706.

5) For Giorgio Maria Raparini (1660-1725) and the collection of Johann Wilhelm, Elector of Palatine, in Düsseldorf, see Haskell, 1980, pp. 281-283. A stray notice in Zanotti (1739, II, p. 101) is relevant here: Raparini was originally a Bolognese painter with whom Donato Creti had studied for a year.

6) Bean, 1979, no. 148, illus.

7) Merriman cat. no. 38.

8) Merriman cat. no. 40.

21 The Flea Hunt (*La pulce*)
Oil on canvas, 55×41 cm.
Musée du Louvre, Paris

Merriman cat. no. 251.

Sources

[No contemporary writers or documents describe Crespi's *Flea Hunt* paintings as such. However, the following remarks by Zanotti and Luigi Crespi seem to refer to pictures of this kind.]

ZANOTTI (1739, II, p. 59): By an English nobleman, who was living some time in Bologna, and was very taken by the style of *lo Spagnuolo*, and delighted in certain of his pleasant and graceful conceptions (for which *lo Spagnuolo* has no equal), he was commissioned some small paintings on copper, which represented the life of a singer, beginning from a low and poor state, and rising in a few years, with the aid of her youth, and her beauty (if she had any, and if she had not, then with that which she did have), to a sweet life, full of everything amusing and delightful. I remember with what beautiful and lively imagination this was expressed, and with such witty observations. I know that those of these pictures that I saw made me split my sides with laughing. Then on to the deplorable end, which such lives eventually encounter, and how, when she had lost her youth, the *virtuosa* became solitary, sorrowful, and devout. He expressed the most amusing things that anyone could imagine; all of this with an indescribable verity, not only in the figure but also in the household effects, which were either miserable and tattered, or pompous and rich, according to the situation being represented.

CRESPI (1769, pp. 215-216): For the greater Faresini in Venice... two cypress panels in one of which he painted the miserable life of a woman of ill repute...

A young woman awakes in a simple room. It is a beautiful day, and sunlight filters through the disarray of her furnishings, such as they are. The woman's family is already up and about: her graybeard father sits and minds a baby. Untroubled by modesty, she contentedly searches in her bosom for a vexsome flea. A story appears to be unfolding in Crespi's painting, as Roberto Longhi was the first to suppose.[1] There are seven extant variations by Crespi or his assistants on the theme of the *Flea Hunt* (in Italian, simply *La pulce*).[2] Longhi thought that the *Flea Hunt* in the Uffizi (fig. 21.1) might reflect the opening vignette of Crespi's lost cycle of paintings depicting the tragi-comic rise and fall of a singer. Pierre Rosenberg[3] and Merriman subsequently refined Longhi's thesis by pointing to certain hints of incipient luxury in the generally shabby surroundings: namely, the lap dog and, most significantly, the spinet which is glimpsed

21.1. Crespi, The Flea Hunt. *Oil on copper. Uffizi, Florence.*

21.2. Crespi, The Flea Hunt. *Museo Nazionale, Pisa.*

at left in the three similar compositions in the Louvre, in Pisa (fig. 21.2) and in Naples (fig. 21.3). Merriman suggested that the papers affixed to the wall in the Paris/Pisa/Naples compositions are *manifesti* of concerts for which the budding singer has enjoyed the sponsorship of nobility.

Merriman foresaw some difficulties with the identification of the *Flea Hunt* as a scene from the *Life of a Singer*. From her study of Zanotti's manuscript for his Crespi biography, she extracted two additional facts: 1) the English patron for these painters had been infatuated with the singer Vittoria Tesi, and 2) he had commissioned the paintings following his return to England. Since Tesi did not perform in Bologna until 1716 (at the age of sixteen), Merriman was able to establish 1716 as the *terminus post quem* for Crespi's missing *Life of a Singer*. By this determination, the Uffizi *Flea Hunt* of ca. 1709 would precede the English series by some years. Merriman concluded that Crespi's design for the Paris/Pisa/Naples *Flea Hunts* — which are the only ones that include a spinet — must likewise have preceded Crespi's *Life of a Singer*, because she would date the Pisa *Flea Hunt* earlier than 1716.

Such an early date for the Pisa *Flea Hunt* seems untenable, however, on the basis of comparison with the Uffizi version. During the first two decades of the eighteenth century, as before, Crespi's paintings were

21.3. *Crespi,* The Flea Hunt. *Museo di Capodimonte, Naples.*

conceived, first and foremost, as paintings of figures, not of places. The robust girl in the Uffizi canvas has barely enough room to sit down or stand up. In the *Seven Sacraments* of ca. 1712 (cat. no. 14), Crespi denied the actors even that much space. The *Fair at Poggio a Caiano* (cat. no. 9) is set out of doors, yet the whole is choked with figures. At the end of the decade, about 1717, Crespi enlarges the space of his composition — as in the *Fair with a Dentist* in Milan (cat. no. 17). But the burden of expression continues to be borne by the figures alone.

In the Paris/Pisa/Naples *Flea Hunts*, the artist situates the leading lady in a more spacious ambiance. He now takes the point of view that where she lives is fully as revealing about her — or perhaps more so — as her appearance. At the heart of this pictorial conception lies the class-consciousness of eighteenth-century art (and culture). In fact, Crespi's *Flea Hunt* in Paris, here dated about 1728, is one of the first Italian paintings in which an interior view fulfills the role of social commentary.[4] Merriman and all writers before her assumed that the Medici provenance of the Pisa *Flea Hunt* was proof of its precedence over the Paris version. However, there is no direct documentary connection between the Pisa canvas and Crespi's patron, Grand Prince Ferdinand de' Medici: it is not cited in his estate inventory of 1713, for instance. Therefore, the Pisa *Flea Hunt* could have entered the Grand Ducal collections at any time prior to 1737, by any of the countless avenues through which the Medici acquired pictures. On the basis of both quality and type, the Paris *Flea Hunt* deserves to be considered the prototype of the related compositions in Pisa and Naples. To recommend it, the Paris canvas is executed with an extraordinary finesse that reminded Rosenberg of the genre technique of David Teniers the younger. On the other hand, the Pisa *Flea Hunt* displays the thin handling frequently encountered in Crespi's paintings of the 1730s.[5] The highlights on the folds are likewise treated with a linearity seen in many of his late works. Overall, the details of the room's furnishings are barely legible in comparison to the greater clarity of the Paris prototype.

Merriman takes the opposite position and describes the Louvre canvas as a derivation of the version in Pisa. She proposed to date the Paris *Flea Hunt* to the early 1720s, but the picture is not comparable to the broader handling of the works commissioned by Cardinal Ruffo early in the decade (cat. no. 19), and must be later. I would argue that the Louvre *Flea Hunt*, although a cabinet picture, exemplifies the superb style of Crespi's two great altarpieces for the Jesuits in Ferrara, painted in 1727 and 1729.[6] This moment in Crespi's evolution is distinguished by its fine balance between his seventeenth-century roots and his response to the incoming tides of the Rococo. The figures are notably more slender and are drawn with grace. They have delicate features, but in

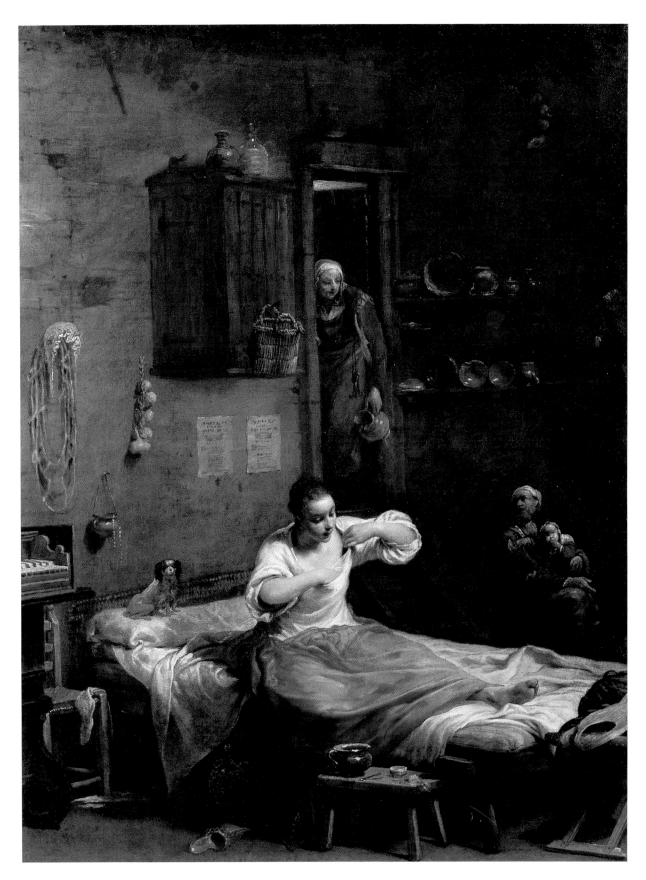

contrast to the later works, the faces are still acutely observed from nature. In comparison to Crespi's other paintings in this present study, the *Flea Hunt* in the Louvre comes closest to the slightly later *Nurture of Jupiter* (cat. no. 22).

The arguments concerning the date of the Paris *Flea Hunt* are pertinent to a larger question, which will only be resolved if and when the missing cycle of *The Life of a Singer* comes to light again. To wit, was Crespi inspired by Hogarth's social satires, which are so alike in outlook, or vice versa? Hogarth claimed to have been the first to paint moralizing genre subjects in series. His first effort was the *Harlot's Progress*, which was probably painted in 1731-1732, and which was widely circulated in a series of prints issued in 1732. Zanotti discusses Crespi's English commission in the context of his works executed near the time of his writing, the 1730s, but he does not indicate the date specifically enough for our purposes in this debate. The fact that the commission originated following the Englishman's return home brings Hogarth too close to the situation to ignore, even if the Louvre *Flea Hunt* is rightly dated to the late 1720s. Given the available evidence, one likely sequence of events is the following: the Englishman resident in Bologna was an admirer of Crespi's genre interiors with young ladies, and he recognized their elements of social commentary. After he had returned to England, this patron was inspired by Hogarth's *Harlot's Progress* to commission an analogous series from Crespi. An alternative hypothesis is, of course, that Hogarth saw Crespi's paintings after they were sent to England and seized upon their innovative subject matter. Whether or not Crespi used the motif of the *Flea Hunt* in his *Life of a Singer* cannot be known for the present. But he apparently never made any other cycles of genre satires.

Notes

1) Longhi, in Bologna, 1948, p. 32, no. 19.

2) Merriman cat. nos. 246-252. My views on the authorship and dates of these versions of the *Flea Hunt* differ from Merriman's and are as follows (with Merriman cat. nos.): 1. Leningrad 246 = Crespi, ca. 1705; 2. Florence 247 = Crespi, ca. 1709; 3. Paris 251 = Crespi, ca. 1727-1729; 4. Pisa 250 = autograph replica by Crespi of Paris 251, mid-1730s; 5. Naples 252 = autograph replica by Crespi of Paris 251, mid-1730s; 6. Birmingham 248 = Crespi, late 1730s; 7. Chicago 249 = Crespi studio replica of Birmingham 248, late 1730s.

3) Rosenberg, 1971, pp. 13-20.

4) Crespi's follower, Giuseppe Gambarini, was moving in the same direction at the time of his premature death in 1725. For example, see his *Party in a Peasant House* in Lisbon: Fiocco, 1948, fig. 1. Both Crespi and Gambarini advance beyond Marco Ricci's earlier scenes of *Concerts*. Ricci's interiors are as yet neutral backdrops for the actions of the figures.

5) The overly contrasted photography published in Merriman cat. no. 250 makes an extraordinarily better impression than the illustration in the recent catalogue of the Museo Civico, Pisa, by Carli (1974, fig. 149).

6) Riccòmini (Bologna, 1979, no. 33) cites documents from these two dates.

22 The Nurture of Jupiter
Oil on copper, 66.7×66.7 cm.
Kimbell Art Museum, Fort Worth

Cf. Merriman cat. no. 160 [the canvas of this subject in Stuttgart].

Sources

ZANOTTI (1739, II, pp. 62 and 65): In the same city of Lucca the noble family of the Conti have his picture of the birth of Jupiter given to the Corybantes to be fed [the Stuttgart canvas] [65]... for the auditor Mansanti [he has painted] the birth of Jupiter and many other things, always with his accustomed mastery.

CRESPI (1769, p. 215): ...and for this city [of Lucca] he also painted a beautiful picture for Giovanni Angelo Conti [the Stuttgart canvas].

Additional Bibliography

Pillsbury and Jordan, 1985, fig. 9; Merriman, 1985, pp. 254-255, color pl. VI.

In August of 1728, Crespi was commissioned by Stefano Conti, a prominent businessman in Lucca, to paint a subject of the artist's choice for Conti's well-known collection of paintings.[1] Crespi elected to paint *The Nurture of Jupiter* (*Jupiter among the Corybantes*), and he completed the work by April 1729. The canvas for Stefano Conti is preserved in the Staatsgalerie, Stuttgart (fig. 22.1); its composition was the source for this newly-discovered painting on copper of the same subject. We are fortunate to have from Crespi's letter to Conti in Lucca (dated August 16, 1728) his own words of explanation of the story of Jupiter among the Corybantes:

I am honored to [make you] a picture for the price of 35 Luigi, inclusive of ten already received, of the dimensions indicated on the paper sent to me, with the story of Cybele,

22.1. Crespi, The Nurture of Jupiter. *Staatsgalerie, Stuttgart.*

who, when she had given birth at the same time to Jupiter and Juno, only showed Juno to Saturn, and secretly gave Jupiter to the Corybantes on Crete, to nurture him. The latter, thinking that his cries might reveal him, as is usual with babies, devised a plan to beat out a certain cadence, which they called Bactili, and so in unison they clanged little cymbals made of bronze, so that the cries of the infant Jupiter could not reach the ears of Saturn, who would devour his male offspring.[2]

In two articles devoted to Crespi's paintings of Jupiter among the Corybantes in Stuttgart and Fort Worth, Merriman has pointed out that Crespi mostly ignored the established iconography of the subject. Jupiter was fed milk from the goat Amalthea, but Crespi was less interested in this detail than he was in evoking the island paradise of the gauzily draped Corybantes.

Merriman observes that the variations between the *Nurture of Jupiter* painted on copper and the canvas of 1728-1720 for Conti represent subsequent refinements by Crespi of the compositional scheme. Indeed, the differences between these pictures amount to much more than the substitution of a few figures, and we may conjecture an interval of a few years between their execution. The *Nurture of Jupiter* recently acquired by the Kimbell Art Museum may or may not be the picture cited by Zanotti as executed for the auditor Mansanti during the 1730s. In any event, the contrast between this picture and the earlier picture for Conti constitutes a valuable demonstration of the evolution in Crespi's style between the 1720s and the 1730s.

Notwithstanding his characteristic liberties with iconography, Crespi's style in the *Jupiter* painted for Conti conforms to the traditional guidelines for history painting: the expressions of the figures are subtly varied, the company comports itself with dignity, the draftsmanship is studied. When later Crespi decided to make his reprise on copper, his mood was to transform the history into an idyll. The *Jupiter* in Fort Worth takes its place in the emergent Rococo; indeed, now in the 1730s, Crespi's style becomes a model for the development of Pietro Longhi. The delicate anatomies, gentle features, and the general celebration of color over drawing were all destined to be adopted by Crespi's Venetian follower. As a work securely dated to the 1730s, the present *Nurture of Jupiter* provides an invaluable point of reference both for our understanding of Crespi's style during this decade and for the analysis of his influence on Longhi.

Notes

1) For the Conti commission and the subject, see Merriman, 1976, pp. 464-472. The existence of correspondance between Crespi and Conti was first made known in 1963 by Haskell (ed. 1980, p. 228, *q.v.* for Conti's collecting in general). Luigi Crespi gives the wrong name of "Giovanni Andrea" for Crespi's patron or is thinking of a different painting.

2) For the transcription of the original Italian text, see Merriman, 1976, p. 472, Letter no. 3.

23 A Lady with a Dog
Oil on canvas, 44.7×35 cm.
Lowe Art Museum, University of Miami, Samuel H. Kress Collection

Merriman cat. no. 214.

A pretty coquette entices her pet with a biscuit; the willing spaniel eyes the prize with eager anticipation. This engaging canvas presents in the guise of a genre subject one of the favorite conceits of Crespi's time. As in the *Girl Holding a Dove* (cat. no. 3) of almost forty years earlier, the lady's pet assumes the role of a man-friend entranced by her charms and captive in the gilded cage of love.

While the theme remained little changed in four decades, the contrasting styles of this *Lady with a Dog* and the earlier *Girl Holding a Dove* exemplify the transformation that European painting underwent during the course of Crespi's career. Crespi was the last artist to turn to the early Baroque for inspiration, yet he was among the inventors of the Italian Rococo style. In the 1690s, when he painted the *Girl Holding a Dove*, he was trying to forge a naturalistic and expressive style based above all on his studies of Annibale and Ludovico Carracci. The early paintings

23.1. *Giambattista Piazzetta*, Boy Feeding a Dog. *Black and white chalk. Courtesy of The Art Institute of Chicago, Helen Regenstein Collection.*

create semblances of volume, texture, and atmosphere. By the 1730s, Crespi's *Lady with a Dog* has become perfectly attuned to the more decorative developments of eighteenth-century painting. Merriman makes the apt comparison to Fragonard's lighthearted paintings of several decades later. Contemporaneous with Crespi, his former pupil Giambattista Piazzetta in Venice was undoubtedly the most famous painter of genre subjects in half-length, and, by the 1730s, we can assume that Crespi was well aware of Piazzetta's drawings in this vein (cf. fig. 23.1).[1]

It is symptomatic of the difficult problems posed by Crespi's chronology that Merriman has quite different views as to the dates of both the *Lady with a Dog* in Miami and the *Girl Holding a Dove* in Birmingham. She considers the Miami picture an early work of ca. 1695-1700 and dates the painting in Birmingham to Crespi's maturity, the 1720s. Most of the exceptions that I would take to Merriman's datings fall into precisely these two periods of the artist's career — the 1690s and the 1730s — during the first and the last complete decades of his activity. Merriman suggests that Crespi experienced a fleeting encounter with "rococo or Arcadian" style at the end of the seventeenth century; in my view, he was still working then in a Baroque idiom, even when painting small figures. The late works — this *Lady with a Dog*, for example — are conceived in terms of compositional pattern, not space, and flickering patches of color, not modeling in the round. Finally, in many of Crespi's late pictures, the delicate balance between light and dark tends to turn in favor of the latter. The figures are less substantial and are frequently isolated against darkened backgrounds. *The Rape of Europa* (cat. no. 26) and *Peasants and Cattle Fording a Stream* (cat. no. 25) are two other paintings here assigned dates in the mid-1730s, although Merriman has dated them earlier. These paintings seem comparable in style to *The Artist in his Studio* (cat. no. 29), which Merriman is also inclined to date after 1730 and for which there exists documentation to suggest a date as late as 1742.

Notes

1) The distribution of Piazzetta's drawings of heads was such that two of them even found their way to the Certosa di S. Michele in Bosco, Bologna, where they decorated the fifth room of the *foresteria*, not far from three early religious pictures in the first chamber by Giuseppe Maria Crespi: Luigi Crespi, 1772, pp. 64 and 66.

24 Singer at the Spinet with an Admirer
Oil on canvas, 57.6×45.7 cm.
Galleria degli Uffizi, Florence

Merriman cat. no. 284.

Sources

[No contemporary writers or documents describe the present picture, which entered the Uffizi at an unknown date. However, the remarks made by Zanotti (1739, II, p. 59) and quoted in cat. no. 21 above seem to refer to a related series of paintings.]

Additional Bibliography
Uffizi cat. 1980, no. P481.

A comedy is unfolding in a fashionable drawing room. The evening's concert has been momentarily interrupted by an impassioned admirer of the diva. She turns from the spinet to receive his gift, a pearl necklace. All about this pair, the party erupts into mischievous delight: a girl at right exhorts us to observe the fun, as a prankster crowns the unwitting admirer with the traditional horns (*corna*) of the cuckold (*cornuto*); the gent at left unleashes his own cornucopia of indecent or insulting hand gestures.

The subject of a singer showered with gifts naturally calls to mind Crespi's lost series depicting the rise and decline of a courtesan-singer. Crespi's contemporary and principal biographer, Giampietro Zanotti, is the source of our knowledge of this commission from an Englishman, which has already been discussed with reference to *The Flea Hunt* in the Louvre (cat. no. 21). Longhi, Rosenberg, and Merriman suggested that the *Flea Hunt* might reflect the opening scene in the melodrama. The present canvas has not had the same critical attention (and in earlier Uffizi catalogues it was unjustly demoted to a studio attribution), but Voss, Merriman, and other writers have noted the possibility that this particular episode might represent Crespi's interpretation of the singer's erstwhile career at its acme.[1] As Merriman points out, the raucous humor certainly accords with Zanotti's report of Crespi's intention to amuse.

This canvas anticipates to a striking degree Pietro Longhi's mature style of the 1740s. On the basis of its style, the picture apparently dates from the mid-1730s. Merriman suggested the span of 1735 to 1740. A date in the mid-1730s is also consistent with arguments made elsewhere in this study: first, it supports a date in the early 1730s for the lost *Life of a Singer* (cf. cat. no. 21), and second, it conforms to a dating in the mid-1730s of Pietro Longhi's studies in Bologna (cf. cat. nos. 38 and 39).

Notes

1) See Merriman cat. no. 284 for the critical history. Merriman rightly restores this painting to full autograph status, although in her essay in this catalogue she compares it unfavorably to a newly discovered version in a Bolognese private collection (cf. fig. 45).

25 Peasants and Cattle Fording a Stream
Oil on canvas, 100.5×134.5 cm.
Private Collection, Bologna

Merriman cat. no. 231.

Crespi's *Peasants and Cattle Fording a Stream* has an elegaic quality that is reminiscent of pastoral poetry. The ample scale of this painting is unusual for Crespi's rustic subjects: indeed, the broad passages of muted tones in the landscape are perhaps more evocative of a pastoral mood than are the actions of the figures. It seems to be dusk, when everyone returns home tired.
Peasants and Cattle Fording a Stream was paired until recently with a painting of cattle grazing and being milked, and shepherds piping[1] — in all, the activities of a different time of day altogether. Merriman has suggested that the present picture can be dated to the same period as the *Woman Washing Dishes* in the Pitti Palace, formerly in the Contini Bonacossi collection (fig. 12), which she dates about 1725.[2] It is true that the same slightly acid colors of orange and turquoise prevail in these works; in addition, the pigment is thinly applied, and the highlights are laid like filaments on top of the deeply shaded backgrounds. The elegaic emotion is an important point in common as well. These qualities are typical of Crespi's style of the mid-1730s (cf. cat. no. 26).

Notes
1) Gasparrini collection, Rome. Merriman cat. no. 232.
2) Merriman cat. no. 259.

26 The Rape of Europa
Oil on canvas, 64.5×86.5 cm.
Private Collection, New York

Merriman cat. no. 157.

Europa, the beautiful daughter of Agenor, ruler of Tyre, became the object of Jupiter's desire. He sent Hermes to drive Agenor's cattle down to the seashore, where Europa and her companions used to walk. Jupiter himself joined the herd, disguised as a snow-white bull with great dewlaps and small gemlike horns. Europa was struck by his beauty and, on finding him as gentle as a lamb, mastered her fear and began to play with him, putting flowers in his mouth and hanging garlands on his horns. She eventually climbed upon his shoulders and let him amble down with her to the edge of the sea. Suddenly he swam away, while she looked in terror at the receding coast. Wading ashore near Cretan Gortyna, Jupiter metamorphosed into an eagle and ravished Europa in a willow-thicket beside a spring.[1]

The painters of the Baroque responded unabashedly to the passion and excitement of the story of Europa. Titian had left his mark on the theme with a tumultuous canvas that he sent to Spain in 1562 for the private delectation of Philip II (now at Fenway Court, Boston). Had Crespi addressed this subject in his youth, he might have painted it in the style of his Titianesque *Tarquin and Lucretia* of the early 1690s (cat. no. 2). To the contrary, this *Rape of Europa* from the mid-1730s has an air of whimsy about it, as if the old master had decided to poke fun at the emotional excesses of both the story and its conventional depictions. For all intents and purposes, Crespi has brought us to a garden party, not to witness an abduction from the serraglio. The girls adorn the cattle with flowers; Europa sits daintily on top of Jupiter, who gently lifts his huge eyes in gratitude for the tidbit she puts before him. Truly, this confection of *The Rape of Europa* would have been the despair of Lancret (the mood is too light for Watteau).[2] In the event, the Venetian Pietro Longhi (cat. nos. 38-45) was to derive much from the intimacy, informality, and painterly technique of Crespi's canvases like this one. The brushwork is free, and Longhi would have appreciated Crespi's handling of such passages as Jupiter's head (fig. 26.1), where a dense impasto is achieved by the build-up of many tiny strokes. The painting can be dated with some certainty to the middle years of the 1730s, a conclusion which is useful to our investigation of Longhi's influences from Crespi.[3] Its date can be determined on the basis of a close comparison to the painting on copper *The Blessed Bernardo Tolomei Visiting Victims of the Plague* (fig. 26.2), recently rediscovered, which Crespi painted for patrons in Florence[4] just as Zanotti was finishing the first draft of his biography of the artist, about 1736.[5] The *Blessed Bernardo Tolomei* provides an invaluable reference point for Crespi's many late works — such as this *Rape of Europa* — in which the pigment is freely scumbled and the highlights are scattered across the deeply shaded background.

26.1. Crespi, The Rape of Europa. *(Detail). Private collection.*

26.2. Crespi, The Blessed Bernardo Tolomei Visiting Victims of the Plague. *J. Paul Getty Museum, Malibu, California.*

Notes

1) This account is adopted from Robert Graves, 1979, pp. 194-195. The antique sources are Ovid *Metamorphoses* II, 103-107; *Fasti* V, 605-616.

2) This sentence paraphrases a *bon mot* of the French critic Thoré-Bürger regarding Chardin and Nicolas Maes's gifts for still life. Many thanks to William W. Robinson.

3) Merriman mistook this picture for an early work and expressed doubts about its state of preservation. The painting is in good condition, however.

4) See note 89 to the essay above, "Giuseppe Maria Crespi and the Emergence of Genre Painting in Italy."

5) Mira Pajes Merriman informed me of this marginal notation to the Zanotti manuscript, MS. B 6, in the Biblioteca Comunale, Bologna.

27 A Courtyard Scene
Oil on canvas, 76×90 cm.
Pinacoteca Nazionale, Bologna

Merriman cat. no. 266.

The tranquil setting of Crespi's *Courtyard Scene*, with its honey-colored buildings, seems at odds with the barnyard humor of its subject. An old hag looks up long enough from her laundry to toss a brickbat at a bumpkin who is contentedly fouling the wall at the other end of the courtyard. From a nook in the same wall, an ornery cat takes his own swipe at the guilty party.

As all previous commentators on this happy canvas have pointed out, this brand of low-life humor was the mainstay of the genre paintings of the Bamboccianti. Scholars are agreed, therefore, in dating the picture to the period immediately following Crespi's deepest exposure to the Bamboccianti, that is, during his Florentine sojourn in 1709. This conclusion may be more reasonable than strictly accurate, since the style of this *Courtyard Scene* does not appear to have anything to do with Crespi's works in the second decade of the eighteenth century. Instead, the thin texture of the pigment and the threadlike manner in which the highlights are laid on top of the forms are both techniques that can be associated with Crespi's frequently delicate approach to painting during the 1730s. Notwithstanding differences in tonality, the figure style and handling of the brush in this painting and in the *Peasants and Cattle Fording a Stream* (cat. no. 25) appear to be closely comparable. In contrast, the genre paintings that are datable to the 1710s, such as *A Peasant Family with Boys Playing* and *Peasants with Donkeys* (cat. nos. 12 and 13) — or, at the other extreme of that decade, the *Fair with a Dentist* (cat. no. 17) — display more emphatic volumes and assertive brushwork.

Merriman has intuited that the *Courtyard Scene* "owes its veracity, its loving, almost photographic rendering of the crumbling stones" to Crespi's use of a device similar to a camera obscura. Luigi Crespi carefully describes his father's installation of a lens in one of the doors of his house and his patient observations in the dark of the images refracted from the street on to a wall in his studio. He specifies that Giuseppe Maria Crespi painted some courtyard scenes of workers laying silk out in the sun to dry, and so forth.[1] Several of these paintings of the cottage silk industry, for which Bologna was once renowned, are extant, and their many points of contact with the present *Courtyard Scene* bear out Merriman's thesis that this picture, too, was painted with the aid of a refractive lens.[2] The apparent conflict between the late dates assigned to the silk manufacture pictures and the early date usually assumed for *Courtyard Scene* disappears with our redating of the latter. The

vividness of Luigi Crespi's recollections of this practice are also likely due to the fact that his father's experimentations with a camera obscura were strictly an activity of his old age. Zanotti, who was almost the contemporary of the elder Crespi, makes no mention at all of his use of a lens.

Notes
1) Luigi Crespi, 1769, p. 218.
2) Merriman cat. nos. 267-269.

28 Portrait of Cardinal Lambertini, Archbishop of Bologna
Oil on canvas, 80×58 cm.
Collezioni Comunali d'Arte, Bologna

Merriman cat. no. 189.

Sources
CRESPI (1756, pp. 307-309; 1769, pp. 219-220): ...Soon thereafter he began another portrait, that of his Eminence the Archbishop [Lambertini], also in life size and standing. While he was working on this, there occurred another amusing mishap that is worthy of note. But first one must know that my father was always extremely opposed to matrimony by any of his sons, and it was always sufficient, if one really wanted to see him enraged, merely to introduce this subject... One day while the Cardinal was in our house, and my father was painting him, one of my brothers entered the room carrying a letter that had arrived in the post from another of my brothers who was in Modena for various matters. Lambertini promptly had the letter given to him, saying to my father as he opened it, to continue painting and he would read it. He then proceeded to read it quickly, fabricating an entirely fictional letter, in

28.1. Crespi, Portrait of Pope Benedict XIV. *Pinacoteca, Vatican.*

166

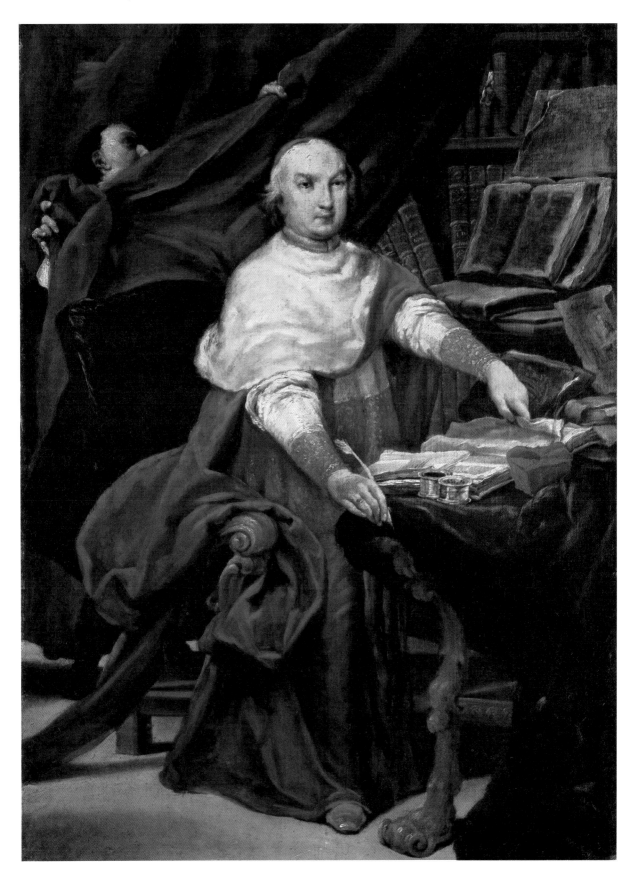

which the absent son, with all kinds of expressions of shame and apology threw himself at his father's feet to beg his forgiveness, explaining that he was unable to release himself from a compelling obligation to wed a certain Signora Apollonia, and — but when he came to this point, my father leapt to his feet, throwing aside his palette, brushes, and seat, upsetting the oil and varnish, and everything else on the little bench, making a thousand different exclamations all at once... Lambertini rose to quiet him, and to tell him that it was only a joke of his own invention... finally, they returned to that morning's work; and thereafter, whenever his Eminence came to visit, before descending from his carriage, he would always make a jest, reassuring my father that he was not accompanied by the Signora Apollonia.

Additional Bibliography
Chiarini, 1982, no. 57.

Among the blessings of Crespi's old age was his friendship with Cardinal Prospero Lambertini (1675-1758), Archbishop of Bologna. In August 1740, Lambertini ascended to the papal throne, taking the name of Benedict XIV. His long papacy was distinguished for its return to vigorous government tempered by common sense. The Pope was beloved as well for his playful sense of humor, and many anecdotes of the kind told by Luigi Crespi circulated during and long after the time of Benedict XIV. On Christmas Day in 1740, Giuseppe Maria Crespi knelt in the church of Saint Peter, Bologna, to receive a knighthood by order of the Pope, his old patron.

In 1739, Crespi had painted the Cardinal's portrait in full length. After his election, Benedict XIV called for the painting to be brought to Rome, and arranged for the artist to change the Cardinal's vestments into those of a Pope. The modified *Portrait of Benedict XIV* is still in the Vatican (fig. 28.1). The small-scale portrait catalogued here represents the original form of Crespi's painting and has always been considered to be a *bozzetto* for the picture. The painting is as likely, however, to have been executed as a *ricordo* of the full-sized portrait prior to the alterations, since *bozzetti* for Crespi's portraits are otherwise unknown and the handling is rather more finished than it is sketchy.

In either case, the result bears an uncanny resemblance to the mature style of Pietro Longhi, which was developed at precisely this time (the earliest example of Longhi's definitive genre style dates from 1741). Even granting the warm relationship between Crespi and the prelate, this diminutive portrait of Cardinal Lambertini is striking for its delicate technique and intimate character, two traits that would prove to be characteristic for Crespi's Venetian follower as well.

29 The Artist in his Studio
Oil on canvas, 57.3×42.9 cm.
Wadsworth Atheneum, Hartford, Connecticut,
The Ella Gallup Sumner and Mary Catlin Sumner
Collection

Merriman cat. no. 222.

Early Provenance
Probably the painting given by the artist to Carlo Vincenzo Ferrero, Marchese d'Ormea, Turin, in 1742.

Source
Extract from a letter written by Abbot Paolo Salani, Bologna, to the Marchese d'Ormea, Turin, December 1742: In the same carton your Eminence will find two other small pictures made by Crespi, and I confess that I was reluctant to take them for fear that you might think that his idea, although wise, was instigated by me. But the fantasy of a painter of such distinctive images is not easily contained, and he persuaded me to concede to his genius and wishes. He desires too much, he says, that his person in the act of painting at the easel in his room should be in the hands of your Eminence, and that the adoration of the Blessed Virgin and Saint Joseph over the new-born Redeemer should pass to the Royal Clemency of his Majesty, King of Sardinia, being a devout subject, and this is what I wished humbly to express to your Eminence for my own indemnity...[1]

The painter is seen quietly at work. He sits before his easel in his simple, uncluttered studio. From the wall hang a few plaster casts and a small copy by his own hand of his favorite painting, *The Ecstasy of Saint Francis* by Guercino. Next to the hearth, the cat sits in his accustomed place.

For the last two decades of his life, Crespi took no pupils or assistants other than his sons Luigi and Antonio. He stayed at home and went about his work. This was the setting in which Cardinal Lambertini posed for his portrait in 1739 (cat. no. 28) and which was sent into momentary commotion when Lambertini made a practical joke at Crespi's expense. "As for our academy, certainly he has never made much of it," wrote Zanotti, the official historian of the Accademia Clementina.[2] Is it any wonder, then, that Crespi allows a view into his studio that is extraordinarily free of intellectual pretensions: the scrambled books and the assorted bits of anatomical casts hardly amount to the cabinet of a *virtuoso*. Dwight C. Miller has made the admirable observation of this picture that "Crespi, native son of Bologna and speaking the flinty Bolognese dialect, has consciously embodied in his characterization a certain air of domesticity, as if determined not to assume the airs of a cosmopolite."[3]

The Hartford *Artist in his Studio* was considered an early work by scholars until Merriman rightly pointed out that the painting is executed in Crespi's late style. This is, after all, a composition of the kind that launched Crespi's follower Pietro Longhi on his career during the 1730s. Merriman endeavored to

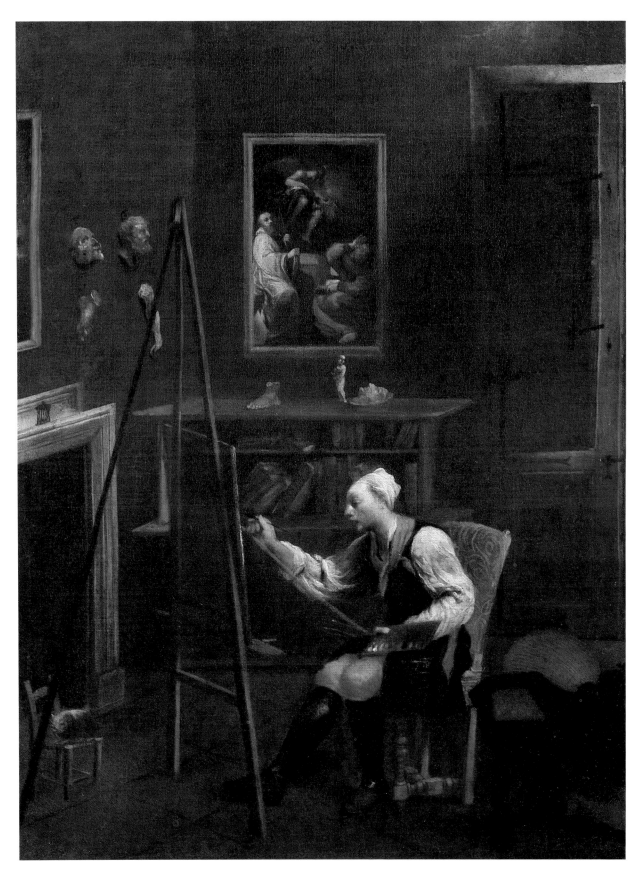

explain the youthful appearance of the painter with the hypothesis that the subject might be one of Crespi's sons. It seems moot whether the painter's age is youthful or merely indeterminate.

The late style of the *Artist in his Studio* lends persuasiveness to its identification as the "small painting" of "his person in the act of painting at the easel in his room" which Crespi sent in 1742 as an unsolicited gift to the Marchese d'Ormea, first minister to Carlo Emanuele III, King of Sardinia.[4] This notice has been hitherto overlooked. In 1916, Ludovico Frati published several letters that d'Ormea at the court of Turin had exchanged with Paolo Salani (1688-1748), the Olivetan Abbot of the monastery of S. Michele in Bosco, Bologna, relating to commissions tendered to Crespi, Donato Creti, and Ercole Graziani. In all, this correspondence clarifies the origins (and dates) of four paintings made by Crespi for d'Ormea (one of which, *Adoration of the Shepherds*, was sent as a spontaneous gift to the king: see the extract translated above).[5] It is clear that Paolo Salani was highly informed about art and was a trusted agent for the leading Bolognese painters.[6] At the end of the following year, 1743, Carlo Emanuele III reimbursed Abbot Salani for his payment to Crespi for the *Saint John of Nepomuk Confessing the Queen of Bohemia* (cat. no. 30).

Notes

1) Frati, 1916, p. 282.

2) Zanotti, 1739, II, p. 72.

3) Miller in Chicago, 1970, no. 46.

4) Frati, 1916, pp. 279-283. Carlo Emanuele III made a pleasant stopover in Bologna between August 24 and 28, 1742, and he visited the principal sights of the city with the Marchese d'Ormea, his Gran Cancelliere, who was also his trusted advisor on art. Between 1737 and 1744, d'Ormea negotiated for Carlo Emanuele III the acquisition and transportation to Turin of the collection of paintings of the deceased Prince Eugene of Savoy. Since none of Crespi's paintings for Prince Eugene came to Turin, having all been sold by the heirs to other parties prior to the sale of the collection as a whole, it almost would appear that d'Ormea set about to rectify these omissions with purchases directly from the artist. Luigi Crespi dedicated his 1769 supplement to the *Felsina pittrice* to Carlo Emanuele III, with a mention of the latter's visit to Bologna in 1742.

5) In a letter of September 23, 1742, d'Ormea informed Paolo Salani that he had received from a Mons. Millo a painting of the Virgin by "Spagnoletto" [his nickname was interchangeable with Ribera's even during his lifetime (!)], and he asked Salani to commission a *compagno* from the artist. By December, Crespi had completed this assignment and had painted in a *maniera forte* a pendant representing the "Redeemer insulted by a *manigoldo*" (ruffian). To judge from these descriptions and the probability of a date in the 1740s, these two paintings are identifiable with two entries in Merriman's catalogue, the *Lamentation of the Virgin* (no. 63, whereabouts unknown) and the *Christ Fallen under the Cross* (no. 57, Musée d'Art et d'Histoire, Geneva). The d'Ormea/Salani documentation thus confirms the hypothesis already advanced by Mauro Natale (1979, no. 42). Into the packing case, Crespi insisted on enclosing two gifts, a *Self-Portrait at the Easel*, which is here identified with the painting at Hartford, and, for Carlo Emanuele III, an *Adoration of the Shepherds*, which is still in the Galleria Sabauda, Turin (Merriman cat. no. 24). This was only one more instance of a strategem that Crespi developed early in his career: such "gifts" to important personages were invariably recompensed, or at least resulted in future patronage.

6) One of the letters published by Frati (1916, p. 283) is a note to Paolo Salani from Luigi Crespi with instructions concerning the price and bargaining, and indicating, moreover, his father's desire that Luigi Crespi should read and approve the abbot's letter to d'Ormea in advance. Zanotti annotated his copy of the *Storia della Accademia Clementina* (1739) with attestations of his friendship with Paolo Salani, as well as with the notice that the abbot was elected an honorary academician (cf. Zanotti, *Commentario*, 1977, p. 132).

30 Saint John of Nepomuk Confessing the Queen of Bohemia
Oil on canvas, 155×120 cm.
Galleria Sabauda, Turin

Merriman cat. no. 133.

Early Provenance
Acquired by Carlo Emanuele III, King of Sardinia, from Abbot Paolo Salani, Bologna, in 1743, probably executed on commission by the artist; thereafter documented in the Royal Galleries, Turin, until the present day.

Source
Extract from the Treasury of the Royal House of Savoy:[1] 1743, 29 October To signor commendatore di Pamparato majordomo of His Majesty for payment of the same in Bologna to Padre Abbot Sellani [Salani] for the price of a picture bought on the order of His Majesty representing St. John Nepomuk, destined for his royal apartments in this city; L. 630.

Saint John was born in Nepomuk in Bohemia about 1345 and died a martyr in Prague in 1393. He was a canon who vigorously defended his archbishop in a series of violent controversies with King Wenceslas IV. It was commonly said that John was murdered by order of the king for his refusal to divulge the confessions of the queen of Bohemia.[2]

Crespi was called upon to paint various images of Saint John of Nepomuk following the saint's canonization in 1729. By curious coincidence, the principal episode in the legend of the saint was concerned with the Sacrament of Confession, which had inspired Crespi to invent a new sort of genre painting near the mid-point in his career (cf. cat. no. 14). In 1743, on assignment from Carlo Emanuele III, Crespi applied his naturalistic vision once again to this motif. The sacred subject that resulted, *Saint John of Nepomuk Confessing the Queen of Bohemia*, is the masterpiece of his old age.[3] In 1948, Roberto Longhi wrote as follows about the *Saint John of Nepomuk* on the occasion of the first monographic exhibition devoted to Crespi:

There is finally another painting that I prefer of all the works by Crespi... It is the painting in the Pinacoteca in Turin, acquired by the Duke of Savoy in Bologna in 1743, and presumably, therefore, a late work by our painter. The extraordinary part is not that Crespi decided to repeat the idea of the "Confessional" of thirty years earlier; but rather that he interpreted it in a manner that was even more human, simple, and modern than before. There, it had been a fluke of light that had provoked a genre painting; here, it is his meditation on an ancient religious argument that has led Crespi to make from this humble scene a mundane picture with an ecclesiastic purpose. If ever Chardin had painted a religious picture, it would have been this one.[4]

As a rule, Longhi was a partisan of Giacomo Ceruti's renditions of daily life: he had difficulty with Crespi's irrepressibly good humor. However, he could not but appreciate the breathtaking technique of the *Saint John of Nepomuk*, remarking that the black shoes of the priest are "details that are halfway between Velázquez and Manet."[5]

The acquisition of this picture by Carlo Emanuele III in October 1743 is proof that Crespi's gifts and sales to the king's first minister, the Marchese d'Ormea, at the beginning of the same year had been met with approval. An examination of the correspondence exchanged between d'Ormea in Turin and Abbot Paolo Salani in Bologna[6] (see cat. no. 29) indicates that the latter acted, on other occasions at least, as a conduit for commissions to Bolognese painters, and, in the absence of other evidence, it can be reasonably assumed that Crespi executed this picture in the course of 1743, in the seventy-eighth year of his life.

Notes
1) Baudi di Vesme, 1963, I, p. 372.
2) The confession-story of St. John of Nepomuk was declared unhistorical by the Roman Catholic Church in 1961.
3) The measure of both the naturalism of Crespi's style and of the eclipse that his reputation suffered during the ensuing epoch of Neo-Classicism can be deduced from the 1822 inventory of the collection of the King of Sardinia, Turin, in which neither the subject nor the artist is correctly identified (Turin, 1982, p. 118). The painting is presumed to be a genre treatment of the *Sacrament of Confession*, and the authorship is given to Bartolomé Murillo. At least, the picture was highly prized: "Such verity, expression, frankness emerges at first sight from this beautiful painting that truly [Murillo] has deserved his sobriquet, 'the Raphael of Spain.'"
4) Longhi, in Bologna, 1948, pp. 21-22.
5) *Ibid.*, p. 22.
6) Frati, 1916, pp. 279-283.

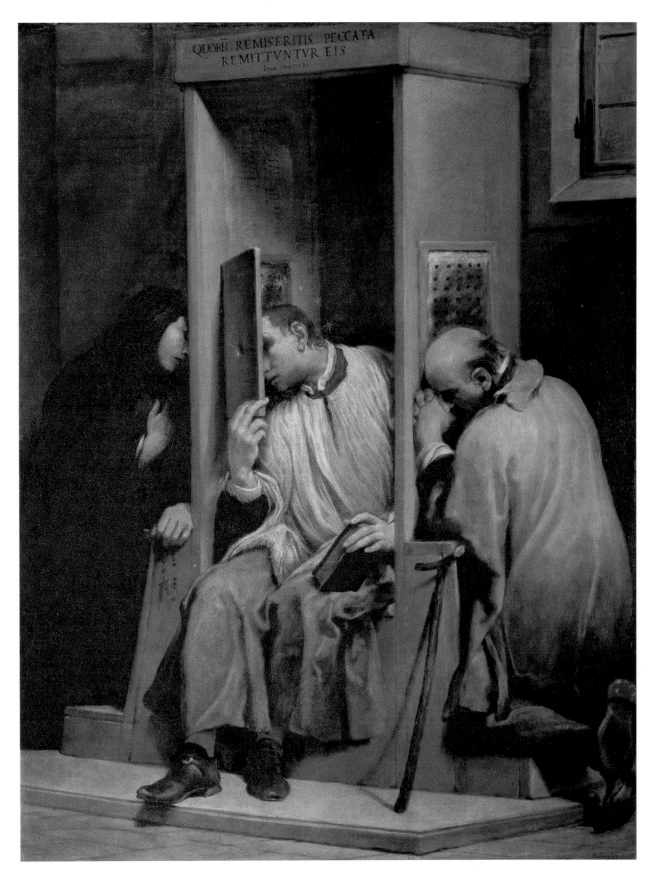

Apart from Crespi, only one other Bolognese painter of the eighteenth century, Giuseppe Gambarini, produced a notable corpus of genre paintings. Gambarini was almost a generation younger than Crespi, but he died in 1725 in mid-career. In contrast to Crespi, Gambarini's aspirations were unashamedly decorative; however, his good-humored paintings of vivacious girls and picturesque friars have been recognized in recent years as worthy antecedents to the "conversation pieces" painted by Pietro Longhi in Venice from the 1740s onward. Indeed, the impact of Gambarini's art may well have supplemented Crespi's own influence on the artistic formation of the younger Venetian.

Gambarini was a product of the school of Lorenzo Pasinelli, and he finished his training with Benedetto Gennari.[1] Zanotti (1739) notes accurately that Gambarini's style represented a combination of both his masters'.[2] He showed an ability to draw the figure at an early age; already in 1698, he collaborated with the older Marcantonio Chiarini in *quadratura* decorations in the Casa Supini in Bergamo.

Oretti notes several decorations in Bolognese palaces done by Gambarini in association with different specialists in architectural painting.[3] In 1708-1709, he accompanied Chiarini to Vienna in order to paint the figures in some frescoes in the new city palace of Prince Eugene of Savoy. He was not happy in Vienna, however, and returned to Bologna in time to be numbered among the forty founding artists of the Accademia Clementina in November 1709.

According to Renato Roli, Gambarini's *The Birth of Adonis* and *The Nurture of Jupiter*, painted for the gallery of Count Buonacorsi in Macerata, were probably executed about 1710.[4] These are both mythologies in which good-sized figures fill the front plane and are arranged all in a row, according to the formula invented by Carlo Cignani, *caposcuola* of Bolognese painting and *principe* in absentia of the Accademia Clementina (he had resided in Forlì since 1686).

During the first years of the second decade, Gambarini attracted the patronage of Giovan Angelo Belloni, *ricchissimo mercante*, who sponsored the artist's visit to Rome in 1712-1713, where he painted frescoes with Pompeo Aldrovandi and Stefano Orlandi in the Bolognese church of SS. Giovanni and Petronio. The same Belloni was coincidentally also one of Crespi's principal patrons; remarkably, the unpublished inventory of Belloni's collections cites no genre paintings by either artist, only sacred or historical themes.[5] Neither Zanotti nor Luigi Crespi makes mention of any connection between Gambarini and Crespi, yet most of Gambarini's genre paintings (the three included in this study are no exception) contain one or more figures copied from Crespi genre works datable to the early 1710s.

The chronology of Gambarini's paintings has yet to be reconstructed. It is generally supposed that he only became a genre painter following his return from Rome.[6] The only dated picture is *Laundresses* (one of a pair) of 1719, which Hermann Voss published in 1928 as belonging to a private collection in Troppau. Although Zanotti, the academician par excellence, failed to cite specific works for specific clients,[7] he succinctly described Gambarini's genre style:

He devoted himself to painting little pictures of humble and low subjects, which depict common things, such as ladies who weave, and others who embroider, and others who teach children, or make lace, and others doing such girlish and feminine activities; sometimes he would add mendicant monks, who receive alms of bread and wine and other such necessities, as they need; in sum, he gave himself to paint such things and to portray them from life with such fidelity that practically nothing else was commissioned from him. In fact, he made many of them, and many noble houses and citizens have them, and admire them. And because of this his fame began to be felt outside of Bologna, so that some of these were commissioned from foreign countries.[8]

Indeed, although populated with Pasinelli or Crespi figure types, Gambarini's school rooms and interiors with weavers, and the like, are closer to the domestic interiors painted in Rome by Antonio Amorosi (1660-1738) and Pasqualino Rossi (1641-1718) than they are to the street criers and tradesmen preferred by the Bolognese. In bringing this style to Bologna, Gambarini did not attract any local followers other than the mediocre Stefano Ghirardelli (1696-1756), but his observations of such scenes were not lost on Pietro Longhi.

Notes

1) Strictly speaking, Gambarini was first a student of Girolamo Negri, called il Boccia, whose studio was attached to that of his own master, Pasinelli.

2) Zanotti, 1739, I, p. 388. All of these biographical particulars are based on Zanotti's complete account.

3) Oretti, ca. 1769, MS. B. 104, [b] 120/1 (Casa Pellegrini) and [b] 18/4 (Palazzo Ghisilieri).

4) Roli, 1977, p. 187, figs. 210a and b. These paintings were first published by D.C. Miller, 1958, *passim*.

5) Luigi Crespi (1769, p. 214) states proudly that Belloni filled his gallery with pictures by Crespi, "*tutti grandi, storiati, e d'una stessa misura.*" This notice is confirmed by the posthumous inventory of Belloni's collection, dated March 28, 1730 (Archivio di Stato, Bologna. Copie degli atti, no. 397, folios 379r-404v). In all, the compiler of the inventory, the painter Pietro Francesco Cavazza, identified four pairs of large pictures by Crespi. Unfortunately, their subjects are only described generally (as Luigi Crespi did) as *quadri grandi istoriati* (394r, 394v). Belloni owned three paintings by Gambarini: *La B. verg.e immaculata con un angelo* (393v), *Sansone e Dalida* [sic] (394v), *Un ovato piccolo della B. V., S. Anna, S. Catterina di Bologna, S. Pietro d'alcantara* (395v). My thanks to Tiziana Di Zio for her assistance in locating this document and transcribing it for future publication.

6) Roli (1977, fig. 345d) illustrates a *testa di carattere* which appears to be an early work, to judge from its strongly Pasinellian flavor.

7) Oretti (*op. cit.*, [a] 75/26) cites "*Pitture con Bambocciate*" in the Palazzo Ranuzzi del Senatore.

8) Zanotti, 1739, I, pp. 390-391.

31 A Dance in the Country
Oil on canvas, 61.5×76.5 cm.
Staatsgalerie, Stuttgart

32 Monks Receiving Alms
Oil on canvas, 62×76.5 cm.
Staatsgalerie, Stuttgart

Early Provenance
Graf Gotter, Vienna; from whom acquired as a pair for the
collection at Schloss Ludwigsburg, 1736 ("*2 stuckh von
dern berühmten Spagnoletto*").

Essential Bibliography
Thöne, 1935, p. 397, repr. pp. 397 and 398; Cat. Stuttgart,
1962, p. 80; Roli, 1977, p. 187, figs. 346a and b; Ewald,
1977-78, nos. 22 and 23.

As Thöne was the first to point out, these two
paintings by Gambarini were already attributed to
"the famous Spagnoletto" [Crespi] by 1736.[1] In view
of the constant traffic of artists and paintings from
Bologna to Vienna in the early eighteenth century, it
is likely that Graf Gotter, who was in the Imperial
service, commissioned the paintings directly from
Gambarini. Yet, within the space of twenty years or
so, the artist's name was forgotten or suppressed in
favor of the more prestigious attribution to Crespi.

Gambarini worked in Vienna in 1708-1709 in the
service of Prince Eugene of Savoy, but the pictures in
Stuttgart could not have been executed so early.
Renato Roli has already observed that these two
paintings are close in style to Gambarini's only dated
genre painting, *Laundresses* of 1719 (ex-collection,
Troppau).[2] Thöne suggested that the Stuttgart
pictures were once part of a series of four, together
with Gambarini's *Monks Playing Tricks* and *Monks
Reading* now in the Dresden Gallery. The four
canvases are alike in size, but the provenance of the
Dresden canvases is apparently different (acquired
from the Wellenstein collection in 1741).[3]

Roli was the first to notice that the two musicians in
the Stuttgart *Dance in the Country* are derivations
from *Peasants Playing Musical Instruments* by Crespi,
which is one of a pair of major genre pictures by the
artist in the collection of Denis Mahon, London (cat.
nos. 10 and 11). The relationship between
Gambarini's pictures in Stuttgart and the Mahon
Crespis goes even deeper, however, than previously
suspected. Gambarini's pendant *Monks Receiving
Alms* derives two figures from Crespi's pendant
Peasants with Donkeys: the donkey and the striding
peasant in the Mahon canvas appear in reverse in
Gambarini's composition, only the peasant has been
transformed into a monk. Similarly, there exists a
Crespian prototype for the lady seated at left in
Gambarini's *Monks Receiving Alms*; this is an
unpublished sketch by Crespi in a private collection
(fig. 32.1).[4] This sketch is clearly contemporary with
the Mahon canvases by Crespi, which are dated on

the basis of style to ca. 1710. It is a mystery how
Gambarini was able to appropriate so many designs
by another artist without prompting a remark from
any of the contemporary critics.

If it appears from these observations that Gambarini
took a piecemeal approach to composition, that
impression is confirmed by the artist's own
preparatory sketches. Only *bozzetti* for fragments of
compositions — random groups of figures, which he
used again and again — are known. He made
drawings in ink or chalk that served rather like
blueprints to assist in the positioning of these
pre-fabricated pieces. An oil sketch depicting the two
ladies and children at the extreme left of *Monks
Receiving Alms* was on the art market in 1969.[5] A
replica of the entire composition was acquired in
1982 by the Louvre, Paris (fig. 32.2).

Renato Roli has neatly discriminated between Crespi's
attitude toward genre painting and Gambarini's more
modest aims:

It is enough to consider the reduction that the motifs of the
Mahon canvases, transferred to Gambarini's pictures in

32.1. Crespi, Study of a Seated Woman. *Private collection.*

174

Stuttgart, experience with regard to their substance and expressive force. Gambarini omits the concreteness that is almost brutal at times, and also the aggressive physicality of Crespi's style, the impact with the existential: Gambarini's bambocciata lingers in Arcadia, and his shepherdesses are pleasing because they belong to a less imposing, austere, boring, and even less costly class than that of the genres of history or mythology.[6]

Ultimately, however, one must agree with Roli's conclusion that it is beside the point to criticize a minor master for not being major. Like a "piccolo Pietro Longhi della Bologna clementina,"[7] Gambarini's best pictures are built on a stratum of visual truth: Zanotti complained that he painted his wife's features in every canvas, and that he did the same with his childrens', as soon as he had them.[8] In fact, the portraitlike details (in which again he may have been emulating Crespi) are exactly the qualities that we most appreciate in Gambarini's genre paintings.

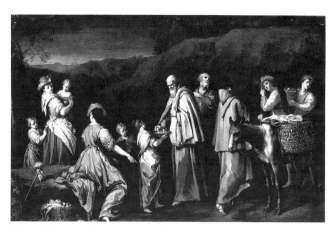

32.2. *Giuseppe Gambarini,* Monks Receiving Alms. *Musée du Louvre, Paris.*

Notes

1) Thöne, 1935, p. 397.

2) Roli, 1977, p. 187.

3) Dresden catalogue, 1929, nos. 763a and b.

4) I am grateful to Thomas Schneider for calling this picture to my attention. Crespi's sketch originally showed a portion of a basket at lower left, which was painted over in recent restoration.

5) Reproduced in *The Connoisseur* (April 1969, vol. 170, p. 113) with a pendant sketch representing a figural group used later for the *Monks Playing Tricks* in Dresden.

6) Roli, 1977, p. 187.

7) *Ibid.,* p. 188.

8) Zanotti, 1739, I, p. 390.

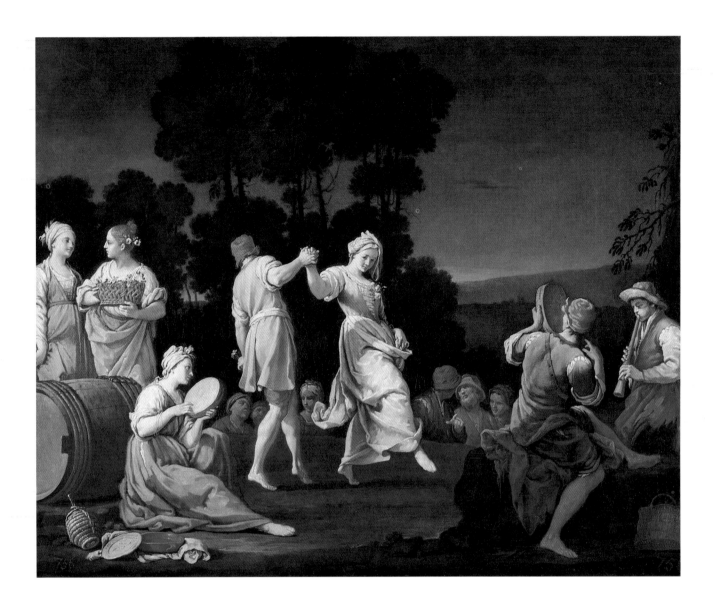

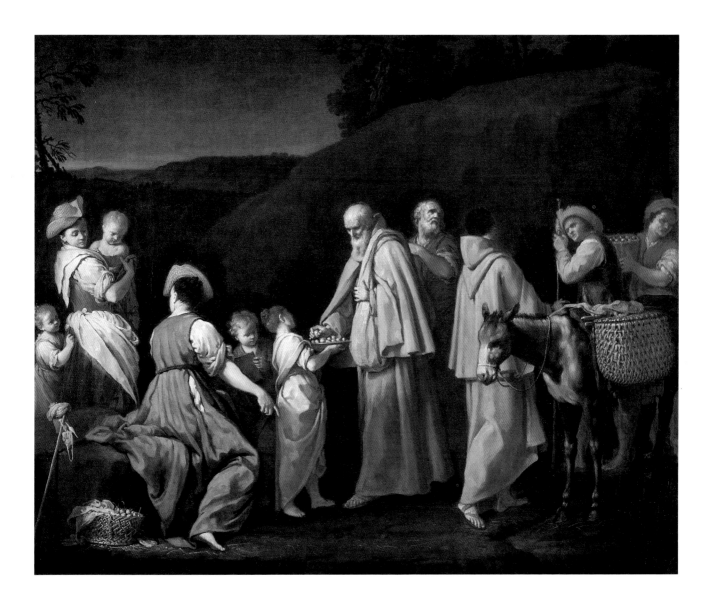

33 A Group of Women Embroidering
Oil on canvas, 60.2×74.2 cm.
Alan E. Salz, New York

Unpublished.

A group of women are plying their trades in unexpectedly fine surroundings. At left a woman and a girl are winding balls of wool; to the right, some women are working on embroidery. Here and there on the terrace, children study their primers. According to Zanotti, scenes of women at their work are Gambarini's most characteristic genre subjects.[1] Zanotti blamed the artist's preoccupation with such domestic matters on his devotion to his wife and children, whom he reportedly portrayed again and again in his paintings.
It is certainly true of Gambarini that he was unafraid to repeat his favorite figures and poses.[2] Suffice it to point out that there is a preparatory drawing in pen and wash for this painting at Windsor Castle (fig. 33.1) and a related oil sketch at Schloss Fachsenfeld (Stuttgart).[3] In the context of the present study, it is also worth noting that the fellow at far right, who wears a fur cap and proffers a strip of cloth, began life as a musician playing a triangle in a canvas by Crespi (cat. no. 10).
The preparatory drawing at Windsor Castle is one of two compositional studies by Gambarini in that collection: the other depicts women washing linen (fig. 33.2),[4] and it is possible that this *Group of Women Embroidering* once had a pendant painting of that subject. The Windsor drawings display the slender proportions and delicate features that are typical of Antonio Gionima and other followers of Crespi during the 1720s. This observation helps to date the painting to the last phase of Gambarini's activity, prior to the onset of his final illness in 1724.

For the most part, however, Gambarini has firmly suppressed the relationship to Crespi in his transfer of his design from study to canvas. At the end of his career, Gambarini appears to have redoubled his efforts to find lodgings for the Bamboccianti within the travertine halls of Accademia. Cool, classical tonalities prevail. The immaculate surface of the canvas is brushed with a restraint that would have been appreciated in the atelier of any Frenchman of the generation of Jacques-Louis David.

Notes
1) Zanotti, 1739, I, p. 390.
2) A related composition, with significant variations, is in the Museu Nacional d'Arte Antiga, Lisbon (cf. Bologna, 1979, cat. no. 55, fig. 48). In the same museum is a pendant, *A Party in a Peasant House* (cf. Fiocco, 1948, fig. 1). The Lisbon compositions are both set in unidealized interiors and both include characterizations of gentlemen who profess considerable interest in these simple ladies. These canvases by Gambarini yield nothing to Crespi's Flea Hunts in their provocative anticipation of Pietro Longhi's favorite motifs of eighteenth-century society. Fiocco (1948, fig. 3) also published an oil sketch in his own collection from which Gambarini derived the group of women at the far left in both the Lisbon *Women Embroidering* and the Salz canvas (with some variations in pose).
3) Kurz, 1955, no. 270. The oil sketch is illustrated in color in Thiem, 1983, no. 71.
4) *Ibid.*, no. 269, fig. 50.

33.1. Giuseppe Gambarini, A Group of Women Embroidering. *Pen and wash drawing. Windsor Castle, Royal Library. Copyright reserved. Reproduced by gracious premission of H.M. Queen Elizabeth II.*

33.2. Giuseppe Gambarini, Women Washing Linen. *Pen and wash drawing. Windsor Castle, Royal Library. Copyright reserved. Reproduced by gracious permission of H.M. Queen Elizabeth II.*

It is symptomatic of Crespi's isolation from the mainstream of eighteenth-century painting in Bologna that his greatest follower was a foreigner, Giambattista Piazzetta from Venice. Piazzetta, it seems, did not formally enter Crespi's studio; he was already twenty years old and had completed an apprenticeship in Venice when he chose to advance his art through additional studies in Bologna.[1] In his later years, Piazzetta is purported to have told an amusing anecdote about his first meeting with Crespi. The date was about 1704, and although Crespi was universally recognized as the most promising Bolognese painter of his generation, he was still only on the threshold of his own artistic development. Piazzetta had brought from Venice a letter of introduction to the celebrated Spagnuolo, who, greeting him cordially, was unaware of Piazzetta's previous training. Crespi asked him to draw a few heads from some reliefs, and as he was doing so, Crespi suddenly broke the silence, saying, "You have come to Bologna in order to learn how to paint from me? It is I who could learn from you!" The conclusion of this anecdote is that in the ensuing years of his sojourn in Bologna, Piazzetta studied the great works of the Carracci and Guercino, with Crespi as his companion.[2]

As amiable as they are, these recollections by Piazzetta do not tell us of the actual state of affairs upon his return to Venice at some point prior to 1711. He was still a very green painter, and the available evidence indicates that Piazzetta's art during the 1710s was closely based on Crespi's. Even so, he never copied the older artist's compositions, facial types, and so forth, as a pupil would have done. After Crespi's meetings with Grand Prince Ferdinand de' Medici in 1708 and 1709, subjects of everyday life and humble people had increasingly occupied his imagination (cf. cat. nos. 10-14); it is probably not by chance, therefore, that the earliest known works by Piazzetta are genre paintings with Crespian motifs, such as flea hunts or sleeping shepherdesses (cat. no. 34).

Under the influence of Crespi, Piazzetta returned to Venice convinced that it was perfectly feasible for a major master to accommodate genre subjects in his oeuvre alongside commissions for altarpieces and history paintings. And so he did. As one of the leading lights in the most brilliant school of the day — the Venetian school in the eighteenth century — Piazzetta's attitude towards genre subjects was immensely influential. With the passage of time, Crespian motifs became rarer in Piazzetta's oeuvre, as the Venetian pursued his particular interest in the bust-length portrait or character head (testa di carattere). However, Piazzetta's art always stood apart from his compatriots' by virtue of its foundation in Bolognese-inspired naturalism. Indeed, no Venetian before Piazzetta had ever assigned such importance to his drawings as independent works of art: this too

had been learned abroad. Finally, Piazzetta was indebted to Crespi for a decisive encouragement of the tenebrist palette that he had first learned during his Venetian apprenticeship under Antonio Molinari. Piazzetta propagated a style based on Guercinesque chiaroscuro, even while Venetian Rococo painting was resplendent with the famous colors of Ricci, Tiepolo, Pittoni, and others.

Piazzetta practiced a singular style, but, unlike Crespi, he never withdrew from the forefront of contemporary painting. On the contrary, he organized an efficient studio comprised of competent and dedicated painters whose names are known in their own right: Domenico Maggiotto, Francesco Cappella, Egidio Dall'Oglio, Antonio Marinetti.[3] One of the thorniest challenges in the connoisseurship of Italian painting has always been the attribution of the small-scale pictures that issued from the Piazzetta workshop. The master's fame was carried throughout Europe, moreover, in hundreds of prints executed after his designs; the engraver Marco Pitteri made more than 140 of them. As if he cared to leave nothing so important as his fame to chance, Piazzetta also took the unusual step of closely collaborating with a publisher, G.B. Albrizzi, on book illustrations.[4] Between 1736 and 1743, Piazzetta produced a corpus of charming vignettes in a pastoral mood as illustrations to several published texts. Especially noteworthy were his designs for a 1745 edition of Tasso's *Gerusalemme liberata*.

Piazzetta's drawings of flirtations between pretty shepherdesses and their suitors often evoke Crespi's pastorales, even at this late date. However, the culmination of his involvement with genre painting was reached in three canvases executed between 1740 and 1745 that must at least be cited here even though their genius is manifested in a sensibility quite different from Crespi's. The common thread is their representation of pensive young men and ladies wrapped in a dreamy ambient (their meanings are enigmatic). The first of this casual series was the nearly life-sized *Fortune Teller* (Accademia, Venice), which appears to represent a procuress (fig. 26).[5] In close succession, Piazzetta painted a pair of pastorales or idylls for his great patron, Field Marshal Johann Matthias von Schulenburg, which are now in the museums in Chicago and Cologne (figs. 27 and 28).[6]

Notes

1) Albrizzi (1760) reports Piazzetta's age. This and other facts in this biographical sketch are taken from the documentary outline compiled by Mariuz (1982, pp. 67-73), to which the reader is referred for specific details and references.

2) Albrizzi (1760) only mentions the earlier Bolognese artists, not Crespi, as the object of Piazzetta's studies. This anecdote was published in Moschini (1806), whose one source, Gianmaria Sasso, had heard it from Piazzetta's pupil Antonio Marinetti; so there was plenty of opportunity for embroidery in the re-tellings. Cf. Mariuz, 1982, p. 67.

3) For the latest and most complete research on Piazzetta's school, see the exhibition catalogue, Venice, 1983, *s.v.*

4) Piazzetta's drawings for book illustrations were extensively treated in an excellent exhibition and catalogue: Venice, Fondazione Cini, 1983, *passim.*

5) For the most recent summation of the tortured scholarship regarding the meaning of this painting, see Ruggeri in Venice, 1983, no. 35.

6) The scholarship regarding the collecting activities of Schulenburg has grown large enough to warrant a separate bibliography: the latest contribution is by Bettagno in Venice, Fondazione Cini, 1983, pp. 83-88.

34 Sleeping Peasant Girl
Oil on canvas, oval, 66×82 cm.
Residenzgalerie, Salzburg

35 Young Peasant
Oil on canvas, oval, 66×83.5 cm.
Residenzgalerie, Salzburg

Bibliography
Salzburger Landessammlungen..., 1980, p. 87; Mariuz, 1982, nos. 15 and 16; Jones, 1981, II, p. 30; Ruggeri in Venice, 1983, no. 8.

A peasant girl has fallen asleep on her arm: her plump bosom spills carelessly forward, and turnips tumble forth from her basket. In the companion picture, a peasant boy is seen in profile; in contrast to the girl, his expression is vigilant.

These two oval canvases were recently acquired by the Residenzgalerie, Salzburg, from the Herzig collection in Vienna. The attribution to Piazzetta was first advanced by Rodolfo Pallucchini, and it is clear that the Salzburg *Sleeping Peasant Girl* and *Young Peasant* are early works of great importance to our knowledge of the artist's development. The foundation for the attribution was established in advance, so to speak, by the existence of numerous Piazzetta workshop derivations of the figure of the sleeping girl.[1] In 1976, Ruggeri published Piazzetta's preparatory drawing for the composition as a whole.[2] His preparatory study for the head of the peasant boy has long been part of the collections of the British Museum (fig. 35.1).[3]

35.1. *Giambattista Piazzetta*, Study of a Boy. *Chalk drawing. British Museum, London.*

The early date of the Salzburg genre pictures is suggested by their affinities to two paintings in the Museum of Fine Arts, Boston: *Flea Hunt* and *Young Farmer Counting Money* (figs. 19 and 20).[4] For one thing, the same drawing of a basket was used for the Salzburg *Sleeping Peasant Girl* and the *Young Farmer Counting Money* in Boston. Jones has convincingly argued for dating the Boston paintings at the beginning of the second decade of the century on two accounts: their hesitant execution and their distinct dependence on the genre style of Giuseppe Maria Crespi.[5] (Piazzetta's return to Venice from Bologna is first documented in 1711.) The Salzburg picture's motif of a peasant girl asleep can be associated with Crespi prototypes, as can the Boston *Flea Hunt*. The dominance of the figure — its imposing physicality — in all four of these single-figure compositions is likewise comparable to Crespi's genre characterizations of the same period (cf. cat. nos. 10 and 11).

In contrast to the slight awkwardness of the Boston pictures, Piazzetta painted the Salzburg canvases with evident confidence in his technique, and with an appreciably more refined conception of his subjects. Indeed, the Boston peasants evince a rustic naturalism that is sufficiently like Crespi — and otherwise unheard of in Piazzetta's known oeuvre — to suggest the possibility that these paintings were executed during his Bolognese sojourn. The Salzburg canvases evidently date from some years later and can be regarded as transitional between the uncompromised naturalism of the Boston peasants and the polished charm of Piazzetta's definitive style of character heads, which he had developed by the 1730s, and perhaps earlier. The oval format and *di sotto in su* perspective in these two paintings are probably evidence, as Ruggeri suggests,[6] that Piazzetta made them as overdoor decorations. Their broad, smooth surfaces and prevailing tonalities of olive green and ivory invite comparison with Piazzetta's altarpiece of *The Martyrdom of St. James* (1722) in the church of S. Stae, Venice. The pair were presumably painted slightly earlier than that date and, to judge from the numerous derivations, must have been prominently placed in an accessible *palazzo*.

Notes
1) See Mariuz (1982, nos. 15 and 16) for the complete list.
2) Ruggeri, 1976.
3) Illustrated in Mariuz, 1982, no. 16c.
4) *Ibid.*, nos. 13 and 14.
5) Jones, 1981, II, nos. 7 and 8.
6) Venice, 1983, no. 8.

36 A Young Huntsman
Oil on canvas, oval, 67×80 cm.
Galerie Cailleux, Paris

Essential Bibliography
Rouen, 1954, no. 73; Mariuz, 1982, p. 12; Toronto, 1981, under no. 128.

The young hunter and his dog are posed in attitudes of anticipation that are only slightly comical. As he peers at an approaching flock, the hunter cocks his rifle in hopes of adding a second trophy to his pile. The oval format and viewpoint from below are indications that this painting, like the *Sleeping Peasant Girl* and *Young Peasant* in Salzburg (cat. nos. 34 and 35), was intended to hang over a door. The three canvases are alike in dimensions as well as in theme, but they do not appear to have been executed as a single commission: the *Young Huntsman* is painted with the distinctive contrasts of claret and white that are the hallmark of Piazzetta's mature style (cf. cat. no. 37).

On the other hand, the vivid characterization of this amiable young man is closer to Piazzetta's early treatments of genre subjects than to the elegant refinements of his later works. The abundant quotient of good humor represents the lingering influence of the artist's Bolognese mentor, Giuseppe Maria Crespi. These factors combine to date *The Young Huntsman* in the transitional decade of the 1720s.

This vignette evidently enjoyed favor among Piazzetta's followers, and it was taken up again at a later date by the master himself in at least two drawings from the early 1740s.[1] His later drawings are more explicitly Rococo in their attenuation of forms and delicate touch. An anonymous painting of this subject (with an added figure, as in Piazzetta's later drawings) is in the Art Gallery of Ontario, Toronto.[2]

Notes
1) See Mariuz (1982, no. 12) for these references. Ruggeri (1977, p. 132, no. 6) advanced, on the basis of the photograph of the *Young Huntsman* seen in the Witt Library, London, an untenable attribution to Piazzetta's mediocre follower, Egidio Dall'Oglio.
2) See Toronto, 1981, no. 128, repr. The painting is by an anonymous Venetian painter, who is not identifiable with either Gian Antonio or Francesco Guardi.

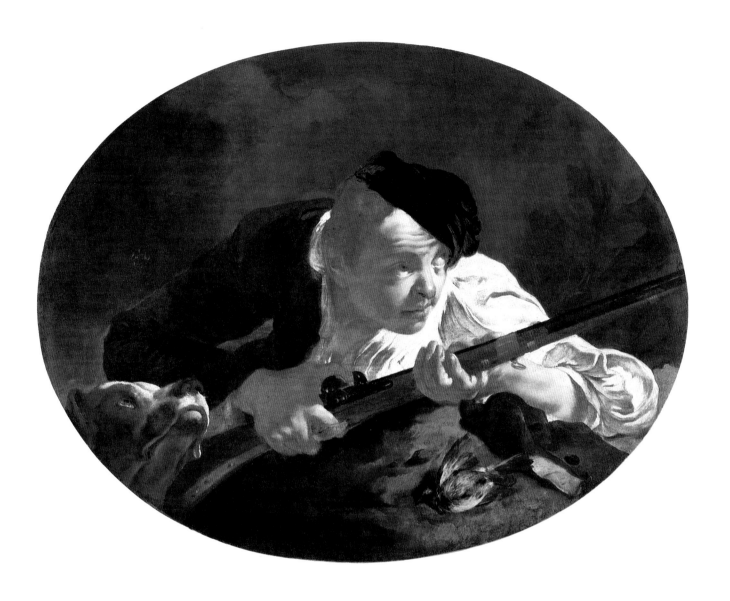

37 Girl with a Basket of Apples
Oil on canvas, oval, 34.4×28.9 cm.
Suida-Manning Collection, New York

Essential Bibliography
Pallucchini, 1936, pp. 193-194, fig. 4; Pallucchini, 1956, p. 36, fig. 84; Manning, 1961, no. 32; Flannagan in Chicago, 1970, no. 31; Jones, 1981, no. 35; Mariuz, 1982, no. 91.

A winsome maiden plucks an apple from a basket. She offers it with a teasing expression to an unseen admirer. Piazzetta has evidently portrayed this girl as a "latter-day Eve," as Jones has pointed out.[1] Such beckoning or flirtatious youths are often met in Piazzetta's heads or in bust-length genre subjects. The theme seems to be a playful celebration of sexual attractiveness. The association of sweetmeats and seduction is likewise made in two canvases by Piazzetta of about the same date — *Girl with a Doughnut*[2] and a *Boy with a Lemon*,[3] both of ca. 1740. These are now in separate American collections but were engraved as pendants in the eighteenth century. Piazzetta also made drawings of these motifs.

Piazzetta, more than any other artist of his time, built a reputation on his paintings and drawings of handsome youths or exotic personages; nevertheless, the genre of the *testa di carattere* was common currency in eighteenth-century art. His interest, therefore, need not have been provoked by his exposure to Crespi's paintings of half-length genre figures (cf. cat. nos. 3 and 23). However, Piazzetta stands apart in contemporary Venetian painting for his commitment to chiaroscuro and for the essentially naturalistic basis of his art: both of these qualities were imparted by Crespi.

There is another Crespian element in this *Girl with a Basket of Apples*, besides: namely, the high-key sense of humor. This pretty girl has a smile as broad as any one of Crespi's nymphs. Flannagan was inclined to an early date for the picture on account of this relationship.[4] However, the tonalities are those of the artist's maturity, and Mariuz makes the apt comment that Piazzetta's paintings of this kind were the point of departure for his pupil Francesco Cappella (1711-1784), who became an independent master in the early 1740s.[5] Pallucchini devoted an evocative analysis to the pictorial vivacity of this little picture and compared its spirit to that of Piazzetta's genre paintings for Marshal Schulenburg (cf. figs. 26-28).[6]

Notes
1) Jones, 1981, II, no. 35.
2) Mariuz, 1982, no. 89 (private collection).
3) *Ibid.*, no. 88 (Wadsworth Atheneum, Hartford).
4) Flannagan in Chicago, 1970, no. 31.
5) Mariuz, 1982, no. 91.
6) Pallucchini, 1956, p. 36.

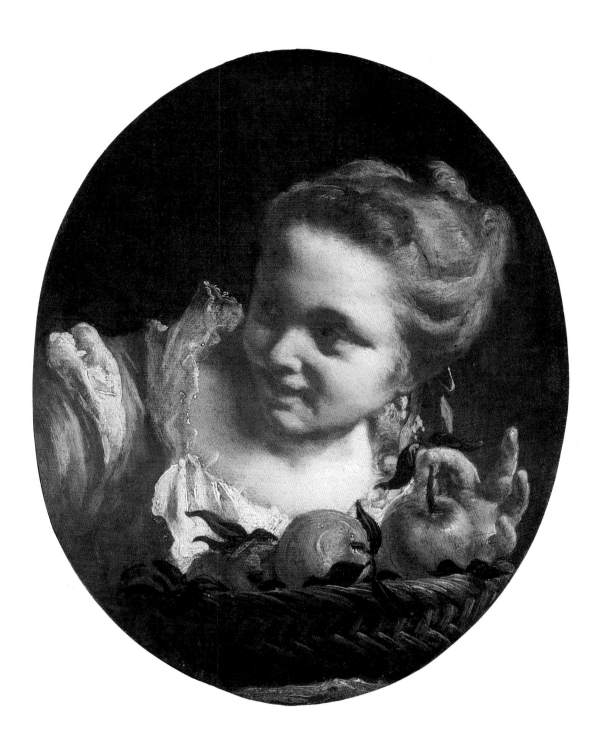

Pietro Longhi was born the son of a silversmith. For his initial training as a painter, he was apprenticed to Antonio Balestra (1666-1740), a highly respected master of sacred and historical painting active in Venice. Years later, Alessandro Longhi recorded that his father was sent by Balestra to Bologna with a recommendation to Giuseppe Maria Crespi, "called lo Spagnoletto, famous painter; and after some years of study, he returned to Venice."[1] Every writer on Longhi since P.J. Mariette (ca. 1774) has concluded that Longhi's experiences in the school of Crespi were the critical factors in his transformation from an erstwhile painter in the grand manner into a specialist in peasant interiors, social teas, and the like.[2] Unfortunately, there is no agreement as to when his Bolognese sojourn took place; as a result, Longhi's activity prior to 1741 remains unclear.

In 1718, Balestra ended his lengthy residence in Venice and returned to his native Verona. The following year would at first seem a likely time for Longhi's own departure to Bologna, which would place his stay there during the 1720s. Pignatti expressed this point of view in his 1968 monograph on the artist. Moreover, if Longhi truly entered Crespi's studio, as Guarienti wrote already in 1753, then this would of necessity have been during the 1720s, since Crespi took no students other than his two sons in the following decade.

On the other hand, there is no visual evidence of Crespi's influence at such an early date. Longhi's altarpiece in San Pellegrino, which is datable 1732 or slightly earlier,[3] shows only the impress of Balestra — nothing at all of Crespi. And further evidence can be cited to attest to some activity by him, at least as a religious painter, in Venice during the 1720s. Zanetti's guide book to paintings on public view was finished by August 1732; no fewer than seven canvases by Longhi (all religious) are cited, although all of these are untraced today.[4]

If Longhi went abroad in the 1730s, the documentary evidence limits the duration of any such absence to three years or less. He married in Venice in 1732, and his son Alessandro was born there in June of 1733. Pignatti thought in 1974 that Longhi's trip to Bologna might have taken place in the same year as Alessandro's birth. In 1734, Longhi completed frescoes depicting the Fall of the Giants in the Ca' Sagredo, Venice. Scholars differ as to whether these crude decorations for the Sagredo staircase reveal Bolognese influence or that of Ludovico Dorigny, who was active in Venice.[5] After 1737, Longhi's presence in Venice is regularly documented in the records of the Fraglia, or painters' society. His first dated genre painting, the Concert of 1741 (Accademia, Venice) (fig. 56), already reveals his mature style: the early peasant scenes must date from earlier years. See cat. nos. 37-39 for a discussion of Longhi's first genre paintings, on the basis of which the present writer is

inclined to date Longhi's studies in Bologna to the mid-1730s, a conclusion that eliminates the possibility that he trained directly with Crespi. From 1741 until his death, dated works continue to be few and far between, but the issue is less important. Once Longhi achieved his definitive style, his paintings underwent very little development during the succeeding decades.

Many authors have endeavored to describe the peculiar charm of Longhi's depictions of Venetian social intercourse. Pietro Guarienti's account in 1753, when Longhi had been working in this style for fewer than twenty years, already captures the sum of his approach. Apparently Longhi made almost an instant sensation:

With his whimsical and capricious skill he forged for himself a new and individual style of painting conversation pieces, games, ridotti, masquerades, all on a small scale and with such veracity and color that at a glance it is easy to recognize the places and people portrayed. With this great talent he rose to high fame, and his works fetch high prices.[6]

Longhi's contemporaries realized as well that his passage from Balestra to Crespi represented a deliberate departure from the grand style of the academy. A journalist of 1761, G. Gozzi, praised Longhi's position in unequivocal terms:

I see above all that the inventions of Signor Pietro Longhi are admired because he omits from the play of his imagination figures dressed in ancient fashion and characters of fancy, and portrays in his canvases what he sees with his own eyes, and contrives to introduce into his scenes certain sentiments which evoke a genial good humor.[7]

Finally, the French taste of Longhi's parlors has often been remarked by critics, beginning with P.J. Mariette in the eighteenth century, "He became another Watteau."[8] The Morning Levee of 1744 (cat. no. 41) is a prime example of Longhi's rapport with Parisian painting. The great critics of the nineteenth century, the Goncourt brothers, were confident that Longhi's sources were French:

What a charming painter of manners is this Longhi! He gives a visual and spiritual account of his scenes, a décor and an environment not in an ideal rural or decorative setting, but in the intimate interiors of Venetian private life... There are two notebooks of sketches which reveal that the painter had completely assimilated the pencil technique of Lancret... with strokes of a pointed black pencil as is usual in the drawings of French artists... Longhi draws from life even chamber-pots.[9]

The Goncourts rightly noted Longhi's painstaking preparations for his canvases. He made as many drawings of footstools as of figures. It is the concreteness in Longhi's vision that prevents him from lapsing into mere decoration. Although the immediate impetus for his scenes of high society no doubt stemmed from contemporary French examples, there was nothing in his approach that Crespi, the author of The Flea Hunt (cat. no. 21) and the Singer at her Spinet (cat. no. 24) would have found foreign.

Notes

1) Longhi, 1762, *sub voce*.

2) Mariette on Longhi is conveniently reprinted in the anthology of Longhiana compiled by Pignatti (1968, p. 60).

3) Pignatti, 1968, p. 84, pl. 1.

4) For these lost works, see Pignatti, 1974, cat. nos. 2-6. It should be noted in the present context that Zanetti (1733, p. 135), who surely knew the answers to all the questions raised in this discussion, simply terms Longhi "pupil of Balestra."

5) See Pignatti (1968, p. 91) for a summary of the debate and the different views of Valcanover and Pallucchini.

6) Orlandi/Guarienti, 1753, p. 427. Quoted in this translation by Pignatti, 1968, p. 58.

7) G. Gozzi, *L'Osservatore Veneto*, 14 February 1761, p. 28. Quoted in this translation by *Ibid.*, p. 60.

8) P.J. Mariette, *Abecedario...*, ed. 1854-1856, p. 221. Quoted in this translation by *Ibid.*, p. 60.

9) E. and J. de Goncourt, *L'Italie d'hier. Notes de voyages 1855-1856*, 1894, pp. 39-41. Quoted in this translation in *Ibid.*, p. 62.

38 A Shepherd Boy with a Staff
Oil on canvas, 60×48 cm.
Museo Civico, Bassano

39 A Shepherd Girl with a Flower
Oil on canvas, 60×48 cm.
Museo Civico, Bassano

Essential Bibliography
Pallucchini, 1946, p. 160; Pignatti, 1969, p. 73; Pignatti, 1974, nos. 9 and 10; Magagnato and Passamani, 1978, nos. 210 and 211.

These congenial pictures of a shepherd and shepherdess are two of a series of four that were bequeathed by the eminent collector Count Giuseppe Riva to the Museo Civico, Bassano, in 1876 (fig. 38.1). They bore an attribution to Giuseppe Maria Crespi until 1937, when the authorship of a different Bolognese genre painter, Giuseppe Gambarini, was proposed.[1] Finally in 1946, Pallucchini recognized that the Bassano shepherds, and a related picture in Rovigo,[2] are not Bolognese at all; they are instead the earliest identifiable genre works by Pietro Longhi. In the absence of dated points of reference within Longhi's own oeuvre, Pallucchini suggested a correlation between the date of the Bassano series and

38.1. Pietro Longhi, A Seated Shepherd Boy. *Museo Civico, Bassano.*

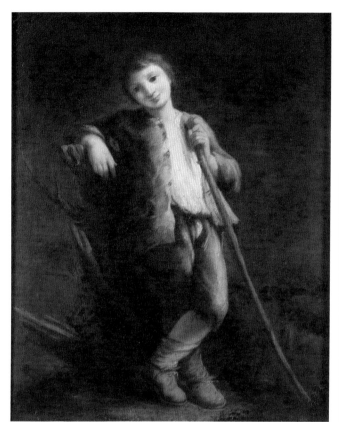
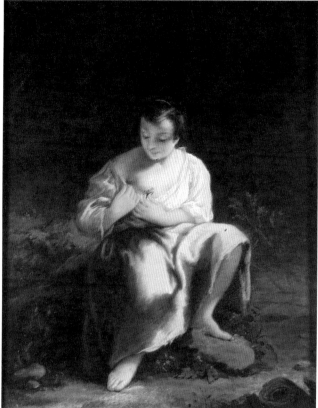

Piazzetta's *Fortune Teller* of 1740. Unfortunately, Pallucchini's point of view, which still seems close to the mark after forty years, came to be interpreted by subsequent writers to mean that 1740 constitutes a *terminus post quem* for Longhi's genre paintings in general. As a result, the current literature supports the Procrustean conclusion that two successive phases of Longhi's development — those represented by the Bassano shepherds as well as the ensuing peasant interiors (cf. cat. no. 40) — must be assigned to the vicinity of a single year, 1740, since the *Concert* of 1741 in the Accademia Gallery, Venice (fig. 56), is already a mature composition.[3]

If the date of Longhi's visit to Bologna were known, it would doubtless be possible to draw parallels between Crespi's development and its effect upon Longhi: it is reasonable to assume that Longhi's early genre pictures would contain indications of the nature and even the date of his studies with Crespi. Indeed, a number of useful observations can be made through comparison of the Bassano *Shepherd Boy with a Staff* and *Shepherd Girl with a Flower* with Crespi's treatments of such themes.

To the best of our knowledge, Crespi painted pastoral motifs in small canvases in every phase of his career. Longhi's little shepherdess specifically evokes the Crespian motif of the Flea Hunt, of which most surviving versions (in the opinion of the present writer) date from the 1730s.[4] Finally, however, it does not seem possible to extract any conclusions regarding chronology from Longhi's choice of subject matter alone.

Some very valuable evidence does come to light when the style of Longhi's juvenilia is examined in the context of Crespi's stylistic development. Longhi's early paintings of shepherds are distinguished by their brown monochromy and by the absence of detail in the shaded background. His brushwork is smooth, and the application of pigment is relatively thin: these qualities are readily found in Crespi's paintings from the mid-1730s. In the present study, the pictures assigned to this period of Crespi's career (cat. nos. 25-28) include the *Courtyard Scene* (Pinacoteca Nazionale, Bologna) and the *Peasants and Cattle Fording a Stream* (Private Collection, Bologna). Is it surprising that these are the very pictures by Crespi that most strikingly anticipate Longhi's own genre paintings?

Any hypothesis that places Longhi in Bologna during the 1730s (the period 1734-1737 is undocumented) must address the issue of his training under Crespi. Zanotti (1739) is explicit in his report that Crespi had closed his school many years before and worked alone with his sons.[5] Longhi, a thirty-year-old student of Balestra and the painter of public commissions in Venetian churches, was hardly a logical candidate for admittance in the first place. On the basis of Longhi's drawings alone, it is reasonable to exclude the possibility that he received any lessons from Crespi.

His approach is typically Venetian: short, patchy strokes put down in a kind of shorthand. Crespi practiced a particularly meticulous brand of Bolognese draftsmanship, of which there is no reflection in Longhi's work. It is noteworthy as well that the three drawings that have been identified as preparatory studies for the *Shepherd Boy* and *Shepherd Girl* in Bassano are not far removed (they are only more clumsy) from his drawings of later date.[6] It seems most likely that Longhi's studies of Crespi were not conducted under the guidance of the elder Bolognese master himself, but rather were on his own, as were, apparently, Piazzetta's some thirty years before in Bologna. Both Piazzetta and Longhi emulated Crespi's keen eye for naturalistic detail, his taste for good humor, and his favorite themes. Both of these Venetian followers were too advanced in their own developments, however, to become mere copyists.

Notes

1) The attribution was in the context of an unpublished inventory made for the Museo Civico by C.L. Ragghianti, who recently renewed this opinion to the cataloguers Magagnato and Passamani (1978, nos. 210 and 211).

2) Pignatti, 1968, p. 84, pl. 13.

3) For example, Pignatti, 1974, cat. nos. 9-17, are cited as Longhi's earliest genre paintings, all dated to ca. 1740.

4) Cf. cat. no. 21 above.

5) Zanotti, 1739, II, p. 71, "*Ebbe lo Spagnuolo, come dissi, molti scolari, ma per non molti anni, anzi moltissimi anni sono, che non ne ha alcuno...*" Luigi Crespi (1769) makes no mention of Pietro Longhi either; one does wonder why Crespi's disputatious son-biographer did not refute the claims made on Longhi's behalf by Orlandi/Guarienti (1753) and Alessandro Longhi (1762).

6) For illustrations, see Pignatti, 1968, pls. 8 and 9. For a drawing at Stuttgart related to the Bassano *Shepherd Girl with a Flower*, cf. Deusch, 1967, p. 93.

40 The Merry Couple
Oil on canvas, 61×50 cm.
Ca' Rezzonico, Venice

Essential Bibliography
Ravà, 1909, fig. 118; Pignatti, 1960, p. 201; Pignatti, 1969, p. 90; Pignatti, 1974, no. 15.

Some patrons at a tavern are enjoying a drink with a lively peasant girl. She raises her pitcher of wine invitingly, while her white-haired suitor pulls her close. The mismatch in their ages suggests that this "merry couple" is not matrimonially inclined.

The *Merry Couple* is one of eight paintings of cheerful peasants that were formerly in the Gambara collection, Venice, and are now divided between the Ca' Rezzonico and the Castello at Zoppola.[1] It is difficult to ascertain the extent to which Longhi conceived his genre paintings in series or as pairs, since practically all of them are of identical dimensions and format (i.e. an upright rectangle of canvas, 61×50 cm.). However, critics agree in distinguishing this *Merry Couple* and the other three pictures at the Ca' Rezzonico from the Zoppola group: in the latter, the figures are noticeably larger and are painted with a broader touch. Pignatti has subtitled the series at the Ca' Rezzonico "Scenes from Peasant Life." It has not hitherto been observed that, notwithstanding the different titles given them by historians, the same four subjects are represented in both the Ca' Rezzonico and Zoppola groups: a tavern scene, the serving of polenta, laundresses, and women spinning fiber.
In this case as always, the chronology of Longhi's undated works is uncertain. Pignatti ascribes a date of about 1740 to the Ca' Rezzonico "Scenes of Peasant Life." The same scholar dates the Zoppola pictures to the end of the 1740s, because certain figures in them recur in other paintings that can be assigned to that period.[2]
I would argue that the figure style of the Zoppola pictures is identical to that of the *Shepherds* and *Shepherdesses* in the Museo Civico, Bassano, which are evidently Longhi's earliest genre paintings (cat. nos. 38 and 39). For reasons stated in the preceding catalogue entry, a date in the mid-1730s is likely for the Bassano series. According to this view, the *Merry Couple* and the other peasant scenes at the Ca' Rezzonico would constitute the successive phase of Longhi's development as a genre painter, but one that presumably also occurred during the decade of the 1730s. The pictures in this group evince a more sophisticated rendition of interior space; the figures are slenderer and are somewhat recessed from the foreground in comparison to the Zoppola compositions.[3] These traits appear to characterize the artist's development in general.

Pignatti has remarked that the "Scenes of Peasant Life" at the Ca' Rezzonico are "inspired by typical themes of the Bolognese school." The same is true, of course, for the mirroring series in Zoppola (which is here presumed to be earlier). Indeed, Longhi's genre subjects of this period call to mind the favorite themes of Giuseppe Gambarini (cf. cat. nos. 31-33), a Bolognese who earlier painted the activities of women. It is possible to see the Ca' Rezzonico and Zoppola series as (slightly mischievous) cycles devoted to Women at Work. The respective scenes entitled *The Polenta* represent cooking; the *Laundresses* and *Girls Spinning* are self-explanatory. According to this scheme, the girls frolicking in the two tavern scenes would be practitioners of the oldest profession in the world.
If Pietro Longhi studied in Bologna during the 1730s, he could not have met Gambarini, who died in 1725. However, Gambarini's motifs were inherited by Stefano Ghirardini, who faithfully and prolifically reproduced them for many years. Both Gambarini's compositions and Ghirardini's seem to have provided Longhi with the points of departure for his first attempts at multifigured genre paintings. One can even find in Ghirardini the precedent for one of Longhi's favorite devices, namely, the positioning of a still life at one side or the other in the foreground. [4] The *Merry Couple* employs an earthenware jug in this role; it is interesting to observe in the later pictures,

40.1. Pietro Longhi, The Polenta. *Ca' Rezzonico, Venice.*

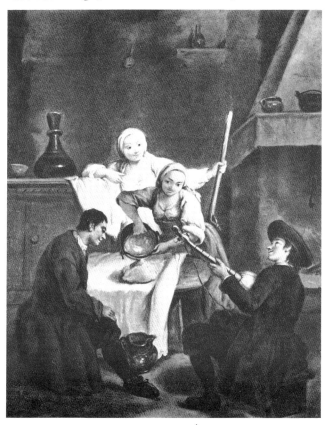

193

after Longhi's genre interiors began to gravitate toward higher society, that the same part is played by a sheaf of music or a lapdog.

Notes

1) Pignatti, 1974, cat. nos. 13-16 and 56-59.

2) See Pignatti (1969, p. 105) for his and Rizzi's later dating for the Zoppola series. Since Longhi frequently repeated favorite poses throughout his career, it does not necessarily follow that similar figures denote contemporaneity.

3) These observations on the diverse styles of the Ca' Rezzonico and Zoppola series are contradicted in each group by the respective paintings of a girl spinning. The Ca' Rezzonico *Girl Spinning* (Pignatti, 1969, pl. 15) contains the repoussoir figure in the foreground that seems typical of the Zoppola style, while the Zoppola *Girl Spinning* (Pignatti, 1969, pl. 27) displays a distancing from the front plane that is common in the Ca' Rezzonico groups. Perhaps it is not too ingenuous to suggest that these two pictures exchanged places when the Gambara collection was divided between Zoppola and Venice.

4) For illustrations of two paintings with such still life elements, one of them dated 1729, see Roli, 1977, 350a and b.

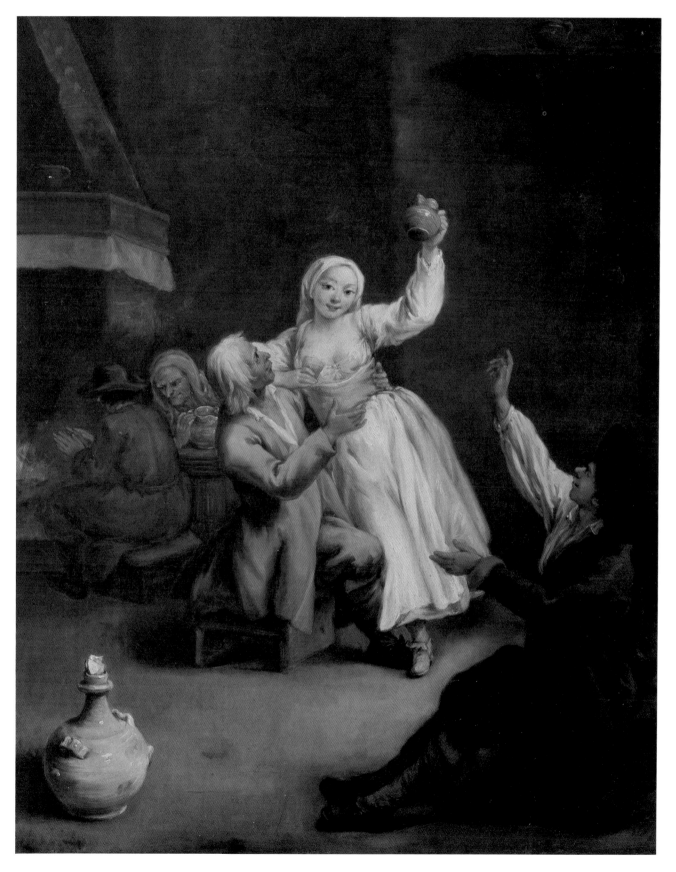

41 The Morning Levee
Oil on panel, 49×60 cm.
H.M. Queen Elizabeth II, Windsor Castle
Signed and dated on reverse: *Petrus Longhi 1744*

Early Provenance
Consul Joseph Smith, Venice; from whom acquired by
George III of England, 1762.

Essential Bibliography
Levey, 1964, no. 537; Pignatti, 1968, pp. 104-105; Pignatti,
1974, no. 38.

A gentleman takes his breakfast in bed, attended by
two servants. His lady joins him for her morning cup
of chocolate and rests her elbow on a convenient
pillow. The walls are decorated with mythological
paintings; the picture behind the lady's shoulder
appears to be *Adonis Departing for the Hunt*.[1]

The painter conceived this reverie as a pendant to the
considerably more energetic *Blind Man's Buff*, which
is also signed and dated 1744 (fig. 41.1).[2] The
pictures once belonged to Consul Smith, British
merchant resident in Venice and an extraordinary
collector of contemporary art. Longhi undertook this
commission in some seriousness: these are among his
few paintings on wood panel, and he took the trouble
to sign them.
The thematic link between these two scenes is
difficult to discern at first. Both represent carefree
moments inside a fine house. The paintings may
contain private allusions known to the artist and
patron: the gentleman who enjoys his morning levee
is characterized with portraitlike care, which calls to
mind Guarienti's remark (1753) that the people in
Longhi's paintings are often recognizable

personalities. On a more general plane, the pairing of
a boudoir scene with blind man's buff is clearly a
kind of statement about the playful wiles of
love-making. Longhi made the same association in his
contemporary pair of paintings, *The Swoon* and the
(blind-folded) *Game of Pignatta* (National Gallery of
Art, Washington).[3]
Pignatti has published five drawings in the Museo
Correr, Venice, as studies for the *Morning Levee*,
including one of Longhi's rare drafts of a composition
in its entirety. In the same museum, there is also a
single sheet related to the pendant *Blind Man's Buff*.[4]

Notes
1) Levey (1964, cat. no. 537) was the first to notice that these are
subjects of Venus and Adonis.
2) Levey, 1964, cat. no. 538; Pignatti, 1968, p. 104 (incorrectly as
on canvas).
3) Shapley, 1973, p. 136 (cat. nos. K146 and K147).
4) Pignatti, 1968, figs. 55 and 56, 58-61.

41.1. Pietro Longhi, Blind Man's Buff. *Windsor Castle. Copyright
reserved. Reproduced by gracious permission of H.M. Queen
Elizabeth II.*

42 Exhibition of a Rhinoceros at Venice
Oil on canvas, 60.4×47 cm.
The National Gallery, London

Early Provenance
Presumably painted on commission for Girolamo Mocenigo, Venice, ca. 1751.

Essential Bibliography
Levey, 1956, p. 72; Pignatti, 1969, p. 77; Levey, 1971, no. 1101; Pignatti, 1974, no. 79.

In 1741, a young female rhinoceros was brought from India to Europe by a Dutch sea captain, Douvemont van der Meer of Leyden. As T.H. Clarke has reported in a lengthy biography of this animal, Captain van der Meer proved to be an enterprising impresario.[1] Between 1741 and 1751, the Leyden rhinoceros played to enthusiastic crowds of the curious in Berlin, Frankfurt, Dresden, Leipzig, Stuttgart, and Paris, arriving in Venice in time for the carnival of 1751. Now 13 years old, and hornless (Longhi paints his keeper in the front row holding the horn in his hand), the Leyden rhinoceros could look back on a distinguished career in which his portrait had been taken by the leading animal painters of the day — J.E. Ridinger in Augsburg, Jean-Baptiste Oudry in Paris. Late in 1751, the rhinoceros performed in his last-known venue, a triumphant appearance at the Roman amphitheater in Verona, where further portraits were done.

Pietro Longhi was hardly an animal painter, but he was a dedicated observer of the behaviorial patterns of the human species. The *Exhibition of a Rhinoceros at Venice* in London is the second of two commissions that the artist executed of this scene. The first version, now in the Ca' Rezzonico, Venice, was painted for Giovanni Grimani (fig. 42.1).[2] The present version followed, and an inscription on the reverse of the canvas identifies the patron as Girolamo Mocenigo. Both gentlemen issued from distinguished Venetian families.

The London canvas is a nearly identical replica of the painting in the Ca' Rezzonico, differing only in two minor but informative variations. In the London version, three of the gentlemen wear carnival masks as opposed to only one of the men in the picture commissioned by Giovanni Grimani. For Grimani, Longhi painted a hatless and bewigged figure standing between the rhinoceros keeper and the lady; the man to the extreme right is also without a mask. These two figures are clearly portraits that Longhi may have been instructed by Grimani to insert among the spectators.

Notes
1) Clark, 1974, pp. 113-122.
2) Pignatti, 1969, p. 90.

42.1. Pietro Longhi, Exhibition of a Rhinoceros. *Ca' Rezzonico, Venice.*

43 Baptism
Oil on canvas, 62×51 cm.
Galleria Querini Stampalia, Venice

Early Provenance

In 1796, the seven *Sacraments* were cited in a bedroom in the palace of Andrea Querini Stampalia at Santa Maria Formosa, Venice.[1]

Essential Bibliography

Moschini, 1956, pp. 26-28; Pignatti, 1969, pp. 96-97; Pignatti, 1974, no. 93; Dazzi and Merkel, 1979, cat. no. 183.

The outstanding works of Longhi's career are his seven paintings of the Sacraments (figs. 43.1-6). In part, these pictures owe their distinction to their extraordinary subject matter. In the early 1750s, at the height of his creative energies, Longhi momentarily put aside his chosen activity as chronicler of the drawing room in order to paint these enactments of the seven holy rites of the Roman Church.[2]

The only painter before Longhi to depict the Sacraments as episodes of contemporary life was Crespi in Bologna, and scholars are agreed that Crespi's *Sacraments* (cat. no. 14) must have directly inspired Longhi's. There is no question of formal influence, however: Longhi did not borrow any

figures or gestures from the older master, and at first sight the two series seem hardly to belong to the same half-century. Crespi's *Sacraments* were executed in a final burst of late Baroque fervor and dramatic compression, both of a kind that the young Guercino would have appreciated. Longhi was fully an artist of the eighteenth century, and his actors are always perceived in relation to their ambiance. Their faces and their gestures are never disturbed by untrammeled emotions. That said, however, no one could overlook the religious conviction in these scenes. Notwithstanding the delicacy of the artist's technique, the faces of the participants in this *Baptism* have all the poignancy of observations taken from life.[3] In defense of Longhi, who is sometimes branded as the favorite artist of the idle aristocracy, it should be pointed out that he chose to portray his social equals, not the upper stratum of Venetian society, in his *Sacraments*. This flicker of popularism, more than any other aspect perhaps, is the most telling evidence of Crespi's influence on Longhi in this undertaking.

The *Baptism* is the most accomplished picture in the series. By comparison, *Communion* and *Matrimony*, especially, seem to have been executed in relative haste. Moschini thought that *Confession* was the earliest painting of the group (as was true of Crespi's

43.1. Pietro Longhi, Communion. *Galleria Querini Stampalia, Venice.*

43.2. Pietro Longhi, Confirmation. *Galleria Querini Stampalia, Venice.*

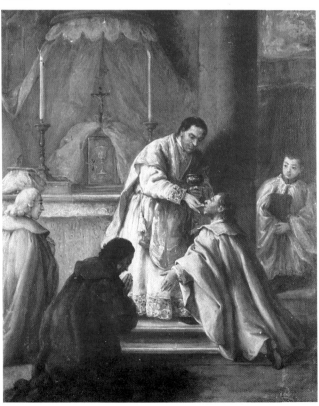

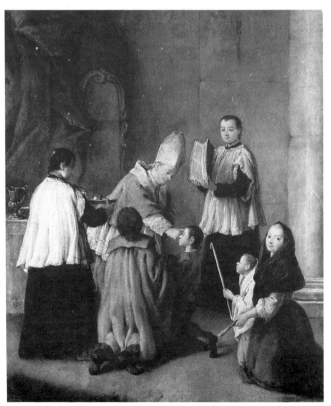

43.3. *Pietro Longhi*, Matrimony. *Galleria Querini Stampalia, Venice.*
43.4. *Pietro Longhi*, Ordination. *Galleria Querini Stampalia, Venice.*

43.5. *Pietro Longhi*, Confession. *Galleria Querini Stampalia, Venice.*
43.6. *Pietro Longhi*, Extreme Unction. *Galleria Querini Stampalia, Venice.*

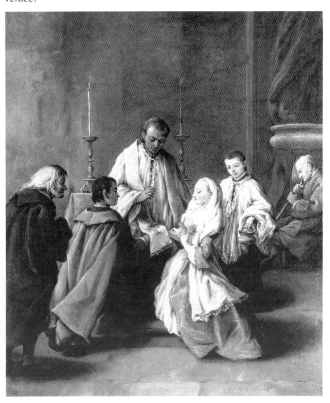

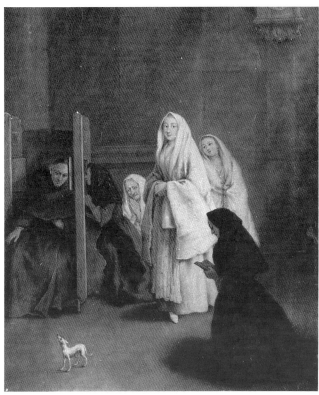

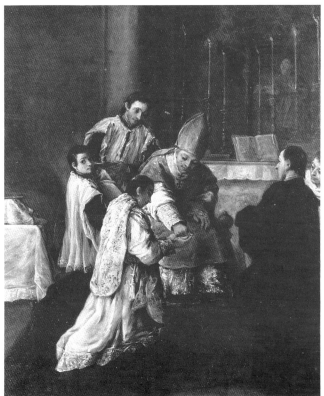

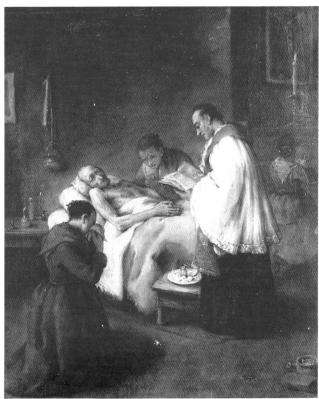

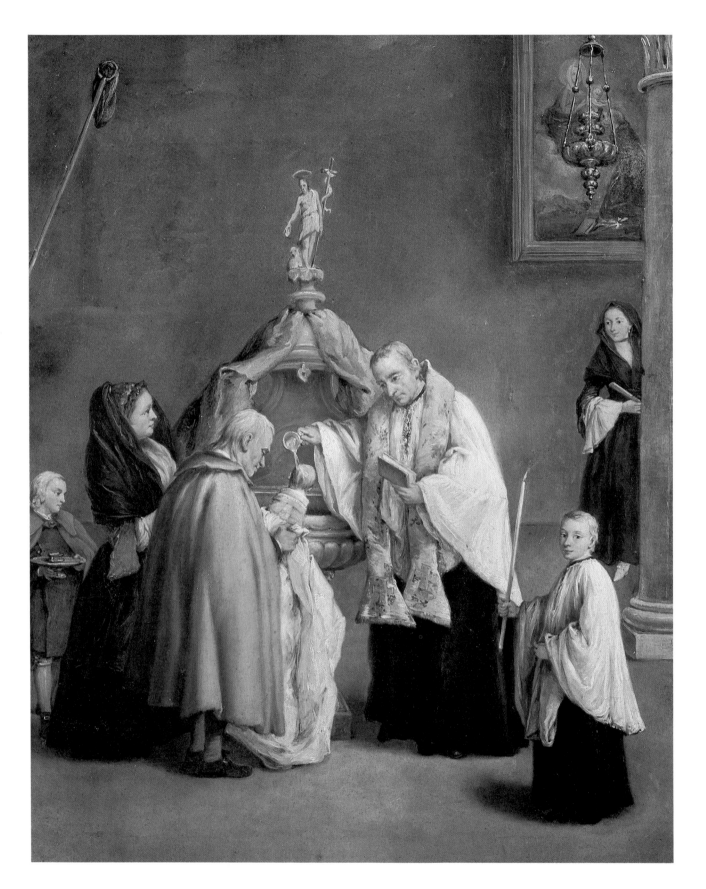

Confession);[4] however, Longhi's mature style is so consistent overall, that we are not able to make such subtle distinctions in the chronology of his works. In the frontispiece to a volume of 1755, the playwright Goldoni, who admired Longhi greatly, mentions that Marco Pitteri was then occupied in making engravings of Longhi's *Sacraments*.[5] It is assumed by scholars that the paintings were of recent date. Longhi was never in a position to know Crespi's original canvases (more than one set of copies were in existence),[6] but it may be relevant that engravings of Crespi's *Sacraments* were published in Dresden in 1754.[7]

Notes

1) Dazzi and Merkel, 1979, cat. no. 183.

2) For a discussion of the subjects, see cat. no. 14.

3) Several of the figures appear to be portraits; Crespi had probably also portrayed his friends in observation of the Sacraments.

4) Moschini, 1956, pp. 26-28.

5) Pignatti, 1969, pp. 96-97. The Pitteri engravings and a complete set of copies after them by Francesco Guardi (Museo Correr, Venice) are illustrated by Pignatti, figs. 39-52.

6) A set of Crespi Sacrament copies were noted by Luigi Crespi in the Palazzo Albani in Urbino; Rosenberg (1979, p. 826, n. 13) writes of two incomplete sets of copies in France.

7) The printmaker was J.A. Riedel, and the British Museum has a complete set of them.

44 A Fortune Teller at Venice
Oil on canvas, 59.1×58.6 cm.
The National Gallery, London
Signed at lower right, *Petrus Longhi*

Essential Bibliography
Levey, 1956, p. 74; Pignatti, 1969, p. 77; Levey, 1971, p. 156, no. 1334; Pignatti, 1974, cat. no. 117.

Under one of the arcades of the Doge's Palace, a gentleman and a lady consent to have their fortunes told. The white mask, or *bauta*, worn by the gentleman is a sign of carnival time, when all sorts of charlatans freely plied their trades in Venice. On the walls are election notices. Levey has ascertained that the inscription dated 1752 refers to the election of Doge Francesco Loredan, while at center, a notice of 1756 — which is very likely the date of the painting itself — boosts the candidacy of a certain Don Farinato for parish priest.[1]

To do justice to the significance of carnival time for Venetians in the eighteenth century, it is worth quoting at length the picturesque account of an eyewitness. In 1730, a voluble Englishman, Edward Wright, *valet de chambre* to George Lord Parker, recorded his impressions of his visit to Venice a decade earlier:

Those times of Masking are the dear Delight of the Venetians; and the Approach of the *Carnaval* seems to be to them, as the Approach of the Sun to the *Polar Nations* after their half year's Night. The most common Masking Dress is a Cloak, a *Baout*, and a white Mask: this Dress with a Hat over all is the general one for both Sexes, Women as well as Men. The *Baout* is a sort of Hood of black Silk, which comes round the Head, leaving only an opening for the Face, with a Border of black Silk lace which falls about the Shoulder. The white Mask comes no lower than the bottom of the Nose, the *Baout* covers the rest...
As the *Carnaval* advances, the Dress grows more various and whimsical: the women make themselves Nymphs and Shepherdesses, the Men Scaramouches and Punchinello's, with twenty other Fancies, whatever first comes uppermost. For further Variety, they sometimes change Sexes; Women appear in Mens Habits, and Men in Womens, and so are now and then pick'd up to the great disappointment of the lover. In these various disguises they go, not only into Assemblies within doors, but publickly all the city over: and during the *Carnaval* 'tis so much the Dress of the season, that whether upon Visits, or any other Occasion, they go continually in Masque.[2]

Roughly half of Longhi's known paintings depict Venetians in carnival costume. The lines quoted from Edward Wright confirm the impression that, for Longhi and his contemporaries, the events of carnival were among the most distinctive aspects of the local culture, and the most memorable.

Notes

1) In the event, Don Farinato was not elected. See Levey (1971, pp. 156-157) for the exact form of the inscriptions and additional details.

2) Wright, 1730, pp. 86-87.

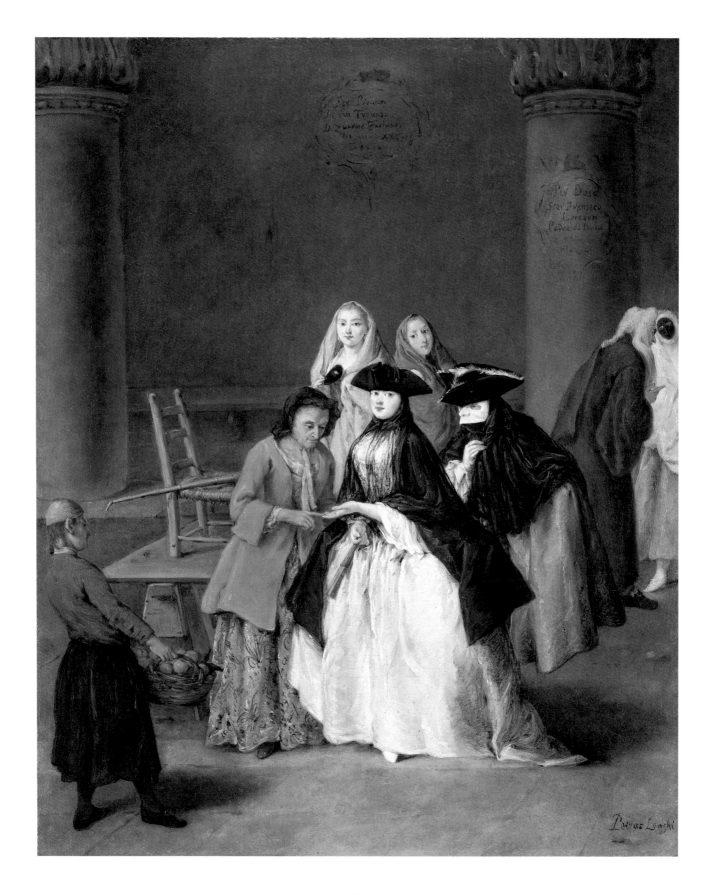

45 The Music Lesson
Oil on copper, 44.6×57.6 cm.
Walters Art Gallery, Baltimore

Essential Bibliography
Zeri, 1966, p. 444, fig. 10; Pignatti, 1974, no. 150; Zeri, 1976, no. 452.

A pretty maiden is giving a private recital at home. Her hand lies on her music book, but for the moment she is distracted by the ardent attentions of her suitor. Presumably he is her music teacher. Like Don Basilio in the *Barber of Seville*, he wears a smirk and a towering peruke. At their feet, her pet dog wants to shake hands too.
The great satirists in eighteenth-century art were Longhi and William Hogarth[1] (Thomas Rowlandson was a respectable third). Otherwise, Longhi and Hogarth have nothing in common: the Englishman set out after his targets with Calvinist fury; Longhi poked fun at foibles, as he does in this *Music Lesson*, but he never quarreled with the system as a whole. He is sometimes criticized, in fact, for not noticing that Venice in the eighteenth century was inexorably declining behind its xenophobic façades. In his book on Venetian painting of the time, Michael Levey is especially impatient with Longhi: "His pictures are therefore, with all their undoubted charm, lazy little pictures: just as the society he pictures is lazy."[2] But Longhi was hardly the only purveyor of escapist entertainments among eighteenth-century painters — witness François Boucher, *peintre du roi*.

The copper support is exceptional in Longhi's oeuvre: only one other painting on copper is known, the *Portrait of a Violinist* in the Suida-Manning collection, New York.[3] As late as 1966, this *Music Lesson* was considered French, and bore the remarkable title of *Voltaire chez la Princesse de Condé*. The attribution to Longhi is owed to Zeri. Pignatti dates the picture to ca. 1760, and has pointed out the existence of a preparatory drawing in the Museo Correr, Venice, with sketches of the parrot and the music books.[4]

Notes
1) Was Goya (1746-1828) an eighteenth-century satirist? The view here is that the eighteenth century ended with the French Revolution.
2) Levey, 1959, p. 112.
3) Pignatti, 1969, pl. 229.
4) *Ibid.*, pl. 384. Museo Correr no. 535.

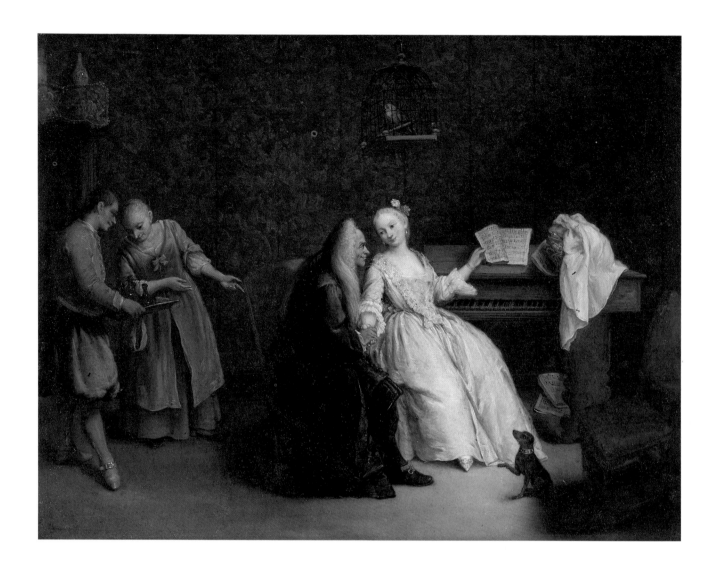

Giacomo Ceruti was native to Milan and worked his entire career in Northern Italy. He would have known of Crespi, but his development was never directly influenced by Crespi nor by genre painting in Bologna. Ceruti was instead the worthy heir of the same tradition of Lombard naturalism that had molded Caravaggio. In the eighteenth century, Crespi and Ceruti were the most sympathetic painters of the poor and the improvident, and this is the basis of Ceruti's inclusion in the present study. Crespi painted laborers and Ceruti beggars without recourse to caricature or to any compromise of the hard facts. But these two artists were very different souls, indeed. Crespi retained an optimistic faith in the redemptive powers of hard work: his porters, peasants and mendicants apply themselves to their tasks, however lowly they may be. Ceruti was a fatalist: his images of beleaguered humanity very rarely hold out any promise of relief.

Although details are still wanting, Ceruti's biography has been greatly clarified recently through archival research.[1] He evidently led a life as restless and unsettled as Crespi's had been stationary and stable. Crespi had kept his family close about him. From 1736 at least, Ceruti struggled to maintain and to keep apart two separate families in different cities. He was first married in Milan in 1717 to Angiola Carozza, who was older than he by a decade. The couple was resident in Brescia by 1721. Ceruti's willingness to accept commissions outside of Brescia after 1734 must have been motivated to some extent by his efforts to share his household with Matilde de Angelis, who bore him a daughter in Padua in February 1738.

The circumstances of Ceruti's training as an artist are not known. He was already working independently in Brescia in 1721. His earliest dated work is a portrait of 1724 (he evidently specialized in portraits from the outset), which closely resembles the Lombard realism of Carlo Ceresa of Bergamo (1609-1679). In general, Ceruti's early activity in Brescia teems with question marks, of which the most pressing regards the extent and nature of his genre paintings. Gregori has traced the provenance of several pictures by Ceruti back to the Avogadro collection in Brescia, and she has proposed to date these paintings prior to Ceruti's departure for Gandino in 1734 on the grounds that such a sustained campaign of patronage could only have taken place then.[2] In light of Ceruti's documented work prior to 1736, however, it is doubtful that his early style possessed anything like the sophistication of such works as the two *Porters* in the Brera, Milan (cat. nos. 48 and 49). Moreover, Ceruti may well have returned to Brescia during any number of undocumented periods in his life.

In 1734, Ceruti signed and dated an altarpiece in Artogne,[3] a town near Brescia, and in March of the same year, he contracted in Gandino, northeast of Bergamo, to execute an extensive series of canvases for the local basilica of Santa Maria Assunta.[4] These paintings of marginal competence are strongly impressed with the manner of Antonio Cifrondi (1656-1730), who had worked in Brescia throughout the previous decade.[5] Cifrondi was doubtless important for Ceruti, since he specialized in single-figures of grimacing beggars and hoary apostles (cf. fig. 61). But Cifrondi typically spiced his subjects with heavy doses of caricature. The appeal of his works is based on their broad humor and breathtakingly causal draftsmanship, two qualities that do not pertain to Ceruti's mature style.

Between 1734 and 1736, Ceruti made an astonishing career change when he supplanted the provincial patronage of Gandino with that of cosmopolitan Venice, where he worked for the renowned collector Marshal Johann Matthias von Schulenburg. In July 1734, he surprised his Gandino patrons by his decision to transfer to Venice prior to the completion of his contract.[6] From February to July 1736, Ceruti's name appears regularly in the Schulenburg accounts, as he received payments for paintings of *pitocchi* (beggars) (cat. no. 46), portraits, and still lifes. A payment of June 1736 mentions Ceruti's "consort" presumably not his legal wife in Brescia. The artist's experiences in Venice must have inspired the development of the monumental compositions that are the hallmark of his maturity. He probably came into contact there with Piazzetta, who advised Schulenburg on art, and he painted several half-length pictures of the kind made famous by Piazzetta.

In the late 1730s, Ceruti was residing in Padua. His residence there with Matilde de Angelis is documented until 1739. In September of 1737, he received the commission for an altarpiece of San Prosdocimo for the basilica of Sant'Antonio, Padua.[7] He probably also executed his altarpiece in the Paduan church of Santa Lucia during this time.[8] Both canvases are unconvincing exercises in the glamorous style of the Venetian G.B. Pittoni. At the heart of Ceruti's difficulties with sacred or historical subjects was his temperamental disinclination to idealize human features or gestures.

Ceruti's itinerary during the early 1740s has not as yet been ascertained. In 1744, he began a sojourn of several years in Piacenza, painting an altarpiece and receiving innumerable assignments for portraits. A census of 1745 finds him as the head of a household with Matilde and two children. The census of 1746 lists him as living in the same house with his wife, Angiola, who left Brescia in order to join him.

Ceruti's activity is undocumented from 1746 to 1757. He reappears as the painter of a full-length portrait in Milan. In the same city, Ceruti made his will in 1762, stating that his health was not good. He named his wife, Angiola Carozza, as heir to his meager

belongings, although he states, "I believe she is located in Piacenza." A few years later (1766), Matilde de Angelis is recorded in a Milanese census, with the occupation of bookseller. In the last year of his life, Ceruti signed and dated a small portrait on copper. He died in August 1767. Angiola Carozza and Matilde de Angelis died within a few months of each other in Milan in the following year; both of them are described in their death certificates as the wife of the late Giacomo Ceruti.

The unorthodox particulars of Ceruti's life led to much uncertainty in the scholarly literature prior to 1982, when Gregori published a catalogue raisonné with an appendix of archival discoveries made by Vittorio Caprara. Until that date, Ceruti's date and place of birth, the date and place of his death, and the identities of his spouses, were unknown. Scholars had previously suspected that Ceruti had been born either in Milan, Brescia, or Piacenza and that he might have died in any of those places, or perhaps in Dresden. Now that these data are in place, Ceruti scholarship can proceed to examine the artist's development as well as to address many pressing questions of attribution. The present study is the first occasion since 1982 on which a group of paintings by Ceruti has been assembled (and the first ever in America), and the hope is that new light will be cast on problems of chronology.

Notes

1) For the specific data cited in this biographical outline, see the *Regesto* of documents in Gregori (1982, pp. 105-116). The documents relative to Ceruti's works in the Basilica of Gandino have also been transcribed with some additions by Anelli (1982, Appendix, pp. 156-159), so that Gregori and Anelli should be consulted together for this period of activity.

2) *Ibid.*, pp. 11-16.

3) *Ibid.*, cat. no. 93.

4) *Ibid.*, cat. nos. 94-104.

5) Ceruti did not complete the series of 24 paintings of prophets over the arches in the nave until sometime between June 1737 and April 1739 (cf. Gregori, 1982, nos. 102-104). These pictures bear witness to Ceruti's attempt to graft Pittoni prototypes onto his early grounding in Cifrondi's religious style.

6) It is interesting to note in the account books of the Gandino Basilica that one of Ceruti's last transactions was his purchase from the church in June of two statuettes, which he must have expected to sell for a profit in Venice. Cf. Anelli, 1982, p. 156 [carta 1, verso], p. 158 [carta 36, recto], p. 159 [carta 37, verso]; Gregori, 1982, p. 108 [6, recto (?). Given as 36, recto by Anelli].

7) *Ibid.*, cat. no. 123.

8) *Ibid.*, cat. no. 140. Ceruti also painted a series of Evangelists and saints in gilt monochromes (*Ibid.*, cat. nos. 141-151), for which he fell back on his recollections of Cifrondi.

46 A Group of Beggars
Oil on canvas, 123.5×94 cm.
Thyssen-Bornemisza Collection, Lugano, Switzerland

Early Provenance
Painted for Marshal von Schulenburg, Venice (probably the picture of "*tre Pitocchi*" for which Ceruti was paid eight *zecchini* in February 1736); cited in Schulenburg collection inventories, Venice, then Berlin, 1738, 1741, ca. 1774, pre-1775; sold in Schulenburg collection sale, Christie's, London, April 13, 1775, no. 45 ("A group of three old peasants, its companion" [meaning no. 44] "An Italian peasant with a child, after nature, very fine.")

Bibliography
Volpe, 1963, pp. 61-63, tav. 63 and 64; Rosenbaum, 1979, no. 7; Gregori, 1982, no. 106.

Three elderly people sit or stand at a crude table. The woman glowers; the men wear mute expressions. All three are wrapped in layers of tattered clothes, the ragtag uniforms of beggars.

Gregori has identified this canvas with a painting of "Three Old Peasants" that was sold from the Schulenburg collection in 1775. As Gregori points out, this was in all probability the painting of "Three Beggars" which Schulenburg acquired from Ceruti in February 1736 for the meager sum of eight *zecchini*. In March 1736, Schulenburg paid the same price for a painting of "A Beggar with a Little Girl." In subsequent Schulenburg inventories, and finally in the London sale catalogue of 1775, Ceruti's two paintings of beggars are always considered as a pair. Gregori has published the photograph of a painting that may be the untraced pendant to the present *Group of Beggars*.[1] These two images of poverty are as moving as any that have ever been represented in art.

The Schulenburg provenance provides a much-needed point of reference for Ceruti's chronology. The *Group of Beggars* is thereby dated to 1735-1736, at the beginning of the artist's activity in Venice and Padua. This is the moment of Ceruti's transition into his mature style, which is evidenced in the *Group of Beggars* by the extraordinary degree of realism and, above all, the dramatic monumentality of the figures. These qualities look ahead to the pair of *Porters* in the Brera (cat. nos. 48 and 49).[2] On the other hand, the slightly crowded composition and the brown monochromy are vestiges of Ceruti's first genre style, which was influenced by Antonio Cifrondi and G.F. Cipper, called Todeschini. It is Ceruti's distinct achievement that he was able to break decisively with the caricatured or trivializing attitudes in these other painters' depictions of humble subjects.

Notes
1) Gregori, 1982, no. 107.

2) Gregori (1982, nos. 87 and 88) does not give dates for the Brera paintings except to catalogue them in the context of works assigned to the early 1730s — that is, earlier than the Thyssen-Bornemisza

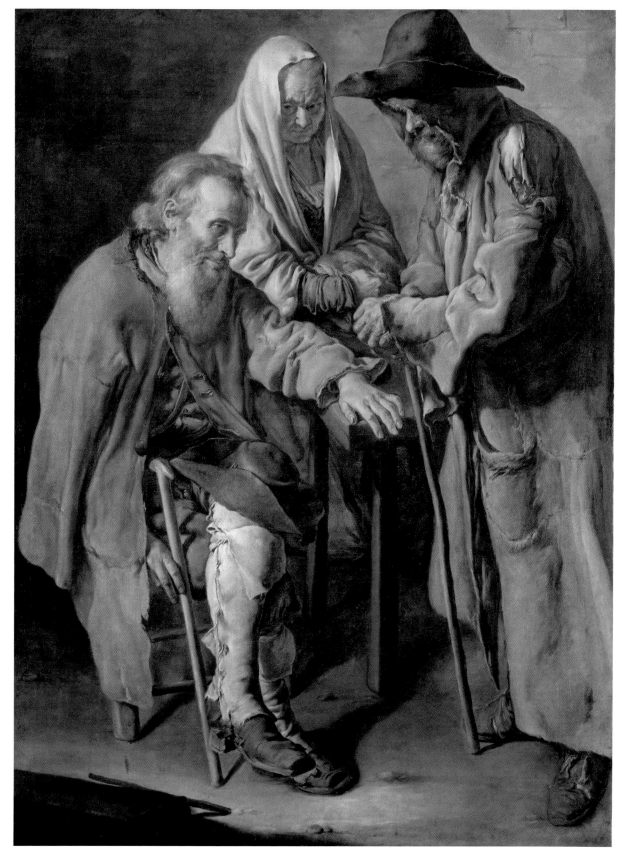

Group of Beggars. In my opinion, the *Soldiers Playing Cards* in the Sciltian collection, Rome (Gregori no. 44) provides a good example of Ceruti's genre style of the early 1730s (figures influenced by Cifrondi, composition adapted from Todeschini) on the basis of comparison with the dated portrait of *Breno Giulio Cattaneo*, 1732 (Gregori no. 36), and the altarpiece at Artogne, 1734 (Gregori no. 93).

47 The Card Game
Oil on canvas, 72.4×103.5 cm.
North Carolina Museum of Art, Raleigh, Gift of the Samuel H. Kress Collection

Essential Bibliography
Morassi, 1967, p. 360, n. 1, p. 365, fig. 25; Shapley, 1973, p. 108, no. K. 2182, fig. 202; Gregori, 1982, no. 166.

A casual game of cards is being enjoyed on a quiet afternoon. A young mother looks after an infant in a wicker crib. Someone daydreams off to the right. Thus, the servants in a noble house might pass the hours between dinner and vespers on a summer Sunday.
Ceruti's *Card Game* is a genre composition in the manner of Giuseppe Gambarini and Pietro Longhi. Even the still life of cooking pots and ladles in the lefthand corner is paraphrased from Longhi. True to form, Ceruti seems more interested in the ennui suggested by his subject than in its potential for pleasantries.
The Card Game is unique of its type in Ceruti's oeuvre. Its date cannot be determined with our present knowledge of the artist's development. Presumably the picture postdates Ceruti's activity in Venice during the late 1730s. At that time, Pietro Longhi had mostly painted peasants in interiors; his first dated painting (1741) is a fancy interior. Ceruti, by contrast, has painted characters from the middle class. Gregori lists the *Card Game* in the context of Ceruti's works of the 1740s, which is a reasonable supposition that must await confirmation.

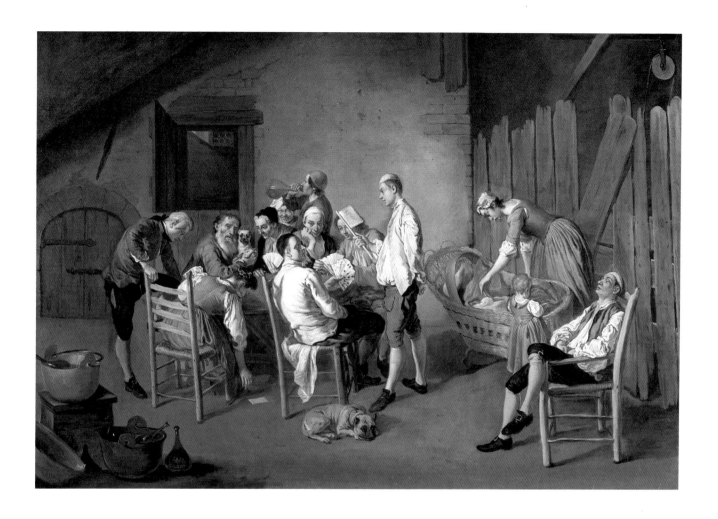

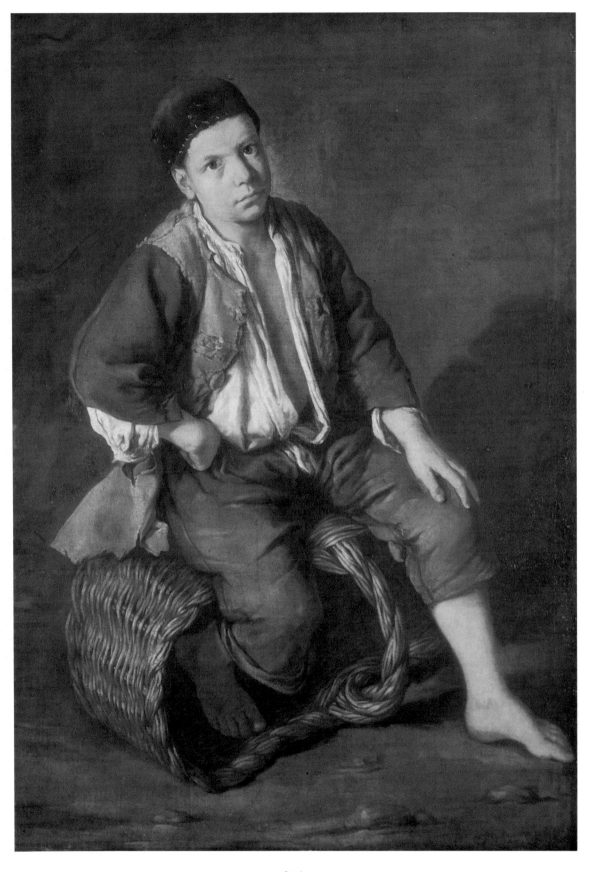

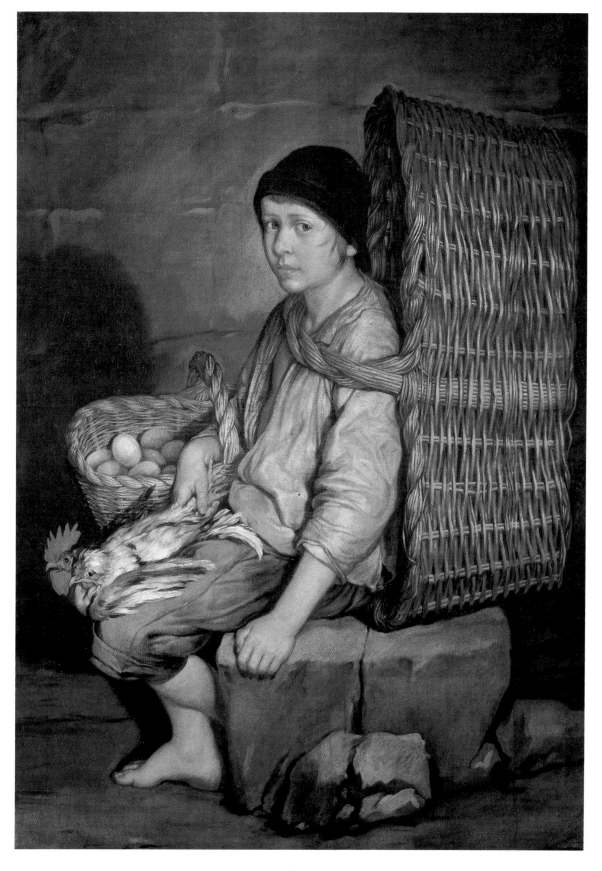

48 Porter
Oil on canvas, 130×91.5 cm.
Pinacoteca di Brera, Milan

49 Porter
Oil on canvas, 130×95 cm.
Pinacoteca di Brera, Milan

Early Provenance
Possibly in the Barbisoni collection, Brescia (1760): "Two
pictures by Ceruti with porters with baskets and chickens
in their hands."

Essential Bibliography
Carboni, 1760, p. 1070; Marini, 1966, pp. 38-39; Testori,
1966, pp. XXVIII, XXIX, 78, n. 29; Gregori, 1982, nos.
87 and 88.

These seem to be portraits of two boys who earned
their subsistence through work as porters for hire in
the city streets. The theme of youth oppressed by
poverty became a commonplace of nineteenth-century
art and literature: the telling difference, of course, is
that Ceruti's pictures never traffic in sentimentality.
Ceruti's life-sized depictions of porters and their
baskets constitute one of the most brilliant chapters in
his oeuvre. These canvases, since they are on
prominent public view, have taken on the status of
touchstones for Ceruti attributions. Given their
qualities as paradigms of Lombard realism, it is
extraordinary to think that they only entered the
Brera in 1968 as gifts.[1] Among Ceruti's several
treatments of this theme, the Brera *Porters*
particularly invite comparison to the genre paintings
by Ceruti's Lombard compatriot of the late sixteenth
century, Michelangelo da Caravaggio. As a rule,
Ceruti posed his porters in front of cityscapes; usually,
more than one boy is depicted. In these paintings,
however, Ceruti has concentrated his attention, as
Caravaggio did most often, on one psychological
portrayal at a time. The two boys sit in isolation with
blank walls behind them. There is a pervasive unity
of tonal values from which the flesh tones emerge
with heightened prominence. Indeed, the broad
handling of paint, the evocative atmosphere, and
harmonious color in these paintings have much in
common with the works of the Spaniard Murillo
almost a century earlier.
Ceruti apparently painted porters and their baskets at
various times in his career; none of these pictures can
as yet be dated with certainty.[2] This pair of works
represent Ceruti's full maturity, and must date from
the late 1740s or the 1750s.

Notes
1) They were the gifts of G. Algranti and G. Testori, respectively.
2) Cf. Gregori, 1982, nos. 58, 62, 65, 66, 70, 71, 89, 109, 195.

50 The Shepherdess
Oil on canvas, 203×139 cm.
Private Collection, New York

Bibliography
Gregori, 1982, no. 253.

A pretty shepherdess poses with her flock. Her dress
is decorated with ribbons, and she cocks her elbow
with studied nonchalance. Only her gaze (is it
diffident or aloof?) hints at emotions beneath the
surface appearances.
This provocative image resists easy explanation. On
first sight, this *Shepherdess* appears to reflect a
Lombard counterpart to the contemporary French
delight in disguised portraiture. F.-H. Drouais
(1727-1775) made a name for himself with fanciful
portraits of court ladies and aristocratic children
garbed in the costumes of gardeners and Savoyards.
Of course, Ceruti would not have shared the taste of

*50.1. Giacomo Ceruti, Girl Winding Yarn and a Peasant with a
Pannier. Civico Museo d'Arte Antica, Castello Sforzesco, Milan.*

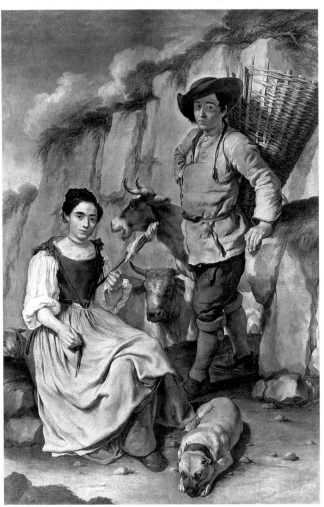

the *Ancien Régime* for work clothes cut from watered silk, but his shepherdess does wear a festive bodice that is out of character with her skirt and shoes. Her fine face is unweathered — powdered and rouged, in fact — quite unlike a shepherd girl. The possibility must be entertained that Ceruti has painted the portrait of a lady dressed beneath her station.

This interpretation fails to satisfy entirely, however, since the lady's expression seems more wistful than superior. Ceruti's painting has undeniably the air of a reverie, its dreamlike qualities being heightened by the disjuncture between the introspective shepherdess and her dull animal companions. The present owner of this painting suggests that its thematic content should be read as follows: the subject is a shepherdess who, in the midst of her daily routine, dreams of having the status and life of a lady. She wears the prettiest clothes that she has, including her simple beads as surrogates for the jewels she will never have. The implications of this point of view are not inconsequential: if such were Ceruti's intent, this *Shepherdess* would be far removed from an exercise in "Frenchifying à la Boucher" (Gregori) and would represent a novel twist of his habitual attitude towards the poor.

Gregori has pointed out the similarities of dimension and technique that exist between the present painting and Ceruti's *Girl Winding Yarn and Peasant with a Pannier* in the Museo del Castello Sforzesco, Milan (fig. 50.1).[1] The two paintings are evidently close in date, but perhaps not pendants as such, given that their compositions do not balance one another. With one quality excepted, the pastorale in Milan does not display the incongruities of dress and role that are found in this *Shepherdess*. The exception is that, once more, the young man and lady have finer and healthier features than Ceruti's peasants ever display. It is possible that these actors are portraits from the artist's circle.

The dates of the *Shepherdess* and the *Girl Winding Yarn and Peasant with a Pannier* in Milan cannot be determined with any specificity. The probability is they are not earlier than the 1750s on account of their marked development over paintings known to pre-date that decade. Gregori suggests that these are among the artist's last works.

Notes
1) Gregori, 1982, no. 252, pls. 252, 252a-b.

Gaetano Gandolfi and Giuseppe Maria Crespi had symmetrical careers in a sense, since Gandolfi dominated Bolognese painting during the latter half of the eighteenth century, while Crespi had been the most important painter during the first five decades. In every other respect, Gandolfi and Crespi were very different personalities, and the contrast between them is instructive. Crespi had forged a highly personal style, based on his independent studies of the Carracci, Guercino, and other founders of seventeenth-century Bolognese painting. He believed in the dignity of artists, but the codifications of academic training were anathema to him.

In their turn, Gaetano Gandolfi and his elder brother, Ubaldo (1728-1781), were similarly challenged to revive Bolognese painting. However, the Gandolfi elected to research contemporary developments in the flourishing school of Venice: most of 1760 was devoted to this study abroad. Upon their return to Bologna, both Gaetano and Ubaldo Gandolfi enjoyed impressive and productive careers, and both were committed professors in the Accademia Clementina. Gaetano is the more considerable artist, whose works evince a good variety of pictorial form and emotional expression. Ubaldo shows at least as much enthusiasm and fluency in his technique; for the most part, however, virtuosity displaces interpretation in his paintings.

51 Head of an Old Man
Oil on canvas, 57×47.5 cm.
Collezioni d'Arte della Cassa di Risparmio, Bologna

52 Head of an Old Woman
Oil on canvas, 57×47.5 cm.
Collezioni d'Arte della Cassa di Risparmio, Bologna

Essential Bibliography
Emiliani and Varignana, 1972, cat. nos. 79 and 80; Roli, 1977, pp. 176 and 263; Bologna, 1979, cat. nos. 235 and 236.

Genre paintings are rare in the Gandolfi oeuvre except for Gaetano's and Ubaldo's interest in the specialized category of the *testa di carattere*.[1] Such bust-length paintings of attractive or picturesque physiognomies were typical forms in contemporary Venetian painting, as well as in French (the so-called *tête d'expression*). For the most part, this genre served to demonstrate the artist's skill at inventing a variety of facial types and costumes. The emphasis was usually on external appearances as opposed to psychological penetration, despite what the denomination of the genre itself suggests.

Gaetano Gandolfi stands apart somewhat from his generation in his capacity to instill authentic personalities into the stereotypes of the *teste di carattere*.[2] These two heads are probably his finest achievements in this field. By this date, 1771, the influence of Giuseppe Maria Crespi had already faded from the face of Bolognese painting.[3] Indeed, Gaetano was probably more inspired by the Venetian specialists in these heads, especially Giuseppe Nogari, than by any of the scattered precedents in the Bolognese school, Crespi among them. In the Gallerie dell'Accademia, Venice, there is a bust-length *Old Woman with Bowl* by Nogari (1699-1763), which seemingly could have been painted *en serie* with this pair by Gandolfi, save that Nogari's image is not encumbered with an ounce of sympathy for its subject.[4] Yet these touching images of old age are appropriate to the scope of the present study, because they testify that even the Venetianized Gandolfi was susceptible to the same strain of Bolognese naturalism that Crespi had championed — anachronistically, perhaps — earlier in the eighteenth century.

Notes
1) See the survey provided by Roli, 1977, pp. 174-176, figs. 331-334.

2) Ubaldo's character heads are more numerous than his brother's, and they are fine objects; however, their intentions are strictly decorative, and they have no conceptual connection with Crespi.

3) When first published in 1953 by Zucchini (*Atti e memorie dell'Accademia Clementina*, pp. 49-50), the *Head of an Old Man* was reported to be monogrammed "G.G." and dated 1771, but the inscription is no longer visible.

4) Marconi, 1970, III, no. 134, fig. 137. The painting has been recently discussed by Chiarini (1982, no. 38). Nogari was a Venetian pupil of Piazzetta, who had learned his chiaroscuro from Crespi — all of which serves to demonstrate once over the reciprocal relationship of Bolognese and Venetian painting during the eighteenth century.

I would like to thank Tiziana Di Zio of the Archivio di Stato, Bologna, for her expert and enthusiastic participation in the research for the following appendices. In addition, most of the transcriptions have been proof-read by Dott.ssa Di Zio. The abbreviations in the original documents have been left unchanged for the most part; in some instances they have been expanded for the convenience of the reader.
J.T.S.

Appendix I

Correspondence received and sent by Grand Prince Ferdinand de' Medici in 1701 with regard to his acquisition of an altarpiece by Giovanni Lanfranco in Cortona and Ferdinand's commission of a replacement from Giuseppe Maria Crespi in Bologna.

Archivio di Stato, Florence

Doc. 1.
Mediceo 5886
c. 282 Unpublished
Letter from Domenico Girolamo Venuti, Pesaro, to Ferdinand
January 4, 1701

Serenissmo Gran Prencipe
Prima che mi giungesse a notizia il desiderio di VAS di unire alla sua notissima Galleria la Pittura del Lanfranco che trovasi in Cortona in una Capella eretta e dotata da miei Antenatj, non mi sarei in alcun tempo lusingato di havere in poter mio cosa che fosse degna di V.A.S. che non haverei aspettato, che con eccesso di tanta bontà, me ne havesse fatto ricerca, ma col farne Io un umilissima oblazione all'AVS, mi sarei gloriato con tal atto manifestare alla medema la stima che faccio del glorioso titoli che Suddito della sua Ser.ma Casa. Uniformandomi per tanto alli sentimenti del Cav.re Giuseppe mio Fratello, umilio tutte quelle ragioni, che sopra tal Pittura mi possono competere, alla sua Suprema Autorità, e godo al magior segno havere havuto in sorte di rimostrare all A.V.S la mia prontissima ubidenza, e supplicandola a degnarsi far nuove esperienze della medema, et a compiacersi di quel poco puo offerirle il mio ossequiossimo rispetto, mi permetta che Io mi rassegni con piena venerazione Di Vra A:za Ser.ma
Pesaro 4 Genaro 1701
umilissimo devotissimo obligatissimo Servitore
domenico Girolamo Venuti

Doc. 2.
Mediceo 5886
c. 388 Unpublished
Minute of letter from Ferdinand to D.G. Venuti in Pesaro
January 28, 1701

Al Sig.re Domenico Girolamo Venuti Aud:re della Legazione di Urbino [in] Pesaro
li 28 Genn.o 1700 ab Inc [1701] di Livorno
Ho prolongato fino a quest'ora la Replica dovuta al foglio compiutto di V.S. de' 4 del cad:e perche aspettavo qui' Franc.o Sammoniati Commissario d' Cortona arrivatoci ultimam.te dal quale pure essendomi stata confirmata la Singolare amorevolezza, con cui tanto Lei che tutti i Suoi mi concedono si volentieri la Bella Tavola del Lanfranco posta in una Cappella di lor Padronato in d.a Città per collocarlo fra le altre mie Pitture di Celebri Autori, vengo Sempre più a riconoscere un piacere sì gradito dalla lor cortesia come pure dal buon cuore di lei le affettuosi espressioni, ch'ella mi fà con la Penna. Eccomio pertanto a dichiarame a V.S. la mia viva gratitud: della quale goderò molto di poter dare a Lei, e alla sua casa positivi Riscontir; onde ella faccia pur capitale della disposta volontà mia, con accertarsi altresi della mia vera parzialità. A suo tempo penserò io a mandare per la d.a Pittura e VS ne sarà informata dal pred:o Comm:sio di Cortona; ed intanto prego il Sig.re che le conceda ogni più bramata fortuna.

Doc. 3.
Mediceo 5886
c. 327
[D.G. Venuti writes to Ferdinand from Urbino, June 14, 1701, with a request for the latter's recommendation to a benefice now open in Bologna.]

Doc. 4.
Mediceo 5886
c. 430
[Ferdinand writes from Livorno, June 25, 1701, on behalf of D.G. Venuti to Prior Prospero Filippo Castelli in Bologna.]

Doc. 5.
Mediceo 5886
c. 431
[Ferdinand writes on the same day to D.G. Venuti to inform him of his recommendation to Prior Castelli.]

Doc. 6.
Mediceo 5886
c. 331
[D.G. Venuti writes to Ferdinand from Urbino, June 27, 1701, to state that the Bolognese benefice has been granted to another, so that Ferdinand need not concern himself with it. Venuti asks that Ferdinand consider him for such posts in the future.]

Doc. 7.
Mediceo 5886
c. 445 Unpublished
Minute of letter from Ferdinand to Marco Martelli, Vienna
July 16, 1701

Al Sig Inviato Marco Martelli. Vienna
li 16 Luglio 1701 di fir.e
Dopo aver fatto commettere al Pittor Bolognese d.o lo Spagnuolo un Quadro di mia gran premura ho inteso di non poterlo aver con la speditezza, che vorrei, per uno certo impegno di lavori, ch'egli suppone di avere con cod.o Mons.e Nunzio, i quali lo tenerano occupato ancor piu' mesi, ma perch'io gradisco molto, di aver prontam.e la Pittura da me commessa, voglio che V.S. in mio nome si porti a preparare Mons.e pred.o, che quando veram.e non abbia un'urgenza particolare de' suoi si compiaccia di permettere che sia terminato prima il mio, e di darne però gli ordini che occorrano al prefato Pittore. Accerti puro il Prelato della gratitud.e ben viva che gli professerò per tal favore, e della piena volontà mia per corrispondergli; Ment'io confermando a Lei la mia cordial benevolenza Resto augurandole dall Ciel ogni Bene.

Doc. 8.
Mediceo 5886
c. 342 Unpublished
Letter from Marco Martelli, Vienna, to Ferdinand
August 6, 1701

Serenissimo Padrone
In esecuzione degli ordini clementiss.mi di Vra Alt:a Se. ho pregato in suo nome questo Mons:re Nunzio a permettere al Pittor Bolognese detto lo Spagnuolo, che siano terminati prima i lavori commessi da lui med.mo, che quelli commessi da V.A.S. rimostrando al Prelato il gusto, che avrebbe avuto V.A.Ser:m di averli prontam:e, e la gratitudine, che l'A.V. li averebbe conservato per una tal condescendenza, et egli mi ha fatto mille gentilissime espressioni sopra la venerazione,

che egli si pregia di professare a V.A.S., et sopra il debito, che li corre d'obedirla, ma mi ha detto che i lavori commessi a Bologna non sono suoi, ma bensi del Sig: Co: d'Gios Cameriere della Chiave d'oro, che ha'già sborsato il danaro con condizione di averli perfettionati per la fine di Ottobre, et forse anche si dubita, che tra i predetti lavori possa esserci qualche cosa per la Mta del Re de Romani, gia che S. Mta Apostolica in similar commissione suole spesso servisi del canale del Pred: Sig: Co: d'Gios, che è un Cav:re molto versato in questa materia, et si diletta molto della Pittura. Io dunque dopo avere informata l'A.V.S. del fatto, et di tutte le sue circostanze, attendero umilmente i suoi ordini se debba fare altri passi, o con il Sig: Conte a dirittura, o con MonS:re Nunzio, che ha' commessi i lavori per compiacque al Sig: Conte, et implorando intanto reverentem:te la continuazione del Real Patrocinio di V.A.S.; in cui ripongo tutte le mie convenienze, et tutte le mie fortune, all A.V.S. profondamente mi inchino di V.A.S.
Vienna 6, Agosto 1701
Umilissimo Suddito,
Marco Martelli

Doc. 9.
Mediceo 5886
c. 359 Unpublished
Letter from Ferdinando Vincenzo Ranuzzi Cospi, Bologna, to Ferdinand
October 8, 1701

Ser.ma Altezza Reale
...Lo Spagnuolo lavora e spero che il quadro sara di sua sodisfazione, essendo innamorato di servirla come saro io fisso ch'avro spirito e profondam. inchinandomi le bacio la veste di VSR
Bologna 8 8bre [Ottobre] 1701
Vassal.me Ser.e
Ferd.o Vinc.o Ranuzzi Cospi

Doc. 10
Mediceo 5886
c. 467 Unpublished
Minute of letter from Ferdinand to F.V. Ranuzzi Cospi in Bologna
October 11, 1701

...Sto molto caro, che lo Spagnuolo proseguisca di genio il lavoro commessogli per me; cho' [che ho] pieno benevolenza verso di lui, e d'affetto, e di [hole] per V.S. Resto augurandole dall Cielo consolazioni perfette.

Doc. 11.
Mediceo 5887
c. 480 Published by Chiarini, 1973, pp. 385-386
Letter from Cav.re Giuseppe Venuti, Cortona, to Ferdinand
January 1, 1702

Porto a VAS i miei umiliss.me ringratiamenti, per la nobilissima Tavola che VA ha auto la bontà di mandare all'Altare di mio Padronato, in conguaglio dell'altra, che si compiacque gradire: Essa Tavola subito gionta, è stata costituita a suo luogo, e per quelli pochi intendenti della Città, che l'hanno veduta, è stata sommamente stimata, si per la vaghezza dell'Opera quanto per la ricchezza delle Figure, con quel giu, che si puole desiderare per godere un opera bella, per la quale, la Città tutta, averà occasione di ammirarLa come proveniente dalla Generosità di V.A., che tale è stata sempre l'espettatione di tutti, et io più d'ogn'altro protesto all'AVS, i miei ossequi, più reverenti...

Doc. 12.
Mediceo 5887
c. 597 Cited by Chiarini, 1973, pp. 385-386
Minute of letter from Ferdinand, Livorno, to Cav.re Venuti
February 13, 1702.

Ho molto caro che riesca di soddisfazione di V.S. et amare dal Publico, la Tavola che mandai per colocarsi nell'Altare di Suo Patronato, d'onde Si cavò quello, che gradij singolarm:e ch'io tengo nella stima dovuta; onde Le sono gratissimo del cortese aviso datamene, e della piena amorevolezza delle Sue espressioni, alle quali corrisponderò sempre cole opere stesse a beneficio di lei med.a, e della Sua Casa...

Appendix II

Part 1. Correspondence received and sent by Grand Prince Ferdinand in 1708 with regard to Crespi's visit to him in January. Minutes of Ferdinand's letters document that on January 13th he was in Pisa, after January 16th, he was in Livorno.
All letters by Grand Prince Ferdinand were sent from Florence or from other Medici territories in Tuscany. Unless otherwise noted, all other correspondents are located in Bologna.

Archivio di Stato, Florence

Doc. 1
Mediceo 5897
c. 183 Published by Haskell, 1980, pp. 390-391
Letter from Count Ferdinand Vincenzo Ranuzzi Cospi, Bologna, to Ferdinand
January 31, 1708

Serenissima Altezza Reale,
Col mio Umilissimo rispetto renderà à V.A.R.le questo foglio, lo Spagnuolo Pittore [*in margin, in a different hand*: Gius.e Crespi d.o]. Vuole che la mia reverenza li sia un ombra di merito per poterla inclinare; Io mi fò ardito à sperarlo, tanto più che la sua mossa, hà per unico oggetto la di Lei alta stima, et ossequio. Al Caldari scrivo informandolo d'un accidente sopra un Suo Quadro, da rappresentarlo à V.A.R. che supplico non tenere oziosa la mia servitù, e prostrato le bacio la Veste Reale Di V.A.R.le

Doc. 2.
Mediceo 5897
c. 184 Unpublished
Letter from Marchesa Eleonora Zambeccari, Bologna, to Ferdinand
February 4, 1708

Doppo aver inchinato con lettera mia VAR mi sopragiunge q.ta nuova suplica con la quale devo ricorrere alla autorità ed alla giustizia di VAR per un favore per cui le rassegno le mie umiliss.me premure. Il Carlo Silva che da me riguarduto con tutta la distinzione e che ha auto l'onoredi inchinare VAR a Pratolino col Sig.e M.se Antonio Pepoli ha [rec]orduto col Pitore nominato lo Spagnolo nella forma che si degnarà rilevare nel ingionto foglio perche li facesse un quadro che rapresenta la Strage degli Innocenti, e che mi vi'en detto l'abbij portato costà come dunque non mi pare che vi sia principio di raggione che il quadro non sia del medemo D Carlo. Inviandole per un altro foglio aciò VAR

meglio conosca tutto il fatto, la suplico umilissimamente a comandare che il quadro sia mandato a Bologna [acer?]tando VAR che mi farà un favore ben distinto...

Doc. 3.
Mediceo 5897
c. 288 Unpublished
Minute of letter from Ferdinand to F.V. Ranuzzi Cospi, Bologna
February 10, 1708

Ho veduto con ogni dimostrazione di cordiatà, e di vera compiacenza, il Pittore Gioseppe Cresti che V.S. si compiacque d'accompagnare con propria lettera: e perche devo una special consideraz.e non meno al talento di lui, che agli amorevolissimi uffici di lei med.o, lo riguarderò con piena benevolenza, avendo intanto gia scritto per esimerlo dal consaputo accidente del Quadro. E confermando a V.S. la mia distinta affezione tanto dovuto al merito, e bontà Sua, Resto augurandole perfette prosperità.

Doc. 4.
Mediceo 5904
c. 330 Unpublished
Minute of letter from Ferdinand to F.V. Ranuzzi Cospi
February 15, 1708

Ritorna costà il Pittor Giuseppe Crispi, che accompagnato dai Caratteri cortesi di VS venne a recarmi il bel Quadro fatto da Lui con tant'attent.ne e maestria di Pennello, ch'io non posso non chiarmarmene appiene contento, et appagato, non meno che d'altre Pitture da esso fattemi nel suo breve soggiorno quà. Ne porto dunque a VS questo attestato, perche sappia, che avendomi data questo Virtuoso una piena sodisfat., e dimostratosi tutto affettuoso verso di me, desidero di essergli corrispond.e in ogni miglior forma; e perciò la raccomando in modo particolare alla cordialità di V.S., acciò voglia dargli in tutte le occorrenze di lui i segni della mia parzialità, e della sua gentile attenz:. Assicurirsi poi Lei della mia vera riconoscenza ovunque Le occorra; e sia certa che sempre mi sarei grate le occasioni di impiegarmi per le convenienze di VS, e del suo Nobil Sangue; con che prego il Cielo che Le conceda ogni maggiore felicità.

Doc. 5.
Mediceo 5904
c. 331 Unpublished
Undated, untitled memorandum, bound after minute of February 15th letter to F.V. Ranuzzi Cospi. Evidently a page of notes taken by a secretary regarding Ferdinand's intentions for Crespi during the latter's visit. Six lines of text separated by double-scoring.

L'annullazione d'ogni sorta di Contratta col Prete, con render gli tutto quello, che [...] Eà [Ellà] del Suo.
La Famigliarità sospirata
La lettera per il S: Gio: Rizzi
Ordine a Giuseppina per le Cassette
farli vedere la Galleria, e le Stanze [S.?]
La risolutione Le vuole il quadro compagno della Strage

Doc. 6.
Mediceo 5904
c. 329 Unpublished
Minute of letter from Ferdinand to Giovanni Ricci, Bologna
February 17, 1708

La stretta amicizia, che sò passare tra Lei et il Pittor Gius. Crispi, il quale è stato qui da me qualche giorno con mia non ordinaria sodisfaz., mi obbliga a scriverle queste righe per certificarla che siccome godo della bell'armonia che corre fra di Loro, così averò anche piacere che continuino ad amarsi scambievolm., e che anche in consideration mia Ella dimostri in ogni congiuntura la buona Legge del suo bel Cuore ad un Amico che merita per ogni capo, e specialm. per il virtuoso suo talento l'affezion sua. Io poi averò anche gusto di rimostrare a Lei ancora che amo e stimo il suo Amico, mentre occorrendole farò che Lei pure entri a parte della propensione che a Lui ha palesata, e di cui voglio ch'Ella faccia capitale, e prego Dio che la feliciti sempre pienamente.

Doc. 7.
Mediceo 5897
c. 287. Cited by Haskell, 1980, p. 237, n. 2., without transcription
Minute of letter from Ferdinand, Livorno, to Marchesa Zambeccari, Bologna
February 20, 1707

Quando D.Carlo Silva commesse il quadro della Strage delli Innocenti al Pittore Giuseppe M. Cresti espressamente gli disse che doveva servir per me; e a tal riguardo vi pose il Pittore tutta la sua applicazione, usandovi ogni studio, ed arricchendolo di figure in tanta copia sopra il convenuto, che ben fece conoscere di non avre in mira la tenuità del pagamento offerto, ma la soddisfazione di me, da cui credevalo ordinato.
Atteso dunque il mio nome vanamente spacciato dal Committente, e l'intenzion Reale avutai dall'Autore nel condurre un'Opera sì elaborata con gran dispendio di tempo, di fatica, e d'applicazione, egli ha portato il Quadro a me, che per impegno del mio decoro non devo permettere che passi in altre mani, onde resti delusa la rispettosa attenzion del pittore, il quale come mio amorevole usò meco un lodevole contegno, nè v'è chi possa dolersene. Io bensì avrei giusto motivo di risentirmi contro il Silva, che con tanto ardimento spese indebitamente il mio nome per allettar il Pittore a fargli con poco denaro un quadro di gran valuta; ma perché vedo che d. Silva gode la parzialità di V.S. e del S. Marchese Antonio Pepoli, io in riguardo d'una dama sì qualificata, e d'un nobil Cav. a me sì caro, cedo ad ogni risentimento, pigliandomi a titolo di sodisfazione il compiacer lei, ed il S.Marchese con mettere in silenziola poca consideration del Silva ad ispacciar il mio nome con un Professoreal quale io istesso ho scritto e fatto scrivere quand'ho voluto sue opere. S'appaghi pertanto cortesemente V.S. di questa mia replica, e si contenti il Silva di Riavere gli argenti, il danaro e l'equivalente d'ogni spesa fatta intorno a d. quadro...

Doc. 8.
Mediceo 5904
c. 22 Published with minor errata in the transcription in Haskell, 1980, Appendix 4, p. 390.
Letter from Giuseppe Maria Crespi, Bologna, to Ferdinand
February 26, 1708

Mi umilio à piedi V:ra Altezza Ser.ma Reale dandogli raguaglio del mio arrivo in Patria colmo di giubilo, e confuso p. le benigniss.me gratie compartitemi dall'Altezza V.S.R. in qualunque luogo sono transitato non mancarò di eternamente conservarne la memoria. Nel vedere le pretiosissime pit.re della Galleria di V.A.S.R. ricercato da me l'autore di un quadro picolo mi fu escritto essere del Tintoreti; posso con verità dirle essere di mia mano. Ho veduto ancora con molta mia sodisfatione l'opere del Sig.Sebastiano Riccii, che per verità, e con tutto candore d'animo sono state esprese con spirito, e sapere e novamente humiliandomi all'A.V.S.R. ardisco di umiliarmi dell'Altezza V.ra Serma Reale.

Doc. 9.
Mediceo 5904
c. 23 Unpublished
Letter from Giovanni Ricci to Ferdinand
February 28, 1708

Troppo altamente mi obliga il Sig. Giuseppe Crespi per doverlo sempre amare se mi fà degno d'ubbedire in ciò a Commandi dell'A.S.V.R., anzi è tanto il peso di questo Commando che troppo pregiudica alle di lui per altro amabilissime qualità, mentre dovrò disponere di tutto il mio cuore in ossequio d'un tanto commando, e nulla mi resterà da impiegare per la di lui Amabilità. In Riconoscimento d'un tant'Onore humilio a piedi dell'A.V.S.R...

Doc. 10.
Mediceo 5904
c. 336 Unpublished
Minute of letter from Ferdinand to Crespi
March 3, 1708

Ho tutto il contento del felice arrivo di Lei alla Patria, e Le aggradisco al vivo l'affettuosa notizia che me ne reca, mentre premendomi la sua salute, avevo anche desiderio di averne nuove. Ascolto con piacere ciò ch'Ella mi asserisce del piccolo Quadro in questa Galleria creduto del Tintoretto; e lodo la sincera sua espressione circa l'Opere che fece quà il Pittor Sebastiano Ricci. Io avero sempre a cuore le convenienze di Lei, e dove mi sia permesso Le ne darò tutte le prove e frattanto prego Dio che la conservi in perfetta salute, e le conceda ogni altro bene...

Doc. 11.
Mediceo 5904
c. 26 Cited by Haskell, 1980, p. 238, n. 1, without transcription.
Letter from Crespi to Ferdinand
March 7, 1708

Io mi humilio all'Altezza V.S.R. con una venerazione di rispetto dedicando à suoi pedi questo picolo Rameto dipinto da me Servitore fedele di V.A.S. ma godendo molto di inchinare per la prima volta la sovranità del suo bel genio, con la Nasita di Giesu, Redentore nostro, così prego Dio che magiormente mi chresca la speranza di magiormente vantagiarmi della mia giurata obedienza alla grandezza della sua Grazia che mi Stabilise.

Doc. 12.
Mediceo 5904
c. 339 Unpublished
Minute of letter from Ferdinand to Crespi
March 10, 1708

Il Rameto inviatomi dall'Amore che in Lei regna per me, e in cui maestrevolm. Ella dipinse la Nascita del Nro Redentore, mi è grato per tutti i capi, e precisam. per l'insigne qualità dell'opera, per il buon Cuore del Donatore, e per la compitenza dell'espressioni che ne accompagnano il Presente. Di tutto dunque le sono bene strettam. tenuto, et

aumentandosene perciò la mia propensione per la virtuosa sua Persona, averò permura di contrasegnargliela all'occas.ni di sua convenienza, e prego il Cielo che a Lei, et alla Casa sua dia continuate consolazioni.

Doc. 13.
Mediceo 5904
c. 38 Cited by Haskell, 1980, p. 238, n. 1, without transcription
Letter from Crespi to Ferdinand
April n.d., 1708

Sotto gl'occhi benigni di V.A.R. comparise il mio Ritratto, unito à questo umilio alla V.A.S.ma riverentisime le Gratie partecipatemi ma senza alcun merito, e se per sorte il ritrato non è simile li sono ancora a torno, suplicandola perdonarmi di tanto ardire che ò preso; con che ratificandole umilisimo il mio Vasallagio mi sotoscrivo

Doc. 14.
Mediceo 5904
c. 357 Cited by Haskell, 1980, p. 238, n. 1, without transcription
Minute of letter from Ferdinand, Florence, to Crespi
April 28, 1708

Mi è stato accettiss.o il Ritratto di sua Persona inviatomi da Lei, in cui il suo Pennello ha effigiato al vivo il suo Volto e la sua ilarità; ed io vi vedo quasi espresso il bel cuore, che amorosam. me lo presenta: onde con tutto l'animo ne la ringrazio, e voglio che mi creda anche per tal capo inclinato viepiù a giovarla, et a darlene autentiche prove nell'opre ogni volta che me se ne dia l'adito: Intanto sia certa della sincerità di tali sentimenti, e viva sempre felice, e contenta.

Doc. 15.
Mediceo 5904
c. 96 Cited by Haskell, 1980, p. 237, n. 2, without transcription
Letter from Carlo Giuseppe Silva to Ferdinand
June 30, 1708

His first letter on the matter, stating that the painting was made at his expense, and that he could produce "le prove delle più forti ragioni gl'Ecquivoci suscitati dal sud.o Pittore".

Doc. 16.
Mediceo 5904
c. 155 Cited by Haskell, 1980, p. 237, n. 2, without transcription
Letter from Carlo Giuseppe Silva to Ferdinand
November 3, 1708

[Another letter, with attached legal papers. "L'incredibile fortuna che ha il sud.o Pittore in trovar qui Chi protegge con caldezza i suoi Equivoci potrebbe mettermi in quale apprensione lo spirito" — if I didn't have your righteousness to appeal to.]

Doc. 17.
Mediceo 5904
c. 158 Unpublished
Letter from Antonio Morosini, Bologna, to Ferdinand
November 20, 1708

[Morosini writes of his arrival in Bologna where he will stay two days. He has met with Ranuzzi and has acquired three

pezzetti di quadri, but specifies only one, a Niccolo dell'Abbate, master of the Carracci.]

Doc. 18.
Mediceo 5904
c. 160 Unpublished
Letter from Crespi to Ferdinand
November 25, 1708

Finalmente V.A.Ser:ma mi ha dato quel contento che una volta desiderano di veder VS. Morosini ma altretanto con mio Rosore mi è convenuto fare à suo modo, come dallo stesso sentira. Unite alle mie debolezze offerita à i Piedi Reali del AV la mia Divota et ossequiosa osservanze mentre vedra che tutto il mio sangue conose l'origine delle Sue fortune dalla Munificenza Reale di V.A alla quale supplico Genoflesso volermi una volta liberare da queste molestie che mi tengano turbato l'Anima è l'core che [...] non essere tutto di notte, e ossequione con tuta la mia famiglia.

Doc. 19.
Mediceo 5904
c. 476 Cited by Haskell, 1980, p. 238, n. 2, without transcription
Minute of letter from Ferdinand to Giovanni Ricci
December 1, 1708

[Thanks him for the quadretto consigned to Antonio Morosini, and for his cordiality in depriving himself of a painting of such value.]
[Must be the Niccolo dell'Abate]

Doc. 20.
Mediceo 5904
c. 475 Cited by Haskell, 1980, p. 238, n. 3. Crespi's copy published in part by Luigi Crespi, 1769, p. 203.
Minute of letter from Ferdinand to Crespi
December 1, 1708

Al ritorno, che ha fatto quà Antonio Morosini, mi ha confermato nell'opinione che avevo della costante affez. di lei, in nome della quale me n'ha fatto espressioni abbondant.me [in margin: come pur leggo nel foglio suo amorevole dei 25 del passato] e mi ha poi presentato due bellis.e Pitture, che una rappresentante la sua propria famiglia, la quale valerà a rendermela tanto più accetta, et a farsi che in ogni congiunt.o io mi dimostri alla med.mo tutto parziale nel procurare i vantaggi di lei, e di quella. L'altra, ch'è una copia fatta dal suo insigne Pennello da un'Opera del Guercino è veram. ammirabile, e posso dirle che mi è stata gratiss.a per ogni conto, e per avervi riconosciuta una imitaz. inarrivabile [*Luigi Crespi insertion:*, e perché può essere tenuta per l'originale medesimo]: onde non sò a bastanza esprimerle la mia riconoscenza, la quale ella meglio riconoscerà sempre che si vaglia di me, ov'io possa giovarle. [*The following is not transcribed by Luigi Crespi*] Et assicurandola che farò quanto p.mo ultimare la consaputa sua pendenza, prego Dio che la renda sempre contenta, e felice.

Doc. 21.
Letter from Ferdinand, Florence, to Niccolò Cassana, Venice. Published by Fogolari, 1937, VI, 1-2, p. 186, no. 124 [who did not know whether a painting by Abate Primaticcio or N. dell'Abbate was concerned: however this is clearly the gift from Giovanni Ricci.]
December 1, 1708

Signor Niccola, avendo ritrovato un rame di mano dell'Abate Maestro de' Caracci, ch'è molto bizzarro, e di buon gusto, dipinto da due bande, ma una di esse in molti luoghi scorzata, et è quella di meglio gusto glielo mando, a ciò mi faccia il piacere, ma con tutto il suo commodo, di raccomandarlo, bastandomi averlo per Pasqua di Resurrezione per portarlo al Poggio a Caiano, mancandomi di questo autore, e le desidero ogni bene.

Amorevole di V.S. ecc.

Doc. 22.
Mediceo 5904
c. 167 Cited by Haskell, 1980, p. 238, n. 2, without transcription
Letter from Giovanni Ricci to Ferdinand
December 4, 1708

[Ricci gave the painting to Morosini as a gift.]
Con pregio troppo qualificato si degna V:A:R: di grazie l'Umil.ma offerta mia del Quadretto consignato qui al Sig: Morosini...

Doc. 23.
Mediceo 5904
c. 486 Cited in Florence, 1978-79, cat. no. 81
Letter from Niccola Caldara, Secretary to Ferdinand, to Ranuzzi Cospi, from Pisa
December 31, 1708

Di Comand.to del Seren.mo Sig.re Prin.pe...
[when the painting by Titian is in your hands, the Prince desires] "ch'Ella chiami lo Spagnuolo per farlo aggiustare in una Cassetta diligentem., e disteso su'l suo Telaio..." so that the painting should arrive in the best manner possible. [Painting had arrived by March, 1709.]

Part 2. The following correspondence was received and sent by Grand Prince Ferdinand in 1709 with regard to Giuseppe Maria Crespi. In January, Ferdinand persuaded Count Alessandro Pepoli not to destroy the frescoes by Crespi in the Palazzo Pepoli, Bologna. Between February and November, 1709, Crespi visited Ferdinand in Florence, and several letters ensued. In December, the legal action between Crespi and Don Carlo Silva was settled thanks to the intervention of Ferdinand.

Doc. 24.
Mediceo 5904
c. 174 Cited by Haskell, 1980, p. 238, n. 2
Letter from Antonio Pepoli, Bologna, to Ferdinand
January 1, 1709

[Antonio Pepoli spoke to Alessandro Pepoli about the paintings by Spagnuolo in Alessandro's palace. Alessandro is agreed to preserve them if Crespi will correct the work: the painter is happy with this solution.]

Doc. 25.
Mediceo 5904
c. 489 Cited by Haskell, 1980, p. 238, n. 2
Minute of letter from Ferdinand to Co: Alessandro Pepoli
January 7, 1709

[Ferdinand is so happy to hear from Marchese Antonio Pepoli of your condescension not to cancel the paintings by Crespi in any of the rooms in your palace. Ferdinand will write to Crespi to be ready for retouches in the rooms according to your intentions.]

Doc. 26.
Mediceo 5904
c. 490 Cited by Haskell, 1980, p. 238, n. 2
Minute of letter from Ferdinand to Marchese Antonio Pepoli
January 7, 1709

[I am so grateful to you and Alessandro; I shall write to GM Crespi to follow Alessandro's instructions.]

Doc. 27.
[Archivio di Stato, Bologna]
Notary Filippo Benacci, Vol. XVII Cited in Bologna, 1948, cat. no. 15; transcribed by Merriman, p. 196, n. 35.
February 6, 1709

[Giuseppe Maria Crespi assigns his power of attorney to Giovanni Ricci.]

Doc. 28.
Letter from Ferdinand, Poggio a Caiano, to Niccolò Cassana, Venice
Published by Fogolari, 1937, VI, 1-2, p. 186, no. 125
[This must be the painting by Abbate returned after restoration by Cassana.]
June 1, 1709

Signor Niccola, le accuso la sua, è la ricevuta dei due rametti ben condizionati, e benissimo raccomodati, ma più di tutto ho contento sentirla libera dal suo incommodo...

Doc. 29.
Mediceo 5904
c. 272 Cited by Haskell, 1980, p. 238, n. 6.
Letter from Crespi to Ferdinand
November 3, 1709

[Crespi reports his safe arrival in Bologna with passing mention of Sig. Colsotrove and of Giovanni Ricci. He thanks the prince on behalf of his whole family.]

Doc. 30.
Mediceo 5904
c. 564 Unpublished. Cf. the publication by Merriman, p. 197, n. 40, of the original received by Crespi (Biblioteca Comunale, Bologna, MS. B15).
Minute of letter from Ferdinand at Poggio Imperiale to Crespi
November 9, 1709

Del felice arrivo di Lei, e della sua familia alla Patria io mi rallegro di cuore, perche desidero che tutto le succeda prosperam., e per tal causa ancora mi chiama grato all'attenz.e ch'ella ebbe nel parteciparmelo, anche con termini di non poca amorevolezza. Io perciò le corrispondo con altrettanta affez.e, e godendo che siasi veduta con sodisfaz.e con cod:ti suoi amici, le auguro pure ogni altra contentezza, e perfetta salute.

Doc. 31.
Mediceo 5904
c. 296 Unpublished
Letter from Crespi to Ferdinand
December 14, 1709

[Crespi sends Christmas greetings.]

Doc. 32.
Mediceo 5904
c. 299 Cited by Haskell, 1980, p. 237, n. 2.
Letter from Carlo Silva to Ferdinand
December 17, 1709

226

[Silva thanks Ferdinand for the resolution of the dispute between him and Crespi.]

Sotto gl'Auspizi clementissimi di Vra Altezza Reale sono rimaste finalmente definite le Pendenze che vertevano tra me, e il Pittor Cresti, avendo io ricevuto il Constante assolutorio d'ogni Contratto dalla prudentissima Mediazione del Sig. Co. Senator Ranuzzi...

Doc. 33.
Mediceo 5904
c. 545 Unpublished
Minute of letter from Ferdinand to Marchesa Eleonora Zambeccari
December 21, 1709

Il Pitt.re Giuseppe Crispi d:o lo Spag.lo farà ricorso quando gli occorra alla Bontà di V.S., la quale deve ascrivere a rispetto dovutoLe da esso, se non viene a darle incomodo senza necessità: ed io Le confermo che le sarò tenuto delle assistenze che gli accorderà nella sua occorrenze, com'io m'impegherò con cordiale attenzione in tutto ciò che sia di soddisfazione di V.S.

Doc. 34.
Mediceo 5904
c. 313 Unpublished
Letter of Marchesa Eleonora Zambeccari to Ferdinand
December 31, 1709

Il Pittore detto lo Spagnuolo e stato novamente da me, io l'ho esibito tutta la mia opera per assisterlo ed esso ha accettato per hora q.to mio desiderio con promessa di prevalersi di me alle sue recorenze. Si preggia (e con raggione) molto della Protteztia che gl ha fatto [unclear: sperare (?)] VAR ed io ho assicurata che sotto ad un cosi autorevole Patrocinio viverà sempre felice.

Doc. 35.
Mediceo 5904
Unpublished
Minute of letter from Ferdinand to Carlo Silva
December 31, 1709

Anche dal S. Co: Ranuzzi fui informato dello ultimaz.e delle differenze, che vertivano trà le, et il Pitt.e Gius.e Crespi, seguita con reciproca sodisfaz.e di ambidue, ch' essendosi contentati di starsene alle mie determinazioni sopre lo med.mo, mi anno dato motivo di esser loro grato, come veramm.e lo sono, e precisam.e a lei, dalla quale ricevo una lettera amorevoliss.a, e ripiene di termini cosi sensati, e prudenti, che ben mi fanno conoscere e la saviezza sua, et il buon cuore ancora di lei.

Doc. 36.
Mediceo 5904
c. 606 Unpublished
Minute of letter from Ferdinand to GM Crespi
December 31, 1709

Non solo aggradisco al buon cuore di lei l'uficio amorevole dell'augurio felice fattomi per occasion del Santo Natale, nel quale, e per l'avvenire ancora desidero a lei, et alla Casa sua contentezza interminabili; ma le sono anche riconoscente per la notizia recatami dell'aggiustamento seguito con reciproco contento trà il Sacro.e D. Carlo Silva, e lei, come pur ne fui ragguagliato dal I. Sen.re Co Ranuzzi Cospi, e ne ho goduto in modo ben particolare, anche perche sento

essersi con tal'aggiustamento sinceramente frà di loro rappacificati. & ratifcandole con questo sempre propensa a procurarle vantaggi la mia volontà, prego Dio Bened:o che le conceda ogni altro Bene ancora.

Appendix III
Documents for the litigation between Giuseppe Maria Crespi and Don Carlo Silva: evidence presented by Crespi.

Archivio di Stato, Bologna
Archivio Notarile
Rogiti Filippo Benacci
Vol. LXV, carta 264 ff.
Cited without transcription in Bologna, 1948, cat. no. 14; Merriman, pp. 198, 245-246.

Doc. 1.
c. 264 [foglio 1r]
Testimony for Crespi by Giovanni Ricci [D. Joannes ol: D. Antonii de Ritijs Cives Nob: Bonie Cap:o S. Laurentij].

Per haver io l'onore da Gente qui in Bologna dell'altezza Ser.ma Elettorale Palatino, servi ancora qui in Bologna l'anno 1706. il Sig.re Giorgio Raparini Secretario, et Intimo Consiliere di S.A.E. con occasione che per interessi delo di Lui Ser:mo venne à Bolog:a, onde frà l'altre volte che mi trovavo in sua Compagnia, una fù nell'andar che egli fece à Casa del Sig.r Giuseppe Crispi Pittore Bolognese denominato il Spagnolo e mio amico per vederlo operare e per vedere se avesse alcun quadro, ò disegno da poter portar seco à Dusseldorf e farli vedere all'A:S.E: sua [foglio 1v] Padrone molto geniale di Pitture de Virtuosi, e però portatoci assieme à Casa d. d: Sig: Crispi Pittore, e vedute alcune sue Operazioni, e particolarm:e un Quadro in cui era figurata la Straggie degl'Innocenti, il quale era quasi come terminato, e conosciuto d: Sig.re Raparini Secretario predetto che questo Quadro sarebbe stato di gran satisfazione al di Lui Ser:mo Padrone e di Lui Sommo gradimento per essere di buon contorno, Mossa, e Colorito fece instanza al med:o Sig:e Crespi per comprarlo, e di sapere il prezzo, ma il Sig:re Crespi li disse che per cosa veruna ne per prezzo che se gli potesse offerire l'avrebbe mai venduto, mentre questo Quadro gli era stato ordinato e gli e l'avea fatto fare un tal Sig:re D. Carlo Silva, Onde ciò inteso dal Sig:re Raparini molto se ne dispiaque per non poter aver questo Quadro che si parea un Operazione che sarebbe stato di molto gradimento, e satisfazione del suo Ser:mo Padrone. Posso dire ancora per verità come doppo partito da Bolog.a questo Sig:re Raparini il quale portò seco alcune Operaz:ni di detto Sig:re Crispi, hà poi scritto à me più [foglio 2] volte di procurare che d: Sig.re Crispi li vendi il Quadro predetto della Stragie degl'Innocenti mà non vì è mai stato modo che io lo potessi indure per averlo fatto come egli dicea à posta per d. Sig.r D. Carlo Silva, e per che più chiaram. si conosca questa verità io esibisco à VS: trè Lettere scrittemi dal d:o Sig.re Secretario Raparini una sotto il di 16 Aprile 1707. di Dusseldorf, e l'altra sotto il di 15 Maggio 1707., l'altra sotto il di 29 dello stesso Mese, et anno, ambedue di Collonia dalla quale VS transuntarà li Trè Capitoli concernenti à questo interesse, e le quali Lettere col mio giuram:to Li dico e aff:mo che sono tutti mano di d: Sig.re Segretario Raparini, e per che quanto io hò deposto e la pura, e mera verità la Conf.o col d.o mio giuram:to. [foglio 2-2v, the notary records in Latin the dates etc. of

Raparini's three letters to Ricci, from which three chapters are then transcribed as follows.]

Doc. 2.
[foglio 3]
Capitolo n.o 1 [= From Giorgio Raparini, Düsseldorf, to Giovanni Ricci, Bologna, April 16, 1707]

Nella graziosa Conferenza ebbi con l'A.S.E. mi occorse di far valere il merito del Sig.e Gioseffo, esagerai la sua facilità e maestria, parlai del quadro della Straggie mostrai il piccolo disegnino dell'altro quadro nello stesso soggetto, che piacque al piu alto segno, onde io sono à pregarla d'interporre seco il suo autorevole talento per far si che io abbia un suo dissegno dell'altro che stà terminando, e se occorre lo paghi, che per due ò tre ongari io ne faro buono à lei, di piu se il quadro non è di più che di trenta sin in quaranta doppie m'avvisi che qui un Pittore di S.A.E. il piu confidente lo vuol comprare per donarglielo affine che nella suá Galeria abbia saggio d'un si gentil penello.

Doc. 3.
Capitolo n.o 2 [= From Giorgio Raparini, Cologne, to Giovanni Ricci, Bologna, May 15, 1707]

Sto attendendo l'avviso sop.a il Quadro del Sig.e Giuseppe, e dissegno, con animo di non essergli di nocumento, se io posso introdurrlo alla conoscenza del Ser:mo P.rone. Egli gia è in stima grande con il dissegno da me fatto vedere della Stragge degl'Innocenti che ella mi donò Repplico l'esibizione del denaro, che subito sarà fatto pagare dal Sig.e Tauben e da mè. E Questo è il Pittore Confidente di S.A.E. che non fa che rittratti. Egli ha gradito gli di lui segni, e curioso vuol vedere il Colorito. Incontrando (di che non dubito) potremo fargli l'esibizione d'un Cento Scudi il mese se qui voglia venire come tant'altri Virtuosi che qui sono.

Doc. 4.
Capitolo n.o 3 [= From Giorgio Raparini, Cologne, to Giovanni Ricci, Bologna, May 28, 1707]

Mi consola il sentire che il Sig.e Giuseppe dia mano à gradire à S.A.E. di che non dubito mentre ama aggiunto q.ti soggetti che vi è movimento, e strepito, e se mai potesse essere che la persona à chi è destinato cadesse à favore del S.A.E. e si riportasse ad altra pari fatica, io con il Sig.e Tauben, che è quel favorito Pittore di S.A.E., Ritrattista semplice, ma intendente pagheressimo sino à 50. doppie il p.mo Cenno e conti che codesto virtuoso con suo onore sarebbe chiamato, e le condit.ni sarebbero di suo vantaggio, e si farebbero poi col tempo ancora più generose arrivato che fosse qui, e lavorando à garra di virtuosissimi Competitori.

Doc. 5.
[foglio 3v]
Lettera n.o 1
Foris = = Al Molt' Ill.re Sig.re P.ron Oss.mo il Sig.re Pier Girolamo Papi Capo Not.o del Torrone di Bologna = =
Intus vero = = Molt' Ill.re Sig.re P.ron mio Oss:mo —

Le scrissi l'ordinario pass.o mà per dubio che non sia andata à male la lettera le replico à favorirmi dir subito al Sig.re Giuseppe Crespi che consegni pure li quadri al Sig:re Quaranta Ghiselieri, e paghi il Sig.re Venturini à pagare al med.o Sig.re Giuseppe Cento Scudi, ed avvisar subito qui, e à chi dovrò fargli pagare, ed in ogni caso mai che il Sig.re Venturini non volesse, ò potesse si vaglia di questa mia con

qualunq. di q.ti Sig:ri Mercanti, ò Negozianti per farli pagare d: Somma di Scudi Cento che all'aviso paghero subito io à chi occorrerà e la prego in tutti i modi à farmi questo favore acciò codesto galant'uomo resti subito sodisfatto; Ho sentire che à d: Sig. Crespi sii restato il quadro degl'Innocenti fatto per il gran Prencipe mi facci favore dirli di che misura sia, ed in ogni caso che le fosse restato se quanto ne domandi, con farmi qualche piacere perche poi lo pregherò à farmi anche il Compagno, mi onori farmene sapere qualche cosa, e pregandola à compatire tanti incomodi le bacio divotam.e le mani - - di VS: In:t
M.re Roma li 24 Xmbre 1707 Div.mo ed oblig:mo Ser.e Ant.o Sabaini

Doc. 6.
Lettera n.o 2
Foris = = Al Molt'Ill;re Sig:re P.ron Oss.mo Il Sig.re Giuseppe Crespi Bologna = =
Intus vero = = Molt' Ill:re Sig:re P.ron mio oss:mo —

Godo che il Sig:re Venturini per mezzo del Sig:re Capo Notaro li abbia pagato li Scudi Cento per prezzo delli due Quadretti fatti per il Sig:re Card:e Ottoboni, quali sò essere gia giunti e spero siino di sodisfazione di S. E:za se bene sopra di ciò non posso dirle cosa di particolare non avendo veduto alcuno à cagione de tempi impraticabili che qui corrono. Circa la Madonina della quale Lei fece pregare [unclear: pagare?] dal Sig:re Capo Notaro non vorei che predesse equivoco con mandarla al Sig. Card:e perche quando lei [Through error in subsequent binding, this letter continues on f. 7r] favorischi deve mandarsi al Sig. Marchese Virgilio Spada Suo Maggior d'Uomo con il quale io ho trattato, e perciò quando l'avrà fatto potrà mandarla al med:o Sig:re. Già che il quadro degl'Innocenti è impegnato desidero che lei anche con suo vantaggio e comodo me ne faccia due à suo gusto e di sua Invenzione in tela d'Imperatore, e creda che voglio che il di lei credito qui s'aumenti perchè quando me ne avrà favorito voglio in prima congiuntura esporli al publico, e che siano di occasione di farne molt'altri perchè avendo cominciato a fare questi effetti la Madalenina molto più lo faranno l'opre studiate e la prego perciò a favorirmi della maniera che lei sa fare. Domani farò rimborsare il denaro cioè dd: [detti] Cento Scudi al figliolo del Sig: Venturini, e la baccio affettuosam:e le mani - - - VS: M: I:re Roma li 14 Genaro 1708.
Div.mo, et Oblig:mo Ser:e Antonio Sabaini

Doc. 7.
[foglio 4]
Die 29 Novembrij 1709
Testimony for Crespi by Zanobio Troni [D. Zenobius filius D.Antoniy de Turris Liburnensis... Testis Inductus...]

Con occasione che Il Sig D. Carlo Giuseppe Silva capitava nella Botega d'Argentiero dove Io lavoro nella Via degl'Orefici di Bologna all'Insegna della mezza Luna, et che quivi si era discorso molte volte della Controversia che vertiva fra esso, e Il Sig.re Giuseppe Crespi detto lo Spagnollo Piture addimandai al medesimo Sig. D. Carlo Silva in che stato si trovasse questa sua diferenza, e questo sara incirca un mese fa, et doppo un lungo discorso sop.a di questo Io feci alsud.o Sig. D. Silva un Interogacione, e li dimandai, non haveria concordato VS. col d.o Sig Crespi quando gl'Ordino il quadro della Strage degli Innocenti che lo voleva far fare per donarlo all'Altezza Serenissima Reale

del gran Principe di Toscana, e d.o Sig.e D. Carlo mi
rispose le precise parole, è vero che Io dissi al Crespi che
facevo fare d.o quadro per donarlo à d.o Serenissimo Ppe
ma lo dissi così per burla, e non perche questa fosse la mia
Intentione Io sogiunsi che cosa dunque va cercando VS con
questi contrasti, e egli mi rispose lo So ben Io; e perche Io
per farlo contrastavo mostravo di Tenere la parte del Crespi
Egli Sogiunse Io non voglio piu dire niente, et indi à poco si
parti da d.a Botega et questa è la pura, e mera verità delle
parole che udij dalla bocca di d.o Sig.r Carlo à me
benissimo not.o da piu d'un anno in qua...

Doc. 8.
[foglio 5]
Die 10 ianuarii 1709
Testimony for Crespi by Lorenzo Manzini [Laurentius olim
d.Dominici de Manzinis civis et pictor Bononiensis capelle
S.Caterine de Saragozia testis...]

Io conosco benissimo tanto il Sig. Giuseppe Crespi, alias
Cresti pitore Bolognese nominato lo Spagnollo quanto il
Sig. D. Carlo Silva sacerdote credo io di Romagna da molto
tempo habitante in Bologna e questa cognitione io l'ho
havuta con occasione, che per la mia professione di Pitore
ho praticato saranno otto, o nove anni nella stanza, o scola
di d.o Sig. Giuseppe nella quale è stato solito
frequentemente con diverse occasioni venire d.o Sig. D.
Carlo massime come amico d'esso Sig. Giuseppe, che si
trattavano insieme come Amici anche di Confidenza, e
saranno circa tre anni che d.o Sig. D. Carlo concordò con
d.o Sig. Giuseppe che li dipingesse in una tela la Stragge
degl'Innocenti, ed in un altra la Storia di Agar per quanto
prezzo io non lo seppi precisamente perche non lo cercai:
So bene che [foglio 5v] d.o Sig. D. Carlo più volte, e certo
quattro ò cinque volte li nella stanza in mia presenza, e del
Sig Astorre Falconi [?] Altro Professore di Pittura, e qualche
volte io solo parlando egli con d.o Sig Crespi per il
proseguimento di d.o Quadro diceva, che haveva gran
premura che fosse fatto con ogni diligenza, e studio perche
lo faceva fare per farne un regalo al Sereniss.o Gran
Principe Reale di Toscana: E qualche volta diceva Sig
Giuseppe mi Raccomando che sia bene instoriato perche
sapete in mano di chi deve andare, e il Sig. Giuseppe
rispondeva che lo faceva con ogni studio, e premura perche
à lui ancora per suo onore premeva, che fosse una cosa ben
fatta e certo per quatro, ò cinque volte mi sono trovato
presente à queste espressioni, ò simili discorsi come anche
più volte c'è stato presente d.o Sig Astorre e forse ci
saranno stati altri che non mi recordo e questa Verità che
d.o Quadro dovesse presentarsi à suo A. dal predetto D.
Carlo lì nella scola pasava per cosa certa. E l'istesso ho
udito dire anche qualche volta al med.o Sig Crespi in
occasione di forestieri, che sono venuti in d.a scola, et
hanno vedutto d.o Quadro à quali egli diceva, che lo faceva
fare un Sig.re per donarlo à S.A.R. di Toscana, che perciò
posso dire col mio giuramento d'havere più volte udita
[foglio 6r] questa verità tanto dalla boca di d.o Sig D. Carlo
quanto da quella del Sig. Giuseppe Crespi senza cercarlo da
nessuno perche a me niente importa questo negocio.
Posso anche dire che dell'anno passato il predetto Sig.
Crespi mi disse che fra lui e d.o Sig D. Carlo era nata
controversia sopra d.o quadro, e che perciò mi pregava, se
io fossi stato ricercato da qualche d'uno che io dicessi la
verità sopra quanto io [precedentemente or presentemente]
Io depongo d'havere udito dall'istesso Sig D. Carlo più
volte, che faceva fare d.o quadro per farne un Regalo à

S.A.R. Il Che disse ancora al predetto Sig Astorre. Io
risposi, che questa era piena verità, et che non potevo dire
nè havere mai detto diversamente perché io non sono
capace di dire una cosa, che non sia: né Il Sig Giuseppe mi
pregò in altro modo, né io ho mai detto ad alcuno, e
particolarmente al Sig Giuseppe Martinelli Pitore, che d.o
Sig Crespi mi havesse addimandato questa attestazione di
verità, e che io non l'havessi voluto fare perche la verità
precisa sta come ho sopra deposto né credo che il Sig
Crespi sia capace di dimandarmi una cosa che io non
dovessi fare, né io sarei capace per far servizio à chi si sia al
mondo di dire una cosa, che non fosse, e se Il Sig.
Martinelli havesse detto di havere udito diversamente [foglio
6v] da me certo l'haverà detto ò per errore nell'havermi
inteso, ò per isbaglio della sua memorizza perché alcerto io
non ho mai detto né posso dire sopra questo fatto
diversamente da quello che ho detto di sopra, essendo tutto
piena, e sicura verità quale mi meraviglio che si controverta
fra detti Signori Silva, e Crespi, et Qui Testi... [Signed] Cosi
depongo per verita Io Lorenzo Manzini sudetto.

Doc. 9.
[foglio 9r]
July 16, 1708
Testimony of Sig. Pietro Girolamo Papi

Dopo che l'Illmo Sig.re Antonio Sabaini già Auditore di
q:to foro del Torrone di Bologna si parti da questa Città, e
andò per loco tenente Criminale dell'Aud.re della Camera di
Roma, ho avuto fortuna di servirlo qui in Bologna e di
ubbidirlo ne suoi comandi fattemi e particolarmente col Sig.
Giuseppe Crispi Pittore di questa Città di Bologna per causa
di certi quadri fattogli fare onde io sò, e posso dir per verità
che esso Sig. Aud.e Sabaini avrebbe molto desiderato
d'avere, e poter comprare dal d:o Sig: Pittore Crispi un
quadro della Straggie degl'Innocenti che egli avea veduto
alla sua Stanza mà per causa che questo Quadro era stato
ordinato e detto Sig. Crispi l'aveva fatto per ordine di un tal
Sig: D. Carlo Silva non gli è l'avea mai voluto vendere, e
però pervenuta notizia al d.o Sig.r Aud.re Sabaini che
questo Quadro degl'Innocenti era rimasto al d: Sig:re
Pittore Crispi mi scrisse una lettera in cui mi esprimeva che
avrebbe desiderato di sapere la grandezza precisa di q.to
quadro e che io gli è l'avessi comprato la qual lettera io
esibisco à lei e è questa la quale in p:mo luogo io col mio
giuram:to la riconosco tutta di mano di d: Sig: Aud.re
Sabaini, e per maggior corroborazione della verità che li
depongo si contenti di transuntarla, e registrarla. [foglio 9v]
In esecuzione di questa lett.a io servi in tutto e per tutto il
Sig. Aud.e Sabaini parlando al Sig. Pittor Crispi circa il
Quadro degl'Innocenti, mà questo mi disse non aver alcuna
libertà circa q.to quadro e non poterlo in modo veruno
vendere, e disse che avrebbe scritto à suo Sig: Illma come in
effetto lo dovette scrivere mentre sotto il di 14 Gen.o di q.to
corr.o anno 1708 in una mia lettera n'aveva inclusa una
diretta al med:o Sig. Giuseppe M.a Crispi la quale io gli è la
feci capitare per il mio Sig. Notaro sostituto doppo il med.o
Sig. Crispi me la portò, e mi disse che molto le dispiaceva
di non poter servire il Sig. Aud.re mostrandomi la d. lett.a e
lasciandola con dirmi che io dessi pur risposta al d: Sig:
Aud.re che non potea servirlo del quadro degl'Innocenti la
qual lett:a diretta al d. Sig. Crispi la conservo ancora presso
di me et è q.ta che esibisco à VS: ad effetto che ne faci il
Transunto, e l'inserisca à piedi di questo mio testificato per
maggior coroborazione di questa mia deposizione lo quale
tutta conf.mo col mio giuram.e ...Epistola del d. Papio...

Appendix IV

Dossier of documents relating to the settlement of the litigation between Giuseppe Maria Crespi and Don Carlo Silva. This dossier was assembled by Count Ferdinando Vincenzo Ranuzzi Cospi, nobleman in Bologna, agent in this matter for Grand Prince Ferdinand de' Medici, Florence.

Archivio di Stato, Bologna
Fondo Ranuzzi-Cospi
Libro 84
no. 22

Doc. 1.
The cover of the dossier summarizes the affair and its resolution.

1709: 14: Dec.e
Pagamento
fatto dal Co. Ferd.o Vinc.o Ranuzzi Cospi di ord.e del Gran Prpe Ferd.o di Toscana a Giuseppe Crespi Pittore di luigi 60. per un Quadro ove era la Strage degl'Innocenti mandato all'A.S., della qual somma si pagano scudi 382:13. a D. Carlo Silva per effetto di un laudo pronunciato dal med.o Gran P.npe sopra la vertenza, e pretensione del D. Silva, che da d.o Crespi in vigore di contratto fatto dovesse farli due quadri, uno della strage degl'Innocenti, l'altro di Agar, e mediante tal laudo, a pagamento resta sciolto d. contratto. Li dd. 60 luigi furono pagati per parte di d.o Gran Pnpe al d.o Co. Ranuzzi, o suo Ministro in Firenze. Qui è unito d.o laudo, et altre memorie per d.o interesse.
Originali

Doc. 2.
Letter from Niccola Caldari, Secretary to Grand Prince Ferdinand, Florence, to Co. Vincenzo Ranuzzi Cospi, Bologna
October 19, 1709

Ill:mo Sig:re e Pron Col.mo
[Marginal notation in Ranuzzi's hand: Il Sig.e Niccola Caldari è un Seg.rio di Camera del Ser.mo Sr Prnpe Ferd Il Sig.e Ant M.a Francheschi è il Suo Cassiere]
Col presente Procaccia ritorno finalm.e a V.S. Ill.ma tutte le scritture attenenti alla differenza tra il Sacerd:c D. Carlo Silva, et il Pittore Giuseppe M.a Crespi, e con questa lettera averà Copia di un Parere Legale, quale, a dirla in confidenza, è del Sig.e Aud.r Fiscale, e deve servire di Sentenza del Seren.mo Sig.re Pnpe Mio Sig.re nella sud.a differenza. È mente però di S.A.R.le, che V.S. Ill.mo tenga per ora tutto celato, né publichi niente sopra di essa differenza finche non ritorni costà il prenomato Pittore, e che allora poi significhi all'una Parte, e l'altra la risoluz.ne dell'A.S. a tenor del Parere qui alligato, ma senza però mostrarlo, bastando ch'Ella o la dica loro in voce, o la dia all'uno, et all'altro in Scritto, e senza spiegare i motivi che S.A. ha avuto di decidere nella forma che dicessi in d.o Parere. Ch'essendo l'unico motivo della presente, mi ristringo a rassegnare a V.S.Ill.ma la mia ossequiosa obbedienza, et a farle per fine umiliss.o inchino.
Firenze 19 Ott.e 1709
Di V.S.Ill.mo Umiliss.mo Servit.re
Niccola Caldari
Alla quale aggiungo, che'l S.r Franceschi mi pagherà domattina Scudi venti a buon Conto, e dice che anderà seguitando, non potendo fare pagamenti grassi, ma che multa pauca faciunt unum Satis. Io prenderò ogni Somma,

e manderò al S.re Masselli, che farà le Ricevute neccessarie, e se si continouerà V.S.Ill.ma sarà pagata col tempo.

Doc. 3.
The legal opinion submitted to Grand Prince Ferdinand and transmitted by him to Count Ranuzzi Cospi

Copia
Seren.mo Sig.re Principe
[Marginal notation in Ranuzzi's hand: Laudo che d ord.e del Ser.mo Pnpe di Toscana deve notificarsi al Prete Silva et al pittore Crespi d.o lo Spagnuolo per terminazione delle loro differenze 1709 19 8tre]
In riverente esecuzione dei benignssmi comandi di V.A. ho visto le Scritture sopra la differenza, che pende trà il R. Silva, et il Pittor Cresti a causa del Contratto trà essi seguito, che questo gli faccesse due Quadri, uno della Strage de gl'Innocenti, l'altro di Agar, e per prezzo dei med.mi ricevesse doppie quaranta, cioè, lire seicento in tante robe consegnategli, e di più il Prete fosse obligato celebrare Messe mille per i Defonti d'esso Pittore; e dalle med.me si ricava, che niuno di loro ha adempito al Convenuto; non il Pittore, perche il Quadro de gl'Innocenti è passato alle mani di V.A., e l'altro non è fatto; non il Prete, perche le Messe non sono state celebrate, e le robe consegnate da lui al Pittore non ascendono che a lire dugento due, e soldi quindici, secondo le stimi dei Periti, che sono la terza parte d:e lire 600, o poco più.
Onde nello stato presente stimo vana la pretensione del Prete di conseguire le doppie sessanta depositate, come prezzo del Quadro primo, che dice, e pretende fosse suo, perche né questo si può dire esser' il Quadro convenuto, eccedendo di molto la forma pattuita, e nemeno le doble sessanta date dalla generosità di V.A. al Pittore, che le presentò in dono d.o Quadro si può fermare sieno il prezzo giusto del med.mo
È però, per terminare questa differenza senz'azzardare le Parti a nuovi disgusti, e contese, come succederebbe, quando s'obligasse il Pittore a fargli li due Quadri nelle forme pattuite, e il Prete a giustificare d'aver celebrate d.e Messe, che parerebbe il termine più giusto, e legale; Stimerci più proprio che delle d.e Dobble 60 depositate si pagassero al Prete le mercedi delle Messe celebrate a ragione di quello si pratica in Bologna, come anco le lire 202.13 per le robe date al Pittore, cosi stimate, come si è detto, e di più doppie dodici per tutto quello potesse esso Prete pretendere o per causa di d.e robe non stimate per il giusto prezzo, secondo il tempo del Contratto, o per mancarvene alcune, come anco per qualsisia altra causa di danno, o interesse, con restare in tal modo ambe le Parti libere da d.o Contratto, et il restante di d.e Doble 60 si consegni al Pittore, quale doverà restituire al Prete l'Orologio datogli per altro conto. Stà però a V.A. il comandar la sua volonta rimettendomi in tutto al suo superiore intendimento, e le faccio umiliss.mo inchino.

Doc. 4.
Letter from Niccola Caldari, Secretary to Grand Prince Ferdinand, to Count Vincenzo Ranuzzi Cospi
November 12, 1709, Florence

Ho letto al Serenissimo Principe nostro Signore li due primi Articoli della lettera umanissima, che trovomi da V.S. Ill.mo segnata nei 9 del corrente, e S.A.R.le dopo averla ascoltata con attenz.e se n'è fatta una risata, parendole che il Prete poco intende il fatto suo. Mi ha poi comandato di replicarle in questi termini: Ch'Ella senza far conto delle ciarle, e del

230

parlare improprio del Prete Silva, il quale a mio credere è un vapore, che non è valido ad oscurare la luce del Sole, gli faccia dire, quando più le paia, che tiene a sua dispoz.e Lire dugento due, e soldi tredici, più dodici dobble, et in oltre li Oriuolo; si se non manda a levar tutto ciò, vuole l'A.S.R.le, che dopo aspettato un tempo ragionevole V.S. Ill.ma dia il rimanente del denaro che tiene presso di sé allo Spagnuolo, e ritenga ciò ch'è del Prete per darglielo sempre ch'egli o venga, or mandi a repeterlo, e come meglio a lei stessa parrà. [Letter continues on personal affairs].

Doc. 5.
Notarized settlement of dispute between Don Carlo Silva and Crespi.
December 14, 1709, Bologna

Al nome di Dio Adi 14 Decembre 1709 in Bologna Ricevendo con somma stima le Parti infrascritte li Veneratissimi Cenni dell'A.R. del Ser.mo Ppe di Toscana che richiesto dalle medesime su le loro pendenze si è degnato farli sapere all Illmo Sig Co: Sen.re Ranuzzi Cospi il quale d'ordine dell'A.S.R. gl'ha participati alle Parti medesime, Perciò Il R. Sig.r Dott.re Carlo Giuseppe Silva riceve dal Sud.o Illmo Sig.re Co: Sen.re Ranuzzi Cospi Lire trecento ottanta due soldi tredici di quattrini e più una mostra di orologgio, e con ciò si dichiara intieramente contento, e sodisfatto dal Sig.re Giuseppe Crespi Pittore per tutto ciò che per qualunque contratto, e per qualunque dipendenza potesse pretendere et hav.re preteso dal medemo Sig.re Crespi fino a questo giorno annullando ogni scrittura d'obligazione che potesse essere passata, e sia passata fra essi e viceversa il Sig Giuseppe Crespi si dichiara contento e pienamente sodisfatto dal detto Sig Dott.re Silva di tutto quello ha havuto à fare seco sino al presente giorno, facendosi reciprocamente finale quietanza e assoluzione di ogni e qualsisia conto, et interesse di dare et hav.re et reciprocam.e dichiarano nulle et invalide ogni e qualunque scrittura si à favore dell'uno, che dell'altro tanto per vigore di messe promesse, che di regalli, che di prezzo di Quadri, che di Quadri promessi, e per tutt'altro, che possa mai esser passato fra loro sino al presente giorno; Per attestato di che facendosi tre coppie della presente scrittura una ne resterà appresso detto Illmo Sig.re Sen.e Co: Ranuzzi Cospi, e l'altro due appresso ciascheduna delle Parti sudette, che per l'osservanza delle cose predette obligano se stesse, loro eredi, e beni presenti, e futuri anco in forma della R. Camera Apostolica
[Signatures]
Carlo Giuseppe Silva affermo quanto di sopra
Io Giuseppe M.a Crespi afermo quanto e di sopra
Io Gio Batta Fabri Sono stato Testim.o à q sopra
Io Ang Cabrini fui Testimon à q di sop

Doc. 6.
Notarized receipt of monies by Crespi
November 14, 1709, Bologna

Adì 14. Xbre 1709 in Bologna
Io sottoscritto ò Ricevuto dall'Illmo S. Senat.re Co: Ferdinando Vincenzo Ranuzzi Cospi, lire Seicento Sette, e Soldi sette q.i, e questi delle novecento novanta, che nel Marzo 1708 il Ser.mo Pnpe di Toscana, passò in mano del Sud.o Sig.re per conto del Quadro dipinto da me per S.A.Ser.ma, in cui è la Strage delli Innocenti, e le altre lire 382.13 So che il med.mo Sig.re le à pagate al Rev.o S. dott.e D. Carlo Silva come per ordine di lettera di 19 ottobre 1709 Scritta dal S. Nicola Caldari, e per la

determinazione di S. A. per la differenza avuta frà il Sud.o Sacerdote Silva, e la mia Persona in fede dico — L 607.7 —
[Signatures]
Il Giuseppe M.a Crespi afermo quanto è di Sopra
Io Gio Batta Fabri Sono Stato Testimonio à quanto di sopra
Io Ang. Cabrini fui Testimonio à q.o di sopra

Appendix V
Paintings by Giuseppe Maria Crespi in the Caprara Collections in Vienna, 1701, and Bologna, 1726.

One of principal patrons of Giuseppe Maria Crespi at the outset of his career during the 1690s was the Imperial general, Marshal Enea Antonio Caprara. Both of Crespi's biographers, Giampietro Zanotti and Luigi Crespi, refer to many works commissioned by Marshal Caprara prior to his death in Vienna in 1701. Included in this group were paintings on pastoral themes — nymphs and putti in landscape settings — that seem to have presaged Crespi's subsequent involvement in light-hearted genre subjects. The discovery in the Bolognese archives of the 1701 and 1726 inventories of the Caprara collections has confirmed the subsequent descriptions by Zanotti, Luigi Crespi, and Oretti regarding the patronage of Marshal Enea Antonio Caprara.[1]
The paintings cited by these early commentators were already part of the Caprara collection in Vienna prior to 1701, which date provides a valuable *terminus ante quem* for our understanding of the artists's early chronology.

Part. 1. Extracts from the inventory compiled upon the death of the Marshal Conte Enea Antonio Caprara in Vienna, Austria, 1701.

Inventario dei beni stabili mobili ... e altro spettanti all'eredità della b.m. del fu Sig. Mares. Conte Enea Antonio Caprara, ritrovati in essere per tutto il giorno della di lui morte seguita in Vienna li 5. feb. della'anno 1701. Fatto da me Nicolò Caprara, nipote ed erede mediato d'esso Maresciallo... (Archivio di Stato, Bologna. Archivio Notarile, Alessandro Trombelli, 1700-1701. [folder apart, numbered separately, 64 pp.]).

foglio 32v.
Inventario de' beni stabili, Mobili ... esistenti in Vienna ... estratti dall'inventario fatto collà in Vienna ... rogato per il notario ser Nicolò Schmidt, di Vienna il primo marzo 1701 ...
foglio 33v.
Due quadri rapresentanti Diana con altre donne ignude ... che si dicono esser di mano del Spagnolo.
foglio 35.
Due quadri compagni dello Sposalitio e fest. di dacho [copyist error for *Bacho* (?)] di mano del Spagnolo.
foglio 36r.
Quattro pezzi di quadretti ... l'uno de' quali rappresenta la Carità, l'altro la Stragge degl'Innocenti,[2] il terzo la Lotta dell'Angelo e Giacobbe, il quarto l'omicidio d'Abel,[3] tutti di mano del Spagnolo

Part 2. Extracts from the inventory compiled on January 8, 1726, upon the death of Senator Nicolò Caprara in Bologna.

Inventario delle Pitture ritrovate nell'Eredità del Sig.r Sen.e Co: Nicolò Caprara stimate, e valutate dal Sig.r Cesare

Giuseppe Mazzoni Pittore... (Archivio di Stato, Bologna. Archivio Notarile, Angelo Michele Galeazzo Bonesi, no. 48 [unpaginated: the folio numbers indicated below are counted from the first page of the inventory of paintings, which occupies fourteen pages.]).

[foglio 5r.]
Due quadri compagni rappresentanti due baccanali con quantità di figure del S.r Crespi detto lo Spagnolo con Cornice dorata.

[foglio 5v.]
Due Ovati, uno con Carità, e l'altro la Stragge degl'Innocenti del Crespi con Cornice dorata
Due quadri, cioè Bagni di Diana con molte figure del Crespi, Spagnolo, con Cornici dorate
Un quadro grande con due figure in piedi, cioè Ritratto della Sig.ra Co:sa Maria Virginia Sacchetti Caprara,[4] e Damigella vicino ad un Fonte con Cagnolino à piedi dello Spagnolo con Cornice dorata
Due Ovati piccoli, in uno la Lotta di Giacobbe, e nell'altro il Fraticidio di Caino del sud.o Spagnolo con Cornice dorata

Part. 3. Published accounts of paintings by Crespi in the Caprara collection, Bologna

Zanotti, 1739, II, pp. 44-45.
The marshal [Enea] Caprara commissioned some small paintings from him, which turned out beautiful and marvelously graceful. They can be seen nowadays in the gallery of senator Caprara, where they were transported from Vienna after the death of the marshal. There is the massacre of the Innocents, the angel Raphael fighting with Jacob, Bacchus returned victorious from the Indies, and a bath of Diana with the Nymphs, and other stories and *poesie.* He also made the portrait of the contessa Virginia Sacchetti, who came at that time from Rome and was wed to senator Caprara, and this picture was likewise commissioned by the marshal, who wrote, pleasantly, that as a bonus, he wished to have depicted in the same painting the lady-in-waiting whom the countess had brought with her from Rome. *Lo Spagnuolo* duly portrayed both of the ladies so that the marshal was satisfied.

Crespi, 1769, pp. 208-209.
For the marshal Caprara he painted the massacre of the Innocents, Jacob's fight, the return of Bacchus from the Indies, and a bath of Diana with the Nymphs: all of which paintings, after his death, were transported from Vienna to the Caprara collection here, where one can also see the standing portrait of the countess Virgina Sacchetti, wife of senator Caprara, with her lady-in-waiting, whom she brought with her from Rome, and other superb little pictures [*quadretti*] painted by him.

Oretti, ca. 1769, MS. B 104, [b] 137/7.
Casa Caprara of the Senator, opposite the church of S. Salvatore:
Portrait of the Countess Virginia Sacchetti Caprara, with that of her lady-in-waiting/ life-sized figures.
Ibid., [b] 138/18-20, 23, 26.
Casa Caprara of the Senator, *ibidem:*
Bath of Diana/
Bacchus returning victorious from the Indies/
Caprici of women with puttini in the air/ quadretti
Four ovals including one in which the angel Raphael fights with Jacob/ small
The Massacre of the Innocent Children

Notes to Appendix V
1) The Caprara inventories, and others, will be published in their entirety and examined in detail in a forthcoming articles, "Notes on the patrons of G.M. Crespi and Bolognese Patronage during the early eighteenth century," by Tiziana Di Zio and the present writer.
2) Cf. Merriman cat. no. 34.
3) Cf. Merriman cat. no. 2.
4) Cf. Merriman cat. no. 185.

Abbate, F. "Generi artistici". *Enciclopedia Feltrinelli Fisher, Arte,* vol. I, part I, Milan, 1971, pp. 184-227.

Agnelli, J. *Galleria di Pitture dell'Emo, e Rmo Principe Tommaso Ruffo Vescovo.* Ferrara, 1734.

Albrizzi, G. *Memorie intorno alla vita di Giambattista Piazzetta.* Venice, 1760.

Algarotti, F. "Progetto per ridurre a compimento il Regio Museo di Dresda (...)" [1742]. *Opere,* Venice, 1792, vol. VIII, pp. 353-88.
Saggio sopra la Pittura, 1762, in *Opere del Conte Algarotti,* Cremona, vol. III, 1779.
An Essay on Painting. London, 1764 [1st Italian edition, 1756].

Alizeri, F. *Notizie dei Professori del Disegno in Liguria dalla fondazione dell'Accademia,* vol. I, Genoa, 1864, pp. 243-356.

Anelli, L. *Antonio Cifrondi a Brescia e il Ceruti giovane.* Brescia, 1982.

Antal, F. *Hogarth and His Place in European Art.* London, 1962.

Antoniazzi, E. "Nuove precisazioni sull'inventario della collezione del Maresciallo von Schulenburg." *Arte Veneta,* 1977, pp. 126-134.

Arcangeli, F. "Nature Morte di Giuseppe Maria Crespi." *Paragone,* 1962, pp. 20-32.

Arese, F. "Una quadreria milanese alla fine del Seicento." *Arte Lombarda,* 1967, pp. 127-142.

Arpaio, A. *La Parca Lachesi: pittura e sentimenti espressi in essa dal Penello del Nobile Signore Pietro de' Bellotti.* Venice, 1685.

L'Arte del Settecento Emiliano. La Pittura. L'Accademia Clementina. See Bologna, 1979.

Attwater, D. *The Penguin Dictionary of Saints.* New York, 1965.

Averoldo, G.A. *Le scelte pitture di Brescia additate al Forestiere.* Brescia, 1700.

Baetjer, K. *European Paintings in the Metropolitan Museum of Art.* New York, 1980.

Baglione, G. *Le vite de' pittori, scultori, architetti ed intagliatori, dal pontificato di Gregorio XIII dal 1572, fino a' tempi di Papa Urbano VIII nel 1642.* Rome, 1642.

Baldinucci, F. *Notizie de' professori del disegno da Cimabue in qua.* 5 vols., Florence, 1847. Barocchi, P., ed., with 2 vols. of Appendices, Florence, 1975.
Vocabolario toscano dell'Arte del Disegno. Florence, 1681.

Baldinucci, F.S. *Vite di Artisti dei Secoli XVII-XVIII, Prima Edizione Integrale del Codice Palatino 565.* Matteoli, A., ed., Rome, 1975.

Baroncelli, M.A. *Faustino Bocchi ed Enrico Albrici pittori di Bambocciate.* Brescia, 1965.

Baroncini, C. "Lorenzo Pasinelli." *Arte Antica e Moderna,* 1958, pp. 180-190.

Barrell, J. *The dark side of the landscape - The rural poor in English painting, 1730-1840.* 2nd ed., Cambridge, 1983.

Bartoli, F. *Notizia delle pitture, sculture ed architetture d'Italia.* Vol. I, Venice, 1776.

Battisti, E. *L'Antirinascimento.* Milan, 1962.

Baudi di Vesme, A. *L'arte negli Stati Sabaudi ai tempi di Carlo Emanuele I, di Vittorio Amedeo I e della Reggenza di Cristina di Francia.* Turin, 1932.
Schede Vesme, L'Arte in Piemonte dal XVII al XVIII. Vol. I, 1963.

Bean, J. "Drawings by Giuseppe Maria Crespi." *Master Drawings,* 1966, pp. 419-421.
17th Century Italian Drawings in the Metropolitan Museum of Art. New York, 1979.

Bellori, G.P. *Le vite de' pittori scultori ed architetti moderni.* Rome, 1672. Borea, E., ed., Turin, 1976.

Bertoldi, E. "Per il collezionismo milanese tra Seicento e Settecento: i D'Adda." *Arte Lombarda,* 1974, pp. 197-204.

Bettagno, A. *Caricature di Anton Maria Zanetti.* Vicenza, 1969.

Biagi, D., ed. *Marcello Oretti e il patrimonio artistico del contado bolognese (Bologna, Biblioteca Comunale, MS. B 110).* Bologna, 1981.

Bianconi, C. *Nuova guida di Milano per gli amanti delle Belle Arti e delle sacre e profane antichità milanesi.* Milan, 1787.

Blazicek, O. "Ancora del Todeschini-Cipper." *Arte in Europa, Saggi in onore di Edoardo Arslan,* Milano, 1966, vol. I, pp. 773-781.

Bloch, V. *Michael Sweerts.* The Hague, 1968.

Blunt, A. *Guide to Baroque Rome.* New York, 1982.

Borromeo, Card. F. *De Pictura Sacra.* Trans. and ed., C. Castiglione, Sora, 1932.

Borroni Salvadori, F. "Le esposizioni d'arte a Firenze 1674-1767." *Mitteilungen des Kunsthistorisches Instituts in Florenz,* vol. XVIII (1974), pp. 1-166.

Boschini, M. *La carta del navegar pitoresco.* Pallucchini, A., ed., Venice-Rome, 1966.

Boston. *Illustrated Handbook, Museum of Fine Arts Boston,* 1975.
Boston: Printmaking in the Age of Rembrandt. Ackley, Clifford S., ed., 1981.

Bottari, G. *Raccolta di lettere sulla pittura scultura ed architettura.* (7 vols.) Rome, 1754-73. Vol. II. (2nd ed. enlarged by S. Ticozzi, Milan, 1822-25.)

Briganti, G. *I Bamboccianti pittori della vita popolare nel Seicento.* Rome, 1950.

Briganti, G., Trezzani, L. and Laureati, L. *I Bamboccianti.* Rome, 1983.

Burke, J. *English Art, 1714-1800.* Oxford, 1976.

Calbi, E. and Scaglietti Kelescian, D., eds. *Marcello Oretti e il patrimonio artistico privato bolognese (Bologna, Biblioteca Comunale, MS. B 104).* Bologna, 1984.

Calvi, J.A. *Versi e prose sopra una serie di eccellenti pitture posseduta dal Signor Marchese Filippo Hercolani Principe del S.R.I.* Bologna, 1780.

Camporesi, P. *Il libro dei vagabondi.* Turin, 1973.
Il paese della fame. 2nd ed., Bologna, 1985.

Campori, G. *Lettere artistiche inedite.* Modena, 1866.
Raccolta di cataloghi ed inventarii inediti di quadri, statue, disegni, bronzi, dorerie, smalti, medaglie avori ecc. dal secolo XV al XIX. Modena, 1870.

Candeloro, G. *Storia dell'Italia moderna. Le Origini del Risorgimento 1700-1815.* Milan, 1978 (1st edition 1956),

vol. I.

Caracciolo, A. *L'albero dei Belloni. Una dinastia di mercanti del Settecento*. Bologna, 1982.

Carboni, G.B. *Le pitture e sculture di Brescia che sono esposte al pubblico con un'appendice di alcune private gallerie*. Brescia, 1760.
Notizie istoriche delli pittori, scultori ed architetti bresciani (Archiginnasio, MS. B 97/XIV). Boselli, Camillo, ed., Brescia, 1962.

Carli, E. *Il Museo di Pisa*. Pisa, 1974.

Castelnuovo, E. and Rosci, M., eds. *Cultura figurativa e architettonica negli Stati del Re di Sardegna 1773-1861*. Turin, 1980, vol. I.

Catalogo dei quadri disegni e dei libri che trattano dell'arte del disegno della galleria del fu Sig. Conte Algarotti in Venezia. [Selva, A., ed.], 1780.

Cera, A. *La pittura emiliana del '600*. Milan, 1982.

Chiarini, M. "La data esatta dell'Estasi di S. Margherita da Cortona di Giuseppe Maria Crespi." *Arte illustrata*, 1973, pp. 385-386.
"I quadri della collezione del principe Ferdinando di Toscana." *Paragone*, vol. 301 (1975), pp. 57-98; vol. 303 (1975), pp. 5-108; vol. 305 (1975), pp. 54-88.
"Tre quadri dei Gandolfi nelle collezioni fiorentine." *Paragone*, 1978, pp. 61-62.
"Sweerts." *Paragone*, 1979, p. 353.

Clark, T.H. "The Iconography of the Rhinoceros." *The Connoisseur*, Feb. 1974, pp. 113-122.

Corti, G. "La collezione Ughi in Firenze nel 1705." *Paragone*, vol. 367 (1980), pp. 69-79.

Crespi, L. *Felsina Pittrice Vite de' Pittori Bolognesi Tomo III che serve di supplemento all'opera del Malvasia*. Rome, 1769.
La Certosa di Bologna descritta nelle sue pitture... Bologna, 1772.
"Descrizione di molti quadri del Principe del Sacro Romano Impero Filippo Hercolani." (Bologna, Biblioteca Comunale, MS. B 384, part II), 1774.

Dacier, E. *La gravure de genre et de moeurs*. Paris and Brussels, 1925.

Dal Poggetto, P. *Antonio Cifrondi*. Bergamo, 1975.
"Antonio Cifrondi." *I pittori bergamaschi dal XIII al XIX secolo. Il Settecento*, part I. Bergamo, 1982.

Dal Pozzo, B. *Le vite de' pittori, degli scultori et architetti veronesi*. Verona, 1718.

D'Azeglio, R. *Notizie storiche e biografiche sopra alcune precipue opere oltramontane nel Museo Torinese*. Florence, 1862.

Dazzi, M. and Merkel, E. *Catalogo della Pinacoteca della Fondazione Scientifica Querini Stampalia*. Venice, 1979.

Delogu, G. *Pittori minori liguri lombardi piemontesi del Seicento e del Settecento*. Venice, 1931.

Descrizione italiana e francese di tutto ciò che si contiene nella Galleria del Signor Marchese Senatore Luigi Sampieri. Bologna, 1795.

Deusch, W.R., 1967: see Stuttgart 1967.

Deyon, P. "A propos du pauperisme au milieu du XVIIᵉ siècle. Peinture et charité chrétienne." *Annales-Economies-Sociétés-Civilisations*, vol. XXII (Jan.-Feb. 1967), pp. 137-158.

Di Giampaolo, M. "Un'Aggiunta a Giuseppe Maria Crespi." *Bollettino d'Arte*, vol. LXV, no. 5 (1980), pp. 87-90.

Dizionario biografico degli Italiani. Rome, 1960.

Dresden. *Die Staatliche Gemäldegalerie zu Dresden*. [Catalogue by H. Posse], 1929.

Durantini, M.F. *The Child in Seventeenth-Century Dutch Painting*. Ann Arbor, Michigan, 1983.

Egerton, J. *George Stubbs 1724-1806*. London, 1984.

Emiliani, A. *La Pinacoteca Nazionale di Bologna*. Bologna, 1967.
Le collezioni d'arte della Cassa di Risparmio in Bologna. I disegni dal Cinquecento al Neoclassicismo. Bologna, 1973, pp. 9-37.

Emiliani, A. and Varignana, F. *Le Collezioni d'Arte della Cassa di Risparmio in Bologna: I Dipinti*. Bologna, 1972.

Evangelisti, S. "Alcuni ritratti di Luigi Crespi." *Paragone*, vol. 379 (1981), pp. 36-52.

Ewald, G. "Appunti sulla Galleria Gerini e sugli affreschi di Anton Domenico Gabbiani." *Kunst des Barock in der Toskana*, Munich, 1976.
See Stuttgart 1977-78.

Faccini, L. "Affitti in denaro e salari in natura. Le contraddizioni apparenti dell'agricoltura lombarda (secoli XVII-XIX)." *Storia d'Italia. Annali*, vol. VI, Turin, 1983, pp. 651-670.

Fantelli, P.L. "Pittura minore padovana del Seicento: Matteo de' Pitocchi," *Atti dell'Istituto Veneto di Scienze, Lettere ed Arti*, 1978/79, pp. 159-164.

Federici, D.M. *Memorie trevigiane sulle opere di disegno dal Mille e cento al Mille e ottocento per servire alla storia delle belle arti d'Italia*. Venice, 1803.

Fiocco, G. *Pitture del Settecento Italiano in Portogallo*. Rome, 1948.

Fiori, G. "Il soggiorno piacentino di Giacomo Ceruti (1744-46)." *Arte lombarda*, 1974, pp. 208-212.

Florence. *Gli Uffizi: Catalogo Generale*. 1980.

Frabetti, A. "Materiali per una ricerca." *Il magnifico apparato. Pubbliche funzioni, feste e giuochi bolognesi nel Settecento*, Bologna, 1982, pp. 143-163.

Franchini Guelfi, F. *Alessandro Magnasco*. Genoa, 1977.

Frati, L. *Opere della bibliografia bolognese*. Bologna, 1888/89.
"Quadri Dipinti per il Marchese D'Ormea e per Carlo Emanuele III." *Bollettino d'Arte*, vol. X (1916), pp. 279-283.

Friedländer, M. *On Art and Connoisseurship*. 2nd ed., London, 1943 (1st ed. 1942).

Gaeta Bertelà, G. and Ferrara, S. *Incisori bolognesi ed emiliani del secolo XVIII*. Bologna, 1974.

Geremek, B. "Il pauperismo nell'età preindustriale (secoli XIV-XVIII)." *Storia d'Italia Einaudi*, 1st ed., vol. V, Turin, 1973, pp. 666-698.

Gilbert, C. "On subject and not subject in Renaissance pictures." *The Art Bulletin*, 1952, pp. 202-216.

Goldberg, E.L. *Patterns in Late Medici Art Patronage*. Princeton, 1983.

Gregori, M. "Per il periodo giovanile di Giovan Domenico Ferretti." *Kunst des Barock in der Toskana*, Munich, 1976.

Giacomo Ceruti. Bergamo, 1982.

Grove (Sadie, S., ed.). *The new Grove Dictionary of Music and Musicians*. Vol. IV, London, 1980.

Guarienti, P., ed. *Abecedario pittorico... P.A. Orlandi*. Venice, 1753.

Guerrini, P. "La galleria d'arte del patrizio bresciano Paolo Brognoli. Note e catalogo." *Commentari dell'ateneo di scienze, lettere ed arti di Brescia*, 1962, pp. 195-256.

Haskell, F. "Taste and reputation: A study of change in Italian art of the 18th century." *Art and Ideas in Eighteenth-Century Italy. Lectures given at the Italian Institute 1957-1958*, Rome, 1960.
"A Note on Artistic Contacts between Florence and Venice in the 18th Century." *Bollettino dei Musei Civici Veneziani*, vol. 3/4 (1960), pp. 32-37.
Patrons and Painters. London, 1963. (2nd ed., New Haven, 1980).
"The Role of Patrons: Baroque Style Changes." *Baroque Art: The Jesuit Contribution*. Wittkower, R. and Jaffe, I., eds., New York, 1972, pp. 51-62.

Haskell, F. and Penny, N. *Taste and the Antique*. New Haven, 1981.

Hauser, A. *The Social History of Art*. New York, 1951.

Heinz, G. "Die Italienischen Maler im Dienste des Prinzen Eugen." *Mitteilungen der Österreichischen Galerie*, 1963, pp. 115-141.
"Zur Dekoration des Schlafzimmers des Prinzen Eugen in seinem Wiener Stadtpalast." *Mitteilungen der Österreichischen Galerie*, vol. 11, no. 5 (1967), pp. 69-79.

Johnston, C., 1982: see Ottawa, 1982.

Jones, L. *The Paintings of Giovanni Battista Piazzetta*. Doctoral Dissertation, New York University, June, 1981.

Kettering, A.M. *The Dutch Arcadia: Pastoral Art and its Audience in the Golden Age*. Totowa, New Jersey, 1983.

Kurz, O. *Bolognese Drawings at Windsor Castle of the XVII and XVIII Centuries*. London, 1955.

Langedijk, K. *The Portraits of the Medici 15th-18th Centuries*. 1981 (I) and 1983 (II).

Lankheit, K. *Florentinische Barockplastik*. Munich, 1962.
"Eine Serie von 'Uomini Famosi' des Florentinischen Barock." *Pantheon*, vol. XXIX (1971), pp. 22-39.

Lanzi, L. *Storia pittorica dell'Italia...* Bassano, 1st ed. 1792, 3rd ed. 1809; Capucci, M., ed., Florence, 1970-1974.

Lechi, F. *I quadri della collezione Lechi in Brescia, Storia e documenti*. Florence, 1968.

Levey, M. *The Eighteenth-Century Italian Schools, National Gallery of Art*. London, 1956.
"A Note on Marshal Schulenberg's Collection." *Arte Veneta*, 1958, p. 221.
Painting in Eighteenth Century Venice. London, 1959. Rev. ed., Ithaca, 1980.
The Later Italian Pictures in the Collection of Her Majesty The Queen. London, 1964.
The Seventeenth and Eighteenth Century Italian Schools. National Gallery Catalogues, London, 1971.

Levi, C.A. *Le collezioni d'arte e d'antichità dal secolo XIV ai nostri giorni*. Venice, 1900.

Liebmann, M. "I pittori della realtà in Italia nei secoli XVII-XVIII." *Acta Historiae Artium*, 1969, pp. 257-279.

Giuseppe Maria Crespi. Dresden, 1976.

Locatelli Milesi, A. "Le collezioni artistiche private in Bergamo nei secoli XVI-XIX." *Bergomum*, 1928, pp. 29-43.

Longhi, A. *Compendio delle vite de' Pittori veneziani istorici più renomati del presente secolo con suoi ritratti*. Venice, 1762.

Longhi, R. "Monsù Bernardo." *La critica d'arte*, 1938, pp. 121-130.
"Ultimi Studi sul Caravaggio e la sua cerchia." *Proporzioni*, vol. I (1943), pp. 5-63.
ed. *I pittori della realtà in Lombardia*. Milan, 1953.

Magagnato, 1978: see Verona, 1978.

Magagnato, L. and Passamani, B. *Il Museo Civico di Bassano del Grappa*. Venice, 1978.

Mahon, D. *Studies in Seicento Art and Theory*. London, 1947.

Mâle, É. *L'art religieux de la fin du XVIe siècle, et du XVIIIe siècle*. Paris, 1951.

Malvasia, C.C. *Felsina pittrice, vite de' pittori bolognesi*. Bologna, 1678 (ed. Bologna, 1841).
The Life of Guido Reni. [Translated by Catherine and Robert Enggass], University Park, Pennsylvania, 1980.

Manca, M.E. *Per la storia delle istituzioni artistiche di Bergamo: la pinacoteca dell'Accademia Carrara (1796-1860)*. Unpublished dissertation, University of Milan, Italy, session 1983/84.

Marabottini, A. *Le arti di Bologna di Annibale Carracci*. Rome, 1979.

Marangoni, M. "Giuseppe Maria Crespi detto Lo Spagnolo." *Dedalo*, 1920-21, pp. 575-591, 647-668.

Marconi Moschini, A. *Gallerie dell'Accademia di Venezia*. vol. III, 1970.

Marini, O. "Qualcosa per la vicenda del 'Pitocchetto.' I. I committenti bresciani del Ceruti; a) il Ceruti nella Galleria Barbisoni." *Paragone*, vol. 199 (1966), pp. 34-42.
"Qualcosa per la vicenda del 'Pitocchetto.' II. I committenti bresciani del Ceruti: Il Ceruti nella Galleria Avogadro." *Paragone*, vol. 215 (1968), pp. 40-58.

Mariuz, A. *L'opera completa del Piazzetta*. Milan, 1982.

Martini, E. *La Pittura del Settecento Veneziano*. Udine, 1981.

Matteoli, A. "Le Vite di Artisti dei Secoli XVII-XVIII di Giovanni Camillo Sagrestani." *Commentari*, 1971, pp. 187-240.

Matteucci, A. *Giuseppe Maria Crespi, 'I maestri del colore'*. Milan, 1965.

Meijer, B.W. "Esempi del comico figurativo nel Rinascimento lombardo." *Arte Lombarda*, vol. XVI (1971), pp. 259-266.
"Cremona e i Paesi Bassi." *I Campi e la cultura artistica cremonese del Cinquecento*, Milan, 1985.

Melzi d'Eril, G. "Una collezione milanese sotto il Regno di Maria Teresa: la galleria Firmian." *Bergomum*, 1971, pp. 55-86.
La galleria Melzi e il collezionismo milanese del tardo Settecento. Milan, 1973.

Memmo, A. *Elementi d'Architettura lodoliana, edizione corretta ed accresciuta all'autore nobile Andrea Memmo*. Milan, 1834.

Merriman, M.P. "Two Late Works by Giuseppe Maria Crespi." *The Burlington Magazine*, 1968, pp. 120-125.
"Giuseppe Maria Crespi's *Jupiter Among the Corybantes.*" *The Burlington Magazine*, 1976, pp. 464-473.
Giuseppe Maria Crespi. Milan, 1980.
"Additions to Giuseppe Maria Crespi's Oeuvre." *Paragone*, 1985, pp. 253-257.

Miller, D.C. "Per Giuseppe Gambarini." *Arte antica e moderna*, 1958, pp. 390-393.
"An unpublished letter by Giuseppe Maria Crespi." *The Burlington Magazine*, 1960, pp. 530-531.
"Virtù et arti esercitate in Bologna, by Giovanni Maria Tamburrini." *Culta Bononia*, vol. 1 (1972), pp. 3-11.

Molinari Pradelli, A. *Gli antichi mestieri di Bologna.* Rome, 1984.

Molmenti, P. "Di Pietro Longhi e di alcuni suoi quadri." *Emporium*, January, 1908, pp. 31-38.

Morassi, A. "Circa Alcune Opere Sconosciute di Giuseppe Zocchi." *Bollettino dei Musei Civici Veneziani*, vol. 1 (1962), pp. 3-10.
"Giacomo Ceruti detto il 'Pitocchetto' pittore verista." *Pantheon*, vol. XXV (1967), pp. 348-367.

Moschini, G.A. *Della letteratura veneziana del secolo XVIII.* Venice, 1806, III.

Moschini, V. *Pietro Longhi.* Milan, 1956.

Natale, M. *Peintures italiennes du XIVᵉ au XVIIIᵉ siècle: musée d'art et d'histoire Genève.* Geneva, 1979.

Novelli, M. "Nuovi Accertamenti sul Soggiorno Bolognese di Sebastiano Ricci e sui suoi Rapporti col Peruzzini." *Arte Veneta*, 1978, pp. 346-351.

Oretti, M. "Le pitture che si ammirano nelli palaggi e case de' nobili della città di Bologna." ca. 1769 (Bologna, Biblioteca Comunale, MS. B 104), Calbi, E. and Scaglietti Kelescian, D., eds., Bologna, 1984.
"Descrizione delle pitture che sono esposte nelle strade di Bologna in occasione delli Apparati fatti per le processioni generali del Santissimo Sacramento che si fanno ogni dieci anni in Bologna" (Bologna, Biblioteca Comunale, MS. B 105).
"Descrizione delle Pitture che ornano le case de Cittadini della città di Bologna" (Bologna, Biblioteca Comunale, MS. B 109).
"Le pitture nelli palazzi e case di villa nel territorio bolognese" (Bologna, Biblioteca Comunale, MS. B 110).

Orlandi/Guarienti 1753: see Guarienti, P., ed. *Abecedario pittorico... P.A. Orlandi*, Venice, 1753.

Osborne, H. ed. *The Oxford Companion to Art.* Oxford, 1971.

Paccanelli, R. *La formazione della galleria di Giacomo Carrara fino al catalogo del 1796.* Unpublished dissertation, University of Milan, Italy, session 1976/77.

Pallucchini, R. "Opere inedite di Giambattista Piazzetta." *L'Arte*, vol. XXXIX (1936), pp. 187-205.
I capolavori dei Musei veneti. Venice, 1946.
Piazzetta. Milan, 1956.
La pittura veneziana del Seicento. Milan, 1981.

Panni, A.M. *Distinto rapporto delle dipinture che trovansi nelle chiese della città e sobborghi di Cremona.* Cremona, 1762.

Pascoli, L. *Vite de' pittori, scultori e d'architetti moderni.* Rome, 1730-36.

Passamani, B. "La pittura nei secoli XVII and XVIII." *Storia di Brescia*, vol. III, Brescia, 1961.
"Per una storia della pittura e del gusto a Brescia nel Settecento." *Brescia pittorica 1700-1760: l'immagine del sacro*, Brescia, 1981, pp. 7-25.

Passeri, G.B. *Vite dei pittori, scultori ed architetti che hanno lavorato in Roma morti dal 1641 al 1673.* Hess, J., ed., Leipzig and Vienna, 1934.

Paulson, R. *Emblem and Expression.* Cambridge, 1975.

Per una storia del collezionismo Sabaudo. Pittura fiamminga e olandese in Galleria Sabauda. Il principe Eugenio di Savoia-Soissons. Uomo d'arme e collezionista. Turin, 1982.

Perini, G. "Luigi Crespi inedito." *Il Carrobbio*, 1985, pp. 235-261.
Luigi Crespi storiografo, mercante ed artista attraverso l'espistolario. Unpublished Ph. D. dissertation, Scuola Normale Superiore di Pisa, Italy, session 1981/82.
Marcello Oretti e il collezionismo artistico a Bologna nella seconda metà del Settecento. Unpublished dissertation, University of Pisa, Italy, session 1978/79.
Introduction to M. Oretti, *Raccolta di alcune marche e sottoscrizioni practicate da pittori e scultori.* Florence, 1983.
"Nuove fonti per la Kunstliteratur settecentesca in Italia: i giornali letterari." *Annali della scuola Normale Superiore di Pisa*, 1984, pp. 797-827.
"La storiografia artistica a Bologna e il collezionismo privato." *Annali della Scuola Normale Superiore di Pisa*, 1981, pp. 181-243.

Petrucci, F. "La ragione trionfante alla corte medicea: il Gran Principe Ferdinando e Giuseppe Maria Crespi." *Artibus et Historie*, vol. 5 (1982), pp. 109-123.

Pigler, A. *Barock-Themen.* Budapest, 1974.

Pignatti, T. *Il Museo Correr di Venezia. Dipinti del XVII e XVIII secolo.* Venice, 1960.
Pietro Longhi. Paintings and Drawings. London, 1969.
L'Opera completa di Pietro Longhi. Milan, 1974.
Pietro Longhi dal disegno alla pittura. Venice, 1975.

Pillsbury E.P. and Jordan W.B. "Recent painting acquisitions. II: Kimbell Art Museum." *The Burlington Magazine*, vol. CXXVII (1985), pp. 408-418.

"Pinacoteche private in Bergamo in principio del secolo XVIII." *Bollettino della Biblioteca civica Angelo Mai di Bergamo*, 1917, pp. 32-33.

Pinetti, A. *Il Conte Giacomo Carrara e la sua galleria secondo il catalogo del 1796.* Bergamo, 1922.

Pio, N. *Le vite di pittori scultori et architetti.* Enggass, C. and Enggass, R., eds., Vatican City, 1977.

Pirovano, C. *La pittura in Lombardia.* Milan, 1973.

Polazzo, M. *Antonio Balestra.* Verona, 1978.

Pomian, K. "Antiquari e collezionisti." *Storia della cultura veneta. Il Seicento*, vol. 4/1, Vicenza, 1983, pp. 493-547.

Posner, D. *Antoine Watteau.* Ithaca, New York, 1984.

Posse, H. "Die Briefe des Graf Francesco Algarotti an den Sächsischen Hof und seine Bilderkäufe für die Dresdner Gemäldegalerie." *Jahrbuch der Preuszischen Kunstsammlungen*, vol. LII, 1931, Appendix 1-73.

Prohaska, W., forthcoming 1986: see Vienna, 1986.

Pullan, B. and Woolf, S.J. "Plebi urbane e plebi rurali: da

poveri a proletari." *Storia d'Italia. Annali*, vol. I, Turin, 1978, pp. 981-1078.

Puncuh, D. "Collezionismo e commercio dei quadri nella Genova sei-settecentesca." *Rassegna degli Archivi di Stato*, 1984, pp. 164-218.

Raimondi, E. *Anatomie secentesche*. Pisa, 1966.

Ratti, C.G. *Istruzione di quanto può vedersi di più bello in Genova in pittura, scultura ed architettura*. 2nd ed., Genoa, 1780 [1st ed., 1766].
Delle Vite de' pittori, scultori ed architetti genovesi e dei forestieri che in Genova hanno operato dall'anno 1594 a tutto il 1765. 2nd ed., Genoa, 1797 [1st ed. 1768-69].

Ravà, A. *Pietro Longhi*. Bergamo, 1909.

Ravelli, L. *Immagini di Antonio Cifrondi*. Bergamo, 1983.

Riccòmini, E. "Giovanni Antonio Burrini." *Arte antica e moderna*. 1959, pp. 219-227.

Ridolfi, C. *Le meraviglie dell'arte*, 2nd ed. by Freiherr von Hadeln, D., Rome, 1965.

Roli, R. "Per Antonio Gionima." *Arte antica e moderna*. 1960, pp. 300-307.
Pittura bolognese 1650-1800: Dal Cignani al Gandolfi. Bologna, 1977.

Romano, G. *Studi sul paesaggio*. Turin, 1978.

Rosenberg, P. "La femme à la puce de G.M. Crespi." *La revue du Louvre*, 1971, pp. 13-20.
"L'Arte del Settecento Emiliano: Exhibitions at Bologna, Parma and Faenza." *The Burlington Magazine*, vol. CXXI (1979), pp. 822-826.

Roversi, G. *Commercio, città e costume. Attività mercantile di tre secoli fa nelle stampe di Giovanni Maria Tamburini*. Bologna, 1984.

Royalton-Kisch, M. *Concise Catalogue of Foreign Paintings: Manchester City Art Gallery*. 1980.

Rudolph, S. "Florentine Patronage..." *Arte Illustrata*, 1972, pp. 287-296.

Ruffo, V. "Galleria Ruffo nel secolo XVII in Messina." *Bollettino d'arte*, 1916, pp. 21-320.

Ruggeri, U. "Piazzetta e la sua bottega." *Critica d'Arte*, vol. XLI (1976), pp. 31-46.
Francesco Capella, Dipinti e disegni. Bergamo, 1977.

Savini Branca, S. *Il collezionismo veneziano nel Seicento*, Padova, 1964.

Schleier, E. *Katalog der ausgestellten Gemälde des 13.-18. Jahrhunderts. Gemäldegalerie SMPK Berlin* [Italian paintings entries], Berlin, 1975.

Schlosser Magnino, J. *La letteratura artistica*. Vienna, 1924; reprinted Florence, 1977.

Sereni, E. "Agricoltura e mondo rurale." *Storia d'Italia Einaudi*, vol. I, Turin, 1972, pp. 135-252.

Serie degli uomini i più illustri in pittura, scultura ed architettura... Florence, 1775.

Sgarbi, V. *Pietro Longhi. I dipinti di Palazzo Leoni Montanari*. Milan, 1982.

Shapley, F.R. *Paintings from the Samuel H. Kress Collection: Italian Schools XVI-XVIII Century*. London, 1973.
Catalogue of the Italian Paintings. National Gallery of Art, Washington, D.C., 1979.

Sirén, O. *Nicodemus Tessin d. y: s studieresor i Danmark, Tyskland, Holland, Frankrike och Italien*. Stockholm, 1914.

Slive, S. *Rembrandt and his Critics 1630-1730*. The Hague, 1953.

Solner, P.L. "Pietro Longhi and Carlo Goldoni: Relations between painting and theatre." *Zeitschrift für Kunstgeschichte*, vol. 45 (1982), pp. 256-273.

Soprani, R. and Ratti, C.G. *Vite de' pittori, scultori ed architetti genovesi*. Genoa, 1768 (I), 1769 (II).

Spear, R.E. *Caravaggio and His Followers*. Rev. ed. New York, 1975 (1st ed. 1971).

Spike, J.T., ed. *The Illustrated Bartsch (XIX)*, 43. New York, 1982.

Spinosa, N. "La pittura con scene di genere." *Storia dell'arte italiana*, vol. 11, Turin, 1982, pp. 33-80.

Stechow, W. and Comer, C. "The history of the term 'genre'." *The Allen Memorial Museum Art Bulletin*, 1975/76, pp. 89-94.

Strocchi, M.L. "Il gabinetto d'opere in piccolo del gran Principe Ferdinando a Poggio a Cajano." *Paragone*, vol. XXVI, no. 309 (1975), pp. 116-126; vol. XXVIII, no. 311 (1976), pp. 84-116.

Stuttgart. *Katalog der Staatsgalerie*. 1962.

Sutton, P.C. ed., 1984: see Philadelphia, 1984.

Tassi, F.M. *Vite de' pittori, scultori ed architetti bergamaschi*. Bergamo, 1793.

Taylor, F.H. *Artisti, principi e mercanti (The Taste of Angels)*. Turin, 1954 (1st ed. 1948).

Testori, G., 1966: see Milan, 1966.

Testori, G. and Mallé, L. *Giacomo Ceruti e la ritrattistica del suo tempo nell'Italia settentrionale*. Turin, 1967.

Thöne, F. "Giuseppe Gambarini, Zwei bislang unbekannte Werke des Meisters." *Pantheon*, 1935.

Thuillier, J., 1978: see Paris, 1978.

Ticozzi, S. *Dizionario degli architetti, scultori, pittori*. Milan, 1830.

Tognoli, L. *G.F. Cipper il Todeschini e la pittura di genere*. Bergamo, 1976.

Trattato dei bianti ovver pitocchi e vagabondi, col modo di imparar la lingua furbesca. s.l., 1828.

Turin. *Conoscere la Galleria Sabauda: Documenti sulla storia delle sue collezioni*. Soprintendenza per i Beni Artistici e Storici del Piemonte, Strumenti per la didattica e la ricerca no. 2, 1982.

Varignana, F. *Le collezioni d'arte della Cassa di Risparmio in Bologna. Le incisioni. Giuseppe Maria Mitelli*. Bologna, 1978.

Vesme, A. "Sull'acquisto fatto da Carlo Emanuele III re di Sardegna della quadreria del Principe Eugenio di Savoia." *Miscellanea di storia italiana*, 1886, pp. 163-253.

Vivian, F. *Il Console Smith mercante e collezionista*. Vicenza, 1971.

Volpe, C. "Antefatti bolognesi ed inizi di Giuseppe Maria Crespi." *Paragone*, 1957, pp. 25-37.
"Parlando del Ceruti." *Paragone*, vol. 161 (1963), pp. 61-63.

Washburn, G.B. *Pictures of everyday life. Genre painting in*

Europe, 1500-1900. Pittsburgh, 1954.
"Genere e profane figurazioni." *Enciclopedia Universale dell'Arte,* vol. V, Novara, 1981, col. 652-670.

Waterhouse, E. *Italian Baroque Painting.* London, 1962.

White, Maxwell, D. and Sewter, A.C. "Piazzetta's so-called 'Group on the Sea Shore'." *The Connoisseur,* vol. 143 (1959), pp. 96-100.
"Piazzetta's so-called 'Indovina', an Interpretation." *The Art Quarterly,* vol. XXIII (1960), pp. 124-138.
"Piazzetta's Pastorale. An Essay in Interpretation." *The Art Quarterly,* vol. XXIV (1961), pp. 15-32.
I disegni di G.B. Piazzetta nella Biblioteca Reale di Torino. Rome, 1969.

Wilton-Ely, J. *The mind and art of Giovan Battista Piranesi.* London, 1978.

Wind, B. "Pitture ridicole: some comic Cinquecento genre paintings." *Storia dell'arte,* no. 20 (1974), pp. 25-35.
"Annibale Carracci's 'Scherzo': The Christ Church Butcher Shop." *Art Bulletin,* vol. LVII (1976), pp. 93-96.
"Vincenzo Campi and Hans Fugger: A Peep at late Cinquecento Bawdy Humour." *Arte Lombarda,* 1977, pp. 108-14.

Wishnevsky, R. "Giacomo Francesco Cipper detto il Todeschini." *Dizionario Biografico degli Italiani,* vol. 25, pp. 725-730.

Wittkower, R. *Art and Architecture in Italy 1660 to 1750.* 3rd rev. ed., Baltimore, 1973 (1st ed. 1958).
Gianlorenzo Bernini: The Sculptor of the Roman Baroque. 3rd ed., Ithaca, 1981 (1st ed. 1955).

Wright, E. *Some Observations made in Travelling through France, Italy & c. in the years 1720, 1721, and 1722.* London, 1730.

Zanelli, I. *Vita del gran pittore Carlo Cignani...* Bologna, 1722.

Zanetti, A.M. *Descrizione di tutte le pubbliche pitture della città di Venezia.* Venice, 1733.

Zanotti, G.P. *Storia dell'Accademia Clementina di Bologna.* Bologna, 2 vols., 1739.

Zeri, F. "Walters Art Gallery, Baltimore." *Apollo,* vol. LXXXIV (1966), pp. 442-452.
"La percezione visiva dell'Italia e degli Italiani nella storia della pittura." *Storia d'Italia Einaudi. Atlante,* vol. VI, Turin, 1976.
Italian Paintings in the Walters Art Gallery. Baltimore, 1976.

Zompini, G. *Le arti che vanno per via nella città di Venezia,* Venice, 1785 (and: Milan, 1980).

EXHIBITIONS

Baltimore
Baltimore Museum of Art. *Three Baroque Masters: Strozzi, Crespi, Piazzetta.* 1944.

Bassano del Grappa
Palazzo Sturm. *Marco Ricci.* Text by G.M. Pilo. 1963.

Bologna
Palazzo Comunale. Salone del Podestà. *Mostra celebrativa di Giuseppe Maria Crespi.* Preface by Roberto Longhi; text by F. Arcangeli and C. Gnudi. 1948.
Palazzo dell'Archiginnasio. *Mostra dei Carracci.* 1956 (3rd ed. 1958).
Palazzo dell'Archiginnasio. *Maestri della Pittura del Seicento Emiliano.* 1959.
Palazzo dell'Archiginnasio. *Il Guercino dipinti.* Text by D. Mahon. 1968.
Palazzo dell'Archiginnasio. *Natura ed espressione nell'arte bolognese ed emiliana.* Text by F. Arcangeli. 1970.
Palazzo dell'Archiginnasio. *Nuove acquisizioni per i musei dello stato 1966-1971.* 1971.
Pinacoteca Nazionale. *Nuove acquisizioni per i musei dello stato, 1966-1971.* 1971.
Soprintendenza alle Gallerie. *Pittura italiana del Settecento.* Text by E. Riccòmini. Traveled to Leningrad, Moscow and Warsaw. 1974.
Palazzi del Podestà e di Re Enzo. *L'arte del Settecento Emiliano: La pittura. L'Accademia Clementina.* 1979.
Palazzo Pepoli Campogrande. *Disegni di Artisti Bolognesi dal Seicento all'Ottocento della Collezione Schloss Fachsenfeld e della Graphische Sammlung Staatsgalerie Stuttgart.* Text by C. Thiem. 1983.

Brescia
Civici musei di storia e arte. *Brescia pittorica 1700-1760: l'immagine del sacro.* 1981.

Cambridge
Fitzwilliam Museum. *The Achievement of a Connoisseur: Philip Pouncey.* Text by J. Stock and D. Scrase. 1985.

Chicago
Art Institute of Chicago. *Painting in Italy in the Eighteenth Century: Rococo to Romanticism.* 1970.

Cremona
Museo Civico. *I Campi e la Cultura artistica cremonese del Cinquecento.* 1985.

Detroit
Detroit Institute of Arts. *Art in Italy, 1600-1700.* 1965.

Detroit/Florence
Detroit Institute of Arts. *The Twilight of the Medici: Late Baroque Art in Florence, 1670-1743.* 1974.

Florence
Palazzo Pitti. *Artisti alla corte granducale.* Text by M. Chiarini. 1969.
Palazzo Pitti. *Tiziano nelle Gallerie fiorentine.* 1978-79.
Palazzo Pitti. *Al servizio del Granduca.* Text by S. Meloni Trkulja. 1980.

Gorizia
Palazzo Attems. *Da Carlevarijs ai Tiepolo. Incisori veneti e friulani del settecento.* 1983. Also traveled to Venice, Museo Correr.

London
Wildenstein and Co. *Artists in 17th-Century Rome.* Text by D. Mahon and D. Sutton. 1955.

Royal Academy of Arts. *Italian Art and Britain*. 1960.
Thomas Agnew & Sons. *Venetian Eighteenth-Century Painting*. 1985.

Milan

Finarte. *Giacomo Ceruti, mostra di trentadue opere inedite*. Text by G. Testori. 1966.
Casiello Sforzesco. *Giambattista Piazzetta e L'Accademia: Disegni*. Text by M. Precerutti Garberi. 1971.

New York

Finch College Museum of Art. *Venetiam Painting of the Eighteenth Century*. Text by R.L. Manning. 1961.
Finch College Museum of Art. *Bolognese Baroque Painters*. Text by R.L. Manning. 1962.
Knoedler & Co. *Masters of the Loaded Brush*. 1967.
The Metropolitan Museum of Art. *Drawings from New York Collections III: The Eighteenth Century in Italy*. Text by J. Bean and F. Stampfle. 1971.
National Academy of Design and Old Masters Exhibition Society of New York. *Italian Still Life Paintings from Three Centuries*. Text by J.T. Spike. 1983.

Norfolk

Norfolk Museum of Arts and Sciences. *Italian Renaissance and Baroque Paintings from the Collection of Walter P. Chrysler, Jr...* Text by R.L. Manning. 1967-68.

Ottawa. National Gallery of Canada. *Bolognese Drawings in North American Collections 1500-1800*. Text by C. Johnston. 1982.

Paris

Grand Palais. *Les frères Le Nain*. Text by J. Thuillier. 1978.
Musée du Petit Palais. *Le Portrait en Italie au Siècle de Tiepolo*. Text by M. Chiarini. 1982.

Philadelphia

Museum of Art. *Masters of Seventeenth-Century Dutch Genre Painting*. Ed. by P. Sutton. 1984. Also traveled to Berlin and London.

Princeton

Art Museum of Princeton University. *Italian Baroque Paintings from New York Private Collections*. Text by J.T. Spike. 1980.

Rouen

Musée des Beaux-Arts. *Chefs d'oeuvres oubliés*. 1954.

Stuttgart

Staatsgalerie. *Das Jahrhundert Tiepolos, Italienische Gemälde des 18. Jahrhunderts aus dem Besitz der Staatsgalerie Stuttgart*. Text by G. Ewald. 1977-78.
Staatsgalerie. *Unbekannte Handzeichnungen Alter Meister, Sammlung Freiherr von Koenig-Fachsenfeld*. Text by W.R. Deusch, G. Ewald, H. Geissler, G. Thiem, C. Thiem. 1967.

Toronto

Art Gallery of Ontario. *The Arts of Italy in Toronto Collections*. 1981.

Venice

Comune di Venezia, Soprintendenza ai Beni Artistici e Storici di Venezia, Civici Musei. *Giambattista Piazzetta: Il suo tempo, la sua scuola*. 1983.
Fondazione Giorgio Cini. S. Giorgio Maggiore. *G.B. Piazzetta, Disegni-Incisioni-Libri-Manoscritti*. 1983.
Museo Correr. *Da Carlevarijs ai Tiepolo. Incisori veneti e friulani del Settecento*. Text by A. Delneri. 1983.

Verona

Museo di Castelvecchio. *La Pittura a Verona tra sei e sette-cento*. Text by L. Magagnato. 1978.

Vienna

Schlosshof-Niederweiden. *Prinz Eugen und das Barock Österreiches*. 1986.

Washington, D.C.

International Exhibitions Foundation. *Old Master Paintings from the Collection of Baron Thyssen-Bornemisza*. Text by A. Rosenbaum. 1979-81.
National Gallery of Art. *Piazzetta: A Tercentenary Exhibition of Drawings, Prints and Books*. Text by G. Knox. 1983.

Photograph credits:

Archivi Alinari, Florence Cat. nos. 21.1, 21.2, 21.3; figs. 16,65.
Archivio Fotografico Direzione Civici Musei, Venice Cat. no. 40.1; fig. 55.
Archivio Fotografico Gallerie Musei Vaticani, Vatican City Cat. no. 28.1.
The Art Institute of Chicago, Chicago Cat. nos. 1, 23.1; fig. 28.
'Arte Fotografica', Rome Cat. no. 14.6; figs. 8, 33, 44a,b.
Pamela Askew, Millbrook, New York Cat. no. 16.
Birmingham Museum and Art Gallery, Birmingham Cat. no. 3.
Michael Bodycombe, Fort Worth Cat. nos. 10, 11.
Osvaldo Böhm, Venice Cat. nos. 40, 42.1; figs. 26, 48, 50, 56.
British Museum, London Cat. nos. 16.1, 16.2, 35.1; figs. 10, 22, 23.
Bullaty-Lomeo, New York Cat. nos. 7.1, 26.1.
Chomon-Perino, Turin Figs. 51, 54.
Christies (A.C. Cooper), London Figs. 13, 25.
The Chrysler Museum, Norfolk, Virginia Cat. no. 6.
City Museum and Art Gallery, Plymouth, England Fig. 32.
Civici Musei d'Arte e Storia, Brescia Figs. 61, 67, 71, 72.
Civico Museo d'Arte Antica, Castello Sforzesco, Milan Cat. no. 50.1.
Color Dielle, Milan Cat. nos. 17, 48.
Piero Corsini Inc., New York Cat. no. 26.2.
Prudence Cuming Ass. Ltd., London Figs. 30, 52.
El Paso Museum of Art, El Paso Cat. nos. 7, 8.
Fondazione Scientifica Querini Stampalia, Venice Cat. nos. 43.1, 43.2, 43.3, 43.4, 43.5, 43.6; fig. 58.
Fototecnica, Vicenza Cat. nos. 38, 39.
Gabinetto Fotografico Soprintendenza per i Beni Artistici e Storici, Florence Figs. 14, 68, 69.
Galerie Cailleux, Paris Cat. no. 36.
Gasparini, Genoa Cat. no. 70.
Antonio Guerra, Bologna Cat. nos. 51, 52.
Harari & Johns Ltd., London Cat. nos. 12, 13.
Hermitage, Leningrad Cat. nos. 18.1, 40, 41; figs. 34, 35.
High Museum of Art, Atlanta Fig. 49.
Bruce C. Jones, New York Cat. no. 37.
Kimbell Art Museum, Fort Worth Cat. no. 22; fig. 1.
Kunsthalle, Hamburg Fig. 24.
Kunsthistorisches Museum, Vienna Cat. no. 4.
Lord Chamberlain's Office, London Cat. nos. 41, 41.1; fig. 63.
The Lowe Art Museum, University of Miami, Coral Gables Cat. no. 23.
Domenico Lucchetti, Bergamo Fig. 66.
The Metropolitan Museum of Art, New York Figs. 2, 3, 9.
Museo, Biblioteca e Archivio di Bassano del Grappa (Fotoservizi Bozzetto, Cartigliano) Cat. no. 38.1.
Museo del Palazzo di Venezia, Rome Cat. no. 19.1.
Museum of Fine Arts, Boston Cat. no. 5; figs. 19, 20, 38.
Národní Galerie (Vladimír Fyman), Prague Figs. 42, 62.
National Galleries of Scotland (Tom Scott), Edinburgh Fig. 4.
The National Gallery, London Cat. nos. 42, 44.
National Gallery of Art, Washington, D.C. Cat. no. 2.
National Gallery of Ireland, Dublin Cat. no. 20.
Newbery, Oxted, Surrey Fig. 29.
North Carolina Museum of Art, Raleigh Cat. no. 47.
Archivio Perotti, Milan Figs. 36, 46, 57, 59, 64.

Pinacoteca Nazionale, Bologna Cat. no. 20.1.
Rheinisches Bildarchiv, Cologne Fig. 27.
Royal Library, Windsor Castle Cat. nos. 33.1, 33.2; figs. 47, 53.
Alan E. Salz, New York Cat. no. 33.
Salzburger Landessammlungen, Salzburg Cat. nos. 34, 35.
Scala, Florence Cat. nos. 9, 18, 19, 24, 27, 28, 30, 43, 49.
Service Photographique de la Réunion des Musées Nationaux, Paris Cat. nos. 21, 32.2.
Spencer Museum of Art, Lawrence, Kansas Figs. 17, 18.
Staatliche Kunstsammlungen, Dresden Cat. nos. 14, 14.1, 14.2, 14.3, 14.4, 14.5.
Staatliche Museen Preussischer Kulturbesitz, Berlin Cat. no. 15.
Staatsgalerie, Stuttgart Cat. nos. 22.1, 31, 32.
Joseph Szaszfai, Branford, Connecticut Fig. 15.
Szépmüvészeti Múzeum, Budapest Fig. 5.
Thyssen-Bornemisza Collection, Lugano Cat. no. 47.
University of Kentucky Art Museum, Lexington, Kentucky Cat. no. 18.2.
A. Villani e Figli, Bologna Cat. nos. 4.1, 16.3; figs. 6, 7, 12, 43.
Wadsworth Atheneum, Hartford, Connecticut Cat. no. 29.
Walters Art Gallery, Baltimore Cat. no. 45.